FASHION:
A CANADIAN PERSPECTIVE

How does a country dress itself? From Montreal's 'Retail Mile,' to Ontario's millinery trade, to how war and television can affect the garment industry or whether tailoring can have a cultural impact, Alexandra Palmer gathers together some of the top curators, designers, fashion writers, historians, and artists in the country to create a dynamic and thought-provoking collection of essays.

Controversial and unconventional, *Fashion: A Canadian Perspective* challenges readers to consider aspects of Canadian identity in terms of what its citizens have chosen to wear for the last three centuries, and the internal and external influences of those socio-cultural decisions. Covering a broad range of topics – such as the iconic Hudson Bay blanket coats, garment factories of the late 1800s, specific Canadian fashion couturiers who have had international influence, and the contemporary role of fashion journalists and their effect on trends – this collection breaks new ground in producing multiple perspectives on fashion.

In a country that has given birth to such global fashion corporations as Club Monaco, Roots, and MAC, *Fashion: A Canadian Perspective* is an intriguing and readable history that links past to future, couture vision to trade trends, and heritage costuming to *Fashion Television*.

ALEXANDRA PALMER is the fashion and costume curator at the Royal Ontario Museum and an adjunct professor in the graduate program in art history at York University and the art history department at the University of Toronto.

Edited by Alexandra Palmer

Fashion
A Canadian Perspective

UNIVERSITY OF TORONTO PRESS
Toronto Buffalo London

© University of Toronto Press Incorporated 2004
Toronto Buffalo London

Printed in Canada

ISBN 0-8020-8809-0 (cloth)
ISBN 0-8020-8590-3 (paper)

Printed on acid-free paper

Library and Archives Canada Cataloguing in Publication

Fashion : a Canadian perspective / edited by Alexandra Palmer.

Includes index.
ISBN 0-8020-8809-0 (bound) ISBN 0-8020-8590-3 (pbk.)

1. Fashion – Social aspects – Canada. 2. Fashion – Canada – History –
19th century. 3. Fashion – Canada – History – 20th century. 4. Clothing
trade – Canada – History – 19th century. I. Palmer, Alexandra, 1957–

GT620.F37 2004 391'.00971'09034 C2004-901257-6

University of Toronto Press acknowledges the financial assistance to its publishing
program of the Canada Council for the Arts and the Ontario Arts Council.

University of Toronto Press acknowledges the financial support for its publishing
activities of the Government of Canada through the Book Publishing Industry
Development Program (BPIDP).

This book has been published with the help of a grant from the Humanities and
Social Sciences Federation of Canada, using funds provided by the Social Sciences and
Humanities Research Council of Canada.

Contents

Colour plates follow page 196

List of Illustrations

Colour Plates

Acknowledgments

I would like to acknowledge the support of many whose advice I have sought in the realization of this project. Jacqueline Beaudoin-Ross is one of pioneers in the area of Canadian fashion history and has given me great encouragement over the years, both as a student and professional. I am grateful for the support of Joy Parr, who offered enthusiasm for this undertaking in its seminal stages, and to Janice Helland, who advised in its latter stages, and to Canadian furniture historian Virginia Wright, who had time for insightful discussions on Canadian design. I am indebted to each of the contributors of this book who have been so patient in its realization. This is indeed a collaborative project. The editors and staff at the University of Toronto Press have guided this book over the years, and I especially thank Len Husband, Diane Mew, and Frances Mundy. I thank Andrea Retfalvi for creating the index, for which funding has been generously provided by the Nora E. Vaughan Curatorship Fund, Royal Ontario Museum. Finally, I must acknowledge the needed distractions of my family, Paul, Wyndham, and Hugo and the support of my sister Susan, who gave me practical advice and who serves as a wonderful role model with her endless enthusiasm for research projects.

FASHION:
A CANADIAN PERSPECTIVE

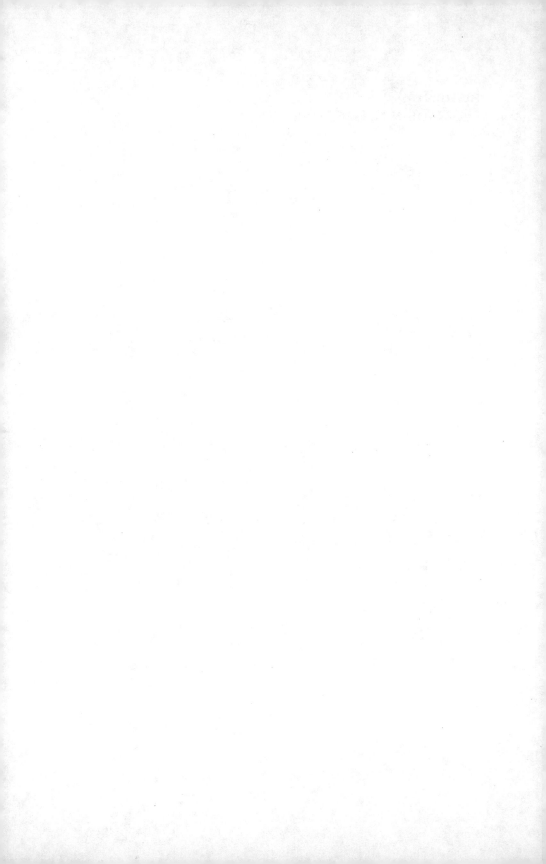

Introduction

ALEXANDRA PALMER

'What?... I didn't know there was any Canadian fashion.'[1] This comment, from a member of the British press who queried the invitation to a Canadian fashion show in London in 1988, highlights the absence of a national design identity for Canada. Unfortunately, such comments might well have come from the Canadian public, who also rarely recognize the work or names of their own fashion designers. This book hopes to begin to redress this situation.

Internationally successful Canadian fashion companies, such as Club Monaco or MAC, both of whom have been bought out by large American corporations, were never linked to their Canadian origins. There would appear to be no political, promotional, or economic advantage to advertising links to Canada because of its non-existent national design identity. Roots, begun by two Americans, is an anomaly; its beaver logo and marketing wed it to those Canadian icons, the great outdoors and wilderness, not to an urban or culturally sophisticated image. Witness, too, the current success of the Montreal-based leather goods merchant Rugby North America, whose name implies United States' ownership and manufacture by the omittance of Canadian specificity. The lack of promotion or recognition of Canadian ancestry also holds true today for contemporary designers, such as the internationally successful Canadian Patrick Cox, who operates his business out of London and is therefore generally considered to be British. These names are not well known within Canada as Canadian in origin. However, other designers who work outside their own country are often still identified with their nationality. We read about the invasion of the Paris couture by the British John Galliano and the Irish Alexander McQueen, or the American Tom Ford's phenomenal success in Milan and Paris. The Canadian press occasionally reports on Canadian ex-pats Dean and Dan in Milan, the success of Marie Saint-Pierre, 'the first Canadian to show in Paris,' or the plethora of Canadians working in fashion journalism in New York, but these stories are usually local and not taken up by the

international press.[2] Canadian fashion design identity languishes unacknowledged, especially when compared to France, America, Italy, Britain, or Spain, and any success by Canadians tends to become subsumed under the more identifiable American fashion scene. In fact, even this recognition denotes real achievement.

The non-Canadianness of Canadian designers and fashion, and why they are not recognized as such, raises complex issues of internationalism and the globalization of fashion and Canada's role within this matrix. On one hand, fashion is becoming more multinational, in terms of both design and manufacture, making trade and international borders increasingly irrelevant. On the other hand, the role of design in fashion shows, marketing, and the resulting press coverage is still very much linked to national identities.[3] Concomitantly, national design identity has become an increasingly important marketing tool in creating a unique fashion product, particularly when there is little distinction between designs. Thus cultural and national identity today often operates as a vital key to deciphering the exclusive and distinguishes the 'original' from the plethora of off-shore knock-offs.

Canadian trade shows have repeatedly attempted to create a national identity by promoting Canadian fashion abroad, but these are often neither recognized nor seen within Canada itself. Undertakings of this sort include Canada Designs for Business held in Tokyo in 1992[4] or the 1988 Liberty of London promotion of Canadian fashion. Both deliberately set out to promote Canadian design as a commercial product. The Liberty showcase featured twelve Canadian designers, yet at the time there were complaints that it was 'conservative and doesn't represent all that's happening in Canada.'[5] Such comments are indicative of the recurring problems in creating or recognizing a Canadian design identity.

At home, Canada continues to struggle to educate and promote its designers. Yet it has developed highly innovative programs such as the Toronto Fashion Incubator, emulated in Quebec and now serving as a model for a similar project in New York City.[6] The Design Exchange mounted the exhibition 'Fall Forward,' 'A showcase of excellence in Canadian fashion design for fall/winter 1996,' that also tried to engender interest in Canadian design, and was a step towards eroding the stereotype of a lack of Canadian fashion design.[7] However, as history reveals, this aim has been repeated by several groups and initiatives, each at various periods constructing their own Canadian fashion identity from zero. Thus by documenting these histories and making them accessible to Canadians, it may be possible to learn about and build upon a recognizable past.

The history of Canadian dress has received extremely little academic attention and is still in its infancy. In 1984 Jacqueline Beaudoin-Ross and Pamela Blackstock stated that 'the documentation of Canadian costume began in Quebec at the turn of this century when historians started to focus on costume of the French Regime and rural Quebec dress in short articles'[8] and pointed out that it was not

until 1966, with the anticipation of the 1967 centennial celebrations, that this interest grew. As their bibliographies demonstrate, there are many studies of Canadian regional dress stemming from an ethnographic and anthropological approach, and it is often these costumes that are clearly identified as Canadian. This has caused real difficulties when Canadians have required a national costume.

This problem was highlighted by an inquiry I received a few years ago. A concerned and proud father telephoned me, an assumed expert on Canadian fashion (given my position as the curator of fashion costume at the Royal Ontario Museum), because his daughter had won the Miss Italian-Canadian beauty contest and she was to represent Canada in the next stage of competition held in Italy. His question was, 'What should she wear to represent Canada?' The problem was that Canada has no national costume. He was very aware that aboriginal-inspired designs were the most readily identifiable to Europeans as Canadian, but also that this was no longer politically acceptable within Canada. Therefore, an aboriginal pastiche or Hollywood-style glamourizing was out of the question. He also commented on the fact that the previous year's contestant had made a faux pas by wearing a Mountie-inspired costume that was interpreted by the judges as too militaristic. He was in a serious quandry. I did suggest that he ask a Canadian designer to make his daughter a dress, but I realized that I did not have a satisfactory answer for him. So this book is in part a response to his question. However, rather than inventing Canadian traditions in a neo-nineteenth-century manner, it discusses diverse social, cultural, and economic historical moments and responses to fashion by Canadian producers, distributors, and consumers, thereby emphasizing Canadian interpretations and reactions to fashion.

The historiography of Canadian fashion studies and the early research and writing, has also been greatly predicated on museum collections and exhibitions that have concentrated on both Canadian-made and Canadian-worn clothing. Thus, as in other European and North American countries, the museum exhibition was often the first means of disseminating historical research on Canadian dress.[9] The larger costume collections include the Royal Ontario Museum in Toronto, the McCord Museum of Canadian History in Montreal, the Costume Museum of Canada in Dugald, Manitoba, and the Canadian Museum of Civilization in Hull, Quebec. Both Ryerson Polytechnic University and Seneca College in Toronto also have costume holdings that include Canadian designs.[10] There are also several smaller museum collections and private collections that contain dress worn and made by Canadians.[11] Yet, while most of these publicly funded costume collections have been exhibited in part over the years, few have been accompanied by publications. Such publications that have appeared have contributed to the seminal documentation and analysis of historical Canadian dress.

These include *Modesty to Mod, Bustles and Rosepetals: Fashion Is Art, 1882–1910* and, more recently, *Panache*, and *Form and Fashion: Nineteenth-Century Montreal Dress*. Cynthia Cooper's work on late-nineteenth-century fancy dress balls began as a book but also stood as an exhibition catalogue that documented and provided rich detail regarding the significance of fancy dress as an important and overlooked form of cultural production.[12]

While historical dress in Canada is only beginning to be documented, the post-1945 work on Canadian fashion is even less recorded in exhibition or textual format. One of the few exhibitions to display the work of the postwar period focused on Marie-Paule, the Montreal couturier, and was organized by the McCord Museum in 1989. Subsequently, curator Jacqueline Beaudoin-Ross's article, 'Marie-Paule Haute Couture,' provided a history of this couturier's business. More recently the travelling exhibit, 'Fabrications: Stitching Ourselves Together' by Kathryn Church, concerning her mother's wedding dress output in Red Deer, Alberta, has provided insight into the mid-western middle-class significance of this particular garment type.[13] The exhibition generated a great deal of interest and an interesting website, *www.grannyg.bc.ca*. Another perspective was undertaken in the exhibition 'Mode et collections' held at the Musée de la Civilisation, Quebec City, Quebec. Eight Quebec fashion designers, selected by a jury, were invited to choose pieces from the historical costume collection and to design an installation. In this instance the fashion designer-cum-artist-cum-curator was treated as a celebrity in his and her own right; it was the intervention and interpretation of the collection, based upon contemporary aesthetic and emotional responses, not historical accuracy, that was the spirit of the exhibit.[14]

The exhibition 'Au Courant: Contemporary Canadian Fashion,' which I curated in the spring of 1997, set out to show the diversity of Canadian fashion to stimulate public awareness of Canadian fashion as a sophisticated and commercial industrial product. It featured men's, women's and children's wear, and showcased accessory designers working in a wide range of styles and markets from across Canada. One of problems with this approach was that it was not a celebration of the most outlandish and attention-grabbing designs, nor even a display of the current most creative or celebrated designers. Unfortunately, the fashion world and the press are more concerned about who was 'in' and 'out,' and a celebrity 'fashion as art' format is much easier to promote than an interest in the successful range of established Canadian fashion companies. The record of this exhibit included a sixteen-page article produced by the Royal Ontario Museum that was inserted into the April issue of *Flare* magazine, and sent to 100,000 Ontario subscribers. It was also distributed as a free gallery guide. Another article discussing new textiles and technologies was published in the museum's magazine,

Rotunda. A biography of the designers included in the exhibition is available on the museum website and still receives interest and inquiries.[15]

Publications dedicated to Canadian fashion that are not linked to an exhibition are also few. Printed in 1989, the *Canadian Fashion Annual* records a particularly vital time in recent Canadian fashion.[16] However, this book was a one-off, and never made it as an annual series, though it emulated other annuals dedicated to fashion that at best survived only a few years.[17] The welcome addition to the scant Canadian literature on fashion, *In Style: 100 Years of Canadian Fashion*, by Caroline Routh, provided a general overview of Canadian-worn and designed fashions, and was one of the first attempts to map out a fashion history that includes designers, manufactures, and boutiques. This later inspired *The Evolution of Canadian Fashion* (1997), 'a multimedia resource exploring the world of fashion through the ages,' that is augmented with an accompanying *Student Study Guide and Glossary*, written by Sharmain Wilson and updated yearly by Dale Peers, professor and costume co-ordinator for Seneca Fashion Resource centre, for the Seneca College, School of Fashion and Merchandising.

The history of fashion design in the twentieth century has tended to centre on the biography and work of well-known designers such as Chanel or Dior. Canadian biographical designer histories are few, though this is currently being addressed by the internet site on Quebec designers spearheaded by Montrealer Gerald Baril, *www.dicomode.qc.ca*. The best-known biography, *Gaby*, describes the life of a successful Montreal couturier during the 1930s and clearly indicates the wealth of material available. Non-fashion biographies do describe designers who were Canadian and left an international mark on fashion – such as the Alberta Mormon bathing-suit designer Rose Marie Reid, the aesthetician Elizabeth Arden, or even the important early twentieth-century couturier Lucille – but few readers recognize these international fashion designers as Canadian.[18]

This volume breaks new ground in that it discusses not only the contribution of individuals to Canadian fashion, but also broader issues of fashion as it has operated within Canada. Canadian fashion is interpreted in multiple contexts, from social, cultural, economic, and labour perspectives. It also consid- ers a broad range of fashion products, from haute couture to mass production. Internal and external influences are addressed in order to understand how fashion has been harnessed to reflect, or deliberately create, diverse identities – feminine, masculine, and national – thereby setting the discussion into a socio-cultural Canadian framework that spans over three centuries.

Current scholarly viewpoints and methodologies are drawn together, not to create a linear chronology of style, but rather to consider a wide perspective of intertextuality and multidisciplinarity, and to look at Canadian fashion from the

centre and the periphery. The varied methodologies shed new light on the significance of fashion and blend traditional archival historical research, both interpretative and primarily documentary, with other resources. Oral history has the ability to capture the narratives of the marginalized, and thus is especially relevant for fashion, which is an arena that is traditionally equated with frivolous feminine trifles or trivialized by research conducted by 'overenthusiastic girls.'[19] While oral history has been championed by academics, the value of traditional descriptive, narrative, and biographical histories is currently considered outmoded and insignificant. Such histories are often pursued by non-academic writers as well as by new scholars who unearth novel and hitherto uncharted areas that can be taken up and developed. Thus, the inclusion of this primary research is especially relevant in this volume, which plots new territory and sets out to encourage future scholarship and new researchers who may not be familiar with this exciting and expanding field.

Beginning with the section Fashion and Identity, this book examines questions of national identity and tradition. These are directly addressed by Eileen Stack in her analysis of a single-garment type, the blanket coat, that has had a long and varied usage in Canada. She discusses the evolution of the garment's use and meaning, thereby writing a biography of a coat long associated with Anglo-Canadian winter sports and rituals, and adopted as a Canadian sartorial symbol in the late nineteenth century.[20] Her research sheds new meanings on the surviving costumes that were worn by both sexes and across generations to represent Canadianness, and she addresses important issues of ownership and perceptions that are self-generated and seen within a colonial and external view. Her work can assist us in contextualizing both historical and modern versions of the coat, such as a high-fashion 1980s blanket coat designed by Alfred Sung.[21] Cynthia Cooper's chapter sets out to analyse one particular aspect of a closed social setting, and shows how the popularity and identity of Canadian fancy dress revealed late nineteenth-century morality, and how an individual's choice of display was scrutinized by the public and press. Both Cooper and Stack clearly describe and analyse how fashion is socially constructed and modified stylistically, and, more profoundly, by issues of gender. Jan Noel examines the dress of three prominent male Montrealers and discusses how their fashionable attire assisted them in maintaining their masculinity and social status. This essay not only illuminates these issues within a Canadian context, but adds to the growing international literature on male fashion and masculinity.[22] The central issue of an identifiable Canadian fashion identity is taken into the twentieth century by my chapter on the Association of Canadian Couturiers. It assesses the impact of this organization's attempt to promote a national design identity in the postwar boom of the 1950s. The group was simultaneously

criticized for being either too provincial or not Canadian enough, and this delicate issue is still dogging contemporary Canadian fashion designers.

In the next section, Fashion and the Trade, Christina Bates, Peter Larocque, Elaine MacKay, Gail Cariou, and Elizabeth Sifton share an interest in the production of fashion but each approaches the subject from a different angle. They address fashion from the viewpoint of the manufacturer, worker, retailer, and consumer, and investigate how events, etiquette, and changes in style have been promoted or understood in response to Canadians' consumption, social, and cultural requirements.

Bates examines the millinery trade and extends her inquiry to include the resultant designs, which are analysed and linked to the impact of the shift in millinery fashionable styles upon the trade itself. Her use of material culture provides insights that are often overlooked, despite the fact that existing objects and materials are powerful reminders of actual, not reconstructed or hypothetical fashions. Larocque's study relates to the labour and the production of fashion by examining a specific year in Saint John, New Brunswick. This particular year was a high point of garment production and he assess the contribution made by female workers. Adding to Larocque's picture of the east coast, MacKay reveals that Halifax was an important centre for employment and garment production, and explores how this centre negotiated changes in manufacture and labour at the turn of the century in order to accommodate social and technological developments. Like Bates, Cariou's work centres around one business, and examines the records of one Montreal merchant tailor. Her essay adds to our understanding of this masculine trade and the difficulties of running a multigenerational business. From another perspective Sifton documents key moments in the changes in merchandising in Montreal's great department stores and illuminates how fashion was always a central focus for merchants who sold a wide range of household goods in a competitive setting. Here, too, the significance of location linked to consumption and clientele is clearly shown.

The following section, Fashion and Transition, addresses the controversial realm of conventional and radical dress and work for women. Barbara Kelcey looks at late nineteenth-century dress reform debates in Canada, including discussion of the contentious corset, which has served as a central issue for both feminists and anti-feminists. Susan Turnbull Caton discusses fashion nearly one hundred years later, during the Second World War, and reveals a similar anxiety regarding the role and appearance of Canadian women wearing trousers. Both corsets and 'bifurcated nether garments,' as the nineteenth-century critics modestly called trousers, threatened to undermine traditional masculine and feminine roles, and both chapters add a Canadian voice to this ongoing area of research.

In contrast, through the biography of one woman and one store, Jane Harris,

Lydia Ferrabee Sharman reveals how an individual created a dynamic fashion salon with its attendant culture in postwar Montreal, thus highlighting an historical and little-known aspect of retailing and the possibilities that it has long held for displaced and marginalized women. The importance of the personality of the individual, and the significance of boutiques as a place women created for themselves in the field of fashion, are histories often obscured by profiles on famous international designers, while small business histories leave few records in public archives, newspapers, or magazines.

Finally, three different perspectives are included on the profession of fashion journalism and advertising in the section Fashion and the Press. Barbara Freeman discusses the elaborate and descriptive newspaper reporting on fashion from low status female journalists in the 1890s. These 'new' women had to negotiate a complex role that catered to masculine authorities, the newspaper they worked for, and the merchandiser who paid for advertising fashion. They had to advise women readers on 'correct' fashionable dress, but as professional working women they could not ignore the controversial issues of dress reform. Ironically, these same reporters were themselves debunking traditional roles of femininity. The struggles of Canadian female journalists, some of whom adopted noms de plumes, are contrasted with those a century later. The late-twentieth-century television fashion reporter Jeanne Beker, a celebrity in her own right, represents a powerful female journalist who is syndicated worldwide. Deborah Fulsang shows how Beker's model of reporting has emanated from Canada and is now a global standard, and examines the legacy of *Fashion Television*'s style on our contemporary understanding and assimilation of fashion information. Both authors show the important role that women play in reporting on fashion and demonstrate the limitations and advancement that has been achieved by Canadians within this discourse.

In her study of the important and successful advertisements for Eaton's in the 1960s and 1970s, Katherine Bosnitch reveals the significance of graphic design that is harnessed to market the modernity of fashion. She shows that international recognition of Canadian design is not lauded in Canada, emphasizing the need for Canadians to record their own histories. Like Sharman and Palmer, Bosnitch also uses oral history in order to gain access to the elusive and unrecorded, thereby reiterating the importance of capturing oral histories while the protagonists are available.

Canadian fashion has not previously been addressed from a centralized stance even within Canadian studies. All the authors have directly contributed to the recording of this neglected subject and have demonstrated its inextricable links to social, cultural, and economic events in times of adversity and prosperity. However, these histories, though centred in Canada, amplify the ongoing examination of fashion internationally and the unique position Canada holds within North

America. Canada is sympathetic to and reliant upon the United States, while simultaneously allied to Europe and a colonial past – a situation that has rarely been discussed in this country in academic terms for fashion. Thus, by recognizing and recording Canadian fashion histories, readers will be better able to set both Canadian history and fashion within an international context as well as provide models for the interpretation of similar or divergent international histories.

We hope that this kaleidoscopic view of Canadian fashion will stimulate further histories and discussion, and that the notes and bibliographies will provide valuable source material. Just as the authors are drawn from diverse areas and foci, it is intended that this volume will be of interest to a varied readership, including those interested in Canadian history, Canadian studies, women's studies, and design and fashion history in general. *Fashion: A Canadian Perspective* demonstrates that there was and is such a thing as Canadian fashion, and that only by examining this history in its complexity can we begin to assess its significance and impact today and for the future.

NOTES

1 Rod McQueen, 'Pursuit of Liberty: Breaking into the British market – The Canadian fashion industry finds itself a London showcase,' *Toronto Life*, September 1988, 32.
2 See, for example, David Graham, 'Twins design for the stars,' *Toronto Star*, 16 March 2000: E5; Tralee Pearce, 'Canada's unsung expats make inroads at home,' *Globe and Mail*, 3 March 2002,' L4; Deborah Fulsang, 'Saint-Pierre tries Paris,' *Style*, 17 April 1995, 1; Deborah Fulsang, 'Saint-Pierre takes Manhattan,' *Style*, 13 May 1996, 26; Bernadette Morra, 'Montreal's Saint-Pierre fashionably late in Paris,' *Toronto Star*, 23 March 1995, C3.
3 See Lou Taylor, 'The Hilfiger Factor and the Flexible Commercial World of Couture,' in Nicola White and Ian Griffiths eds., *The Fashion Business: Theory, Practice, Image* (Oxford: Berg, 2000), 121–42.
4 Canada Designs for Business, held 19 June to 17 July 1992 at Ontario House, Tokyo, Japan. The fashions represented were by Hoax Couture, Mountain Equipment Co-op, North Accessories, John Fluevog, Zapata, and Alfred Sung. This was put on by the Design Exchange and the Group for Design in Business.
5 Rod McQueen, 'Pursuit of Liberty,' 32. The designers were Alfred Sung, Babel, Anne Seally, Bent Boys, Comrags, Zapata, Price Roman, Laura Kapp, Tu Ly, Michael Tong, Dénommé Vincent, and Thalie. This was part of a three-week event sponsored by the Canadian High Commission to promote Canadian arts and culture in London. It was given about 10 per cent of the annual cultural affairs budget ($30,000), and additional monies came from Tourism Canada.

6 *www.fashionincubator.on.ca*

7 Held 6 September to 13 October 1996 at the Design Exchange, the exhibition featured designers Mimi Bizjak, Ron Leal, Wayne Clark, Marie Saint-Pierre, Marisa Minicucci, Jennifer Halchuk, Catherine Regehr, Brian Bailey, Franco Mirabelli, Jean Claude Poitras, Lida Baday, and Loucas Kleanthous.

8 Beaudoin-Ross and Blackstock, 'Costume in Canada,' 59.

9 A similar mapping of the history is currently being undertaken in Canadian craft history. See several articles in Johnson, ed., *Exploring Contemporary Craft*. See Gottlieb and Golden, *Design in Canada: Fifty Years from Teakettles to Task Chairs* for a discussion of industrial design that includes textiles. See also Lou Taylor's discussion of the history of fashion in museums, 'Doing the Laundry? A Reassessment of Object-Based Dress History,' *Fashion Theory* 4, no. 2 (1998): 337–58.

10 Most provincial museums and historical societies also have costume and textiles, such as the Provincial Museum of British Columbia, Victoria; Manitoba Museum of Man and Nature, Winnipeg; and the Glenbow Museum, Calgary; Nova Scotia Museum, Halifax; and the New Brunswick Museum, Saint John.

11 Alan and Mary Suddon Collection, Toronto, that has recently been donated to Ryerson University; Jonathan Walford collection, Toronto; Ivan Sayers collection, Vancouver.

12 The exhibition called 'Dressing Up Canada: Late Victorian Fancy Dress Balls' was held at the Canadian Museum of Civilization, 24 October 1997 to December 1998.

13 This was seen at the Red Deer and District Museum, 25 July to 27 September 1998 and travelled to six additional venues across Canada.

14 'Mode et Collections' was held in 1998. The designers were Jean Airoldi, Hélèn Barbeau, Line Bussière, Christian Chenail, Michel Desjardins, Véronique Miljkovitch, Jean-Claude Poitras, and Marie Saint-Pierre. This exhibit is archived on the website *www.mcq.org*. Thanks to Cynthia Cooper for informing me of this.

15 Palmer, 'High-Tech, Streetwise and Eco-Natural'; 'Au Courant: Contemporary Canadian Fashion,' was held at the Institute of Contemporary Culture, Royal Ontario Museum from 19 April 1997 to 4 January 1998. Supplement to *Flare*, April 1997; see also *www.rom.on.ca*.

16 *Canadian Fashion Annual, 1989.*

17 Polan, ed., *Fashion 84 Annual*; White, ed. *Fashion 85*; *Fashion 86*.

18 Burr and Petersen, *Rose Marie Reid*; Lewis and Woodward, *Miss Elizabeth Arden*; Lucille, *Lady Duff Gordon*; Etherington-Smith and Pilcher, *The 'It' Girls: Elinor Glyn, Novelist, and Her Sister Lucille, Couturiere*.

19 Lomas, '"I know nothing about fashion. There's no point in interviewing me": The Use and Value of Oral History to the Fashion Historian.' For work on fashion history methodologies that includes the use of oral history, see Taylor, *The Study of Dress*

History; and Palmer, 'New Directions: Fashion History Studies and Research in North America and England.'

20 Kopytoff, 'The Cultural Biography of Things: Commoditization as Process.'

21 Royal Ontario Museum, Alfred Sung coat, ROM 982.49.1.

22 For a more contemporary reading of the issue of masculinity in Canada, see Higgins, 'A la Mode: Fashioning Gay Community in Montreal.'

SELECTED BIBLIOGRAPHY

Beaudoin-Ross, Jacqueline. *Form and Fashion: Nineteenth-Century Montreal Dress*. Montreal: McCord Museum of Canadian History, 1992.

– 'Marie-Paule Haute Couture,' *Dress* 18 (1991): 14–25.

Beaudoin-Ross, Jacqueline, and Pamela Blackstock. 'Costume in Canada: An Annotated Bibliography,' *Material History Bulletin* 19 (Spring 1984): 59–92.

– 'Costume in Canada: The Sequel.' *Material History Review* 34 (Fall 1991): 42–67.

Bovey, Patricia E. *Bustles and Rosepetals: Fashion Is Art, 1882–1910*. Winnipeg: Winnipeg Art Gallery, 1980.

Brett, Katherine B. *From Modesty to Mod: Dress and Underdress in Canada, 1780–1967*. Toronto: Royal Ontario Museum / University of Toronto, 1967.

Breward, Christopher. *The Hidden Consumer: Masculinities, Fashion and City Life, 1860–1914*. Manchester: Manchester University Press, 1999.

Burr, Carole Reid, and Roger K. Petersen. *Rose Marie Reid: An Extraordinary Life Story*. American Fork, Utah: Covenant Communications, 1995.

Canadian Fashion Annual, 1989. Scarborough, ON: Prentice-Hall Canada, 1988.

Cooper, Cynthia. *Magnificent Entertainments: Fancy Dress Balls of Canada's Governors General, 1876–1898*. Fredericton and Hull: Goose Lane Editions and Canadian Museum of Civilization, 1997.

Etherington-Smith, Meredith and Jeremy Pilcher. *The 'It' Girls: Elinor Glyn, Novelist, and Her Sister Lucille, Couturiere*. New York: Harcourt Brace Jovanovich, 1986.

Fashion 86: The Must-Have Book for Fashion Insiders. New York: St Martin's Press, 1985.

Gottlieb, Rachel, and Cora Golden. *Design in Canada: Fifty Years from Teakettles to Task Chairs*. Toronto: Alfred A. Knopf Canada, 2001.

Guernsey, Betty. *Gaby: The Life and Times of Gaby Bernier, Couturière Extraordinaire*. Toronto: Marincourt Press, 1982.

Higgins, Ross. 'A la Mode: Fashioning Gay Community in Montreal.' Pp. 129–61 in Anne Brydon and Sandra Niessen, eds., *Consuming Fashion: Adorning the Transnational Body*. Oxford: Berg, 1998.

Hobsbawm, Eric, and Terence Ranger, eds. *The Invention of Tradition*. Cambridge: Cambridge University Press, 1984.

Johnson, Jean, ed. *Exploring Contemporary Craft: History, Theory and Critical Writing.* Toronto: Coach House Books with Harbourfront Centre, 2002.

Kopytoff, Igor. 'The Cultural Biography of Things: Commoditization as Process.' Pp. 64–91 in Arjun Appadurai, ed., *The Social Life of Things: Commodities in Cultural Perspective.* Cambridge: Cambridge University Press, 1986.

Lewis, Alfred Allan, and Constance Woodward. *Miss Elizabeth Arden: An Unretouched Portrait.* New York: Coward, McCann & Geoghegan, 1972.

Lomas, Clare. '"I know nothing about fashion. There's no point in interviewing me." The Use and Value of Oral History to the Fashion Historian,' pp. 363–70. Stella Brussi and Pamela Church Gibson, eds., in *Fashion Cultures. Theories, Explorations and Analysis.* New York and London: Routledge. 2000.

Lucille. *Lady Duff Gordon: Discretions and Indiscretions.* London: Jarrolds, 1932.

Palmer, Alexandra. *Couture and Commerce: The Transatlantic Fashion Trade in the 1950s.* Vancouver: UBC Press and ROM, 2001.

– 'High-Tech, Streetwise and Eco-Natural.' *Rotunda* 29 no. 3 (Spring 1997): 24–33.

– 'New Directions: Fashion History Studies and Research in North America and England.' *Fashion Theory, The Journal of Dress, Body and Culture* 3 (1997): 1–16.

Panache: 200 Years of the Fashionable Woman. Vancouver Museum, December 1990– August 1991.

Polan, Brenda, ed. *Fashion 84: The Must-Have Book for Fashion Insiders.* New York: St Martin's Press, 1983.

Routh, Caroline. *In Style: 100 Years of Canadian Fashion.* Toronto: Stoddart Publishing, 1993.

Taylor, Lou. *The Study of Dress History.* Manchester and New York: Manchester University Press, 2002.

White, Emily, ed. *Fashion 85: The Must-Have Book for Fashion Insiders.* New York: St Martin's Press, 1984.

FASHION AND
IDENTITY

'Very Picturesque and Very Canadian': The Blanket Coat and Anglo-Canadian Identity in the Second Half of the Nineteenth Century

EILEEN STACK

The task of identifying Canada's national dress is not an easy one. Indeed, even costume historians hesitate when queried. During the second half of the nineteenth century, however, one garment was readily identified as Canadian costume: the blanket coat. Cut and sewn from a wool blanket or blanket-like material and constructed with a distinctive hood, the blanket coat has been worn in North America since the mid-seventeenth century.[1] Although the blanket coat is mentioned in several studies, little or no interpretation of the phenomenon has been offered.[2]

This chapter examines Anglo-Canadian use of the blanket coat in the second half of the nineteenth century and explores the reasons why the coat came to be viewed as representative of Canadian identity. Complementing this review is a survey of the coat's depiction in photographs taken at the Montreal studio of William Notman from 1860 to 1900.[3]

To understand the cultural connotations of the blanket coat as it was perceived in the late nineteenth century, it is necessary to review the garment's history in North America as well as that of its predecessor, the *capote*. Costume historian Francis Back identifies the *capote* as a hooded coat worn by French sailors and traded to First Nations tribes in the early 1600s, and used by French settlers and the French military from the mid-seventeenth century onwards.[4] The earliest reference to the blanket coat is by the First Nations and dates to 1644.[5] By the mid-eighteenth century, blanket coats were traded by the French and English, worn by members of the French community, and associated with the voyageurs and coureurs de bois, the men involved in the fur trade's rigorous work. By the third quarter of the eighteenth century, references to blanket coats commented on their widespread use by 'Canadian peasants' as well as American, German, and British soldiers stationed in Canada.[6]

Though military use of the blanket coat tapered off in the nineteenth century,

the coat remained popular with First Nations and French-Canadian *habitant* men as a variation of the *capote*.[7] In the second half of the century the blanket coat emerged as a popular garment among middle- and upper-class Anglo-Canadian men and women for winter sports and recreational activities. Though the style of blanket coat used by Anglo-Canadians maintained the garment's trademark hood and contrasting stripes of colour, its cut and construction conformed to nine-teenth-century Euro-American fashions. Amongst the coat's new group of consum-ers were two influential figures in Anglo-Canadian society, the elite Montreal Snow Shoe Club and Canada's governors general. The adoption and public endorsement of the blanket coat by these two groups is key to understanding the garment's popular-ity and cultural significance to Victorian Anglo-Canadian society.

Anglo-Canadian use of the blanket coat was notably linked to the development of the sport of snowshoeing. The earliest records of recreational snowshoeing in Canada date to 1840 when twelve prominent members of Montreal society undertook weekly treks through the city.[8] Until this time, the snowshoe was used as a practical winter transportation method, invented and refined by the First Nations and adopted by French and English fur traders, settlers, and farmers.

In 1843 these early snowshoe enthusiasts founded the Montreal Snow Shoe Club (MSSC), and organized weekly tramps as well as competitive races. Typical of nineteenth-century gentlemen's sporting clubs, the MSSC functioned as an exclusive social network affirming economic, cultural, and homo-social relation-ships. By the mid-1850s the club had grown to fifty members, and in 1858 two other Montreal snowshoe clubs were formed.[9] An 1859 article appearing in the *Montreal Transcript* offered the first mention of the MSSC's adoption of the blanket coat for its outings, describing the outfit as 'a blanket coat, with capote attached, firmly bound round the waist with a sash or belt; blanket continuations, and moccasins of moose-hide; together with the indispensable snow-shoe.'[10]

In the 1860s snowshoeing in Montreal was affected by the political turbulence of the American Civil War and concerns about Canada's possible annexation. While pre-occupation with military preparedness in the early 1860s resulted in a lessening of MSSC activity, the second half of the decade was marked by a new emphasis on military-like organization and an increased spirit of imperialism. These interests were expressed in a more rigorous training program and the awarding of medals at races. Though snowshoeing had been for years credited with inspiring the qualities essential to a virile Victorian, in the second half of the 1860s it was extolled as providing the stamina, skill, and devotion necessary to securing a nation's viability. A speech made in 1867 by longtime club member Nicholas 'Evergreen' Hughes, linked the snowshoer's 'bodily superiority' to the success of the 'future Kingdom of Canada.'[11]

In the late 1860s, participation and spectatorship at snowshoe races increased dramatically. With the rise in the popularity of racing, interest in trekking lessened. To help boost interest in and increase the visibility of the tramps, club

colours were adopted in 1869 and displayed through the use of tuques adorned with decorative wool tassels. The colour blue was selected for the club's tuque, and soon the term 'Tuque Bleu' became synonymous with the MSSC and its members. Annual club membership badges were appliqued onto the front of the coat, red or white in the early 1870s, and red, white, and blue after 1875.[12]

Morrow contends that the MSSC made a concerted effort in the 1870s to promote an ethos of snowshoeing and foster a public image of recreational snowshoers as noble and upstanding 'Knights of the Snowshoe.' To this end, it was membership policy to carefully screen applicants, ban alcohol at MSSC gatherings, and promote general revelry in military-influenced rituals such as the wearing of uniforms and awarding of medals and badges. The public persona of the club was realized through its involvement in events such as charity concerts at which the wearing of full snowshoe uniform was compulsory for members.[13] Additional publicity was garnered through the writings of longtime MSSC member and journalist George Beers. Beers published numerous articles in Canada and abroad that passionately extolled the benefits of snowshoeing for the development of physical and moral character of the individual and nation.[14]

Members of the MSSC channelled great effort into promulgating the club's allegiance to the British crown and to the success of the Anglo-Saxon race in Canada. British dignitaries were feted at club dinners, and the Prince of Wales was offered an honorary life membership in 1870. Songs sung at tramp receptions pledged the club's commitment to Britain. Essays by the likes of Beers reflected a fervent belief in the importance of sports such as snowshoeing to the success of 'Anglo-Saxon heritage in Canada.'[15]

A composite photograph of the MSSC exhibited in Paris in 1878 shows the club's social standing in Canada and its use of the blanket coat in this period. Created by the studio of William Notman, the composite features the governor general, Lord Dufferin, an honorary life member of the club, front and centre in the photograph (illustration 1). Although it is difficult to isolate the exact moment at which the blanket coat changed from being simply a sportsman's uniform to a symbol of Anglo-Canadian identity, this photograph is surely expressive of that transformation.

The 1880s presented additional opportunities for the aggrandizement of the snowshoers' public image through a series of well-attended and publicized winter carnivals in Montreal. Initially conceived in 1882 by the vice president of the MSSC as a celebration of winter sports, the athletic component of the carnivals was rivalled by the hyperbole surrounding other activities, such as masquerade skating parties, parades, and ice castles. Merchants were quick to seize upon this lucrative opportunity to market carnival-related goods and souvenirs. Blanket coats were advertised as 'carnival costumes' and furnished free of charge by photography studios as winterizing props.[16]

Winter sports remained the key feature of the carnivals, and snowshoeing was

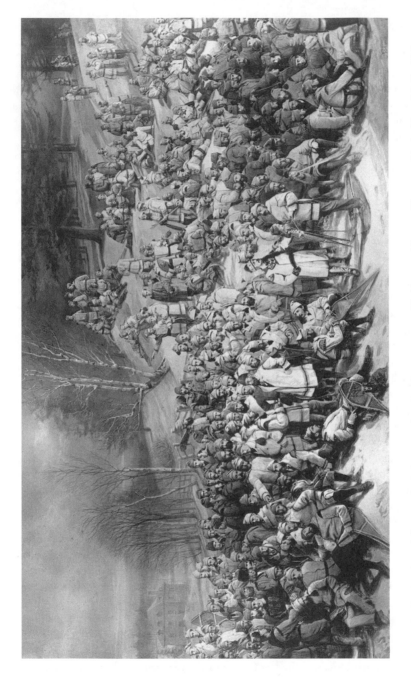

1 *Montreal Snow Shoe Club, Mount Royal,* Montreal, QC, composite, 1877 (II-44798.1, Notman Photographic Archives, McCord Museum of Canadian History, Montreal)

most prominent among these. By 1885 there were twenty-five clubs in Montreal and membership in the MSSC was at an all-time high of one thousand. At the winter carnival, snowshoers from Montreal and surrounding clubs were conspicuous in their blanket coats, and the adoption of the garment by women and the social elite was especially noted in the press.

Over the course of this decade the MSSC promoted its official club uniform more energetically. In December 1884 the club formed a committee to select 'a special blanket pattern for a Club Blanket' to be sold exclusively to its members. Though the colors of the new blanket remained the Club's traditional red, white, and blue, the width and placement of each stripe of color was standardized.[17] Whereas earlier club by-laws called for a white blanket coat of no particular design, the 1886 by-laws specified 'a blanket coat of registered pattern.'[18]

Although snowshoeing was a celebrated feature at the winter carnivals and club membership levels were high in the 1880s, the sport was experiencing a decline in active participation in tramps. As the decade drew to a close and the 1890s began, interest in other sports such as tobogganing, ice skating, and hockey took precedence. Despite fewer participants, the popular perception of the virile, noble snowshoer in his striking blanket coat had been well established in the public imagination. While snowshoeing played less of a role at the winter carnivals of the 1890s, the blanket coat continued to be worn, noted, and celebrated.

With the socially prominent snowshoers' appropriation and ennoblement of the blanket coat, the garment entered the repertoire of winter wear of the Anglo-Canadian elite. The blanket coat was also modified into women's and children's wear and was worn for a greater variety of winter sporting and leisure activities. Despite this shift in use, the blanket coat continued to be most closely associated with winter sports considered indigenous to Canada, snowshoeing and tobogganing.

As the representative of the crown in Canada, the governor general symbolized the pinnacle of Anglo-Canadian identity in the nineteenth century. Whether in residence at Rideau Hall in Ottawa or touring the country, the habits and activities of the viceroyalty were widely reported in the press and emulated by Canadians. Between 1872 and 1898, a period in which five governors general served in Canada, four were photographed or observed by the press as wearing a blanket coat. Furthermore, two of the governors general's wives remarked in their private journals on their families' use of the garments, providing important insight as to how the coat was perceived and consumed by this elite group.[19]

The use of the blanket coat by Canada's governors general can be viewed as an extension of their involvement in Canadian sports. Support was given to imported sports believed to strengthen ties with Great Britain, such as cricket and curling, and to those perceived to be native to Canada's northern climate, namely snowshoeing and tobogganing.[20] Patronage of sport was also intended to foster an

imperial cultural bond.[21] Lord Dufferin's pronounced effort to cultivate participation in sports in the 1870s set the standard for vice-regal activity in Canada. Dufferin installed a curling rink at Rideau Hall and renovated the existing toboggan slide. His patronage of snowshoeing dated from 1873 when he was made an honorary life member of the MSSC. Lady Dufferin kept a journal chronicling her family's involvement at sporting events, and she noted their use of the blanket coat. In November 1872, she described the sight of her children playing in the snow: 'You should see them all five in blanket coats, which are made of thick blue cloth, with red epaulets and sashes, and pointed hoods lined and piped in red. The coats are very long and straight, and the little figures in them look both funny and picturesque.'

In describing the reception she and her husband were given by the Montreal Snow Shoe Club in January 1873, Lady Dufferin makes clear her romantic impression of the garment's nationalistic connotations: 'This evening we attended a snowshoe torchlight procession given in our honour ... They wore white blanket coats, tight leggings, and red caps, and the sight was really very picturesque and very Canadian.'[22]

Living in Canada from 1883 to 1888, the Marquis and Marchioness of Lansdowne experienced the height of the blanket coat's popularity. During the very first months of his tenure, Lansdowne was caricatured in *Punch* wearing a blanket coat and tuque (illustration 2). Making reference to the perception of his appointment to Canada as a kind of banishment, the caption reads 'Lord Lansdowne, in his new Canadian Costume, specially adapted to remaining for some time out in the cold.' The cartoon's identification of the blanket coat as a Canadian costume shows that by 1883 the garment was understood and promoted as a kind of national dress in the popular vocabulary of Anglo communities in Canada and abroad.

Perhaps the best-remembered of the governor general families were the Aberdeens, stationed in Canada from 1893 to 1898. A socially active couple with four children, the Aberdeens made full use of Rideau Hall's three toboggan slides, three ice rinks, and acres of land for snowshoeing. In their memoir published in 1925, the Aberdeens described their first winter in Canada:

> Those Saturday skating and tobogganing parties, which we gave weekly, were great features of Government House life during the winter ... the scene was a very gay and merry one, blanket coats and costumes with belts of many colours woven by the french 'habitants' being the correct attire.[23]

Lady Aberdeen also kept a journal that detailed her family's involvement in winter sports and their use of the blanket coat. During her first winter in Canada, Lady Aberdeen wore one while making her Christmas gift-giving rounds, noting

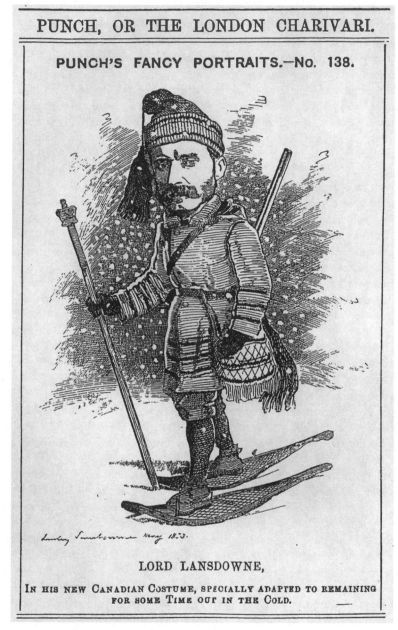

2 Lord Lansdowne as depicted in *Punch*. (*Punch or the London Charivari*, 2 June 1883, 262)

that a 'white blanket coat trimmed with red makes an excellent costume for Santa Claus.' An appreciation for the more pragmatic use of the blanket coat is given two days later when she mentioned purchasing them for her family as part of her 'necessary winter shopping.' Four days after this excursion, photographs of the Aberdeen family and entourage were taken on the steps of Rideau Hall. The chosen garments for the image-making session were blanket coats.[24]

Lady Aberdeen had a keen interest in the blanket coat's cultural origins and took up the cause of its promotion in Canada. In her article entitled 'Our First Winter in Canada,' published in January 1895, she dedicated a lengthy paragraph to the garment:

> There is a material made in Canada called blanket cloth which is admirably fitted for winter wear; it is, in fact, an adaptation of the blanketing worn by the Indians, and has been greatly in vogue amongst the merry tobogganers. But we are disposed to think that it is not sufficiently appreciated or worn by the general public. We think that the members of the Government House staff never look so well as when they turn out in their dark blue blanket suits ... with the many colored scarfs, woven in times gone by by [sic] the French peasants wound round their waists. It is a pity that a photograph of our own family could not have been rendered in colors to illustrate the variety that may be obtained in these costumes.[25]

The photograph to which Lady Aberdeen referred was likely the one taken in 1894. This photograph appeared in the *Toronto Globe* and was reproduced as a line drawing in the *Chicago Herald* alongside an article introducing 'Canada's new Governor General.'[26] These features and the press coverage given during the Quebec Winter Carnival served to create a public connection between the Aberdeens and the blanket coat. Through this action, the relationship between Anglo-Canadian identity and the blanket coat was further reinforced and disseminated.

William Notman emigrated from Scotland in 1856 and opened a photography studio in Montreal later that year. In operation for close to eight decades, the studio produced approximately four hundred thousand photographs. The archives are now at the McCord Museum of Canadian History in Montreal.[27] In a review of this collection, over 450 photographs of sitters wearing blanket coats were found dating from the years 1860 to 1900.[28] The blanket coat's appearance in these photographs is perhaps the most overt example of the garment's use as an image-making device. Whether a studio-owned prop or the client's own coat, a choice was repeatedly made by sitters to have their image reproduced wearing a blanket coat. Just as the use of fur garments in Notman's photographic portraits has been interpreted as a symbol of conspicuous consumption intended to mark

wealth and social status, the popularity of the blanket coat worn in images produced by the Notman studio suggests that it too had its own set of meaningful properties.

Although nineteenth-century photographs are often used to determine actual clothing use as opposed to the more idealized or fanciful dress depicted in period fashion plates or painted portraits, caution must be exercised when applying this practice to the Notman photographs. As noted by art historian Jana Bara, the frequency with which specific garments appeared in Notman's images suggests that the studio kept a collection of clothing as props.[29] Certainly rival photographers provided blanket coats to their patrons, even advertising 'Sitters furnished with Snow-Shoe Costume, free of charge.'[30] Regardless of whether or not every blanket coat depicted in these photographs was actually owned by the sitter, its presence in these carefully contrived images is nonetheless telling of the patron's desire to be represented wearing this particular garment.

In addition to the impressive size of the collection, the work of the Notman studio is significant for the role it played in the development and dissemination of photographic trends and visual imagery that portrayed a specifically Canadian identity. Notman's souvenir photographs presented a stereotypical image of Canada as a 'snow bound wilderness, endowed with enormous natural bounty, and as a playground' for the privileged classes.[31]

In Notman photographs of the 1860s, the blanket coat is depicted almost exclusively on men posed as hunters or sportsmen against backdrops of a winter landscape. During this period, Notman catered to the tastes of newly made merchants and British garrison officers who desired visual evidence of their real or imagined battles in the new land. Bara interprets the appearance of the British gentleman-sportsman as a variation of the stereotype of the imperialist pioneer in Canada and notes the importance of clothing to these images. She states 'the gentleman-hunter, dressed in buckskins, or embroidered Canadian habitant woolen coat, was a direct continuation of the already existing archetype of a hero-hunter, indigenous to Canadian iconography since its beginnings.'[32]

The Notman studio went to great lengths to market a new genre of winter portraiture in this period, even patenting a technique for simulating falling snow in 1867.[33] In an advertisement of the same year, the studio promoted its specialty:

Portraits in Winter Costume
W. Notman has just completed a new
arrangement for
PORTRAITS IN WINTER COSTUME.
This style is very effective and has the
additional advantage of affording

> friends at a distance an excellent idea of
> our Canadian winters and the following
> Canadian sports and outdoor
> amusements.
> Snowshoeing,
> Tobogganing.[34]

Visitors to the studio often chose to have a set of photographs taken showing two images of Anglo-Canadian life, the urban and civilized versus the rural and untamed. The first features the sitter in formal or street clothes posed among ornate furniture and drapery expressive of European portraiture conventions. Those affiliated with the British garrison typically wear their full military uniform. The second type of photograph features the same sitter dressed in a blanket coat against a scene mimicking a snowy Canadian winter. As the advertisement suggested, the photographs were sent home to 'friends at a distance' as souvenirs, a practice which would have further disseminated this contrived portrait of Canadian identity.

Notman photographs of men produced during the 1860s feature two kinds of blanket coats. The first is a knee-length, hooded coat made of a dark-coloured material, with plain fabric epaulettes. With its hood, double front closure, and waist sash, this coat is reminiscent of the *capote*. In the second half of the decade, a light-coloured coat with contrasting stripes appears that more closely meets the standard criterion of a blanket coat. It is frequently worn with pale-coloured leggings with contrasting bands under each knee. Given the context of the 'Native'-inspired origins of the blanket coat, these leggings can be interpreted as representing *mitasses* – that is, the lower leg gear worn originally by First Nations for protection in deep brush.[35]

In the 1870s the Notman studio turned its attention to the production of elaborate composite photographs.[36] The studio took as its subject visuals particular to the Canadian landscape and featured outdoor winter activities in which the blanket coat was the dominant garment worn by sitters. The Montreal Snow Shoe Club was photographed several times by the Notman studio. The first of these composites, 'The Rendez-Vous,' was created in 1872 and depicts the arrival of the Club at Lumkins Hotel.[37] A number of the snowshoers are depicted in the knee-length, light-coloured blanket coats identified as props in portraits of the 1860s. Also visible is a new style of coat with a shorter, boxier cut and stripes on the coat's lower sleeves.

The Notman studio also actively produced souvenir photographs of men, women, and children dressed in blanket coats, posed individually or in small groups. The theme of these photos was typically a jovial snowshoeing or tobogganing outing. Some images were later cut out and pasted into composites or posters

reproduced for sale or exhibition. Stylistic features introduced to men's blanket coats in the 1870s appear as standard in the 1880s, including the use of light-coloured fabric for the coat and trim elements including piping, epaulettes and stripes at hem, sleeve cuffs, and hood. Around 1882–83 membership and participation ribbons begin to appear on the left breast of the coats.[38]

The number of Notman studio portraits featuring sitters in blanket coats decreased dramatically in the 1890s and there were few stylistic changes. While approximately two hundred images date from the 1880s, less than fifty were found for the 1890s. This drop parallels a general decrease in enthusiasm for winter sports. The fiftieth anniversary of the Montreal Snow Shoe Club in 1890, for example, had considerably fewer active participants than the celebrated levels of the 1870s and 1880s. Though winter carnivals were hosted in Quebec City in 1894 and Ottawa in 1895, their occurrence had little impact on the Notman studio's trade in winter photographs.

Notman's photographs of women wearing blanket coats also first appear in the 1860s, though they are scarce compared with those of men, with only four women appearing throughout the entire decade.[39] Most of the coats look oversized and ill-fitting, suggesting that the garments were borrowed directly from menswear. In contrast, Louisa Erskine Wolseley was photographed in 1868 with her husband, Viscount Garnet Wolseley, wearing a blanket coat cut to follow the proportions of her frame and the silhouette of her skirt. This photograph signals the blanket coat's true assimilation into women's wear.

During the 1870s, photographs of women in blanket coats appear only in the second half of the decade. In the 1876 composite image entitled 'Carol Group at Longueuil,' three women singers wear mid-thigh-length, pale-coloured coats with stripes over dark skirts. The year 1878 marks the first appearance of the blanket coat with a matching striped skirt, a style that would be popular in the 1880s. Two basic styles of blanket coat are found in that decade: a thigh-length coat with a matching skirt first seen in the late 1870s, and a full-length blanket coat. As with certain men's coats that appear repeatedly in Notman's photographs, two blanket coats for women are photographed with such frequency that they appear to be studio props. By 1892, a more up-to-date version of the blanket coat appears with exaggerated epaulettes that emulate the period trend for upper-sleeve fullness.[40]

Children dressed in blanket coats were a popular subject at the Notman studio. In fact, the earliest Notman photograph featuring the light-coloured blanket coat with dark stripes is of a young child, and William Notman photographed his own son wearing a blanket coat in 1867. There are approximately two dozen images of children, mostly males, in blanket coats, dating from the 1860s and 1870s. In the 1880s, the number of children rises to nearly sixty and girls appear almost as frequently as boys. In the 1890s, the number of children wearing blanket coats

drops to about a dozen, evenly mixed by sex. Styles of blanket coats for children paralleled those of adults.[41]

Children were photographed alone, with siblings, and sometimes with parents or other adults. Like adults who visited the studio, children often posed against two studio backgrounds and wore different sets of clothing. The first photograph mimicked a traditional European parlour and featured the child in a starched dress if a girl, and in a sailor suit or Little Lord Fauntleroy ensemble if a boy. The second portrait displayed the outdoor winter background common to adult photographs and featured the child dressed in a blanket coat, sash, and tuque.

Notman's images of children offer important insight as to what meaning the blanket coat might have held for nineteenth-century Anglo-Canadians. When Notman photographed his own son in 1867 against a winter landscape wearing a blanket coat, sash, and snowshoes, at the bottom of where the name of the sitter would habitually be inscribed by the studio is written 'Young Canada.' Bara interprets this photograph as 'a photo-allegorical idea of the new country' expressive of Notman's patriotism and personal interest in determining Canada's national identity. She identifies the multicultural origin of the clothing and props as a key to the image's symbolism, noting that through the use of these objects 'the photograph commingles the cultural heritage and the hopes which the colonials held for the future of their new country.'[42]

Sociologist Nathan Joseph explains the use of a child as a 'symbol bearer' of national identity and cultural myths, linking this practice to the Romantic belief in childhood purity. He argues: 'Since they are "innocents" – cognitively and morally – and representatives of the future, they are most fit to wear costumes incorporating sacred symbols of a culture. It is therefore the children who are singled out to wear costumes denoting patriotism.'[43] Indeed, the image of a child in a blanket coat was used on numerous occasions to symbolize the emerging dominion of Canada.

Perhaps the most pronounced example of this thought is an engraved illustration, entitled 'Old and Young Canada,' that appeared in an 1884 carnival supplement (illustration 3). The image is based upon a photograph originally taken at the Notman studio in 1876. When this lithograph was published in 1884, it was accompanied by a description that provides important insight as to how the image was interpreted at the time. It reads:

The first page shows a capital sketch of Old Canada and Young Canada. The figures are those of hale old age, and he stands looking down at the younger Canada as if wondering what he will be twenty years hence. The youngster stands with both hands in his sash, as though in trouser pockets, and he looks at this senior as if he were impatient to be as big, as sturdy, and as capital a snowshoer. There seems to be a

3 'Old and Young Canada.' (*The Winter Carnival Illustrated.* Montreal: Geo. Bishop & Co., 1884)

spring about the young fellow from his moccasins to his jaunty *tuque* that speaks volumes for him.

May he be all he promises and may we have a nation like him.[44]

Other images that appeared in the 1880s, many of them having their origin in the Notman studio, take up this theme of the young nation symbolized by a child in a blanket coat. 'Young Canada,' a composite published in the 1885 *Montreal Daily Star Carnival Number,* features lithographed photographs of three children, each wearing a blanket coat, surrounded by other iconic symbols of Canada, including maple leaves, a beaver, and the shield of Canada.

A number of perplexing questions remain. Why was the blanket coat adopted as the mandatory uniform of the prestigious Montreal Snow Shoe Club? What fuelled the garment's enthusiastic public endorsement by Canada's governors general? What factors motivated its adoption as a favoured prop in four decades of Notman photographs and how did it come to symbolize 'Young Canada?' Indeed, with its humble First Nations and working-class French-Canadian origins, the reasons why the blanket coat should have become a coveted and fashionable item for Anglo-Canadian men, women, and children is not readily apparent. To answer some of these questions, it is necessary to explore the political and social context of the period.

Canadian political history in the second half of the nineteenth century is marked by a search for national unity and identity. Although Confederation in 1867 was undertaken in an effort to assuage internal power struggles and deter annexation by the United States, these two issues continued to threaten the new nation's stability and growth in the decades that followed. From this sense of uncertainty and defensiveness grew the desire to establish a definitive sense of national identity. Among the Canadian nationalist movements that developed in the period was imperialism. Imperialism identified Canada's relationship with the British Empire as the key means through which Canada could gain power as a nation. Explains historian Carl Berger, 'Canadian imperialism rested upon an intense awareness of Canadian nationality combined with an equally decided desire to unify and transform the British Empire so that this nationality could attain a position of equality within it.'[45]

The particular nature of Canadian identity was the topic of R.G. Haliburton's influential lecture 'The Men of the North and their Place in History,' delivered at the Montreal Literary Club in 1869. Haliburton proposed that Canada's identity and potential for power resided in the superior racial origin of its Anglo citizens and in the formative qualities of its northern climate. Haliburton's theory was readily adopted into the rhetoric of nationalists who were grateful for a reason to celebrate Canada's northern climate. Canada's winter weather was now promoted

as ensuring the development of a 'healthy, hardy, virtuous, dominant race.'[46] The concept of Canada's northern climate acting as a beneficial agent to the nation's character was incorporated into all areas of public discourse, from political speeches to artwork and poetry, and it was used to develop the notion of a unique and racially superior Canadian character. Berger notes that for many Canadians the concept 'became a vehicle for expressing their faith in themselves and the distinctiveness of their character. Canadians, ran the conclusion, were a strong and serious race, enjoying advantages over Britain as well as the United States.'[47]

Among those who embraced Haliburton's theories were promoters of Canadian winter sports, who argued that participation in outdoor athletics produced 'a robust hardihood' in Canadians and brought a distinctive element to their national character. The application of this theme to the promotion of winter sports incorporated the existing theories of muscular christianity and the British games ethic. These theories argued that participation in carefully structured athletic activities produced a physically and morally superior British subject, whose leadership skills and compliance with the rules of sportsmanship could, in turn, be readily extended to the larger goals of the Empire.[48] Within the context of Canadian imperialism, the perceived benefits of athletics were channelled towards the building of Canada as a nation and Great Britain as an empire. This belief in winter athletics serving the goals of imperialism is evident in 'The Snow Shoe Call':

Here's to our Queen's command!
By England's throne we'll stand,
When time and strength will make at length
A nation of our land,
Never may her standard
Beneath another fall,
And ever loyal live the men
Who shout the snowshoe call.[49]

When discussing the significance of sports to the development of a Canadian national character, its advocates distinguished between indigenous and imported sports, and emphasized Anglo-Canadian modifications to the native activities. In an article entitled *Canadian Sports*, journalist and sportsman George Beers identified the native origin of snowshoeing and tobogganing, stating, 'For all of these we are indebted to the Indians.' He then proceeded to describe the essential role Anglo-Canadians played in the transition of the activities into sports; claiming, 'It was left to the Saxons to start the ball rolling' and initiate a tradition of 'the pure athletic idea of sport.' Beers repeated this pattern of attribution later in the article,

describing the efforts of a Montreal Snow Shoe Club member who 'applied the shape of the Sioux shoe to that made and used by the Iroquois, and introduced into general use what has now become the popular shoe.'[50]

While period sources acknowledged the indigenous origin of snowshoeing and tobogganing, ultimate emphasis was placed upon the changes brought on by Anglo-Canadians. Notes Gillian Poulter, 'These were Native activities which British colonists had made "civilized" through the imposition of the British ideology of discipline and fair play.'[51] The impact of this ideology is evident in all areas of recreational snowshoeing and tobogganing practices, from the military-inspired organization of tramps to a club policy that revoked club membership for 'ungentlemanly conduct.' Anglo-Canadian modifications enabled indigenous sports to be claimed uniquely 'Canadian' in the imperialist's quest for national identity. Participants were offered a hybrid activity that combined an indigenous pedigree safely tempered by the familiar rules and goals of British sportsmanship.

In an examination of the significance of winter recreational activities in Montreal of the 1880s, Poulter explores the relationship of winter carnivals and sport activities to the period interest in nation-building. Poulter specifically examines the connection between sports promoted as indigenous to Canada and the 'invention' of national identity. She reasons that 'if snowshoeing was Canadian, then the act of snowshoeing was an embodiment and performance of one's identity as a Canadian.' Anglo-Canadians attempted to access a national character distinct from that of Great Britain or the United States through active participation in culturally and historically charged activities such as snowshoeing and tobogganing.[52]

Poulter's analysis borrows from Eric Hobsbawm's theory of invented traditions, which he defines as 'a set of practices, normally governed by overtly or tacitly accepted rules and of a ritual or symbolic nature, which seek to inculcate certain values and norms of behaviour by repetition.'[53] Certainly the contrived activities adopted by snowshoe club members and sports participants were carefully delineated in the clubs' booklets and meticulously planned by carnival committees. These practices were repeated season after season and required an adherence to behavior of a ceremonial nature, including the compulsory wearing of club uniforms and badges, initiation rites for new snowshoe club members, and carefully choreographed public displays at the winter carnivals.[54]

The invention of tradition, argues Hobsbawm, occurs frequently during times of nation-building when a newly formed political structure attempts to substantiate itself through evidence of a link to the past. Materials and practices relating to the nation's authentic past are often adopted and used to 'construct invented traditions of a novel type for quite novel purposes.'[55] The authentic practice of snowshoeing as a means of transportation, for example, was adopted by Anglo-Canadians from First Nations communities and modified into a new sporting

activity. Through the process of appropriation, the significance of the authentic practice of snowshoeing was redefined, and a link to the past was created.

Anglo-Canadian use of the blanket coat and its accessories fits within Hobsbawm's theory of invented traditions. In 1895 Lady Aberdeen described the coat as 'an adaptation of the blanketing worn by the Indians' and that its waist sash was 'woven in times gone by by the French peasants.'[56] Her comment expresses the imperialist need to both acknowledge the garment's indigenous or authentic origin, and, through the use of the terms 'adaptation' and 'times gone by,' establish Anglo-Canadian ownership over the contemporary context of its use.

The blanket coat and its accessories were often labelled in the popular press and private journals as a national costume representative of Canadian identity. This interpretation of the garment is in keeping with late-nineteenth century interest in determining 'national' costume from European geographical regions or cultural groups. In an analysis of the function of so-called national dress or folk costume, Nathan Joseph notes that it has often been used during periods of nation-building as a type of propaganda by those seeking power.[57] Clearly the blanket coat, much like the act of snowshoeing, was used in the construction and promotion of Canadian imperialist ambitions.

In certain respects, Anglo-Canadian use of the blanket coat and participation in activities such as snowshoeing was symptomatic of the practice of 'going native.' American Sioux author Vine Deloria Jr. theorizes that Europeans were motivated to 'go native' by a desire to feel as sense of belonging in the New World. Daniel Francis identifies the political intent of 'going Native,' stating, 'By appropriating elements of Native Culture, non-Natives have tried to establish a relationship with the country that pre-dates their arrival and validates their occupation of the land.'[58]

Although Anglo-Canadians were indeed appropriating elements of First Nations and French-Canadian culture through their adoption of the blanket coat, their goal was not wholly to abandon European cultural identity and assume that of the indigenous people. While Anglo-Canadians were seeking to establish their right to Canadian territory, they were not trying to attain this through the absolute mimicry of Native cultures. Rather, Anglo-Canadians were adopting and modifying aspects of First Nations and French-Canadian culture in an attempt to construct a uniquely Canadian identity distinct from that of the United States and Great Britain. Because this goal was informed by imperialist theory, its objective was not to sever Anglo-Canadian connections with British culture and completely 'go native.' Native artifacts and practices were reworked, restructured, and redefined to meet British standards of 'civilized' taste and ideology.

While the blanket coats worn by the MSSC and Canada's governors general resembled the garments traded to First Nation tribes and worn by French-Canadian habitants, the garments had been redesigned and styled to meet the

standards of contemporary Euro-American dress. Lady Aberdeen, for example, was careful to comment that the blanket coat worn by her family was 'an *adaptation* of the blanketing worn by the Indians' (emphasis added).

The use of the blanket coat by Victorian Anglo-Canadians therefore exemplifies how the social significance of dress is dependent upon the cultural context in which it is constructed and worn. Though it was recognized for its French-Canadian and First Nations origins, the blanket coat in the second half of the nineteenth century became associated with a Canadian identity representative of the ambitions of the British Empire.

NOTES

1 Back, 'The Canadian Capot (*Capote*),' 10.

2 Anderes and Agranoff, *Ice Palaces*; Bara, 'Cradled in Furs: Winter Fashions in Montreal in the 1860s'; Bara, 'The Image of Canada'; Beaudoin-Ross, 'A la Canadienne: Some Aspects of 19th Century Habitant Dress.'

3 This article is drawn from the author's graduate thesis, '"Very Picturesque and Very Canadian": The Significance of the Blanket Coat to Anglo-Canadian Identity in the Second Half of the Nineteenth Century.'

4 Back, 'The Canadian Capot.' 4, 8; Chartrand, 'The Winter Costume of Soldiers in Canada,' 156.

5 Though the origin of the practice of converting a blanket into a coat remains unde-termined, the availability of the trade blanket and its inherent qualities of warmth and durability would have made it a ready choice. Back refutes the popular percep-tion that the Hudson's Bay Company originated the design, pointing out that the first noted use of the blanket coat in North America predates the company's charter by over twenty-five years (p. 10). Blankets were a trade staple for French and First Nations communities from the first decades of the seventeenth century. See also Back, 'The Trade Blanket in New France,' 2–3.

6 It is important to note the term 'Canadian' was used in this period to refer to the French in Canada. The look of this period's blanket coat is delineated in a 1778 watercolour by Friedrich von Germann. Entitled 'Ein Canadischer Bauer,' the image features a Canadian peasant wearing a coat that appears to be made from a white trade blanket with a striped border at the coat's hem, sleeve cuffs, and hood.

7 For evidence of mid-century developments in blanket coat design, Jacqueline Beaudoin-Ross looks to Cornelius Krieghoff's oil paintings of rural Quebec and notes that the coat appears in white, grey, and blue. (Beaudoin-Ross, 'A la Canadienne,' 77) Visible in Krieghoff's work are two other clothing items relevant to the blanket coat's history and lore: the waist sash, a variation of which is the finger-woven woollen sash

of the nineteenth century; and the tuque, a knitted woollen cap worn by French sailors and first used in New France in the eighteenth century. Back, 'S'habiller a la canadienne,' 40; Beaudoin-Ross, 'A la Canadienne,' 82.

8 Although the sport of snowshoeing is believed to have originated in Montreal, the popularity of the sport spread to other Canadian cities including Quebec City, Ottawa, and Winnipeg in the 1880s and 1890s. Snowshoe clubs were also founded in American cities such as St. Paul and Boston.

9 Morrow, 'The Knights of the Snowshoe,' 8, 11.

10 Becket, The Montreal Snow Shoe Club, 51.

11 Morrow, 'The Knights of the Snowshoe,' 14–16.

12 Ibid., 27–8.

13 Ibid., 29, 30, 34.

14 See Beers, 'Canadian Sports' and 'Canada in Winter.'

15 Beers, *Over the Snow, or, The Montreal Carnival*, 13.

16 See, for example, the advertisement placed by G.C. Arless & Co. in *Montreal Winter Carnival Souvenir*, 1889 n.p.

17 *Montreal Snow Shoe Club Minute Books, 1861–1885,* 10, 17, 24, 31 December 1884; 7 January 1885.

18 *Constitution and By-Laws of the Montreal Snow Shoe Club, 1875*, 3. A blanket coat in the McCord Museum bears coloured stripes that correspond to the width specifications recorded in the MSSC minute book of 17 December 1884.

19 Marchioness of Dufferin and Ava, *My Canadian Journal, 1872–1878*; Lord and Lady Aberdeen, '*We Twa*': *Reminiscence of Lord and Lady Aberdeen*, 2: 50; Saywell, ed., *The Canadian Journal of Lady Aberdeen 1893–1898*.

20 McLaughlin, 'Vice-Regal Patronage of Canadian Sport: 1867–1916,' 4.

21 Redmond, 'Imperial Viceregal Patronage,' 194.

22 Dufferin, *My Canadian Journal*, 46, 57.

23 Lord and Lady Aberdeen, '*We Twa*,' 50.

24 Countess of Aberdeen, *Canadian Journal*, 43, 44, 45.

25 *Montreal Daily Star*, 26 January 1895.

26 *Toronto Globe*, 3 March 1894; *Chicago Herald*, 3 February 1894.

27 The Notman studio specialized in portraiture and catered to the tastes of the social elite as well as those of more modest means. Prominent patrons included Montreal merchants such as the Molsons and Redpaths, Governors General Lansdowne and Dufferin, and international visitors, Prince Arthur and Frederick Remington.

28 Extant photographs and newspaper advertisements indicate that other Montreal photographers featured blanket coats during this period. The work of the Notman Studio, however, was used for this study as its sitter index allowed for a continuous analysis of blanket coat depiction from 1860 to 1900.

29 Bara, 'Cradled in Furs,' 41.

30 *Montreal Winter Carnival Souvenir 1889.*

31 Bara, 'The Image of Canada,' 208. William Notman disseminated this vision through his active contribution of articles and images to *The Philadelphia Photographer*, a leading journal in the United States. See Greenhill and Burrell, *Canadian Photography, 1839–1920*, 66. The Notman studio also submitted its work to key international exhibitions and sold its photographs at stationery stores, hotels, and branch studios across North America. Finally, the work of the studio was printed in newspapers and magazines such as the *Illustrated London News* and the *Canadian Illustrated News*. Triggs, 'The Notman Photographic Archives,' 181.

32 Bara, 'The Image of Canada,' 175.

33 Bara, 'Furs in Fashion as Illustrated in the Photo-Portraiture of William Notman in the 1860s,' 152–60.

34 *Montreal Gazette*, 14 February 1867, 4.

35 Summers and Chartrand, *Military Uniforms in Canada*, 12.

36 To create a composite photograph, a photograph of an individual sitter was cut out from an original print and then pasted onto an already painted or photographed background. The resulting image would then be rephotographed.

37 Triggs, *The Composite Photographs of William Notman*, 27; Though a group photograph was taken in 1860, the resulting image was deemed 'rather gloomy' by the club.

38 Though Morrow dates the use of these ribbons to the Montreal Snow Shoe Club's use in the mid-1870s, their presence in Notman photographs was not consistent until the following decade. 'The Knights of the Snowshoe,' 28.

39 The typical look of women's blanket coats during this period is a three-quarters length, light-coloured coat embellished with contrasting stripes, piping, and tufted epaulettes.

40 Severa, *Dressed for the Photographer*, 485.

41 Most boys wore a dark-coloured coat in the 1860s and a light-coloured, striped coat in the 1870s. The light-coloured coat was adopted by girls in the 1880s and remained a favourite for both sexes in the 1890s.

42 Bara, 'The Image of Canada,' 230, 232.

43 Joseph, *Uniforms and Nonuniforms*, 195.

44 *The Winter Carnival Illustrated,* 12.

45 Berger, *The Sense of Power*, 49.

46 Haliburton, *The Men of the North and Their Place in History*, 1. The means by which Canada's climate was believed to help achieve this end was threefold: the cold winter discouraged the immigration of physically and morally weak peoples; the 'tonic properties' of its air nourished intellectual and physical development; and the harshness of its winters encouraged the formation of a courageous and independent people. Berger, *The Sense of Power*, 130.

47 Berger, *The Sense of Power*, 133.

48 Orton, 'Canadian Winter Pastimes,' 143–44; Brown, 'The Northern Character
 Theme and Sport in Nineteenth-Century Canada,' 47–8; and Redmond, 'Diffusion
 in the Dominion: 'Muscular Christianity' in Canada, to 1914,' 100–1.
49 Becket, *The Montreal Snow Shoe Club*, 282.
50 Beers, 'Canadian Sports.' 507, 518.
51 Poulter, 'Inventing Canadians: Carnivals, Parades and Ice Palaces in Victorian
 Montreal,' 2.
52 Ibid., 2–4.
53 Hobsbawm, 'Introduction: Inventing Traditions,' 1–14.
54 Dusfresne, 'Le Carnaval d'Hiver de Montréal'; Morrow, 'Frozen Festivals.'
55 Hobsbawm, 'Inventing Tradition,' 13, 6.
56 *Montreal Daily Star*, 26 January 1895.
57 Joseph, *Uniforms and Nonuniforms*, 187, 201.
58 Deloria, 'Foreword: American Fantasy,' xvi; Francis, *The Imaginary Indian*, 189–90.

SELECTED BIBLIOGRAPHY

Primary Sources

Aberdeen, Countess of (Ishbel Maria Marjoribanks Gordon). *The Canadian Journal of
 Lady Aberdeen, 1893–1898*. Edited by John T. Saywell. Toronto: Champlain Society,
 1960.
Aberdeen, Lord and Lady. *'We Twa': Reminiscence of Lord and Lady Aberdeen*. Vol. 2.
 London: W. Collins Sons & Co, 1925.
Becket, Hugh W. *The Montreal Snow Shoe Club, Its History and Record with a Synopsis of
 the Racing Events of Other Clubs Throughout the Dominion, From 1840 to the Present
 Time*. Montreal: Becket Brothers, 1882.
Beers, George W. 'Canada in Winter.' *British American Magazine* 2 (December 1863):
 166–71.
– 'Canadian Sports.' *Century Magazine* 14 (August 1877): 506–27.
– *Over the Snow, or, The Montreal Carnival*. Montreal: W. Drysdale & Co. and J. Theo.
 Robinson, 1883.
Constitution and By-Laws of the Montreal Snow Shoe Club. Montreal: Louis Perrault &
 Co., 1870.
Constitution and By-Laws of the Montreal Snow Shoe Club. Montreal: John C. Becket,
 1875.
'Constitution and By-Laws of the Montreal Snow Shoe Club, 1886.' In *Constitution and
 By-Laws of the Montreal Amateur Athletic Association and Affiliated Clubs*. Montreal:
 Fulton, Richards, and Waters, 1886.

Dufferin and Ava, Marchioness. *My Canadian Journal, 1872–1878*. London: John Murray, 1891. Reprint, Toronto: Coles Publishing Company, 1971.

Haliburton, R.G. *The Men of the North and Their Place in History: A Lecture Delivered Before the Montreal Literary Club, March 31st 1869*. Montreal: J. Lovell, 1869.

Montreal Winter Carnival Souvenir. Montreal: Canada Railway News Co., 1889.

Orton, George W. 'Canadian Winter Pastimes.' *Outing Magazine* XXIVI, no. 4 (January 1898): 332–7.

Souvenir of the Montreal Winter Carnival, 1884. Montreal: Canadian Railway News Co., 1884.

The Winter Carnival Illustrated. Montreal: Geo. Bishop & Co., 1884.

Secondary Sources

Anderes, Fred, and Ann Agranoff. *Ice Palaces*. New York: Abbeville Press, 1983.

Avis, Walter S., ed. *A Dictionary of Canadianisms on Historical Principles*. Toronto: Gage Educational Publishing, 1991.

Back, Francis. 'The Canadian Capot (*Capote*).' *Museum of the Fur Trade Quarterly* 27, no. 3 (1991): 4–15.

– 'S'habiller a la canadienne.' *Cap-Aux-Diamants* 24 (winter 1991): 38–41.

– 'The Trade Blanket in New France.' *Museum of the Fur Trade Quarterly* 26, no. 3 (1990): 2–8.

Bara, Jana. 'Cradled in Furs: Winter Fashions in Montreal in the 1860s.' *Dress* 16 (1990): 38–47.

– 'Furs in Fashion as Illustrated in the Photo-Portraiture of William Notman in the 1860s.' Master's thesis, Concordia University, 1986.

– 'The Image of Canada: Iconological Sources of Canadian Popular Symbolism: Nine-teenth-Century Souvenir Photographs.' Ph.D. dissertation, Concordia University, 1991.

Beaudoin-Ross, Jacqueline. 'A la Canadienne': Some Aspects of 19th Century Habitant Dress.' *Dress* 5 (1980): 71–82.

Berger, Carl. *The Sense of Power: Studies in the Ideas of Canadian Imperialism, 1867–1914*. Toronto: University of Toronto Press, 1973.

Blackstock, Pamela. 'Nineteenth Century Fur Trade Costume.' *Canadian Folklore Canadien* 10, nos. 1–2 (1988): 183–208.

Borcoman, Katherine J. 'William Notman's Portraits of Children.' Master's thesis, Concordia University, 1991.

Brown, David. 'The Northern Character Theme and Sport in Nineteenth-Century Canada.' *Canadian Journal of the History of Sport* 20, no. 1 (1989): 47–56.

Burnham, Dorothy K. *Cut My Cote*. Toronto: MacKinnon-Moncur, 1973.

Chartrand, Réné. 'The Winter Costume of Soldiers in Canada.' *Canadian Folklore Canadien* 10, nos. 1–2 (1988): 155–80.

Cooper, Cynthia E. 'Brilliant and Instructive Spectacles: Canada's Fancy Dress Balls 1876–1898.' *Dress* 22 (1995): 3–21.

Deloria, Vine Jr. 'Foreword: American Fantasy.' Pp. ix–xvi in *The Pretend Indians*, eds. Gretchen M. Bataille and Charles L.P. Silet. Ames: Iowa State Press, 1980.

Dusfresne, Sylvie. 'Le Carnaval d'Hiver de Montreal (1883–1889).' Master's thesis, Université du Québec, 1980.

Engages. 'Some Observations of Nineteenth Century Canadian Clothing.' *Museum of the Fur Trade Quarterly* 15, no. 2 (1979): 5–9.

Forrest, Alison, and Jill Oakes. 'The Blanket Coat: Unique Canadian Dress.' *Canadian Home Economics Journal* 41, no. 3 (1991): 121–7.

Francis, Daniel. *The Imaginary Indian: The Image of the Indian in Canadian Culture.* Vancouver: Arsenal Pulp Press, 1993.

Francis, R. Douglas, Richard Jones, and Donald B. Smith. *Destinies: Canadian History since Confederation.* Toronto: Harcourt Brace, 1992.

Greenhill, Ralph, and Andrew Burrell. *Canadian Photography, 1839–1920.* Toronto: Coach House Press, 1979.

Hobsbawm, Eric. 'Introduction: Inventing Traditions.' Pp. 1–14 in *The Invention of Tradition*, eds. Eric Hobsbawm and Terence Ranger. Cambridge: Cambridge University Press, 1983.

Hubbard, R.H. *Rideau Hall: An Illustrated History of Government House, Ottawa, from Victorian Times to the Present Day.* Montreal: McGill-Queen's University Press, 1977.

Joseph, Nathan. *Uniforms and Nonuniforms: Communication through Clothing.* New York: Greenwood Press, 1986.

Levitt, Sarah. 'Registered Designs: New Source Material for the Study of the Mid-Nineteenth Century Fashion Industry.' *Costume* 15 (1981): 49–59.

McLaughlin, M.K. 'Vice-regal Patronage of Canadian Sport, 1867–1898.' Master's thesis, University of Alberta, 1981.

Morrow, Don. 'Frozen Festivals: Ceremony and the *Carnaval* in the Montreal Winter Carnivals, 1883–1889.' *Sport History Review* 27 (1996): 173–90.

– 'The Knights of the Snowshoe: A Study of the Evolution of Sport in Nineteenth Century Montreal.' *Journal of Sport History* 15, no. 1 (1988): 5–40.

Poulter, Gillian. 'Becoming Native in a Foreign Land: Visual Culture, Sport, and Spectacle in the Construction of National Identity in Victorian Montreal, 1840–1885.' Ph.D dissertation, York University, Toronto, 2000.

– 'Inventing Canadians: Carnivals, Parades and Ice Palaces in Victorian Montreal.' Canadian Historical Association Annual Conference, University of Sherbrooke and Bishop's University, 6–8 June 1999.

Redmond, Gerald. 'Diffusion in the Dominion: "Muscular Christianity" in Canada, to 1914.' *Proceedings of the 1982 Annual Conference of the History of Education Society in Great Britain* (1983): 100–18.

– 'Imperial Viceregal Patronage: The Governors-General of Canada and Sport in the Dominion, 1867–1909.' *International Journal of the History of Sport* 6, no. 2 (1988): 193–217.

Severa, Joan L. *Dressed for the Photographer: Ordinary Americans and Fashion, 1840–1900.* Kent, Ohio: Kent State University Press, 1995.

Snowdon, James. *The Folk Dress of Europe.* New York: Mayflower Books, 1979.

Stack, Eileen. '"Very Picturesque and Very Canadian": The Significance of the Blanket Coat to Anglo-Canadian Identity in the Second Half of the Nineteenth Century.' Master's thesis, University of Rhode Island, 1999.

Summers, Jack L., and Réné Chartrand. *Military Uniforms in Canada, 1665–1970.* Ottawa: National Museums of Canada, 1981.

Triggs, Stanley. *The Composite Photographs of William Notman.* Montreal: McCord Museum of Canadian History, 1994.

– 'The Notman Photographic Archives.' *History of Photography* 20 (Summer 1996): 180–5.

– *William Notman: The Stamp of a Studio.* Toronto: Art Gallery of Ontario, 1985.

Dressing Up: A Consuming Passion

CYNTHIA COOPER

In the late nineteenth century, moral contradictions underlying fashionable dress were heightened for clothing worn for dressing up, known as 'fancy dress.' The vogue in Canada was in many ways similar to that in Europe and the United States; in fact, Victorians of all walks of life were taken with a passion for costumed entertainments. Amateur theatricals and tableaux vivants were popular parlour versions of this entertainment; fancy-dress skating carnivals were its public manifestation, and elaborate fancy-dress balls, either by invitation or with expensive tickets, the most prestigious and decorous form. This chapter examines the cultural tensions over the issue of consumption, which coloured Canadians' engagement with dress in the late nineteenth century.

Four highly acclaimed balls in the last quarter of the century, presided over by governors general and their wives, were the pinnacle of society entertainment in Canada. In 1876 Lord Dufferin, governor general from 1872 to 1878, held a fancy-dress ball at Rideau Hall, which surpassed all other entertainments seen in the new capital to that time. From 1896 to 1898, elite society in Ottawa, Toronto, and Montreal each had its turn to attend a magnificent fancy-dress ball held under the aegis of the Countess of Aberdeen, wife of Lord Aberdeen, governor general from 1893 to 1898. Never content to pass up opportunities for edification, Lady Aberdeen embued her social entertainments with a higher educational purpose: two of these balls became celebrations of Canadian history, and another, of the British Empire. In Ottawa in 1896, at her historical fancy-dress ball, guests were organized into sets representing periods of Canadian history. In Toronto in 1897, sets at the Victorian Era ball highlighted the vastness of the Empire and Britain's strengths in the fields of technological progress, art, and literature. In Montreal in 1898, the Ladies' Antiquarian and Numismatic Society held an historical ball patterned after the Ottawa event with the Aberdeens as guests of honour.

Through participation in this popular form of Victorian amusement, ballgoers

at these four events simultaneously indulged in social opportunities and endorsed their hosts' intents, which for Lord Dufferin was that of raising Ottawa's profile as a society capital, and for Lady Aberdeen was that of raising public historical and national consciousness. Fancy dress, chosen with a heightened sense of its communicative function, played a pivotal role in this individual appropriation and nuancing of the organizers' concepts of Canadian patriotism.

The Canadian discourse of fancy dress and consumption will be approached by first attempting to contextualize dress-related issues within Victorian ideology, particularly that of separate spheres. Secondly, it will illustrate how these became entangled in the much broader public and political nature of the Canadian reaction. Finally, it will examine some of the ways in which the complexities of this cultural tension gave way to material expression, through the medium of dress.

The immense appeal of these events generated a good deal of controversy, focused on the issue of consumption in the Canadian context. Opinions expressed through the press frequently emanated from men of considerable influence in Canadian political or economic spheres. This discourse revealed deep-rooted tensions over the morality of dress and consumption in Victorian culture, heightened by the experience of Canada's colonial identity and economic circumstances. Simultaneously, it belies a male fascination with a matter normally within the feminine sphere, but for once socially condoned for men's attention, and transposed to the masculine sphere of economics and politics.

Journalists who chronicled the preparations, actual events, and their aftermath in the Canadian papers frequently echoed tenets found in a specialized body of literature providing advice for fancy-dress ballgoers. A profusion of recommendations and sanctions attests to a general uneasiness about the genre in general. Fashion plates and articles devoted especially to fancy dress were featured in many women's magazines. Specialized books, especially the well-known volumes by Ardern Holt, provided a compendium of character descriptions. Canadian periodicals also featured occasional articles recommending costumes and characters; in the 1870s *Canadian Illustrated News* carried short articles with character recommendations. In 1889 *Saturday Night* featured a general article on the subject of character choice, entitled 'What to Wear at a Fancy Dress Ball,' which acknowledged its debt to Holt. It is illuminating that the author's pseudonym, Cermer Mada, was that of Canadian author, editor, and publisher Graeme Mercer Adam, better known for his contributions to a range of literary and political papers and books.[1]

In the guise of recommending appropriate characters and costumes, this literature raised a series of moral considerations. The Victorian nature of the fancy-dress phenomenon can be seen as a careful circumscribing of the fantasy experience; it was undesirable to allow a sense of 'otherness' to negate or disguise one's socially

constructed self. Many of the issues regarding negotiation of boundaries of social acceptability to construct a performative identity were presented in a highly gendered manner. Others were considered of equal import to both men and women. Honesty in the presentation and ephemeral reconstruction of the self were at the heart of the discourse. Like the tenet which applied to art, which deemed that the best faithfully respected the natural and true, the moral code intrinsic to the practice of fancy dress dictated that the chosen character's qualities would be perceived not as a transformation of the individual, but as an enhancement or amplification of his or her own traits, both physical and personal. 'It is by portraying a character to whom one bears some resemblance, or that one is especially fitted by nature to assume that success "on the night" is assured,' stated *Everywoman's Encyclopedia.*[2]

Honest assessment of one's physique was a key element in a successful costume. 'A plain woman should not appear as the Queen of Hearts, nor an elderly lady dress up as a shepherdess,' stated the section on fancy dress in *The Ball-Room Guide.* Physical traits aside, the overwhelming importance of self-knowledge in choosing the best character was emphasized. At the Montreal historical fancy-dress ball, Dr Wilson as Samuel de Champlain was found to be 'the living presentment of the first Governor General of Canada.' More frequently, journalists decried the 'utter inability of most persons to choose a dress suited to them.' Ardern Holt warned male readers that 'people at Fancy Balls often render themselves absolutely ridiculous because they assume characters in every way opposed to their own personality.'[3]

Beauty and truth were also equated with historical accuracy that was considered morally correct. As Cermer Mada warned, 'Historical dresses usually present the most difficulty, as is evidenced by the many lamentably incorrect representations and the glaring incongruities of dress and make-up to be seen when such are attempted.' Ardern Holt explained further: 'In our day, when taste and culture are considered worthy of a thought, historical costumes should not be chosen by people of education without some little study.' The process of selecting and wearing an historical garment could be perceived as educational and edifying. Lady Aberdeen capitalized on this view when she imposed an historical theme for the ball in Ottawa, designing it as a deliberate attempt to educate society.[4]

Other issues within the redefinition of selfhood reinforced existing gendered mores. Advice regarding the enhancement of personal attractiveness was directed primarily at women. Ardern Holt explained, 'There are few occasions when a woman has a better opportunity of showing her charms to advantage than at a Fancy Ball.' Fancy-dress balls provided women with an opportunity, however fleeting, to transcend the limits which the dictates of fashion imposed. A perception of the superior attractiveness of most historic styles over current feminine

fashion was borne out in wistful editorial commentary. A journalist reporting on the eighteenth-century style gowns seen in large numbers at the Montreal historical ball of 1898 noted that 'those beautiful old-fashioned pink and white gowns, and great skirts of rich brocaded silk that fell in such heavy clear folds, made one wonder if the nineteenth century had not lost the art of dressing.'[5]

As Holt's comment suggests, for women a licensed eroticism was the primary appeal of fancy dress. This component of these costumes may be seen as the culmination of several elements: the exceptional enhancement of body and self; the performative aspect of the opportunity for self-display, and the heavily circumscribed expression of the distant and mysterious, or 'otherness.' 'She who represents Cleopatra, or some other Oriental queen, blazing with jewels, will not be allowed to sit in a corner,' advised Mrs Aria. Excessive amounts of jewellery, which might normally signify ostentation and poor taste, could be worn with impunity. As well, contrasting codes of sexual modesty of the female 'other' might provide fuel for the imagination. Two conventions of dress, normally associated with sexual permissiveness, could be cast aside without consequence at fancy-dress balls. Thus, the attractiveness of long loose hair which could not be displayed at other formal occasions was recognized and exploited, and shortened skirts enabled the wearers to reveal more of their legs and calves than ordinary ball dress allowed.[6]

Nonetheless, the sexual excitement which these costumes created was severely curtailed by strict limitations on the degree of disguise, and hence anonymity. Masks were never allowed at the larger, more public events. Limits on wearing masks at skating carnivals were carefully spelled out. *The Ball-Room Guide* stated that: 'A masked ball is rarely given in England ... it is a question whether the national character adapts itself readily to this description of entertainment.' In this respect, the Canadian 'national character' was no different.[7]

For men, fancy dress brought out issues of a somewhat different nature. Under ordinary circumstances, dress enforced the ideology of separate spheres through the sober colours and straight lines worn by men, juxtaposed with the rich colours, texture, and elaborate details of women's clothing. For men, black became a symbol of standing, power, and mastery. Yet at a fancy-dress ball, for once men were called on to embrace sartorial magnificence. The logistical aspects of this unusual situation were difficult enough, but negotiating their way around the thorny moral issue of consumption left men in unfamiliar territory. The discourse of feminine consumption placed women in a perpetual difficulty. A double standard advocated a display of wealth commensurate with the family's class on the one hand, and personal goodness and strong moral fibre, the antithesis of ostentation, on the other. Such a wide margin for social error was generally outside the masculine sphere. Ardern Holt's introduction to *Gentlemen's Fancy Dress* summarized the dilemma with the statement that 'many are deterred from accept-

ing invitations to Fancy Balls by the difficulties which surround appearing in appropriate guise.'[8]

As illustration 4 suggests, many men welcomed this reprieve from their typically narrow range of choice. After the Ottawa historical ball of 1896, it was suggested that 'perhaps many present, particularly among the men, found in their minds a wish that something of the picturesqueness and colour of the past survived in the attire of the present.' And an observer at the Dufferin ball recognized 'a few of the masculines who pride themselves on a portly or genteel figure, or by a taste in dress whose luxuriance is too much pruned by our present severe and sombre costumes.'[9]

Women were thought to have intuitive abilities in matters of dress, which enabled many to make a choice of costume easily. 'The poor men ... They're not in it with women when it comes to a matter of costuming for a fancy ball,' wrote a Toronto paper. 'Colour, trimmings, and diversities of shade occupy a large portion of [women's] thoughts at every time, and it is scarcely extraordinary or unfeminine that what to wear at the fancy ball should have created a lively sensation in their camp of humanity,' wrote a reporter at the Dufferin ball. This statement implied, however, that for men the 'lively sensation' might indeed have been extraordinary – and unmasculine.[10]

Indeed, the process of preparing for and attending a fancy-dress ball was equated with crossing over to the feminine sphere. While it was generally taboo for a man to dress as a woman on such occasions, considerable evidence suggests that for men, wearing fancy dress bore a marked similarity to cross-dressing. The equation with femininity was stated outright. For instance, Ardern Holt introduced the 1899 edition of *Gentlemen's Fancy Dress* by saying: 'I trust that the suggestions therein contained may be of some practical usefulness when ... the whole lexicon of female fopperies come under the consideration of the Lords of the Creation.' Contemporary comments reveal that fancy dress gave men sudden licence for preoccupation with becoming silhouettes, flattering colours, and tasteful embellishments. This exceptional, if short-lived masculine interest in body and dress helps to subvert assumptions rooted in traditional theories of the gendering of nineteenth-century fashion. Breward refers to the nineteenth-century man as the 'hidden consumer,' whose interest in dress has been underestimated due to Veblen's interpretation of elaborate attire as a symbol of women's enforced leisure, and men's power and vicarious consumption expressed through women. Examining the fancy-dress phenomenon forces male consumers out of their historical hiding place.[11]

Certain physical characteristics became a particular cause of anxiety for men as they exercised their newfound freedom of choice. Perhaps the greatest trauma was the inappropriateness of facial hair to the dress of many previous historical periods.

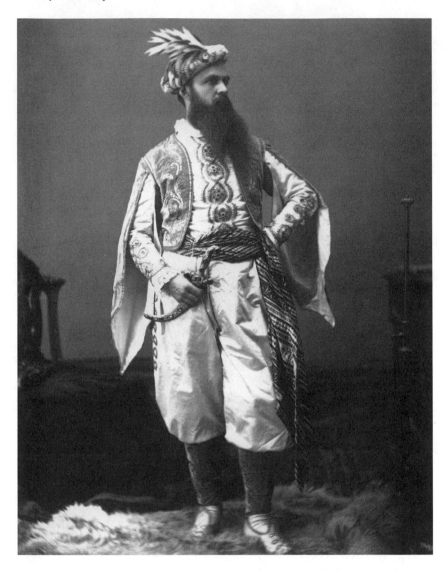

4 Walter Chesterton as 'Lyconides, an Athenian,' at the Dufferin ball, Ottawa, 1876. A note in the architect's obituary in 1931 states that this photograph was one of his most prized possessions, attesting to the enduring appeal this exceptional reprieve from sombre dress held in some men's lives. (William James Topley, National Archives of Canada, PA804163)

Reporters frequently chronicled the sacrifices. 'Even elderly gentlemen have offered up on the altar of *comme il faut* dearly beloved hirsute appendages, and men like brothers passed each other as strangers. Just what a difference a mustache does make!' Photographic evidence confirms that some men whose regular portrait was taken with a moustache had none in their fancy-dress portrait.[12]

Legs were another particular subject of discussion, as most men's historical costumes exposed the calves. Many men also exposed their thighs, and sixteenth-century historical and literary costume where short breeches were required were frequently seen at balls. A man whose legs were thought less than adequate, however, could be subject to derision, yet might be ridiculed for being overly cautious if he kept them covered. The *Toronto Daily Mail* reporter found it a laughable consideration that prior to the Dufferin ball 'lean politicians [were] nearly kept out of the House by their fear of rising to a dignity that would require an exposure of their calves in silk stockings.' Following the ball, the *Ottawa Free Press* described 'a certain gay gallant who supplemented his meagre calves by – nothing, so that although there was an abundance of room and to spare in the stocking for a calf, there was no calf to fill it. A long well-defined crease down the back of the leg showed where a calf should have been, but where alas! it was not.'[13]

Excess weight was another problem which might not ordinarily be much of a source of shame, but which could be in fancy dress. The *Toronto Daily Mail* referred to the perturbation of 'stout parties forgetful of their loss of figure, so long as the conventional black suit met the requirements of the evening.' The *Nation* asserted that 'the victims of obesity who for three months before place themselves under the Banting system, in order that they may appear to advantage in tights and embroidered vests, derive a solid advantage from their sacrifices to fashion.'[14]

As interest in dress became a masculine prerogative, the discussion of fancy-dress balls was thrown into the arena of consumption and morality. The attention to matters of dress and to expenditure for a single event became the subject of great public interest prior to the major events.[14]

Lord Dufferin's ball of 1876 was subject to the greatest fascination with expenditure. Of course, the public had yet to hear of the American excesses of the next two decades engendered by the Vanderbilts and Bradley-Martins, whose balls cost amounts in the realm of $300,000. But Canada was in economic depression in 1876, so the amount spent on pleasure for an elite few was subject to intense scrutiny. While the rental agents advertised the price of outfitting an individual from $10 to $20, journalists calculated that the average amount paid for an individual costume was in a range of $30 to $100, and in some cases $200. Then there were the exceptional rumoured cases: the many shoe buckles purchased for $25 a pair, the jewellery insured for $6,000, the American whose costume cost

$30,000, Dufferin's own expenditure of $800 on dress. The *Nation*, in its report of the Dufferin ball, made an estimate for the entire event as follows: 'Curious inquirers estimate the aggregate cost of the dresses at $25,000, which added to the cost of a most sumptuous entertainment for 900 guests, and the travelling expenses of the visitors would probably give a total considerably exceeding $30,000.' 'The governor general's own outlay could not have been much less than a year's salary,' wrote the *Saint John Daily News*, putting that amount at $50,000. By the time of the Aberdeen balls of the 1890s, journalists paid comparatively little attention to guessing figures, though they still discussed the expenditure in general terms.[16]

Given the economic impact of such spending, the benefits on trade were also discussed. The Dufferin ball was seen as the impetus for tradespeople to enjoy a busy season, thanks to the magnanimity of the elite. Those in the dressmaking and tailoring trades were thought the most affected, while drygoods merchants and those who dealt in accessories were among the fortunate as well. At the time of the Victorian Era ball, journalists recognized that the impact extended to carpenters and electricians. The point of view of the tradespeople who supposedly benefited was never publicly recorded. The perceived benefits were in fact a journalistic argument used to counter statements against excess. Moral overtones crept into these reports: 'The note of preparation descended like a gleam of sunshine on that industrious and deserving class, the milliners and dressmakers, at whose earnings all philanthropic people will rejoice.'[17]

By the time of the Aberdeen balls of the 1890s social pressure to rationalize the expenditure on dress began well before the events. Prior to the Victorian Era ball, journalists suggested that for the city to reap fully the economic benefits of the event, guests should spend to have a costume made, and avoid the cheaper option of rental. 'It seems a pity that those who can give a little time and consideration to the work of planning out and arranging suitable costumes to wear at the coming Victorian Era Ball should instead content themselves with renting these garments, thus possibly depriving our merchants and seamstresses of the benefits that might otherwise accrue to them from the holding of this function,' wrote the *Toronto Globe*, continuing, 'It is in no way the wish of Their Excellencies that any should go to the expense of purchasing rich fabrics or the like.' If the *Globe*'s comment seems to contradict itself, it was par for the course in the discussion of fancy-dress balls – and consumption.[18]

In fact, both the Dufferin ball of 1876 and the Victorian Era ball of 1897 were the subject of biting attacks. Editorials in many papers gave ample space to criticism of overspending, but most balanced it with an opposing viewpoint. The *Canadian Home Journal* noted that 'There is no doubt that as to Ottawa itself the effect will be to run the heads of families and young civil service men heavily into

debt.' A Saint John paper countered, 'Hard times are just the periods when people with good incomes or fat salaries ought to indulge in extravagances of this fancy ball type.'[19]

Compounding the issue of whether the expenditure had been beneficial to the economy was the fact that not all the money had gone into Canadian pockets. 'The Wives of members of Parliament, who are pathetic in their petitions for Protection to manufacturers, appeared with diamond coronets and stomachers of pearl, and more than one of the gentlemen themselves we see in "superb purple velvet" doublets and cloaks. The costumes came mostly from New York and the Old Country.' 'A large aggregate amount sent out of the country for profitless luxury,' echoed the *Nation*.[20]

Particularly at issue was the Earl of Dufferin's endorsement of these events. Critics implied that as colonials, Canadians had allowed themselves to be led into vice by the excesses of a British peer used to a far more extravagant lifestyle. They felt conspicuous consumption to be unbecoming to Canadians, and more appropriate on British soil. The *Nation* stated that 'some whisper misgivings as to the influence of the example on a community ... already a little too much debarred by deference for the English standard of expenditure and display.' The *Canadian Gleaner* asserted more firmly that 'the show and glitter are past but the permanent injury to the simplicity of our country's tastes and habits wrought by such an entertainment are incalculable ... If the Governor wishes to do a service to Canada, let him reserve such gorgeous displays until he goes back to England where there are people who can afford to go to them and maintain the style of living they induce.'[21]

The most biting attack, however, came in a long editorial column in the *Nation*, which, though not signed, was likely penned by Goldwin Smith, one of the founders and editors of that paper. The article on the ball was both humorous and acerbic. The author moralized about the form of entertainment, men's uneasiness with it, the vanity it inculcated, its incitement to consumption all too soon to be regretted, and finally, about Dufferin himself: 'It was a mistake in both place and time ... We are a poor people and if gaieties are to be welcome they must be cheap ... When Lord Dufferin addressed one of our schools ..., he made some remarks on the beauty and virtue of plainness and simplicity ... He may be certain THAT is the true social mine to work rather than the deceptive "pocket" of fancy dress balls.'[22]

The criticism appeared to be long forgotten by the time Lady Aberdeen held her fancy-dress ball in Ottawa. A life in the public eye had honed her sense of the need to justify extravagance. Her historical theme and its attendant educational benefits elevated the entertainment to an almost philanthropic plane. Lord Dufferin's ways came back to haunt her at the time of the Victorian Era ball, however. Goldwin

Smith had taken an aloof stance towards the Aberdeens, but in August of 1897 hosted an entertainment which seemed to show a change of heart. The couple and Smith thereafter remained on cordial terms, and a statement in Lady Aberdeen's journal would indicate the relationship was blossoming. 'Mr. Goldwin Smith is quite interested about our Victorian Era Ball,' she wrote. But the day before the ball, the following letter, with Goldwin Smith's byline 'Bystander' appeared in the *Toronto Star*.

> Editor *Star* – I have just read the item in this evening's *Star* entitled 'A Costly Ball' in which you estimate at $15,000 the expenditure upon the Vice-Regal entertainment to be given in the Armouries on Tuesday next ... It may be worth the while of a very rich lady like Mrs. Bradley-Martin or the Countess of Aberdeen (often, but improperly styled Her Excellency) to squander upon a night's amusement the endowment of a hospital or a college professorship ... But is this a fitting time to ask Toronto people to spend money on a 'passing show' far more than they can afford? I know of many who are purchasing costumes for Tuesday night with money which is in fact not their own; money which is due to – and therefore practically stolen from – the butcher, the baker, and the candlestick maker ... Bystander.[23]

The editor of the *Star* condemned the letter and mentioned that it had not come from the 'well-known writer who writes under that title,' so Smith's authorship must remain in some doubt. The paper pointed out that the ball could only benefit the city's economy, and blamed the unpaid tradespeople themselves for mismanagement. The *Ottawa Citizen* countered the objection with arguments similar to those presented by the *Star*, and added:

> No doubt Bystander is right in his statement that some who attended the ball cannot, or at least do not, pay their tailors, their butchers or their landlords, and it would have been much better if these persons had stayed at home, and given their creditors the money they spent in costumes. But the Victorian Era Ball was not to blame for that ... 'Bystander' would not think of blaming wine for the fact that some men spend more money than they can afford in buying wine.'[24]

While public criticism always took particular aim at the hosts, it was not limited to them. Journalists chastised the ball-goers, implying an excess of vanity and weakness of moral fibre behind their excessive outlay of money: 'The ardour displayed in preparing for the event was only equalled by utter disregard for pecuniary considerations. Nor need we dwell on the reasons which prompted such universal desire to appear in splendour on the occasion,' moralized the *Ottawa Times*. The *Nation* had a slightly more sympathetic tone, illustrating how spending too much could backfire and limit one's enjoyment.

A great many go to all sumptuary entertainments with a very practical thread running through the woof of excitement and hopeful feeling. Beneath the costly headdress is the large price paid for it, and the heart beating under a new brocade, not infrequently keeps sad time to calculations of ways and means. The ordinary headdress and the brocade will be useful again; but only in an exceptional society can there be recurring opportunities for rewearing the costume purchased for a fancy ball, and neither the society nor the opportunities are within the reach of persons of moderate position and means. The money is as good as thrown into the lake.'[25]

Similar moral overtones were felt in the criticism aimed at those who attended the Ottawa historical fancy dress ball. One journalist stated: 'If a criticism may be made, there was too much silk, satin, velvet and gold – rather too many people wanted to look handsome.' But it was the story of the $3 dress, written by a female journalist, which had the sharpest barb for women whose vanity encouraged consumption.

It is said one lady, about whose costume certain rumors had reached Her Excellency's ears, assured her when questioned on the subject that the dress cost only three dollars! It arrived, however, express from New York in a box that was both large and long, and the brilliancy of whose contents was an astonishing illustration of what may be done with three dollars judiciously expended.[26]

Given so much controversy over fancy-dress balls – not to mention the expenditure they required, and for men the difficulties in negotiating their foray into the feminine sphere – what are some of the ways in which the dilemma found material expression in the dress of the invited guests?

There were always a number of male guests who wished to attend balls without dressing up at all. It was an accepted fact, however, that guests in evening dress on a ballroom floor would spoil the effect. 'It would be very bad taste to go to a fancy ball in plain evening dress. If you cannot comply with the conditions you should stay away,' wrote *The Ball-Room Guide*. A private ball held in Ottawa on 19 January 1872, where many attended in evening dress, turned into a tempest. At the annual meeting of the Dominion Board of Trade an invitation to attend the ball was extended to all those present by the Bachelors of Ottawa. The announcement was inadvertently made without the all-important mention, 'costume *de rigueur.*' When the fifty or sixty guests showed up at the door they were greeted by a sign stating 'The members of the Dominion Board of Trade who purpose attending the ball are requested to appear in fancy costume.' The spurned guests met to vent their anger collectively. Several letters to the editor from both sides on the matter were printed in various papers over the next few days, but the ostensible reason boiled down to the following: the presence of this number of guests in

evening dress would have spoiled the ball, and for the youthful organizers that factor had briefly empowered them to overrule the political importance of a snub to some of the most influential businessmen in the country.[27]

Governors general were of course more socially adroit than the Bachelor's Club of Ottawa. At their large events, a restricted number of male and female guests not in costume could attend as spectators and observe from a gallery, but they were not to take part in the festivities. Men were nonetheless given a greater freedom of choice. Invitations usually specified that those associated with the vice-regal court (by special invitation) could wear legal robes or Windsor uniform, if their station entitled them to. Fancy dress was rarely the sole option for men who were not spectators, while it was for women. Clearly women bore greater responsibility for the success of the overall impression.

Perhaps the strongest statement was made by those who did not attend the vice-regal events. After the Dufferin ball it was noted that less than fifty of the 250 members of Parliament and senators turned out, a substantial number of absences given that a vice-regal invitation was to be turned down only in the most dire circumstances. The *Canadian Gleaner* felt that a combination of personal and moral issues had come into play:

> Some ... felt a disinclination probably to masquerade in costume ... Others may have been influenced by prudential or economic considerations. Others, still, I have no doubt, felt that the fifty or one hundred dollars which a preparation to attend the ball would cost them, could be much more worthily and satisfactorily employed in relieving the wants of the poor, or in aiding benevolent enterprises among their constituents.'[28]

Some men attended in spite of their ambivalence to the sartorial free-for-all, and got away with as little effort as they could. There were many 'who thought the (Dufferin) ball a "very good thing" but voted the toilet an intolerable bore.' This ambivalence might lead men to leave the decision to the last minute. Costume rental agents worked up until the final hours before both the Dufferin and the Ottawa historical ball. 'With the proverbial carelessness of their sex, most of the gentlemen had waited until the last to secure costumes,' noted the *Ottawa Free Press*. Still others chose a fancy-dress costume which greatly resembled their usual garb. At the Dufferin ball, member of Parliament A.P. Cockburn turned up in a black coat as 'a gentleman of 1806.' 'It was exceedingly striking because there is such a vast difference between the clothes of 1806 and those of 1805 and 1807 that a man on horseback could not fail to notice it.'[29]

Costumes which made a statement against consumption were also noted. At the

Dufferin ball, the secretary of state, R.W. Scott, came in plain dress as the Puritan Miles Standish, as did Isaac Burpee, minister of customs as John Alden. 'Mr. Burpee, ... dressed as the sober John Alden, the Puritan ... , could not have exceeded his means, and cannot be charged with having set an extravagant example,' the *Saint John Daily News* proclaimed.[30]

As the controversy over the excesses of the Dufferin ball escalated, perhaps it was only after the fact that several guests questioned the practicality of their outlay. While the *Ottawa Free Press* had admonished that 'no dress, no matter how costly the material, nor how elaborate the making up can possibly be worn twice, at least in the same city, on a similar occasion,' evidence suggests that several guests got a good deal of wear out of their costumes. A ball for the opening of the Library of Parliament was held the week following the Dufferin ball, and many guests requested permission to appear in costume, as it was suggested that they 'from an economic point of view wished to "get the good" out of their fancy dresses they had ordered for the Governor's ball by wearing them again.' It was estimated that half the guests appeared in fancy dress. This type of secondary event on the heels of a fancy-dress ball became the norm. Following the Ottawa ball of 1896, a skating carnival was held, and the rental agents offered a discount to those renting the same costumes. After the Victorian Era ball, a charity benefit was held where several sets did their historical dances in costume for spectators who paid admission. In that instance, guests could rationalize their expenditure not only through the extra wear, but through their philanthropy their dress gave way to as well.[31]

Several costumes worn at the Dufferin ball made at least one other appearance five years later, at a skating carnival held in Ottawa on 31 January 1881 (Illustration 5). Mrs McLeod Stewart wore the dress she had worn to the Dufferin ball, making the gown more appropriate for wear on a rink by looping up the train of her skirt and adding a high collar. Mr Waldo's costume had been worn by J.G. Macklin to the Dufferin ball. Ball costumes reappeared at skating carnivals on a regular basis, judging from some comments in the press. Reports on a Montreal skating carnival of 1881 mentioned that 'many of the handsome dresses worn to the late private fancy dress balls will make their appearance on ice,' and after the event that 'many of the more beautiful and picturesque costumes seen at the recent private society events and already described in the columns, which made their first appearance on ice last evening.'[32]

One might suspect the costume worn by Mr Macklin and then Mr Waldo was a rental were it not for the fact that the doublet was remade into a jacket for Waldo's character, the Baron de Longueuil, at the Ottawa historical fancy dress ball in 1896, twenty years after its first appearance in a photograph. After all this time, the garment still met with great approval: 'Mr. Edward Waldo ... was attired in an

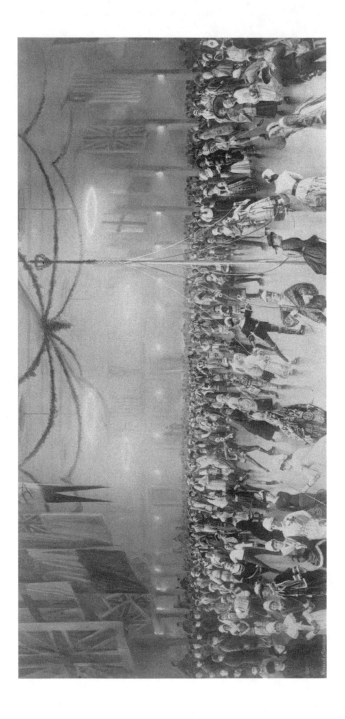

5 Skating carnival, Ottawa, 31 January 1881. This composite image illustrates how two costumes worn to the Dufferin ball of 1876 continued to be worn. As organizer of the event, Edward Waldo was given prominent treatment in the photograph and can be spotted just to the left of the maypole with leg extended in his 'Portuguese Officer's' costume. To the right of the maypole, near the back, Mrs McLeod Stewart can be seen in the dress she wore to the Dufferin ball, accessorized with a wide-brimmed white hat, for her character of 'Lady of the Time of Charles I.' (Norman and Sandham, National Archives of Canada, PA138553)

exceedingly handsome costume. A doublet of rich dark brown velvet, bordered with gold ... His costume was one of the most striking of this brilliant gathering'[33] (illustrations 6a, 6b, 6c).

This costume was not the only one to see at least twenty years of use. The bright red and yellow dress worn by Mrs McLeod Stewart to the Dufferin ball was reincarnated with a new bodice for her character, the Duchess of Suffolk, at the historical fancy dress ball in 1896. Further alterations to the bodice of the extant garment suggest a still later wearing.[34] (illustrations 7a and 7b).

The dress worn by Mrs Lindsay as a lady of the time of Marie Antoinette at the Montreal ball given by Mrs D. Lorn Macdougall on 25 February 1881, is illustrative of another common practice: the remaking of evening dresses into fancy dress. 'A woman can unearth wonderful odds and ends of evening gowns and turn them into a marvellous facsimile of something historic,' wrote the *Toronto Sunday World* in a comparison of the options open to women and men in obtaining fancy dress. Indeed, Mrs Lindsay's dress appears to be made from the front of a princess-style evening dress from the 1870s and a crudely constructed Watteau-pleated back added later (illustration 8).[35]

A few guests wore heirloom articles, which are comparatively well represented among the extant garments located. These were almost always combined with contemporary elements. Perhaps the best example of such a pastiche is that worn by Norman Leslie as his ancestor, Captain James Leslie of the 15th Regiment of Foot, in 'exactly the same uniform he wore at the taking of Quebec.' Analysis of Leslie's costume reveals that his grenadier's cap was indeed from this period, while his gorget and sword belonged to a more recent ancestor in the early nineteenth century, and his uniform was created by the department store Henry Morgan and Co. for the ball. Leslie nonetheless made a strong statement about the importance of his ancestors in the history of Canada, all the while personifying this significant event in Canadian history.[36]

Perhaps the impact of the dynamic of dress within the discourse of consumption in Canadian society is best illustrated by the costume worn by Lord Dufferin at the ball he hosted. The *Ottawa Free Press* published his story with the title 'Vice-Royalty in a Quandary.' With his typical extravagance, Dufferin had spared no expense in sending to England for his costume. After all, if anyone could afford to stand at a distance from the issue, it was this British peer. When the garb arrived, Dufferin could well afford to find it 'not to suit his fancy,' and send to New York for another one. When that one arrived, however, he found it had 'inexcusable defects,' making it 'entirely useless.' Dufferin's saga continues in the words of the press:

Those who admired the magnificent costume worn by His Excellency ... scarcely imagined that two days before the ball, Lord Dufferin found himself on the eve of the

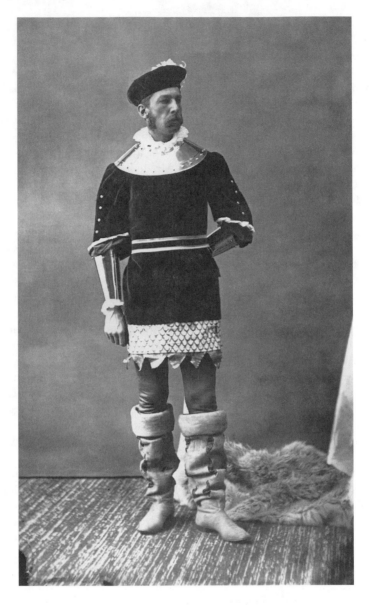

6a J.G. Macklin as a 'Portuguese Officer, 1598,' Dufferin ball, Ottawa, 1876. The short garment illustrates how men frequently chose to expose their legs in this exceptional setting. (William James Topley, National Archives of Canada, PA204781)

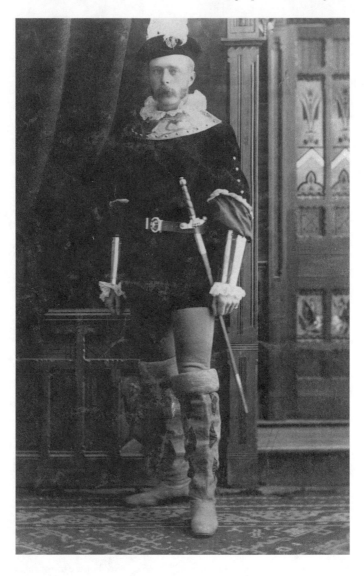

6b Edward Waldo as 'Portuguese Officer, 1598,' Montreal, 1881. Waldo wore the same costume Macklin had worn five years earlier, but replaced the skirt with shorter breeches. He appeared in this costume at the ball held by Mrs D. Lorn Macdougall in Montreal, as well as at a skating carnival in Ottawa three weeks earlier. (Notman Photographic Archives, McCord Museum of Canadian History)

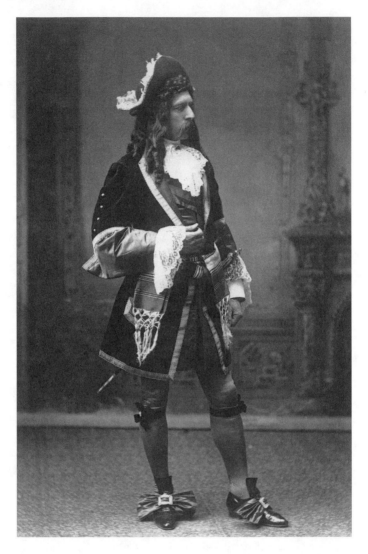

6c Edward Waldo as 'the Baron de Longueuil,' Ottawa, 1896. For the historical fancy dress ball held by Lady Aberdeen, Waldo had the doublet he wore in 1881 trimmed with braid and lengthened to give it a seventeenth-century air. The vertical inset on the sleeve and button trim provide proof that it is the same garment. The twenty years of wear on the jacket did not prevent the press from commenting on the attractiveness of Waldo's costume. (William James Topley, National Archives of Canada, PA204783)

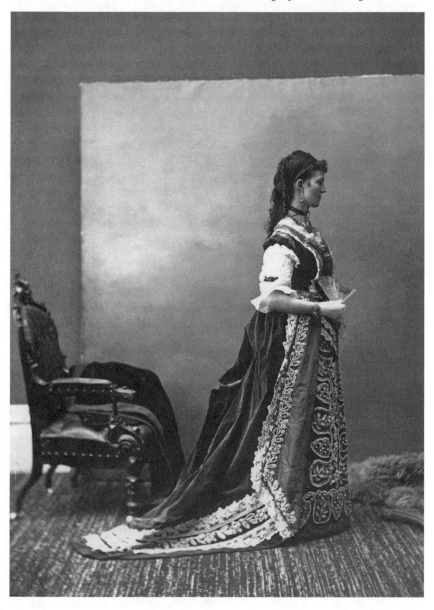

7a Mrs McLeod Stewart in 'court dress of the reign of Charles II,' Dufferin ball, Ottawa, 1876. (William James Topley, National Archives of Canada, PA193683)

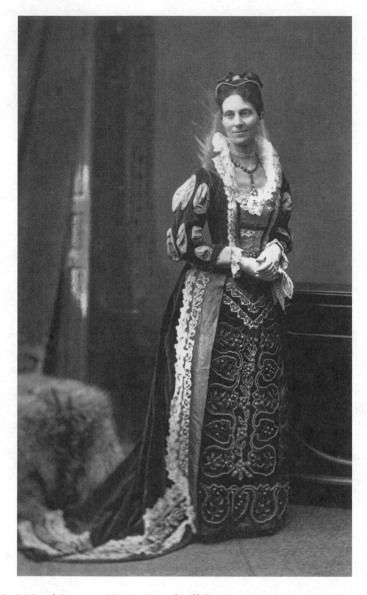

7b Mrs McLeod Stewart as 'the Duchess of Suffolk,' Ottawa, 1896. A new bodice gave the garment a very different appearance, and a sixteenth-century air. By 1896 the skirt had lost a few beads, attesting to the effects of two decades of wear. (William James Topley, National Archives of Canada, PA197370)

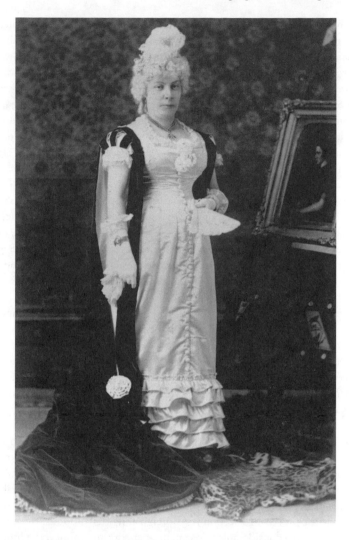

8 Mrs Lindsay as 'a lady of the time of Marie Antoinette,' Montreal, 1881, as she appeared
at the ball given by Mrs D. Lorn Macdougall. The garment bears witness to the remaking of
an outmoded evening dress into fancy dress. Her costume is highly unlike anything worn in
the late eighteenth century, however, revealing the degree of liberty frequently taken despite
the social pressure for accuracy. The extant garment is in the collection of the Canadian
Museum of Civilization. (McCord Museum of Canadian History, Notman Photographic
Archives)

most brilliant *fête* ever held in Ottawa, given by himself, in the unpleasant predica-
ment of having no costume suitable to the occasion to wear and the still more
unpleasant fact staring him in the face, that there was no apparent possible means of
supplying the deficiency ... In this dilemma His Excellency had recourse to the
services of Mr. G.M. Holbrook, merchant tailor ... Although the time in which to get
up a costume of the most difficult and elaborate design was barely two days, and
although as may well be imagined, the work was entirely out of his line of business,
Mr. Holbrook undertook his task, and had the satisfaction of not only turning out the
costume complete in every detail in ample time for His Excellency's use, but also of
eliciting from the Governor General the warmest approval of the excellence and
elegance of the workmanship, and his gratification at knowing that work of this
exceptional nature could be done in our midst, and that it could be accomplished in
such an incredibly short space of time. The costume as worn by His Excellency was
generally admired, on account of its elegance and richness, and its adaptation to the
'style' of the wearer. It was of rich black silk velvet ... a cap of black velvet with white
feather fastened by a diamond *aigrette* completed a costume by all odds the handsom-
est of the hundreds of brilliant and elegant costumes which thronged the room.'[37]

Dufferin, as the British vice-regal host, and furthermore well known for exceed-
ing his means, might well have made a very different sartorial statement if one of
the other costumes had suited him. Yet even with the knowledge that the extrava-
gant governor general had actually ordered three costumes, the press revealed their
ambivalence by using Dufferin's example to moralize about the beauty of simplic-
ity and plainness of dress, and point out how it put all the Canadian colonial
extravagance to shame.

The exceptional nature of fancy dress as a reprieve from the fashion system
brought into play a number of issues. For women, the concern was to balance
enhanced beauty with edification and a quest for an honest reconstruction of the
self. General opinion implied that women ought to possess an intuitive ability to
accomplish this balance, and yet needed ample warning to avoid pitfalls. The
much greater departure for men approximated a shift in the gendering of dress,
which made the process of selection very foreign and often arduous. As these issues
always resulted in a considerable investment of energy and money, the morality of
fancy-dress balls was frequently called into question. Ball-goers had to carefully
tread around the moral issue of consumption, which targeted them as a group, all
the while striving to conform to the internal ethical code for this type of dress to
avoid criticism of themselves as individuals. In the Canadian context, the vice-
regal endorsement of the fancy-dress vogue in times of economic difficulty fuelled
this problematic discourse, which situated dress as both a philanthropic opportu-
nity for benefit to tradespeople and a sagging economy, and the particular focus of

the distaste for excess. The very public and political nature of the reaction to the fancy-dress phenomenon can be seen as men's reaction to having to negotiate their socially condoned immersion into the unfamiliar feminine sphere, and a transfer of their simultaneous fascination and abhorrence with such an opportunity to the masculine sphere of economics and politics.

NOTES

1 Holt's book for women, entitled *Fancy Dresses Described, or What to Wear to Fancy Balls*, was published in six editions between 1879 and 1896, and her companion piece, *Gentlemen's Fancy Dress: How to Choose It*, also went through six editions from 1882 to 1905. Holt also wrote frequently in the British society magazine *The Queen*, providing numerous reports of recent British events and fancy-dress recommendations. The U.S.-based Butterick Company's *Masquerade and Carnival: Their Customs and Costumes* (New York, 1892) paraphrased Holt heavily in the introduction, and also enjoyed wide distribution. A slightly later publication, Mrs Aria's *Costume: Fanciful, Historical, and Theatrical*, was heavily paraphrased in Crozier, 'The Art of Choosing Fancy Dress.' Holt's life and work are discussed in Farrer, *Borrowed Plumes* 25–31. Cermer Mada, 'What to Wear to Fancy Dress Balls, *Saturday Night*, 5 January 1889, 9.

2 Sources which examine the cultural context of nineteenth-century fancy dress include Anthea Jarvis, '"There was a young man from Bengal ...": The Vogue for Fancy Dress, 1830–1950,' 33–46; Stevenson and Bennet, *Van Dyck in Checked Trousers: Fancy Dress in Art and Life, 1700–1900*; and Gordon, 'Dressing the Colonial Past: Nineteenth Century New Englanders Look Back.'

3 *The Ball-Room Guide: A Handy Manual*, 63–4; Cooper, *Magnificent Entertainments*, 144, ill; *Montreal Star*, 19 January 1898; *Ottawa Free Press*, 24 February 1876; Holt, *Gentlemen's Fancy Dress*, 3.

4 Cermer Mada, 'What to Wear,' 9; Holt, *Gentlemen's Fancy Dress*, 3; Cooper, *Magnificent Entertainments*, 69–70.

5 Holt, *Fancy Dresses Described* (1896), xiii; *Montreal Herald*, 19 January 1898.

6 Mrs Aria, *Costume*, 185; Cooper, *Magnificent Entertainments*, 31–3.

7 *Ball-Room Guide*, 63–4.

8 Harvey, *Men in Black*, 9–21; see Noel, 'Montreal Men in Black: Masculinity and Male Codes of Dress, 1700–1860' in this volume for a more local interpretation of these gender issues in dress; Breward, *The Hidden Consumer* and *The Culture of Fashion*, 170–78. Similar arguments are developed in Edwards, *Men in the Mirror* and Craik, *The Face of Fashion*, Holt, *Gentlemen's Fancy Dress* (1899), 4.

9 *Ottawa Journal*, 18 February 1896; *Montreal Herald*, 24 February 1876.

10 Breward, *The Culture of Fashion*, 170–71; *Toronto Sunday World*, 2 January 1898; *Toronto Daily Mail*, 24 February 1876.

11 Holt, *Gentlemen's Fancy Dress* (1899), i; Breward, *The Hidden Consumer*.

12 *Montreal Star*, 19 January 1898; Cooper, *Magnificent Entertainments*, 148, ill. A formal photograph of Louis-Joseph Forget from a year earlier shows him with moustache; his fancy-dress portrait shows him clean-shaven.

13 *Toronto Daily Mail*, 24 February 1876; *Ottawa Free Press*, 29 February 1876.

14 *Toronto Daily Mail*, 24 February 1876; *Nation*, 3 March 1876.

15 Even in the day of Queen Victoria's fancy-dress balls, consumption issues were being carefully headed off by the royal hosts. The weaving of historical reproduction fabrics for costumes was said to benefit the economy in a troubled time. A credulous public seemed ready to accept their monarch's stated intent. Finkel, '*Le Bal Costumé.*'

16 *Nation*, 3 March 1876; *Saint John Daily News*, 28 February 1876.

17 *Ottawa Times*, 24 February 1876; the many tradespeople and merchants who advertised specifically for the balls are mentioned throughout *Magnficent Entertainments*.

18 *Toronto Globe*, 16 December 1897.

19 *Canadian Home Journal*, 25 February 1876, 5; *Saint John Daily News*, 28 February 1876.

20 *Canadian Gleaner*, 2 March 1876; *Nation*, 3 March 1876.

21 *Nation*, 3 March 1876; *Canadian Gleaner*, 2 March 1876.

22 *Nation*, 3 March 1876.

23 National Archives of Canada. Countess Aberdeen, journal, 24 November 1897; *Toronto Star*, 27 December 1897. The Bradley-Martins of New York held a ball earlier that year which also attracted a great deal of controversy over the expenditure, although the cost of their event was estimated at $370,000, making the $15,000 mentioned in this letter seem paltry in comparison.

24 *Ottawa Free Press*, 28 December 1897; *Toronto Star*, 28 December 1897; *Ottawa Daily Citizen*, 30 December 1897.

25 *Ottawa Times*, 24 February 1876; *Nation*, 3 March 1876.

26 *Toronto Globe*, 19 February 1896; *Lounger*, July 1896. Sandra Gwyn's citations from this source first directed me to it; her research has shown that Agnes Scott, alias 'Amaryllis,' was the author of the article in this short-lived publication. See Gwyn, *The Private Capital*. This book also contains a wealth of information on the social context of these fancy-dress balls and the motivations of their hosts.

27 *Ottawa Times, Ottawa Free Press, Ottawa Daily Citizen*, 20 January 1872.

28 *Canadian Gleaner*, 9 March 1876.

29 See Cooper, *Magnificent Entertainments*, for photographs of costumes which have been identified as rentals; *Ottawa Free Press*, 24 February 1876.

30 *Saint John Daily News*, 28 February 1876. At the Bradley-Martin's New York ball of 1897, many guests came as Puritans as a reaction to the public outcry over the cost of the event.

31 *Ottawa Free Press*, 24 February 1876; *New York Daily Graphic*, 4 March 1876.

32 *Montreal Gazette*, 4 March 1881; *Montreal Star*, 7 March 1881.
33 *Ottawa Free Press*, February 18, 1896.
34 The dress was exhibited in *Dressing Up Canada: Victorian Fancy Dress Balls*, at the Canadian Museum of Civilization, October 1997 to January 1999.
35 *Toronto Sunday World*, 2 January 1898. Cooper, *Magnificent Entertainments* 148, ill., shows another costume definitely remade from an evening gown.
36 *Montreal Star*, 19 January 1898; Cooper, *Magnificent Entertainments* 141, ill. All items in the photograph but for the headdress belong to the collection of Fort Henry, Kingston; the grenadier's cap has been exhibited at the Canadian War Museum. See Sifton, 'Montreal's Fashion Mile: St Catherine Street, 1890–1930' in this volume for more on the well-known department store, Morgan & Co.
37 See Cariou, 'Enduring Roots: Gibb & Co. and the Nineteenth-Century Tailoring Trade in Montreal' in this volume for more on the difficulties of ordering clothing by mail at this time. *Ottawa Times*, 25 February 1876; *Ottawa Free Press*, 25 February 1876.

SELECTED BIBLIOGRAPHY

Aria, Mrs, comp. *Costume: Fanciful, Historical, and Theatrical*. London: Macmillan, 1906.
Ball-Room Guide: A Handy Manual. London and New York: Frederick Warne, [1900].
Book of the Victorian Era Ball Given at Toronto on the Eighth of December MDCCCXCVII. Toronto: Rowsell and Hutchins, 1898.
Breward, Christopher. *The Culture of Fashion: A New History of Fashionable Dress*. Manchester: Manchester University Press, 1995.
– 'Femininity and Consumption: The Problem of the Late Nineteenth-Century Fashion Journal.' *Journal of Design History* 7, no. 2(1994): 71–89.
– *The Hidden Consumer: Masculinities, Fashion and City Life, 1860–1914*. Manchester: Manchester University Press, 1999.
Cooper, Cynthia. *Magnificent Entertainments: Fancy Dress Balls of Canada's Governors General, 1876–1898*. Fredericton and Hull: Goose Lane Editions and the Canadian Museum of Civilization, 1997.
– 'Toronto's Victorian Era Ball: Fancy Dress for the Diamond Jubilee.' Pp. 121–40 in *Victorian: The Style of Empire*, ed. Howard Creel Collinson. Toronto: Decorative Arts Institute, 1996.
Cooper, Cynthia, and Linda Welters. 'Brilliant and Instructive Spectacles: Canada's Fancy Dress Balls, 1976–1898.' *Dress* 22 (1995): 3–21.
Craik, Jennifer. *The Face of Fashion: Cultural Studies in Fashion*. London and New York: Routledge, 1994.

Crozier, Gladys Beattie. 'The Art of Choosing Fancy Dress.' *Everywoman's Encyclopedia*. UK: n.p. [1906–12].

Davis, Fred. 'Clothing, Fashion, and the Dialectic of Identity.' Pp. 23–36 in *Communication and Social Structure*, ed. David R. Maines and Carl J. Couch. Springfield, IL.: Charles C. Thomas, 1988.

Edwards, Tim. *Men in the Mirror: Men's Fashion, Masculinity and Consumer Society*. London: Cassell, 1997.

Farrer, Peter. *Borrowed Plumes: Letters from Edwardian Newspapers on Male Cross Dressing*. Liverpool: Karn Publications, 1994.

Finkel, Alicia. '*Le Bal Costumé*: History and Spectacle in the Court of Queen Victoria.' *Dress* 10 (1984): 64–72.

Fox, Celina, and Aileen Ribeiro. *Masquerade*. London: Museum of London, 1983.

Glassberg, David. *American Historical Pageantry*. Chapel Hill: University of North Carolina Press, 1990.

Gordon, Beverly. 'The Nineteenth Century Looks Back: Costuming the Colonial Past.' Pp. 109–39 in *Dress and American Culture*, ed. Patricia A. Cunningham and Susan Voso-Lab. Bowling Green, OH: Bowling Green Popular Press, 1993.

Gwyn, Sandra. *The Private Capital: Ambition and Love in the Age of Macdonald and Laurier*. Toronto: McClelland and Stewart, 1985.

Halttunen, Karen. *Confidence Men and Painted Women: A Study of Middle Class Culture in America, 1830–1870*. New Haven: Yale University Press, 1982.

Harvey, John R. *Men in Black*. Chicago: University of Chicago Press, 1995.

Holt, Ardern. *Fancy Dresses Described, or What to Wear at Fancy Balls*. 5th ed. London: Debenham and Freebody, 1887. 6th ed., 1896.

– *Gentlemen's Fancy Dress*. London: Wyman, 1882.

Hubbard, R.H. 'Viceregal influences on Canadian Society.' Pp. 256–74 in *The Shield of Achilles: Aspects of Canada in the Victorian Age*, ed. W.L. Morton. Toronto: McClelland and Stewart, 1968.

Illustrations of the Historical Ball Given by Their Excellencies the Earl and Countess of Aberdeen – Ottawa, 1896. With an introduction by Sir John George Bourinot. Ottawa: Durie, 1896.

Jarvis, Anthea. '"There was a young man from Bengal ...": The Vogue for Fancy Dress, 1830–1950.' *Costume* 16 (1982): 33–46.

Jarvis, Anthea, and Patricia Raine. *Fancy Dress*. UK: Shire, 1984.

Joseph, Nathan. 'Costumes.' Pp. 183–202 in *Uniforms and Nonuniforms: Communication through Clothing*. New York: Greenwood, 1986.

Male Character Costumes: A Guide to Gentlemen's Costume. 2nd ed. London: Samuel Miller [1895].

Masquerade and Carnival: Their Customs and Costumes. New York: Butterick, 1892.

Maynard, Margaret. '"A Dream of Fair Women": Revival Dress and the Formation of Late Victorian Images of Femininity.' *Art History* 12, no. 3 (1989): 322–41.

Morgan, Henry James, ed. *The Canadian Men and Women of the Time: A Handbook of Canadian Biography.* Toronto: Briggs, 1898. 2nd ed. 1912.

Morton, W.L. 'Victorian Canada.' Pp. 311–34 in *The Shield of Achilles: Aspects of Canada in the Victorian Age.* Toronto: McClelland and Stewart, 1968.

Murphy, Sophia. *The Duchess of Devonshire's Ball.* London: Sidgwick and Jackson, 1984.

Nathan, Archie. *Costumes by Nathan.* London: Newnes, 1960.

Rieger, Jennifer and Mary Williamson. *Toronto Dancing Then and Now.* Toronto: Metropolitan Toronto Reference Library, 1995.

Rowat, Teresa. *Aperçu: Dressing Up.* Ottawa: National Archives of Canada, 1986.

Rutherford, Paul. *A Victorian Authority: The Daily Press in Late Nineteenth-Century Canada.* Toronto: University of Toronto Press, 1982.

Steele, Valerie. *Fashion and Eroticism: Ideals of Feminine Beauty from the Victorian Era to the Jazz Age.* New York: Oxford University Press, 1985.

Stevenson, Sara, and Helen Bennet. *Van Dyck in Check Trousers: Fancy Dress in Art and Life, 1700–1900.* Scotland: Scottish National Portrait Gallery, 1978.

Sutherland, Fraser. *The Monthly Epic: A History of Canadian Magazines, 1789–1989.* Markham, ON: Fitzhenry and Whiteside, 1989.

Travestissements. 3 vols. Paris: Abel Goubaud [1880–90].

Turner, Victor. *The Anthropology of Performance.* New York: PAJ Publications, 1986.

Wason, Janet. 'The Victorian Era Ball and its Role in Toronto Society.' *Canadian Dance Studies* 1 (1994): 27–42.

Wecter, Dixon. *The Saga of American Society: A Record of Social Aspiration, 1607–1937.* New York: Scribners, 1937.

Weldon's Limited. *Weldon's Fancy Dress for Ladies.* 1st Series and 2nd Series. London: Weldon's [1895–1900].

Defrocking Dad:
Masculinity and Dress in Montreal, 1700–1867

JAN NOEL

The Montreal lawyer Arthur Davidson wrote to his London tailor in 1791: 'I want, by one of the first ships ... cambrick, enough to ruffle seven shirts. Also a suit of black clothes such as are now worn by Gentlemen of the Bar. The Breeches, you know, I wish to be long and sit easy ... The bodies of both the coat and waistcoat ought to be rather wider.'[1] In a later letter Davidson asked the tailor to double-stitch all seams, anticipating Montreal tailors would be so offended at his ordering fashions from London they would refuse to make repairs. Not just the tailors despised the imported styles; so did Davidson's colleagues. Many were fined for resisting a 1779 bar society rule that members come to court in 'black coat, gown and bands.' They also broke the 1781 rule of 'black coat, waistcoat and breeches.' One handsome French-Canadian lawyer, declaring he 'objected to the garb of an undertaker's man,' appeared in a coloured coat and flesh-coloured nankeen breeches.[2]

Maybe they were silly to balk. Analysing the predominance of black in nine-teenth-century male fashions, John Harvey in *Men in Black* associates the colour with increasing male authority and with the 'impersonality of expertise.' He notes that dark clothing coincided with constraints on playfulness and personal feeling. He considers black 'the agent of a serious power, and of a power claimed over women and the feminine.' Barbara Vinken also associates a sombre, asexual masculine appearance with increasing dominance. But it came at a price. Earlier, courtly males had revelled in snowy lace that set off their fine skin, frockcoats hugging their shapely torsos, tight breeches and embroidered stockings rounding their calves, and – least modest of all – their ornamental codpieces. 'All the ornaments of masculinity came to an end,' Vinken writes, with that item of 'masculine renunciation,' the drainpipe trousers. 'To the extent to which he renounces fashion and indulges in the ... simplistic rhetoric of anti-rhetoric, what man gains thereby is in no way insignificant: identity, authenticity, unquestioned masculinity, seriousness.'[3]

This chapter studies the masculinity displayed by a trio of gentlemen whose wealth or political prominence placed them at the summit of Montreal society between 1700 and 1860. Their increasingly restrained dress accompanied a rise of masculine hegemony on several fronts, including the legal, the administrative, and the economic. One man was an early eighteenth-century town governor, another a political hero of the 1830s, the third a mid-nineteenth-century industrialist. In contrast to governor Claude de Ramezay, the two nineteenth-century figures, nationalist Louis-Joseph Papineau and magnate John Redpath, were less splendid in appearance. However, their actions and their dress show an evolution towards male productivity and authority.

A second theme is that as successful men assumed heavier burdens of work and responsibility, their women assumed the splendid dress styles and lifestyles of the nobility. Increasingly, the sexes were assigned to separate spheres. Prints and portraits reveal that costumes were also diverging. As male rights advanced in the half-century following the French and American Revolutions, women received a consolation prize of sorts. Attributes of nobility such as wearing elaborate, recherché dress and 'living nobly' (avoiding money-making and manual toil) were wholly transferred to a relatively large segment of women. The new nineteenth-century 'lady' no longer need be of noble birth.

These trends had roots in earlier centuries. In 1666 Charles II's injunction to his court to replace their extravagant doublets with vests of English wool began a long association of simple dress with manly patriotism. Several Enlightenment thinkers decried the fashions of their day as elitist and effeminate. They 'posited the pure republic against so much triviality; against the corrupt, weak, effeminate monarchy rose up a masculine republic sworn to virtue.'[4] Even before trousers set them apart, mid-eighteenth-century noblemen began wearing the heavier luxury fabrics such as velvet in contrast to their wives' satin and taffeta, although both sexes still used silk, embroidery, and lace. Parisian fashions came to be associated with the elaborate, 'feminine' presentation, London with the simpler, functional, more democratic 'masculine' style. The late eighteenth century 'macaroni' style featuring elaborate hairstyles, nosegays, multiple watches, floral decorations, and pastel colours was ridiculed and associated with lack of virility, with French aristocratic decadence, gambling excesses, and even monetary crisis.[5] In the nineteenth century, the new, more muted male presentation hardened into the accepted convention in offices and parlours throughout the western world. Comparing the decades before and after the 1760 British conquest of Canada provides a clear example of the transfer of the aristocratic ideal from nobles of both sexes in the eighteenth century to bourgeois women in the nineteenth century. The corresponding fashion development saw the man at the top of society transfer his fancy 'frock' to women and learn to 'wear the pants.'

These findings are only preliminary; a full-scale synthesis of fashion and history would require systematic analysis of data such as inventories, tailoring accounts and newspaper ads, portraits and photographs, and costume collections. The history of masculinity is just beginning to take its place beside women's history. Men have, of course, been the traditional subject of history, but only recently have historians paid much attention to ways their concepts of masculinity affected their behaviour and changed over time. One Canadian historian who attempted to analyse male fashion lamented the dearth of studies that 'establish a rapport between clothing and socio-economic and political factors has left this field of study behind current developments in history.'[6]

There is one caveat. Montreal was a town whose elite came from two distinctive cultures, French-Canadian and Anglo-American. Clothing styles differed in France and England, and attitudes to dress were also different. Numerous articles in the great *Encyclopedie* on clothing's manufacture, consumption, and social meaning reveal Gallic appreciation of this aspect of human behaviour. French culture, Susan Sontag observed, 'allows a link between ideas of vanguard art and fashion. The French have never shared the Anglo-American conviction that makes the fashionable the opposite of the serious.'[7] Perhaps this meant that French-Canadian gentlemen dressed with greater care or expense. Judging by nineteenth-century portraits, though, French colonials fell victim to London's male fashion dictates, just as their nineteenth-century Parisian cousins did.[8] Fine distinctions between Montreal's two cultural groups await further study. Here we assume that their common masculinity drove them together more than their cultures drove them apart, both in concepts of manhood and in dress.

Nonetheless, it is not surprising that French Canadians initially objected to colourless masculine garb. Their mother country of France, according to John Harvey, had been

> the country of colour ... its civility had taken the tonalities of Watteau, of Fragonard, of dancers in rose and azure satin ... [during the 18th century] the use of bright colours (red, yellow, blue) rises in the nobility from eight to thirty eight per cent of their clothing ... bright colour by those in waged labour also increased.[9]

French colonists were inheritors of a tradition of male splendour. Their own parents had gazed on local reflections of the court of Versailles. They might have watched Governor General Jonquière being inaugurated in Quebec in 1749, 'dressed in a suit of red, with an abundance of gold lace ... [h]is servants ... before him in green.'[10] The patterned frockcoat and lavish trim were characteristic of a noble of the early reign of Louis XIV, a time when Claude de Ramezay was emigrating to New France. Perchance the colonists espied Governor de Ramezay

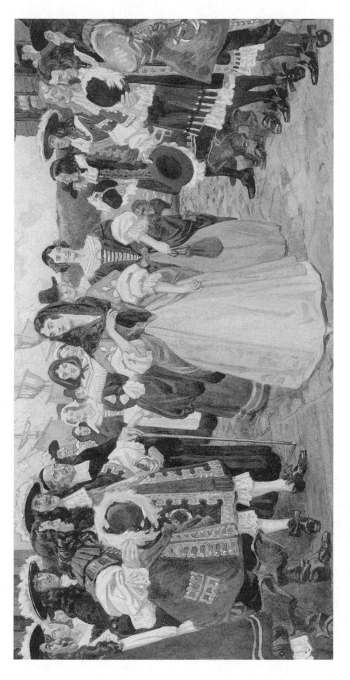

9 Seventeenth-century nobles dressed more to display their rank than their gender, with men as well as women sporting ruffles, feathers, ribbons, and high heels. It was the prerogative of nobles of both sexes to wear lace, brocades, and other luxury fabrics, which European sumptuary laws sometimes forbade commoners to use. There were also limitations on nobles earning money through trade or manual labour. Their task as members of the king's 'family' was to live (and dress) graciously, upholding society's hierarchical order by entertaining other elites, rendering the king social, political, and military services as needed. (National Archives of Canada, C-010688)

himself, punctilious in observance of rank and ritual, strutting in high heels in the vicinity of his riverfront chateau.

'A Real Gentleman'

Claude de Ramezay represents an ancien régime form of masculinity. We look not just at his dress but at what kind of man he was. His lifestyle was very different from that of the nineteenth-century gentlemen who came after him. De Ramezay began his career when he arrived as a lieutenant in the French colonial troops. A competent but unremarkable warrior, he turned his hand to administration. Purchasing the office of governor of the little town of Trois-Rivières, he made a name for himself by entertaining officials and visitors who stopped there on their way between the two bigger towns of Quebec City and Montreal. His superior, Governor Frontenac, rewarded his efforts by declaring him 'a real gentleman.'

As a nobleman, de Ramezay belonged to a caste dedicated to enhancing the king's honour. They were not to toil at growing crops, fabricating goods, or anything else that dirtied the hands literally or figuratively. Though prohibitions on noble commerce had been abolished by decree in both the colony and the mother country, such enterprise was to remain adjunct to military or administrative service and must not interfere with 'living nobly.' The tiny ruling caste of nobles comprised about 5 per cent of the population. These 'bluebloods' were considered so far above the common people as to have different blood from the ordinary vileins or 'vile persons.' They prided themselves on their (largely mythical) descent from ancient Frankish warriors: Governor Frontenac's wife posed for her portrait in a military helmet, and Governor de Ramezay chose to be portrayed in his armour. Another of their trademarks was physical grace, developed from childhood. Little nobles learned how to bow precisely the appropriate degree to persons of varying rank, to ride and fence – and above all, to dance, a particular Canadian passion. Gracefulness, later to be cultivated as a feminine trait, distinguished nobles of both sexes. Ceremonious slowness of movement also announced superiority over faster-moving subordinates. These attributes made the noble body itself a fashionable object. Both sexes obligingly showed it off, with flashy, form-fitting attire.

Proudly different from the common breed, nobles dressed not so much to display gender as to display rank. 'Aristocratic dress,' Philippe Perrot writes, 'openly performed a sociopolitical function – self-affirmation for some and subordination for others – freezing everyone in their places.'[11] Though only the men wore swords, nobles of both sexes exercised their prerogative to wear wigs, floral brocades, satins, velvets, and rich colours derived from expensive dyes or precious

metals. They also wore braid and feather trimmings, silk stockings and silver-buckled shoes with red high heels. Ever ready to demand full honours for himself, de Ramezay was infuriated when he felt the governor general addressed him with too little respect at a public gathering. Distinctive clothes helped satisfy the craving for unambiguous public recognition of status. As de Ramezay was rising to power around 1690, Louis XIV's sumptuary laws were in effect, minutely regulating 'even such details as gold braid and buttons ... according to estate, rank, season and circumstances.'[12] French noble styles of the 1690s included the wig or peruke dressed into towering twin peaks with profuse curls falling down breast and back and shoes with block-like heels and toes. 'These massively architectural, heavily built accessories,' Geoffrey Squire observes, 'would have assured an exaggeratedly strutting deportment fully expressive of the pompous grandeur which marked ... the court of the Sun King.'[13] During the decades around 1700 Canadian noblemen's inventories included habits trimmed in silk and gold buttons, and silver vests with gold flowers. (Showy vests – which also served as corsets – were embroidered with big flowers or even battle scenes, and would continue to flash out beneath the darkening coats of the early nineteenth century.)

Governor de Ramezay's conduct matched his attire; for speech, like dress, was extravagant in those days. He boasted his home was 'unquestionably the most beautiful in Canada.' He quarrelled, bragged, and acted with little foresight about consequences. 'Brusque and ill-tempered,' he was accused of improper immersion in the fur trade, giving 'all the members of his numerous family the means of pursuing it in preference to all the other *habitants.*' He quarrelled with the Jesuits and directly attacked his superior, Governor General Vaudreuil. Vaudreuil charged that de Ramezay's violent temper made him unfit to govern; Ramezay conceded he had a quick temper but countercharged that Vaudreuil in a moment of anger had slapped a man in the face and kicked him in the stomach.[14]

Just as those governors did not dress or speak in a businesslike way, they did not go to the office; much of the business of governing took place at home. They conferred with other members of the ruling circle who frequented the chateau's guest beds, banquet table, ballroom, with up to forty at a time residing at the governor general's house. If an occasional document was needed, it was drawn up and signed on the writing desk at home. Nor was there clear distinction between domestic and government expenditures.

If the high-heeled, beruffled ancien regime noble did not appear a sober financial mainstay, indeed he was not. From the 1670s Canadian nobles increasingly sought crown support, claiming inability to support their large families. The French traveller La Potherie wrote that Canada was a poor country, heavily dependent on crown handouts, that 'the officers who are married have only their appointments to sustain their families; their wives are in distress when they die.'[15]

Dispatch after dispatch from the governor and intendant solicited the king's 'graces' for those left in the lurch.

In Claude de Ramezay's case, even as he took possession of his mansion he began imploring the crown for subsidies, the governorship requiring 'much expense to sustain ... with honour.' When de Ramezay died in 1724, Governor Vaudreuil commented that he had served 'with honour ... and lived very comfortably, having always spent more than his salary, which is the reason he has left only a very small estate to his widow and children.'[16] Wrapped in his lace and satin, gold and silver, cocooned in his big house, Claude de Ramezay typified the gorgeous peacock male who would have been mortified by a missing shoe buckle but saw no disgrace in begging for subsidies and leaving his family in debt. Male honour required show, not solvency.

In the ancien régime, breadwinning was, after all, not a male responsibility, but a family one. Just as peasant couples worked the farm together, noble couples worked the banquet tables together. A family story recounts a tired Madame de Ramezay sighing for a peaceful life on their remote seigneurie, but telling her daughters it was their duty to entertain 'his Majesty's high-ranking citizens.'[17] Even the children served, accompanying their parents to review the troops.

When her husband died, it came naturally for Madame de Ramezay to take over the task of writing the crown to secure pensions for herself and her daughters, and military promotion for her sons.[18] The governor's widow and daughter also carried on the family timber and sawmilling operation located near their seigneurie, the daughter showing real talent in expanding the family holdings. Though the men alone fought, most other noble endeavours were family ones. Women tended to monopolize direction of the colony's health and social relief agencies, with mother superiors of noble background, including one de Ramezay daughter, administering the hospitals and asylums.[19]

Women dressed and posed to show their rank, not their motherliness. Indeed, the colony's painters left few portraits of mothers with children. An exception is a 1703 *ex voto* of Madame Riverin which shows mother and children at prayer. The children, as was typical of the period, were dressed as small adults, as was appropriate in a family economy. The son wore frockcoat and cravat, and his hair resembled a wig, while the oldest daughter's tiered lace headdress matched her mother's. Certainly noblewomen were not 'motherly' towards their young in the modern sense. They typically sent their newborns out to rural nursemaids until age two. Those who survived nursing (about half) were sent off again a few years later to boarding schools or regimental training.

Elite men continued to dazzle as the regime drew to a close. Sieur de Bouat in 1753 had a silk habit and a scarlet vest, and black velvet breeches.[20] A French lieutenant fighting with Montcalm's army left an impressive wardrobe that was

auctioned off to the sound of tambour at Fort Carillon in 1758:

> ... velvet breeches, linen gaiters, three linen nightcaps, scarlet vest trimmed in gold, two scarlet hats ... satin coat embroidered with gold, old gold buttons, white breeches with gold garters, three shirts with scalloped cuffs, six shirts with embroidered scalloped cuffs.[21]

Luxurious display filtered to lower levels of society as the eighteenth century progressed. In France 'barbers, printers, tailors, shop assistants, and shop clerks wore powdered wigs and thick layers of pomade, and strutted about with swords even when this practice was waning at court.' In 1749 when Peter Kalm visited New France he reported people of rank were accustomed to wear lace-trimmed clothes and some of the gentlemen wore wigs.[22] But he also noted other classes aping their betters, and this was captured in a Conquest-era illustration of a male habitant dressed for mass in a fancy vest and lacy coat. Travellers contrasted the comparatively wealthy but thrifty New Englanders to the French colonists who might eat sparingly and spend on dress to 'display that which they had not.'

Certainly merchants appropriated noble finery after the British conquest of 1760. A 1793 portrait shows Eustache-Ignace Trottier with embroidered vest, large decorative buttons, and profusions of lace on his chest and wrists. He evinced no shame in being portrayed gambling over a game of cards. Fur trade merchants who gathered at early nineteenth-century meetings of the Montreal's Beaver Club also arrived lavishly adorned with medals, ruffles, gold lace, gold-clasped garters and silver-buckled shoes.[23]

A World Transformed

The advent of the plain dark suit, such as the one Arthur Davidson ordered in 1791, signalled a century of such heightened gender differentiation in clothing that males and females, according to one fashion historian, seemed to belong to different species.[24] Men became extremely uncomfortable with ornate costume. Fittingly enough, patriarchy was also on the rise. As historians of both the French and American Revolutions such as Lynn Hunt, Joan Landes, and Linda Kerber have shown, the Rights of Man became defined as those of males, not those of humans. By the end of the French Revolution women were banned from political clubs. Public women became associated with intriguing courtesans or risqué salons, so feminine virtue became defined narrowly as staying home and bringing up good citizens. By the time the 1837 Rebellion broke out, such attitudes had reached even the peasantry of remote Lower Canada.

Women were restricted on various fronts. Although a number of Lower Cana-

dian female property-owners had voted in the decades after 1791, this was banned temporarily in 1834 and permanently in 1849. The English system of primogenture and male property rights gradually replaced the equal inheritance rights of both sexes and the well-protected wifely claims of the traditional *Coutume de Paris*. At the same time, the western world witnessed the gradual movement of economic production away from cottages, family farms, and other homesites. Now singled out as both the family's breadwinner and its political representative, the male assumed a new degree of public power. Although it was of course still possible for 'Lady Astor to oppress her footman,' authority based on male gender tended to supplant the old authority based on rank.

Fashion historians note a corresponding turn to gendered dress. Both French and Canadian writers have asserted that the French Revolution transformed men's clothing in the long run, establishing the lasting reign of dark trousers and matching jacket. Yet, even as men experienced the French Revolution's political and sartorial upheaval, the period was deeply reactionary for women. On 8 Brumaire, Year II (1793), France's National Convention decreed an end to the old vestimentary codes: 'No person of either sex can force any citizen, male or female, to dress in a particular way, under penalty ... everyone is free to wear the garment or garb *suitable to his or her sex* [my italics] that he or she pleases.'

Happy to strike down sumptuary notions of clothing based on rank and occupation, the revolutionaries were unblinkingly reactionary about gender distinctions. Some women apparently did not conform, since on 16 Brumaire, Year IX (1800), a police ordinance expressly forbade Parisian women to wear trousers without special dispensation. By that time women's political participation had already been banned.[25]

Men, however, walked into a new world. Before Claude de Ramezay's century was out, the men at the top discarded their gorgeous frockcoats, pumps, and cascading wigs for the short natural hair and dark suits that began to appear on the streets of Montreal in the 1790s. Since many of the Canadian nobility had fled to France after the British conquest of 1760, those who filled the upper ranks were no longer necessarily bluebloods. Indeed, the two nineteenth-century gentlemen we next discuss were not.

The direction in which Montreal gentlemen marched was towards greater power and greater duty. Claude de Ramezay, after some youthful military campaigning, had become a government functionary with what his biographer calls 'a mediocre military mind' who 'did not leave a deep imprint on the history of New France.'[26] His success lay in impressing his contemporaries with an extravagant and hospitable lifestyle, playing the grand seigneur. By contrast, the two nineteenth-century leaders, Louis-Joseph Papineau and John Redpath, applied their energies to attacking establishment evils and challenging entrenched orders – moral, political, ecclesiastic, economic.

The Romantic, Transitional Male

Louis-Joseph Papineau, our second Montreal leader, was a transitional male. A middle-class professional, he stood halfway between the knightly nobleman and the civilian self-made man. While not a blueblood of de Ramezay's kind, he was not quite self-made either. Though Papineau's grandfather had been a cooper, his father had risen to become a notary and a member of Lower Canada's rather rustic Legislative Assembly. This was a career path the son would follow, albeit in a grander way. It was Papineau senior who acquired the family seigneurie of Petit Nation in the Ottawa valley. The son, Louis-Joseph, was a hobby gardener, and in retirement a gentleman farmer. His claim to fame was political, becoming the mouthpiece of a vibrant young nationalism. His fiery words did much to lead some seven thousand Lower Canadian habitants into rebellion in 1837. Papineau, who lacked the nobleman's martial training, left the scene just before the key battle of St Denis, and on this account lost face with followers who were still sufficiently old-fashioned to expect the men at the top to be warriors.

As a boy Louis-Joseph had been sent to the seminary by a pious mother who hoped he would become a priest. All too soon the precocious lad polished off the syllabus and proceeded to the impious tracts of the *philosophes*. Losing interest in the priesthood, he studied law instead; but his initial experiences persuaded him the legal profession was a 'den of chicanery.' Choosing politics, he was elected assemblyman in 1809, Speaker of the Assembly in 1815.

Papineau was a book-loving, emotional being who longed to escape the burdens of office. Weeping and depressed by the death of one of his children, he had trouble performing in the Assembly. He was exhorted to be more practical, since 'domestic sorrow should not work to the detriment of public affairs. Be firm at your post. Behind the draperies, we mourn for our beloved.' Papineau was also berated posthumously by his biographer Fernand Ouellet, who called him 'a divided soul,' 'weak-willed and intensely emotional ... so sensitive ... given to high enthusiasms but also ... hesitations and fits of melancholy.'[27] More sympathetic biographers concede he was more a thinker than a man of action. Papineau himself once complained that 'complete and stupid inaction ... is my wretched dominating inclination.' Throughout his career Papineau expressed a desire to retire from public life.[28]

Papineau's biographer questioned who wore the pants in the family. 'By abandoning his post he would have run the risk of losing his wife's esteem; she would not have stood for such weakness in her husband.' 'Pushed by his wife and former supporters, he agreed to stand for election' although 'his wife obstinately resisted this constantly renewed project, for it ran contrary to her tastes and her need to dominate, as well as to her ambitions.'[29] But Julie Papineau seems altogether in the tradition of the de Ramezay women, and of more ordinary French-Canadian

women of the early nineteenth century whose extensive influence was noted by British observers, and sometimes attributed to their property rights. It is only by later standards that early nineteenth-century French-Canadian men – and Romantic men – seem henpecked or 'weak willed.'

There was a tension in the Papineau marriage that related to the changing gender roles of the period. Papineau chastised his wife for her unladylike fascination with politics; she in turn chastised him for championing liberty for the nation but autocracy at home.[30] Indeed, he had much to say about the running of the house, proffering advice he had gleaned from Rousseau and other writers on breast-feeding, exercise, and nutrition. In the legislature he fostered political measures that diminished women's rights. He advocated withdrawing the vote from women, saying public voting was an affront to their modesty. As for nuns, such as the de Ramezays' daughter who had administered health and welfare institutions, Papineau challenged their ability to do so. He wanted Assembly control over convent expenditures. He was also laying the groundwork for politics and financial administration to emerge as purely masculine endeavours.

Papineau represents the romantic masculinity of the early nineteenth century. Romantics were among the first to adopt trousers, the traditional garb of sailors and *sans culottes,* as a way of expressing solidarity with the common man. By the 1830s Lower Canadian professionals were spending a greater proportion of their income (some 20 per cent) on attire than any other class, making them leaders in fashion as well as politics. They were, for example, early purchasers not only of trousers but also of the stylish Wellington and Brunswick boots advertised in Lower Canadian newspapers after 1815.[31] When Papineau was young, these men went from wearing wigs or tying back their own long hair (as his father Joseph did) to short natural styles.[32]

In Papineau's day such styles were not dull but dashing. Wearing them, young lawyers, notaries, politicians, and physicians nurtured romantic sensibilities inspired by Goethe and the English poets, the barricades, and the star-spangled banner. When Papineau first entered the Assembly, he was a tall, elegant young man with a broad chest, handsome face, and eagle eyes. His ringing voice, grandiose gestures, and withering countenance 'made Lower Canada's English rulers tremble,' especially since the masses lionized him:

> When he went from village to village, hurling everywhere his words of fire, bolts of eloquence – what ovations! what processions! what joyful demonstrations! The flags came out; women waved their handkerchiefs; children threw bouquets; and with one voice they all cried: Vive Papineau![33]

By the 1830s elegance and eloquence were not enough; a man had to act. As

British and American historians have pointed out, nineteenth-century man came to be defined by his work. (Hall and Davidoff cite the Essex seed merchant whose self-esteem fluctuated with his ability to meet creditors: 'I may be a man one day, a mouse the next.'[34]) Career difficulties began to have more than economic significance; they became a form of emasculation. Papineau's flight from battle, and his impractical radicalism won the scorn of former supporters after his 1845 return from exile in Paris. They ridiculed him as a loose cannon and, worse, a coward. He in turn criticized them as mere professionals, too absorbed in careers and compromises. But the compromisers and the careerists prevailed. Papineau, after a series of humiliations, retired to the solitude of his Ottawa valley seigneurie. During two decades of isolation he had little influence of public affairs, showing a penchant for hopeless causes.[35] In his final years, though, a new generation of nationalists made pilgrimages to sit at the feet of the founding father.

Though some found him wanting in masculine restraint, Papineau's successive portraits clearly show him becoming a man in black.[36] He looked aristocratically androgynous with flowing locks and wide collar in a pre-adolescent portrait. Midlife portraits from the 1830s reveal him in black professional garb, with minute concessions to lace and ruffling. In an 1858 portrait by Napoleon Bourassa he wore ebony tie, buttons, vest, and suit. His stiff figure stood against a romantic landscape that was expressive in a way no longer permitted to the subject himself, for Papineau was now a fully evolved 'Man in Black.'

An 1836 pair of portraits by Plamondon illustrate the way the aristocratic role was passing to women. Julie Papineau, a merchant's daughter, aped the aristocracy. Decked out in a lavish golden gown, lace stole, and gold and ruby jewelry, she was supervising her daughter Ezilda's piano training (see colour plate A). Julie's portrait underscored both the maternal role and the family's gentility. By contrast, her husband was portrayed at work, wearing his robes of office. The portraits illustrate the point originating with Thorstein Veblen and embraced by fashion historians, that well-dressed wives and children became men's status symbols. As Philippe Perrot observed, the bourgeois 'amassed wealth but did not exhibit it ... [which] condemned a woman to wear the livery of the man who kept her, and to serve him as a foil. As signs of wealth and ornamental objects, women replaced the lace and jewels banished from men's clothing by the Revolution.'[37]

In dress, a man began to diverge not only from his wife, but also from his offspring. Quebec fashion historian Louise Gagnon noted that in the century after 1780, boys' clothes became quite distinct from those of men.[38] Girls differed only slightly from their mothers (Ezilda Papineau is an example), notably in their shorter sleeves and protruding pantaloons. Boys, once they shed the complete androgyny of dresses around age four, were decked out in a whole range of sailor, Highlander, and Lord Fauntleroy suits. This emphasized the difference between

man the provider and his still economically dependent sons. The bourgeois boy with feminine, sophisticated outfits, not to mention the footman decked out as ancien régime courtier, demonstrated the prosperity of the master of the house, the man in black.

Though he donned the drab garb of the professionals, Papineau kept the heart of a poet. He spent many hours in his library, a solitary square tower containing three thousand volumes. His end seems fittingly romantic: he caught pneumonia after going out in his dressing gown on a frosty fall morning to direct labourers improving the grounds. He was, one mourner reminisced, 'accustomed to imprudent exposure in all weather.'

Papineau straddled a great divide in the history of masculinity. He parted company with Governor Ramezay, the old-fashioned noble who was unabashedly spendthrift and hotheaded, who dressed for show and left the family to depend on his king's largesse and the business talents of his widow and daughter. Like de Ramezay, Papineau was emotionally extravagant; there were times when his activities cast his family into physical danger or debt. On the whole, however, he supported them, and his parliamentary salary allowed comfortable retirement at Montebello.

Papineau was a romantic soul born into a world where deep sensitivity and a life of seclusion were fast becoming female attributes. The biographer who hinted at his 'unmanliness' was oblivious to the context: during Papineau's lifetime the gender codes changed. Papineau was indeed a divided soul, uncomfortably crossing the great divide that would leave the soulful male behind. Another way to regard him is as an adolescent in the evolution towards a 'modern' conception of manhood that would harden into orthodoxy around 1840 and endure for more than a century. By the time Papineau returned from exile in 1845, the simple black suit and starched collar had firmly supplanted the ruffled sleeve and frothy cravat of his youth, in the same way as his bombastic politics had also gone out of style. In both dress and career, men headed to a more practical state, marching away from dramatics and off to work.

The Full-Blown Man in Black

In John Redpath we discern the classic 'Man in Black.' Even the fashion historian Christopher Breward, who cautioned against exaggerating the 'Great Masculine Renunciation,' conceded that the 1850s and 1860s were a period of 'stovepipe severity.'[39] Coming to prominence in those two decades, Redpath was a renouncer. Long past the point when he could afford ease and comfort, he stayed on duty. He combined hardheaded money-making with tireless Protestant zeal. An orphan who arrived from Scotland at the age of twenty, he is said to have walked

barefoot from Quebec City to Montreal to save his one pair of shoes. Redpath rose from stonemason to Rideau Canal contractor to Montreal's first big industrialist. His piety manifested itself in perfectionist religion, a movement emanating from American evangelical circles between 1815 and 1860. Convinced of the 'infinite worthiness' of all persons, they believed even the outcast dregs of humanity could attain near-perfection – and prepare for Christ's Second Coming. Believers were called to the strenuous work of rooting out baneful traditions and dissolute practices such as slavery, drunkenness, and debauchery. Redpath plied that straight, narrow path of driving capitalism and exacting Christianity.

Though not all Montreal's elite marched to this tune, the improving species of male was clearly on the rise in the early Victorian period. By the third decade of the nineteenth century, raucous men's groups such as the Beaver Club, whose members drank themselves under the table, were falling out of fashion. Redpath and other born-again merchants were replacing the fur trade elite at the city's social summit. Pious men filled the pews of Montreal's churches and presided over reforming societies and institutions. An 1839 Montreal guidebook claimed 'perhaps there is no place where in relation to the number and wealth of its inhabitants, more has been done to relieve the wretched and support the weak by means of real charity than in this city' – and this not with 'thoughtless profusion' but through 'cautious and painstaking administration' by businessmen such as Redpath.[40] Believing their mission extended to the whole colony, they banded together and sent Christian schoolteachers to rural areas. They dispatched temperance circuit riders to the far reaches of Gaspé and Lake Huron, a crusade so successful that the 1849 Parliamentary Committee on Intemperance declared drunkenness had ceased to be 'a gentlemanly vice.'

Male fashion, as we have seen in our discussion of Papineau, was also shedding all trace of riotous excess. Beaver Club lace and ruffles gave way to the black uniform seen in John Redpath's 1862 photograph (illustration 10). The garb, with antecedents among Puritans and Quakers, perfectly suited our self-made entrepreneur and teetotaller. 'The extinction of color,' Philippe Perrot observed, 'signalled the onset of a new ethic based on will, self-denial, thrift and merit.' The stiff black suit of the bourgeois, like that of a clergyman, 'disguised or effaced his body, allowing the wearer to distance himself from it, abandon it, and forget its embarassing or inopportune presence.'[41] Here was the man's man, bereft of frivolity. Redpath's portrait reveals not the tiniest playful wisp or ruffle. He is all angularity, all in black, with only a stiff white shirt to set it off. He seems ill at ease in the armchair. Is he anxious to return to work?

One must not carry gendered analysis of nineteenth-century costume to an extreme. Though gender distinctions now overshadowed those of rank, this was certainly no classless society. The bourgeois gave vent to his aristocratic yearnings

10 Self-made industrialist John Redpath, a Scottish orphan said to have arrived barefoot in Montreal, became one of its richest men. From his top hat to his boots, Redpath represents the classic mid-nineteenth-century Man in Black. A driving entrepreneur, Presbyterian philanthropist, and teetotaller, he embodies the self-control and efficiency associated with the gentleman of his day, who spend business hours 'in almost any sort of degrading occupation ... and be a gentleman still.' (John Redpath, Montreal, QC, 1866, 1-20963.1, Notman Photographic Archives, McCord Museum of Canadian History, Montreal)

in the privacy of his own home in his coloured satin dressing-gown and velvet slippers. Even in public he could hint at wealth and pedigree with 'the immaculate whiteness of starched shirtfronts, collars, cravats, and shirt cuffs ... with prestige conferred ... by its brief existence (threatened by a thousand accidents), the gestural contraints implied, and especially the costs entailed in laundering and replacement.'[42]

The new gent also claimed distinction with his black silk top hat, an item fashionable in England by 1815. Since this imported model supplanted earlier ones made of Canadian beaver, the item was doubly dysfunctional for Montrealers. Philippe Perrot wryly deconstructs the haberdashery that swept the western world:

> It fulfilled no useful purpose; its narrow brim provided little protection from rain or sun, and its height exposed it to every wind ... This gleaming cylinder owed its long life to other virtues: notably, that of incorporating bourgeois propriety, through its stiffness and funereal sobriety, and aristocratic bearing, because it made any physical activity completely impossible.[43]

In replacing noble wigs and feathers, the hat symbolized equality; but its shimmer, cleanliness, and distinctive details subverted that message. Redpath – self-made but very rich – posed for the camera with his democratic/undemocratic headwear at the ready.

Apart from that mixed message on his head, Redpath paraded not so much his person as his accomplishments. He was justly proud of the sugar refinery he opened in 1854. His belching factory was honoured at the 1855 Paris Exhibition, where he touted it with a panoramic print and a boastful booklet. It was a celebration of grubby productivity that would have shocked Claude de Ramezay. Redpath's actions of national significance included co-founding the stern but relatively democratic Canadian Free Kirk in 1843, and presiding over the Businessmen's Annexation Association in 1849. He served as Montreal alderman, helped design federal tariff policy, and contributed handsomely to philanthropies and reforms. In a single lifetime he heaved stone, made money, and shaped policy of church and state. In the Redpath Sugar Refinery and the Canadian Presbyterian Kirk he fathered two of his adopted country's enduring institutions.

Redpath shouldered the male role made famous in Samuel Smiles's account of self-made men. He typically worked three or four hours longer than his associates. He founded the sugar refinery to assure the financial future of his family, and his sons noted it caused him great anxiety. Serving on boards of banks and companies, he was a voice for caution and sound business practices. Like many a self-made industrialist he was a commanding presence, often to the discomfit of those around him. He made strong and seemingly somewhat arbitrary demands of his

sons, ultimately deciding only two of them were fit for the family business.[44] (In contrast to ancien régime practice, sons could no longer count on lineage or patronage to outweigh personal failings.) It was said Redpath remained humble and generous, never becoming 'vain, proud and heartless'; but he was clearly tough-minded.

This 'no-frills' gentleman was highly productive. In addition to his overtime at the office, Redpath also did 'women's work,' showing an engagement with the young, sick, and abandoned that is more often associated with the other sex. An 1819 town guidebook indicated nearly all the benevolent activity was performed by women, with lay or religious women running the hospitals, asylums, and benevolent societies. A few decades later Protestant laymen (and Catholic clergymen) had taken closer control of the purse strings and administration of social assistance. In 1831 Redpath and his male colleagues began administering an enlarged version of Montreal General Hospital that the Female Benevolent Society had founded. Redpath performed his work with devotion. At the hospital for example, for decades he 'took a deep interest and spent many hours there ... offering the consolation of the everlasting gospel to the sick and dying in its wards.' He supported the Magdalen Asylum to redeem 'unfortunate females, many of whom have been decoyed into the abodes of ... shame which abound in this city.' At home he lived 'a lovely private life ... [of] humble and unassuming deportment amid the enjoyment of much wealth.'[45] His letters indicate active involvement in the careful moral upbringing of his children, and a jocular affection for the young.[46]

With the paterfamilias such an active figure at work, in civic affairs, and at home, how were the women occupying themselves? We know little about Redpath's two successive wives, other than that they bore him seventeen children between them. The temperance journal Redpath sponsored lamented in the 1840s that women were not doing more to aid that cause. Jane Redpath was evidently a dutiful Presbyterian churchwoman. Fortunately there is more information about Redpath's daughter Helen. She married refinery engineer George Drummond, a dynamic individual who eventually directed the company's operation. In their Sherbrooke Street mansion she

> planned the rooms, the decorations, the arrangement of the priceless objects of *virtu* with which it was the delight of [Mr.Drummond] to surround himself ... when he could spare the leisure to enjoy his artistic leanings. This beautiful home ... housed many a notable guest. It echoed to soft laughter, to brilliant music ... all that is most select in Montreal society gathered in its drawing rooms.[47]

Drummond family portraits are instructive. An 1876 portrait of Helen Redpath

Drummond depicts her as a showy aristocrat, in the costume of the Victorian lady. Probably she was wearing tightly laced stays to produce her small waist, an agony ladies suffered during much of the nineteenth century. The skirt grew to mammoth volume due to the evolving proliferation of undergarments: multiple petticoats before 1840, horsehair crinolines in the 1840s and 1850s, then artificial cage crinolines that allowed skirts to reach their fullest circumference. Helen's body carried all the weighty fabric and aggressive ornamentation of the old noblesse. A portrait of her sons from the 1860s showed how little boys still dressed in the knee breeches and ornamental clothing associated with eighteenth-century elites, acquiring their father's long pants as they grew older.

These styles reflected the very divergent lifestyles of Victorian men and women. Helen Redpath Drummond, unlike the de Ramezay women, took no part in the family business. Statecraft, bread-winning, and social welfare administration had moved out of the home to become male responsibilities. Life insurance, a nineteenth-century development, now made doubly sure that the widow need never drag her billowing sea of fabric across the factory floor. Loss of *Coutume de Paris* wifely property rights let the Man in Black exercise control even from the grave, now having discretion to write a will disinheriting his widow should she remarry.[48] The lavishly dressed but economically dependent person presiding over the gracious home was now female, but the estate was no longer the economic and political hub it had been in the de Ramezays' day. Vinken observes:

> The more securely women are excluded from the sphere of power and authority that is divided up among men, the more generously the attributes of nobility are distributed among them: they are elevated to ... queen of hearts, tyrannical mistress, whose least whim is yielded to and at whose feet everything is laid – everything, on condition that they remain completely powerless.[49]

Conclusion

John Redpath and Louis-Joseph Papineau, the two nineteenth-century 'Men in Black' in a Canadian city, strike us with their power and the complexity of their concerns. They seem to have borne a heavy set of responsibilities of both a public and private nature. Their stories indicate that taking more exclusive control of civic and bread-winning roles did not necessarily mean a man gave up his private life, somehow delegating it to the womenfolk. Some men retained a very active presence in family, neighbourhood, church, community. For the political reformer Papineau and the social reformer Redpath, conscience would scarcely let them rest.

Montreal was the leading city of the Province of Canada, which in the 1840s and 1850s experienced remarkable growth and economic changes. Our two

paragons were not the only tireless activists of that vigorous era; the black suit of early- and mid-Victorian Montreal clothed many a serious, accomplished individual. By contrast, the lavish attire that slowed the body's movement and the gracious life of the manor once expected of the nobleman were transferred to the bourgeois wife. While she did the honours at home, John Redpath and his fellow evangelicals changed the city's character, initiating an industrial revolution, and a moral revolution as well. For his part, Louis-Joseph Papineau was the first great spokesman of a nationalism so powerful it has kept a conquered people intact on an anglophone continent for more than two centuries – still French, still in fighting trim.

The Montreal cases we have studied affirm the dramatic impact of the Revolutionary Age on both male appearance and male authority. After black suits made their first, controversial appearance in town streets in 1791, a gentleman's costume increasingly took the nature of a uniform common across the western world. In contrast to the vain and showy Claude de Ramezay, our two black-clad nineteenth-century public men assume true moral gravitas. Louis-Joseph Papineau's transition to modern masculinity showed more growing pains than did John Redpath's. But both of these men bore their troubles, supported their families, rallied their communities, transformed their country. Without condoning the highly gendered division of power that called forth their energies, one can still admire the bravura performance. Might it be said they earned their pants?

NOTES

1 McCord Archives, Montreal, McCord Family Papers 144, Arthur Davidson to John Chalmers, 25 June 1791.
2 William Wood, *The Storied Province of Quebec: Past and Present* (Toronto, Dominion Publishing, 1931), 2: 1061.
3 Harvey, *Men in Black*, 9, 257; Vinken, 'Transvesty – Travesty: Fashion and Gender,' 35–6.
4 Vinken, 'Transvestry,' 35. On Charles II and the connections between dress and manly patriotism in England, see Kuchta, *The Three-Piece Suit and Modern Masculinity*.
5 On the macaronies, see McNeil, 'Macaroni Masculinities.' On the change from Paris to London fashions, see Ribeiro, *The Art of Dress*, 30.
6 Ruddel, 'Consumer Trends, Clothing, Textiles and Equipment in the Montreal Area, 1792–1835,' 46.
7 Cited in Ribeiro, *The Art of Dress*, 14.
8 Philippe Aubert de Gaspé noted that past glorious military heroism was downplayed

by elites for fear of being labelled 'French and bad subjects.' The ambitious perhaps tried to blend in sartorially too, judging by a glance at portraits from the two cultures in Beland, ed., *La Peinture au Québec, 1820–1850.*

9 Harvey, *Men in Black*, 125. The figures on coloured clothing he attributes to Daniel Roche.

10 Peter Kalm, *The America of 1750: Peter Kalm's Travels in North America* (New York: Dover, 1964), 2: 465.

11 Perrot, *Fashioning the Bourgeoisie*, 10.

12 See the essay by E.L.R. Williamson, 'Period Costume,' 154ff; Perrot, *Fashioning the Bougeoisie*, 16.

13 Squire, *Dress Art and Society 1560–1970*, 94.

14 See 'Claude de Ramezay,' *Dictionary of Canadian Biography* (Toronto: University of Toronto Press, 1969) 2: 545–8 for the governor's character and career.

15 Charles Le Roy Bacqueville de la Potherie, *Histoire de l'Amerique septentrionale* (Paris: Nyon, 1753), I: 367–68; see also Louis Franquet, *Voyages et mémoires sur le Canada* (Montreal: Editions Elysée, 1974), 56.

16 See 'Claude de Ramezay.' *Dictionary of Canadian Biography* 2: 548.

17 Abbé A. Daniel, *Histoire des grandes familles francaises du Canada* (Montreal: E. Senecal, 1867), 438–40.

18 NA, C11A, vol. 50, 24 May 1728; ibid., Madame de Ramezay to Maurepas, 8 October 1728; vol. 56, Mme. Ramezay to Maurepas, 25 August, 1731; vol. 58, Hocquart to Maurepas, 15 October 1732.

19 The forceful character and convent life of Mother St Claude de Ramezay is discussed in my 'Caste and Clientage in an Eighteenth Century Convent,' *Canadian Historical Review* 82, no. 3 (2001): 465–90.

20 Robert-Lionel Séguin, *La Civilisation traditionnelle de l''habitant' aux 17e et 18e siècles* (Montreal: Fides, 1973), 492.

21 Marius Barbeau, *Saintes Artisans*, I: *Les Brodeuses* (Montreal: Editions Fides, 1946), 67 (my translation).

22 Perrot, *Fashioning the Bourgeoisie*, 18; Kalm, *The America of 1750*, II: 446–47.

23 Charles Bert Reed, *Masters of the Wilderness* (Chicago, 1914), 68. For an intriguing analysis, see Carolyn Podruchny, 'Festivities, Fortitude and Fraternalism: Fur Trade Masculinity and the Beaver Club, 1785–1827,' in *New Faces of the Fur Trade: Selected Papers of the Seventh North American Fur Trade Conference* (Halifax, 1995).

24 Laver, *The Concise History of Fashion and Costume*, 184.

25 Perrot, *Fashioning the Bourgeoisie*, 20.

26 'Claude de Ramezay.' *Dictionary of Canadian Biography* 2: 547–8.

27 Fernand Ouellet, *Louis-Joseph Papineau: A Divided Soul* (Ottawa: Canadian Historical Association, 1961), 3. This was the opinion of fellow rebels T.S. Brown and Robert

Nelson. The latter referred to him as 'a man good for speaking but not for acting.'
Cited in Fermand Ouellet, *Economic and Social History of Quebec, 1760–1850*
(Ottawa: 1989), 420–47, 635–36.

28 L-J Papineau to John Neilson, cited in Mason Wade, *The French Canadians* (Toronto:
Macmillan, 1968), 1: 135; see also the letter to his wife reprinted in R. Rumilly,
Papineau et son temps (Montreal: Fides, 1977), 1: 374.

29 Ouellet, *Papineau*, 14, 17–18.

30 Letter of 24 November 1831, quoted in Rumilly, *Rapineau*, 1: 245.

31 Ruddel, 'Consumer Trends,' 51, 52, 62 n.25.

32 Historian-archivist P-G Roy estimated that wigs were abandoned about fifty years
after the Conquest, about 1810, and the *couette*, long hair tied behind, between 1800
and 1825. Roy, 'Nos coutumes et nos traditions francaises,' *Cahiers des Dix* 4 (1939).

33 Thomas Storrow Brown, *L'Hon. L-J Papineau* (Montreal, 1872), 11 (my translation).

34 Leonore Davidoff and Catherine Hall, *Family Fortunes: Men and Women of the
English Middle Class, 1780–1850* (Chicago: University of Chicago Press, 1987), 229.
See also E. Anthony Rotundo, *American Manhood* (New York: Basic Books, 1993),
13–14.

35 Chiefly annexation to the United States (in the very year Confederation occurred)
and retention of the seigneurial system, which was abolished to the approval of all
parties in the legislature in 1854.

36 His friend and biographer said he was (falsely) accused of being a man of ungovern-
able passions. See E.B. O'Callaghan, *Biographical Sketch of Hon. Louis Joseph
Papineau* (Saratoga, NY, 1838), 6–7.

37 Perrot, *Fashioning the Bourgeoisie*, 34–45.

38 Louise Gagnon, *L'Apparition des modes enfantines au Québec* (Quebec: Institut
québécois de recherche sur la culture, 1992), 39, 61, 78, 120–63.

39 Christopher Breward, *The Hidden Consumer: Masculinities, Fashion and City Life,
1860–1914* (Manchester: Manchester University Press, 1999), 258.

40 F. Bosworth, *Hochelega Depicta* (1839), cited in W.H. Atherton, *Montreal, 1535–
1914* (Montreal: S.J. Clarke, 1914), 493.

41 Perrot, *Fashioning the Bourgeoisie*, 30, 32.

42 Ibid., 33, 127.

43 Ibid., 122.

44 Rev. D.H. MacVicar, *In Memoriam: A Sermon Preached in the Presbyterian Church ...
on the Death of John Redpath, Esq.* (Montreal: J. Lovell, 1869). On Redpath's factory
and family business relationships, see Richard Feltoe, *Redpath: The History of a Sugar
House* (Toronto: Natural Heritage/Natural History, 1991), 39–73.

45 MacVicar, *In Memoriam*. See also Gerald Tulchinsky, 'John Redpath,' *Dictionary of
Canadian Biography* (Toronto: University of Toronto Press, 1976), 9: 654–55.

46 This is evident in the small collection of Redpath letters at the McCord Museum in Montreal.
47 From E.A.Collard, *Call Back Yesterday*, cited in Feltoe, *History of a Sugar House*, 147. Numerous Redpath and Drummond portraits are reprinted in Feltoe's book. An 1876 portrait of George Drummond is consonant is Christopher Heward's point that there was a slight relaxation of 'Man in Black' conventions after 1870. Drummond posed in the now permitted neutral shades and a coat of a more relaxed cut than that seen in the earlier portrait of his father-in-law, John Redpath. This function of the middle-class female in the United States is discussed in Stuart Blumin, *The Emergence of the Middle Class: Social Experience in the American City, 1760–1900* (Cambridge: Cambridge University Press, 1989), 179ff. See also Christine Stansell, *City of Women: Sex and Class in New York, 1789–1860* (New York: Knopf, 1986).
48 English-Canadian inheritance law is discussed in Lori Chambers, *Married Women and Property Law in Victorian Ontario* (Toronto: Osgoode Society, 1997), and in David Gagan, *Hopeful Travellers: Families, Land, and Social Change in Mid-Victorian Peel County, Canada West* (Toronto: University of Toronto Press, 1981).
49 Vinken, 'Transvestry,' 35, 38.

SELECTED BIBLIOGRAPHY

Beland, Mario, ed. *La Peinture au Quebec, 1820–1850*. Quebec, 1991.
Harvey, John. *Men in Black*. Chicago: University of Chicago Press, 1995.
Kuchta, David. *The Three-Piece Suit and Modern Masculinity: England, 1550–1850*. Berkeley, University of California Press, 2002.
Laver, James. *The Concise History of Fashion and Costume*. New York, 1969.
McNeil, Peter. 'Macaroni Masculinities.' *Fashion Theory* 4 (): 4373–404.
Perrot, Philippe. *Fashioning the Bourgeoisie: A History of Clothing in the Nineteenth Century*. Princeton, NJ: Princeton University Press, 1994.
Ribeiro, Aileen. *The Art of Dress: Fashion in England and France, 1750 to 1820*. New Haven: Yale University Press, 1995.
Ruddel, David-Theiry. 'Consumer Trends, Clothing, Textiles and Equipment in the Montreal Area, 1792–1835,' *Material History Bulletin* 32 (Fall 1990).
Squire, Geoffrey. *Dress Art and Society 1560–1970*. London, Studio Vista, 1974.
Vinken, Barbara. 'Transvesty – Travesty: Fashion and Gender.' *Fashion Theory* 3, no.1 (1999).
Williamson, E.L.R. 'Period Costume,' *Encyclopedia Canadiana*. Toronto, 1972.

The Association of Canadian Couturiers

ALEXANDRA PALMER

During the 1950s there was a concentrated effort to establish a Canadian couture industry. Through the Association of Canadian Couturiers (ACC) an attempt was made to create a national voice for Canadian fashion design. Thus far this organization is a neglected aspect of the discussion surrounding the creation of a Canadian cultural identity though, as Stack and Cooper have clearly shown elsewhere in this volume, fashion can be manipulated for this result. The impetus for the ACC initiative lay in the general economic and cultural growth of the country, as well as the blossoming of Canada's social and cultural life. That a couture group could be achieved in the mid-twentieth century was due, in no small part, to the influx of postwar European immigrants, many of whom had the technical skills to be able to realize complex design concepts. This was coupled with growing numbers of participants in an expanding social season. This chapter sets out to appraise the success of this group in establishing a Canadian fashion identity.

The Association of Canadian Couturiers was founded in Montreal in April 1954. The idea of pioneering such a group came from Freda Garmaise and Kay Rex, editors for *Style*, the Canadian fashion and textile trade magazine.

> [They] felt that Canada was ready for her own couture ... that such a group could promote the Canadian textile industry (through the use of Canadian fabrics) and focus attention nationally and internationally on the Canadian fashion industry ... that eventually Canadian manufacturers would reproduce these original Canadian designs and that Canadian and foreign retailers would purchase Canadian originals for the same prestige reasons that prompt them to buy from other countries.[1]

This concept was based upon the European model of the Chambre syndicale de la couture in Paris and the idea was presented to Raoul-Jean Fouré, an established Montreal couturier, who became the first president of the group.[2] By June a

charter was drawn up, in July the Primary Textile Institute of Canada offered assistance, and in September the ACC showed its first collection to the press at the Ritz-Carlton Hotel, Montreal.

The inaugural show attracted much publicity for the group, the individual designers, and the textile manufacturers. It featured twelve designers from among its fourteen members. Jacques de Montejoye, Marie-France de Paris, Germaine et Rene, France Davies, Bianca Gusmaroli, Jacques Michel d'Anjou, Louis Philippe de Seve, Raoul-Jean Fouré, were all from Montreal; Federica and Tibor de Nagay were the only Torontonians. Out of the group half were of Canadian descent, the rest new immigrants.[3] The commentary for the collection was given by Raoul-Jean Fouré who announced that, 'For Canadian prestige we want to show what can be done by Canadian designers using only Canadian textiles.'[4]

A special feature of the inaugural fashion show was a section devoted to designs made from Canadian woollen blanket material. As Eileen Stack's chapter in this volume makes clear, this textile was considered to be traditionally Canadian: historically blanket coats were made from Hudson's Bay Company trade blankets, worn by habitants and later adopted by Canadian winter sports clubs. Designs included a pale coral skirt embroidered with black braid by Federica and a turquoise jacket with a scarf for après ski wear shown with black velvet pants by Tibor de Nagay. Bianca Gusmaroli lined a cocktail coat in white blanket cloth.[5] The Canadianness of the show was reinforced by one of the models, Barbara Markham, the 1954 Miss Canada, and also by the use of appropriately nationalistic names such as 'Mount Royal,' 'Algonquin,' and 'Jasper Blue' for the designs[5] (illustration 11).

After it travelled to Vancouver and Ottawa, the show was taken to New York City. The New York show was held at the Hotel Pierre on 7 December 1954. The program stated that it was 'one of a series designed to acquaint the fashion-minded American public with the work of Canadian couturiers.'[6] Forty designs were seen and introduced by Ray Lawson, the Canadian consul general:

> It will give you a new concept of Canada ... You know us well as a country with vast natural resources, growing industrial power, and expanding opportunities for investment. You have noticed the attention given to fine arts in Canada in the last few years. Now you are about to see what has been simmering in fashions in Canada. From this day on we hope fashion authorities of the U.S. will include Canada whenever they think of fabrics or styles that are different.[7]

Lawson admitted that Canada did not yet have a national image of promoting design, but was starting a campaign to promote Canadian fashion design at the level of a serious national 'fine art.' This was the same year that the Massey

DESIGNS BY GUSMAROLI, FREDERICA, DE NAGAY & MARIE FRANCE* AT MONTREAL'S ALL-CANADIAN FASHION SHOW
After the flat look, long torsos and a terrifying color.

Dwight E. Dolan

11 *Time* magazine's feature of the first Association of Canadian Couturiers collection using only Canadian textiles, including Canadian wool blanket fabric seen in Federica's 'pale coral skirt ... embroidered with great loops of black braid' and De Nagay's design that 'turned a turquoise blanket into a luxurious looking jacket with a long scarf for after ski wear.' (*Time*, 4 October 1954, 27)

Commission Report concluded that Canadian cultural life was in its infancy, was very weakly supported, and that there was widespread ignorance of Canada abroad. Lawson also acknowledged that the country's prevailing cultural institutions owed their existence to work by women's volunteer groups. These women were often the ones who patronized Canadian couturiers, thereby setting the standards of fashionable dress in Canada.[8] Canadian couturiers, by uniting and collaborating with each other and with the textile industry internally and externally, played a significant role in representing Canada's emerging postwar culture.

The response from the American audience was favourable, and the recorded comments reveal that they were in fact quite surprised by the high quality: 'I think the clothes are terrific ... I can't get over the amount of talent and good taste, ... they are internationally elegant.' The success of the New York showing succeeded in securing the attention of Canadian government officials who attended, and who went on to announce that the couture clothes would possibly be accompanying the Canadian fur display that was already scheduled to go to trade fairs in Milan, Brussels, and Paris in the following spring, 'to help build prestige and extend Canadian textile markets.'[9] Thus, as soon as an identifiable group of couturiers had emerged, it was their success outside Canada that secured them their first national support. Unfortunately, this situation is still all too familiar for many Canadian artists and designers.

The success of the New York venture served to publicize the group and the individual designers. Frederica later used the press reviews of her New York showing to promote her new fall collection. Tibor de Nagay was invited back to New York to have a solo showing in February.

The second presentation of the ACC was held 21 to 23 April 1955 in Montreal's Mount Royal Hotel (illustration 12). The event was called 'Panorama of Fabrics and Fashions,' and the opening of each daily show featured a 'fully-clad model' emerging from an oversized chemists' beaker to emphasize the modernity of the new synthetic fabrics and was accompanied by displays of products from Canadian mills, dyers and textile manufacturers. The event was hugely successful, attracting over ten thousand people from both the trade and the general public, while an estimated five thousand were turned away due to lack of space.[10] As the chair of the event, Leon Moody, remarked:

> Our object in mounting this show, which has been six months in preparation, was to gain more recognition for our technical association and publicity for our textile industry. Both of those objectives were accomplished and those who ... saw the show went away surprised at the ability of our technicians, fabric mills and Canadian couturiers to produce a quality of fabric and design which is not surpassed in any country in the world.[11]

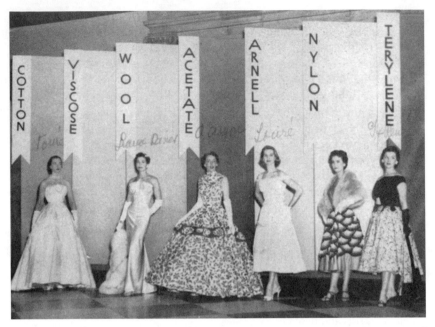

12 The second presentation of the Association of Canadian Couturiers in 1955. Pictured here are several of the twenty-four couturier-designed ensembles seen in the finale of the show called 'Panorama of Fabrics and Fashions.' The couturiers' designs went on to be shown in trade shows in Brussels and Milan. (Supplement to the *Huntington Gleaner*, 27 April 1955)

The show, coordinated by Lissa Taylor and supported by the federal government's Department of Trade and Commerce, travelled to trade shows in Milan, Paris, and Brussels. The cooperation of the Canadian government, textile industry, couturiers, and furriers (who were also promoting Canadian furs and fur designs) was described as 'a concentrated frontal attack on European markets [and] marks Canada's coming of age in the world of high fashion.' Jean Lesage, the federal minister of Northern Affairs and Natural Resources said that 'the government of Canada is aware of the paramount importance of securing overseas markets, not only for our wheat, but also for all our commodities ... such as fashion textile fabrics and furs.'[12] Nonetheless, it was also acknowledged that 'all this activity on the other side of the Atlantic is aimed at creating prestige for the industry here, at home, rather than opening up European markets.'[13] Such statements are in direct contrast to Paris couture production that was fully supported by tax laws and subsidies for textile manufacturers, and the couture houses, and viewed as an important economic and cultural French export.

To some extent the new Canadian policy worked in winning the attention of the home market. In July 1955 the *Canadian Home Journal* featured some of the clothes shown in Montreal and Europe. The text accompanying the photographs ran as follows:

> Look long at the stunning fashions on these pages. Would you be happy to wear them? Would you know at a glance where they were made – or by whom? ... Yet because of an adolescent quality of Canadian thinking that tends to believe other nations create things better than we, there are women who would pass up such fashions if they knew they were Canadian designs, and choose the costume with the New York, London, or Paris label.

The article admonished Canadian women who did not support Canadian design.[14] However, the magazine ran the feature only after the couturiers had been shown in New York and Europe, which showed that the editors were as culpable as their readers.

The couturiers continued to show together even though they began to be frustrated individually. The designs by members of the ACC were the vehicles for publicizing Canadian textiles but resulted in little profit for the couturiers, as they did not sell many models. This was in sharp contrast to the publicity and the financial gains for the Canadian textile manufacturers.[15] However, promotional showcases were influential in establishing the trans-Canada reputation of a couturier. An example of this occurred on 30 December 1957, when six Canadian couturier dress models made of nylon were shown on television during the Du Pont sponsorship of the popular family program *Father Knows Best*.[16] Yet the couturiers who had already been established prior to the creation of the group felt that association membership, even with its publicity, had not helped their private business. In contrast, the younger, less established couturiers felt that they were better known to the general public due to the publicity received by the group. Marie-France credited half her sales increase to the association.[17]

Members and press were not always satisfied with the designs of the ACC, or with its membership structure. In order to be considered for membership a couturier had to make his or her living by designing. There were only a limited number of Canadian couturiers who could do so, as was revealed in 1958; although association membership was limited to twenty, in fact it had only twelve members. The membership rules seem to have been vague and based more upon a referral and veto system than rigid regulations such as those imposed by the Chambre syndicale de la couture parisienne. Somebody applied for Angelina Fabbro to be included and she went to Montreal to be interviewed by Marie-Paule. She had on a coat she had made, and when she asked Marie-Paule how to get into the association, she was told she only had to ask. Marie-Paule had noted Angelina's

ensemble and determined the quality of her atelier, as well as her design skills based upon Angelina's personal appearance. She did not closely examine her technical expertise. When Rodolphe Liska became a member around the same time, he said he had to be invited and was sponsored by a mill. He met Monsieur Fouré, the president, and was interviewed by the Textile Association in Montreal.[18]

The inconsistency of the quality of the fashion designs was constantly under attack by the press, and was a recurring difficulty recognized by the couturiers themselves.[19] The fact that the members had to show collectively and could use only Canadian textiles led to conflicts. A year after the creation of the association, the Canadian press began to suggest that some of the designs in the fall 1955 show 'should never have left the drawing board ... there is still readiness to confuse wild originality with good design.' The reporter continued in a scathing review:

> The use of drapery material for ball gowns is not in itself the mark of an original designer nor is it an excuse for bad taste ... Throughout the show there was a tendency towards too much frou-frou – the obvious result of trying too hard to be creative and trying to get away from a ready-made look ... The chief trouble ... is that in enlarging their membership they have, or seem to have, lowered their standards.[20]

In the spring 1957 show another reporter voiced opposite complaints, saying that 'at their best ... designs were wearable, but that they had that touch of restrained individuality which is distinctly Canadian.'[21] Thus, the designers were simultaneously accused of being too dramatic and not dramatic enough, and of having weak membership standards.

As the group entered its third year, the couturiers' collection was shown on the heels of imported European fashion shows and did not compare favourably. The charges of copying or relying upon European, and particularly Paris-inspired, designs were similar to those levied at internationally recognized London couturiers, who got around this problem by showing in advance of Paris. This same strategy worked for the ACC for their spring 1962 collection, when it was noted that 'copying was impossible because the Canadian designers created their collections weeks ago in time for photography and definitely before the Paris collections were shown.'[22] In 1956 the thirty-five designs by sixteen couturiers were considered at their best when content with 'unpretentiousness.' The same reporter went on to say that 'the general level ... is dragged down by certain members who strive for originality with tricky and devious details which produce nothing so much as banality.'[23]

The charge of inconsistent standards pointed up one of the dilemmas of showing as a collective, and perhaps could have been resolved if the couturiers were

given their own shows while still being part of a larger membership and marketing collective, as were their contemporaries in Paris or London. As the Canadian organization grew, this central problem was bound to result in uneven shows. Freda Garmaise, of *Style*, reviewing the collection in February 1959, went further:

> ... models in the spring and summer collection ... were both in interpretation and workmanship generally below the level of better-class Canadian manufacturers ... From the point of view of assessing each couturier's worth, it would certainly be fairer if small individual collections could be held.[24]

However, for individual couturiers to mount solo shows was not financially possible without more backing from the industry. Canada did not have enough of a couture industry or even a large enough number of clients to generate individual showings that would attract the international press. In fact, even American postwar fashion design was still strongly reliant upon European couture collections, and did not have either a nationally or internationally recognized couture association.

Nonetheless, each couturier ran a salon quite independently from the association, and in order to remain in business had to satisfy its clientele. So in a sense, members of the ACC had two public façades and two types of consumers for their designs. The primary focus was their private salon catering to a small clientele, designing and producing custom fashions closely based upon the Paris couture system; this was their livelihood. The other façade was a public one loosely linked to manufacturers and intended for a wider, less elite audience. Thus, the charges of weak or too flamboyant designs were perhaps more a question of the ambiguity of this dual role and an attempt to please two groups rather than a lack of design knowledge or taste. Further, each couturier showed only a few garments; for instance, in the fall 1959 show fourteen couturiers were represented by thirty-seven garments.[25] In Europe, single couturiers presented fifty or more garments in one collection. Thus the individual designer was never represented in the context of a larger line with developing themes, but only in direct competition with fellow couturiers who may be suggesting disparate design ideas. Yet Canadian couturiers never collaborated with each other on one collection to produce a unifying design scheme and presentation, which may have solved this problem even though it might also have had enormous potential for frustration. Further, the notion of couture design by committee is in direct contrast to the historical couture system that promotes the individual designer as a great artist.[26]

The charge of lack of originality was also levelled at Canadian industrial designers in the 1946 exhibition, 'Design in Industry.' At that time it was hoped that a change could be achieved by encouraging Canadian design talent through

training programs, research, design competitions, by setting up design education and coordinating designers and manufacturers. Many of these recommendations were in place by 1953.[27] However, no such initiatives were ever forthcoming in regards to couture production.

The international couture trade was rapidly changing at this time. The very term 'couture' was confused with new developments in European couturier boutique and ready-to-wear designs. The further diffusion of 'couture' and the overall lessening of quality was exemplified in the many copies and adaptations that were mass produced and distributed. So, while European couturiers themselves were reinventing the marketing and understanding of international haute couture, Canadian couturiers were attempting to emulate the traditional and outdated operations of European couture within a North American environment. The fact that the couturiers were working in Canada, with a limited base of skilled labour and no supporting industries, was not acknowledged. Too, Freda Garmaise noted that 'The group is suffering from a disadvantage ... the press and trade are generally seeing a great deal of couturier clothes. Their eyes are accustomed to couturier standards and ... the Association does not come up to these standards.'[28] The ACC could never have achieved the credibility and support of their European counterparts; no allowances were made for their particular environment that necessitated modification of European-inspired designs, limited resources for textiles, and very different working conditions and marketplace demands.

The inconsistent quality of the fashion designs was a recurring difficulty, and mentioned by the couturiers themselves.[29] One of the most fundamental differences from European couturiers production, and a large obstacle, was that as members of the association they had to use Canadian textiles produced and intended for lower and medium-priced garments, and not the European imported luxury goods. One reporter writing on the fall 1955 collection was not pleased with the designs but commented upon the fact that the textiles were very good and that 'no Canadian woman need be ashamed to wear those that are available.' In 1959 Gwen Cowley wrote that 'the collection presented with the Canadian Fabrics Foundation and the Primary Textile Institute, introduced some exciting new Canadian-made fabrics, many of them in the experimental stages.' Her article called this the best collection from the group. However, that same year Olive Dickason voiced the feeling of the couturiers that one of the reasons they were restricted in their designs was because they had to use Canadian fabric, which was generally new synthetic textiles, in order to gain the sponsorship of the textile manufacturers.[30] With each new textile the couturiers had to learn its properties and design around the textile's drape and weight, rather than select a textile to suit a design. Paris couturiers also experimented with new synthetics, but they were not limited to their use for an entire collection. However, the difficulty of working with

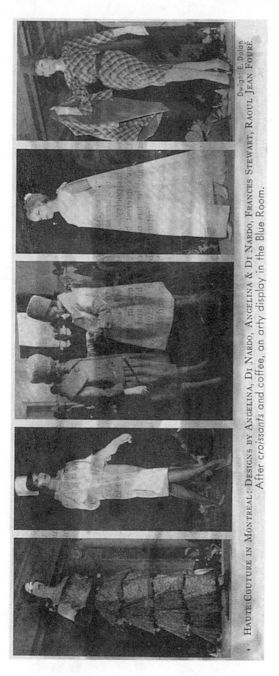

· HAUTE COUTURE IN MONTREAL: DESIGNS BY ANGELINA, DI NARDO, ANGELINA & DI NARDO, FRANCES STEWART, RAOUL JEAN FOURÉ.
After croissants and coffee, an arty display in the Blue Room.

Dwigh-E. Dolan

13 Designs by members of the Association of Canadian Couturiers shown in the Fall 1960 collection. (*Time*, 5 September 1960. Angelina Archives ROM)

new synthetics and unfamiliar textiles was tackled and it was noted that by 1959 the fabrics were 'much more suited to subtle handling than they were in the earlier collections'[31] (illustration 13).

In their own salons the couturiers used international couture quality textiles woven by the best European producers. All the Toronto designers interviewed mentioned the problem of having to use the Canadian cloth, which was not up to the same standard that they were accustomed to using. The couturiers felt they had to employ great ingenuity in their designs in order to transform the fabric. For a spring 1955 afternoon dress of 'shell pink acetate and cotton pongee from Associated Textiles,' Federica machine embroidered the fabric after it was cut to shape, in order to enhance the design and transform a plain dress into a more original couture quality garment[32] (illustration 14).

In France, couture houses were obliged to use 80 per cent French fabric. But they were subsidized by the government from a tax paid from 1950 to 1963 by the textile manufacturers.[33] This reciprocal arrangement worked to everyone's mutual advantage and greatly explains France's prestige and cultural dominance in fashion. An editorial in *Style* commented upon the couturiers need for the assistance of the Canadian textile industry. But it also noted that they should be paid, and should be given time to research and experiment with textiles in collaboration with the industry and retailers. It was felt that if Canadian couturiers and designers were given help, they 'should be able to replace New York as the principal source of Canadian design ideas.'[34] However, they were never given such support from government or industry.

Both Federica and de Nagay advocated that ACC members not be restricted to Canadian fabrics. As Federica commented, 'Manufacturers will never use garments that we have in shows for the general market ... A fashion show is expected to produce something different – but the materials are not different at all. We must produce styles which are. Our designs are sometimes criticized but we cannot show a plain style in a plain fabric.' Tibor de Nagay echoed her: 'The mills are only interested in what sells. They supply the couturiers with the same materials they give the manufacturers – nothing different, nothing to stir the imagination. But the mills have money. The couturiers have none.'[35]

A solution to this problem was attempted in the fall 1956 collection. Without the backing of the Canadian textile industry the couturiers showed new designs to a group of Montreal buyers and manufacturers. In this instance the designers used imported as well as Canadian fabrics and thus were not so restricted. However, as the group entered its third year, even though there was dissent amongst the couturiers regarding the logistics and management of the association and its relationship with the Canadian mills, all agreed that they could not survive without the support of the textile industries.

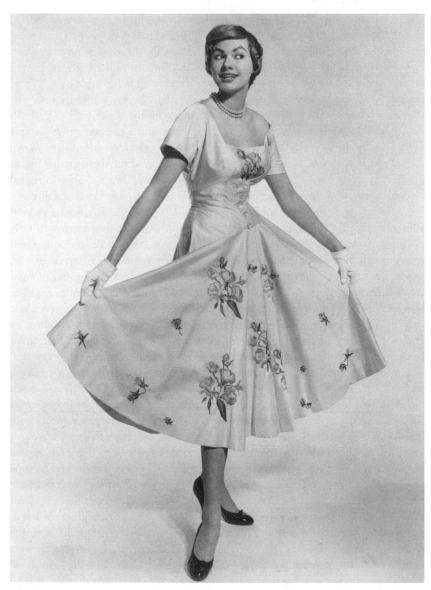

14 Federica's Spring 1955 afternoon dress of 'shell pink acetate and cotton pongee from Associated Textiles,' that she had machine-embroidered and was shown in the Panorama of Canadian Fabric and Fashion held in Montreal. (Photograph by Richard Arless; Frederica Archives, ROM).

The liaison continued, and in the summer of 1958 a bridal show was supported by the Canadian Textile Conference. In the spring of that same year an agreement was reached with the Canadian Fabrics Foundation for the association to produce two shows a year that would alternate between Toronto and Montreal. It took several years for the ACC to achieve its aim of 'Producing fashionable clothes more cheaply.' Fashion reporter Lillian Foster noted that 'if you wanted one of the dresses you had to make your own arrangements with the designer,' but by 1959 Canadian manufacturers were seriously attempting to use the couturiers' designs as sources for copies and adaptations.[36] Six ready-to-wear adaptations were shown following the fall show, including a dress of 'a viscose and silk mixture that makes a taffeta type of fabric.'[37] The following spring season, 'More than 60 original designs ... are being reproduced by seven well-known Montreal manufacturers in medium-priced adaptations for sale across Canada,' and Eaton's held a fashion show featuring the originals and the adaptations on 24 February, thereby seriously promoting the designs and the designers.[38] However, the next collection received mixed reaction. It was noted by one reviewer that 'it was more parading talent than seeking to show a good basic dress for you and me,' while another reporter thought that it '... may well be remembered as one of the most dramatic fashion shows to be seen locally.' This same reviewer noted the mixed reception but went on to conclude that 'if Canadian designers can produce well-designed clothes – even if inspired by Paris – I feel they are doing their job.'[39] Thus the ACC members were continually being reassessed by the local press, and usually from various viewpoints.

One of the more successful ventures involving Canadian textiles occurred in the spring 1963 season when the couturiers were supported by the Canadian Cotton Council. The object of this sponsorship was to 'take cotton from the kitchen to the ballroom,' and a similar example in England by Horrockses had proven successful. This collection was well received by the press, who thought that the nine couturiers involved 'showed an imaginative, experimental approach to the international couture trends for the season.' Specially mentioned was Angelina of Toronto's ensemble 'of turquoise dress with a Damon Runyon-type of striped blazer jacket.'[40] One of the reasons for the success of this collection may have been due to the use of a natural fibre that would easily drape and hold a shape, rather than the use of synthetics that could be stiff and more unforgiving as well as less familiar to the couturiers themselves. Perhaps, too, the sportswear implications of cotton were considered more appropriate and up-to-date by this time than the traditional 1950s structured couture garments. Many of the designs were themed around 'convertability ... Models were continually coming out in dresses and ensembles and peeling down to puffy romper suits or one-piece jumpsuits.'[41] Further, the promotion of cotton by the British Cotton Council, and the acceptance of high-style cottons produced by such internationally recognized textile firms as Ascher,

used by the French couturiers, or the success of Horrockes, may also have added to the acceptance and accomplishment of this collection.[42]

By the mid-1960s the interest in the group by the Canadian fashion press and public had gradually diminished. *Style* scarcely mentioned the collections, focusing its attention on ready-to-wear and Canadian manufacturers' copies of imported couture. The press opinion on the fall 1964 showing was 'that more designs didn't relate to the lives and fashion requirements of women in attendance,' who were from the suburban community of Dorval, Quebec, and directly reflected the international lessening importance of couture as a single design source. The reviewer went on to note that 'fashion ideas such as jumpsuits, for sports car racing, helmet-hat, knickers and gaiters brought laughter rather than applause.'[43] In fact, all these ideas were in perfect step with the avant-garde designs of French couturiers such as André Courreges, Pierre Cardin, and Yves St Laurent. However, these designs were also in line with ideas generated by young, new ready-to-wear designers such as Mary Quant and Tuffin and Foale who were setting up their own boutiques that catered to their own generation. In Toronto this trend was synthesised by Marilyn Brooks and her boutique, Unicorn, followed by Mr. Smith, Poupée Rouge, and Shelagh's. Young women were no longer imitating their mother's dress style but were preferring and inventing a youthful one of their own that was interpreted by the international couturiers. Thus, the diminishing importance of the ACC was a direct result of the international demise and significance of couture in general, and not solely a reflection of the good or bad quality of the Canadian designs themselves.

Additionally, Canadian manufacturers and merchants were not consistently supportive of either Canadian fashion or the ACC. For commercial reasons they were preoccupied with aligning themselves to international design trends, and often ignored occasions where they could have deliberately forwarded Canadian fashion design. In 1955 there was supposed to be an all-Canadian fashion show in conjunction with the launching and promotion of a new Canadian Pacific Railway train. This was held in the United States and aimed to encourage tourism and trade. The show was a collaboration of the leading department stores, Eaton's, Simpson's, Morgan's and Holt Renfrew. The fashions that were shown were European imports, with only Eaton's showing a few Canadian-made garments. Interestingly, *Style*'s editor considered this a missed opportunity, and felt that the department stores were too anxious to show off their modern and international up-to-date merchandise, in order to impress Americans, but in so doing,

> overlooked the fact that to sell Canada as a tourist centre it must be promoted as a place where visitors can buy something different ... There is a big variety of original, saleable Canadian-made apparel that could have been shown. It would have made a

greater impression than imports which are seen every day in the big American stores. And, at the same time it might have added a little badly needed prestige to the Canadian fashion industry.[44]

Canadian merchants' perception and publicity of themselves, however, especially with regard to fashion, was in terms of Europe, not Canada, and rarely North America. For most Canadians it was inconceivable that Canadian design could be desired or admired by other nations, and it is doubtful whether Canadians themselves found it desirable. Canadian merchants rarely considered this as a marketable or alluring feature in its own right, or as a commercial or cultural export.

In these circumstances, the success of the ACC was limited, given that its original objective was to sell Canadian-designed garments as models to manufacturers for mass-market copying. Some designs were sold to Canadian manufacturers, and reproduced to retail from $30 to $125 across the range of middle to upper priced garments.[45] However, Canadian couture models never succeeded in capturing a large local or overseas markets at any competitive or commercial level. Though the ACC and its links with the textile industry were based on selling models for copying, as was the mainstay of the Paris couture at this time, a key difference was that European couturiers sold their designs in their own choice of textiles directly to manufacturers. It was then up to the manufacturer to alter the design and select lower-end or alternative textiles for their own market and price point. The ACC was established to create an end product that other couturiers were never expected to produce, only to initiate. Too, Canadian couturiers' own production within their salons was in an entirely different arena.

The problems the ACC members faced by allying themselves with existing European couture organizations, in a country that had no such tradition and at a time when the nature of couture itself was changing, set up insurmountable problems. Angelina commented that the manufacturers kept the clothes for shows and promotions lasting three months, resulting in her ideas being in circulation too long and sometimes used without her being compensated.[46] The ACC had none of the restrictions on the press and publicity photographs that the Paris Chambre Syndicale imposed, so their designs could be easily copied. Even if Canadian couturiers had tried to dictate equivalent regulations, it is unlikely that they would have succeeded.

The mandatory use of Canadian textiles intended for mass-produced clothing was an on-going problem for the couturiers. In this area the couturiers received little design support from the textile industry that had never seriously attempted to satisfy the couturiers' needs or tastes. Canadian couturiers were left to rely heavily on the promotional skills of the textile industry and on the Canadian press, both of whom wanted immediate news and unlimited circulation of designs, thereby

depending on the couturiers as suppliers. However much the couturiers gained in prestige and press, the textile companies were the financial beneficiaries of the venture. By 1958 the Canadian textile industry was a leader in the production of synthetic fabrics, as the country was rich in the raw material required – wood, coal, and water that were combined to produce man-made fibres.[47] The ACC gave a blossoming national textile industry cultural affiliations and a high standard of creativity that was translated into some mass-manufactured garments.

The real successes of the association was its capacity to attract publicity for the individual couturiers and for the mills. In 1958 Stan Cornthwaite, the publicist, commented that the demand from fashion editors for pictures and copy on the group grew with each collection.[48] The press itself went further and noted that the association was influential as a cultural export, commenting that 'their greatest achievement ... has been the favourable publicity they have attracted not only for themselves, but for Canada in their showings abroad as well as within our own country.'[49] Two Brussels shops bought Canadian clothes as a result of the 1955 trade show, and further sales were expected. However, international recognition was limited and never achieved any coverage in the leading fashion magazines of the period.[50] The Massey Report noted the value of projecting Canada's image abroad, and the importance of national cultural exports. In fact, it went as far as to say that 'the promotion abroad of a knowledge of Canada is not a luxury but an obligation.'[51] The ACC succeeded in this capacity and was even compared to the 'most honoured movement in Canadian painting ... the Group of Seven.' This article in the Canadian edition of *Time* magazine went on to acknowledge that the then fourteen members 'made [their] bow in an art form rarer in Canada: *haute couture*.'[52]

The ACC's most important contribution was certainly in promoting a national design identity and in its role as cultural ambassador for Canada, internally and externally. This aspect of the association was its real strength and succeeded in attracting press for the couturiers, the mills, and for Canada as a nation. When the Association was established, one of the manufacturers compared Canadians' preoccupation with couture and fashion to their simultaneous interests in design and the home in general. He cited the example of the National Industrial Design Council, which was was formed to promote Canadian design for export through better design – a similar initiative to the couturiers selling models and toiles.[53] However, unlike Canadian industrial design, the Association of Canadian Couturiers never received encouragement or financial backing from the government, possibly because Ottawa wanted to sustain wartime manufacturing levels, which were much higher than prewar output. During the war the clothing industry was placed under federal restrictions and decreased production while the textile industry was seen as a vital contribution to the economy and increased production.

One of the keys of success for the ACC and its ability to command national and

international attention may have been that Canadian couturiers never faced the problem of traditional versus modernist design that Canadian artists, crafts people, and industrial designers had to combat. No such problem existed with fashion that conformed to an internationally accepted and recognized Paris-based style. The Toronto couturier Federica described this as elegance, which, she said, 'is timeless, and fashion is the essence of changeability, often made of brilliant or amusing ideas which burn out quickly.'[54] The very nature of fashion, because of its concentration on seasonally developing style changes, implied modernism. Thus, when considered in the context of other art and design groups, Canadian couture achieved remarkable international and national recognition, despite very real obstacles. As fashion reporter Olive Dickason noted, the Association of Canadian Couturiers designs 'stood up well internationally' and added 'a distinct element to Canadian society.'[55]

NOTES

1 'Association Launched by Style Editors,' 33. *Style* is the Canadian fashion industry trade magazine that functions in a similar role to that of the American newspaper, *Women's Wear Daily*.

2 For information on Raoul-Jean Fouré, see Guernsey, *Gaby*, 101, 141; 'Raoul-Jean Fouré,' *Style*, 15 September 1954, 6.

3 The importance of new Canadians in creating culture is discussed by Lydia Sharman in this book. For similar postwar immigration in Australia, see Butler, ed., *The Europeans*.

4 Gwen Cowley, 'Canadian Fashion Show Wins Plaudits in N.Y.,' *Star*, Federica Scrapbook, collection Royal Ontario Museum (ROM).

5 *Time*, 4 October 1954, 27. Mount Royal is an upper-class anglophone residential area in Montreal; Algonquin was named after a Native band in Northern Ontario and is also an Ontario national park; Jasper is a well-known ski resort in the Rockies in Alberta.

6 L'Association des Couturiers Canadiens Inc., 7 December 1954, program, Federica Scrapbook, ROM.

7 Cowley, 'Canadian Fashion Show Wins Plaudits in N.Y.'

8 See Palmer, *Couture and Commerce*, 237–92.

9 Cowley, 'Canadian Fashion Show Wins Plaudits in N.Y.'

10 There is little academic work to date on the postwar Canadian textile industry. See Allan Collier, 'Design in Western Canada,' and Virginia Wright, 'Design in Central and Eastern Canada,' in *Achieving the Modern*, 102–48; Gottlieb and Golden, *Design in Canada*, 134–45.

11 *Huntingdon Gleaner*, 27 April 1955, Federica Scrapbook.

12 'Canada Invades Fashion Field,' 10; 'Government Support Indicated for Export Campaign,' *Style*, 27 April 1955, 1.

13 Rex, 'Canadian Made Fabrics and Fashions to be Seen in Brussels Fashion Show,' *Style*, 30 March 1955, 1.

14 'At Last,' *Canadian Home Journal*, July 1955, 14.

15 See promotions in *Mayfair* for Acetate by the Canadian Chemical & Cellulose Company Ltd. designed by the following: Jacques Michel, November 1955, 15; Olivia of Hamilton, December 1956, 9; Frances Stewart, June 1956, 18; Chemcell by the Canadian Chemical & Cellulose Co Ltd., design by Raoul-Jean Fouré, October 1956, 4.

16 *Nylon News*, Winter 1957, Federica Scrapbook, ROM.

17 Freda Garmaise, 'Couturiers "Cautiously Optimistic" as Group Enters 3rd Year of Activity,' *Style*, 1957, *Style* Archives.

18 Angelina Fabbro, interview with author, 13 October 1988 and 19 May 1999; Rodolphe Liska, interview with author, 16 August 1991 and 13 December 1993.

19 Comments to this effect were made in interviews with Federica Hecht (13 June 1992), Angelina Fabbro, Rodolphe Liska, and Maria R. De Nagay (9 August 1991).

20 Zoe Bieler, 'Couturier Show Is Disappointing,' n.d., Federica Scrapbook, ROM.

21 Dickason, 'Couturier Show Mixed in Merit,' 11.

22 Zoe Beiler, 'Canadian Couturiers Collection in Line with Paris and NY,' *Montreal Star*, 14 February 1962, 42.

23 Freda Garmaise, 'Canadian Couturiers Show Competes with Imports,' *Style*, 26 September 1956, 12.

24 Freda Garmaise, 'Couturiers Said at Disadvantage,' *Style*, 11 February 1959, 20.

25 Cowley, 'Canadian Couturiers Show Fashion,' *Toronto Daily Star*, 16 September 1958, 27.

26 See Nancy J. Troy's work on Paul Poiret, *Couture Culture*.

27 Virginia Wright, 'Design in Western Canada,' in *Achieving the Modern*.

28 Garmaise, 'Courturiers Said at Disadvantage.'

29 Comments to this effect were made in interviews with Federica Hecht, Angelina Fabbro, Rodolphe Liska, and Maria R. de Nagay.

30 Bieler, 'Couturier Show Is Disappointing'; Gwen Cowley, 'Designs Better Every Year,' *Toronto Daily Star*, 4 February 1959, 31; Olive Dickason, 'Canadian Designs, Canadian Materials,' *Globe and Mail Magazine*, 21 March 1959, 29.

31 Margaret Cragg, 'Maturity Seen in New Collection of Canadian Couturiers Association,' *Globe and Mail*, 3 September 1959, 15.

32 Angelina Fabbro, Federica Hecht, Rodolphe Liska interviews.

33 Jarnow and Judelle, *Inside the Fashion Business*, 95.

34 'National Pride – Or Is It?' *Style*, 27 April 1955, 2.

35 Freda Garmaise, 'Couturiers "Cautiously Optimistic" As Group Enters 3rd Year of Activity,' *Style,* 1957, *Style* Archives.

36 Lillian Foster, 'High Style for Low Price,' *Toronto Telegram,* 5 February 1960, 29.

37 Vivian M. Wilcox, 'Hobble Skirts, Big Collars, Intrigue Canadian Designers,' *Style,* 9 September 1959, 22; Lillian Foster, 'Now Couturier Clothes Are Right at Home in Toronto,' *Toronto Telegram,* 3 September 1959, 33.

38 *Toronto Star Weekly,* 9 April 1960, Angelina Archives, ROM; Foster, 'High Style for Low Price,' 29; Olive Dickason, 'Couturiers Follow Trends,' *Globe and Mail,* article dated Montreal 4 February. Angelina Archives, ROM.

39 Lillian Foster, 'Here Are Canada's Contributions,' *Toronto Telegram,* 26 August 1960, 28; Hilda Meehan, 'Canadian Couturiers Present Fall Line,' *Montreal Gazette,* 26 August 1960, 22.

40 Helen Baker, 'Cotton Fashions Featured in Couturier Spring Showing,' *Style,* 1 April 1963, 38.

41 Beverley Mitchell, 'Couturiers Go All Out in Cotton,' *Montreal Gazette,* 22 March 1963, 19.

42 Christine Boydell, 'Pat Albeck: Textile Designer for Horrockses Fashions Limited 1953–58,' *Text: For the Study of Textile Art, Design and History* 29 (2001–2): 5–10; de la Haye, *The Cutting Edge,* 25–26.

43 'Latest Fashion Ideas Shown by Couturiers,' *Style,* 28 September 1964, 22.

44 'National Pride – Or Is It?' *Style,* 27 April 1955, 2.

45 *CBC Newsmagazine,* 19 February 1956, Canada, NFA 76-11-305; 13-0859. This records the Association of Canadian Couturiers show, 14 February 1956, at the Royal York Hotel, Toronto.

46 Interview with Angelina Fabbro.

47 'The Driving Force,' *Style,* 23 April 1958, 33. Six major companies were involved in the production of synthetic fibres under the umbrella of the Silk and Rayon Institute: Courtaulds (Canada) founded in 1926, Canadian Chemical & Cellulose, Canadian Industries Limited, Canadian Celanese, Du Pont of Canada, and Richmond Plastics.

48 'Canadian Couturiers Get Tremendous Publicity,' *Style,* 23 April 1958, *Style* Archives.

49 Marney Roe, 'Next Week Londoners Will See Canada's Bid for Fashion Fame,' *London Free Press,* 25–8 January 1958, *Style* Archives.

50 'Our Couturiers Woo Europe,' *Financial Post,* 16 July 1955, 1.

51 *Report of the Royal Commission on National Development in the Arts, Letters and Sciences* (Ottawa: King's Printer, 1951), 254.

52 'Canadian Accents,' *Time,* 5 September 1960.

53 'Says Couturier's Can Lead In Setting Canadian Trends,' *Style,* 10 November 1954, 23.

54 Newspaper clipping hand-dated, 27 February 1966, Federica Scrapbook, ROM.

55 Telephone interview with Olive Dickason, 27 June 1994.

SELECTED BIBLIOGRAPHY

Achieving the Modern: Canadian Abstract Painting and Design in the 1950s. Winnipeg: Winnipeg Art Gallery, 1993.

'Association Launched by Style Editors: Canadian Couturiers Get Tremendous Publicity.' *Style*, 23 April 1958, 33.

Butler, Roger, ed. *The Europeans: Emigré artists in Australia 1930–1960.* Canberra: National Gallery of Australia, 1997.

'Canada Invades Fashion Field: Furs, Designs and Materials Shown in Europe.' *Financial Post*, 14 May 1955, 10.

de la Haye, Amy. *The Cutting Edge: 50 Years of British Fashion 1947–1997.* London: V&A Publications, 1997.

Dickason, Olive. 'Couturier Show Mixed in Merit.' *Globe and Mail*, 6 February 1957, 11.

Gottlieb, Rachael, and Golden, Cora. *Design in Canada: Fifty Years from Teakettles to Task Chairs.* Toronto: Alfred A. Knopf, 2001.

Grumbach, Didier. *Histoires de la Mode.* Paris: Seuil, 1993.

Guernsey, Betty. *Gaby: The Life and Times of Gaby Bernier Couturière Extraordinaire.* Toronto: Marincourt Press, 1982.

Jarnow, Jeanette A., and Judelle, Beatrice. *Inside the Fashion Business.* New York: John Wiley and Sons, 1965.

Palmer, Alexandra. *Couture and Commerce: The Transatlantic Fashion Trade in the 1950s.* Vancouver: UBC Press and ROM, 2001.

Report of the Royal Commission on National Development in the Arts, Letters and Sciences. Ottawa: King's Printer, 1951.

Troy, Nancy J. *Couture Culture: A Study in Modern Art and Fashion.* Cambridge, Mass: MIT Press, 2003.

FASHION, TRADE, AND CONSUMPTION

Shop and Factory: The Ontario Millinery Trade in Transition, 1870–1930

CHRISTINA BATES

'The most fashionable and popular millinery and dress making establishment in Toronto,' according to a commercial directory of 1893, 'is that of Miss Paynter ... An extensive display is made of Paris, London and New York millinery ... in rooms fitted up with mirrors, plate glass showcases and all modern conveniences ... by a lady of most excellent taste and judgement.'[1] Miss Paynter was one of a growing number of talented and ambitious women who set up millinery shops, not just in cities such as Toronto, but in virtually every town and village across Ontario (see colour plate B). At the same time, men entered the millinery marketplace, importing and producing hats in factories. The resulting mechanization of ladies' hat-making, coupled with a trend towards simpler hat styles, led to the demise of the custom millinery trade. Large department stores, the first to retail ready-made hats, began to overshadow small millinery shops. Custom milliners developed different competitive strategies, but the demand for hand-made hats declined, as did the numbers of milliners. The more than five thousand milliners in Ontario in 1911 had dwindled to one thousand in 1931.

These changes in millinery fashion, technology, marketing, and consumption from 1870 to 1930 occurred not only for millinery, but for all the garment trades in Canadian urban centres. The tension between custom and ready-made became more pronounced as Canada's economy moved towards industrialization and mass-production of clothing.

While a small body of research on garment manufacturing in Canada exists, there is little information on the custom millinery trade and its sister occupation, dressmaking. Wendy Gamber's seminal book on the trades in New England is the most thorough documentary study for North America.[2] This essay will begin the discussion for Canada.

The Millinery Trade Defined, 1850–1890

Throughout the nineteenth century, women covered their heads with bonnets, hats, and caps, and supplying these most essential and ornamental parts of the wardrobe was the domain of female milliners. Until the 1850s, the bonnet was the most common outdoor head covering for women, designed for modesty, protection from the elements, and ornament. The bonnet cradled the back of the head, its crescent-shaped brim shaded the face, and the pleated curtain at the bottom of the crown protected the neck. Silk flowers and other trims inside and outside the brim and long silk ribbon ties softened the appearance. The foundations of these bonnets were pasteboard (cardboard), crinoline (woven horsehair or fine, stiffened cotton), willow (woven wood fibre), or buckram (woven and stiffened cotton), reinforced with cane, whalebone, or wire. Soft, unstructured caps were worn under the bonnets and for indoors. Milliners made both bonnets and caps, along with gowns, mantles, and other garments, as part of the dressmaking trade.

In the late 1850s, another head covering began to rival the bonnet. Broad-brimmed hats and small 'pork pie' toques that sat flat on top of the head became popular among young women for sport and informal wear. Correspondingly, bonnets began to tip up onto the top of the head. Caps were no longer worn for fashion. The bonnet was no longer worn for modesty, and was treated essentially as an ornament, giving way to a great variety of shapes and decoration. With the introduction of the bustle in the 1870s, bonnets and hats kept pace with the greater elaboration and complexity of dress styles. The imaginative combinations of materials, textures, and colours, and the layering of ornamentation characteristic of the bustle era, were reflected in head-dress. Hats in the 1870s and 1880s were available in every shape: crowns could rise to any height, brims flat, cocked, or irregular, all covered with a profusion of ribbons, flowers, and sometimes birds, giving great scope to the milliner's skills and ingenuity. Bonnets, now also worn indoors, became pure decoration. The tiny bonnet in colour plate B is based on a lace-edged handkerchief, cleverly draped to create a frill – a vestigial curtain – at the back, the brim decorated with ruched, brocaded ribbon and sprays of velvet flowers.[3]

Millinery became a trade separate from dressmaking, requiring specific skills and artistic sense. Although businesses sometimes included the services of both dressmaking and millinery, there was a distinct division of labour between the workers in these two trades. This separation can clearly be seen in the commercial directory for Toronto. Of the fifty-two dressmakers in the 1856 *Toronto City Directory*, nine were also indicated as milliners. By 1861 there was a separate listing for milliners, and only two of the thirteen milliners were also listed under dressmaking. By the 1880s the names in the dressmaking and millinery columns seldom cross referenced.[4]

The 1871 census gives us the first detailed picture of the importance of the millinery trade in Ontario in the nineteenth century. Enumerators were instructed to make extensive notes on any business which manufactured, altered, or repaired goods, including millinery shops where women's bonnets and hats were made. These reports contain a wealth of information on the type of business, the number, sex, and age of employees, the types of raw materials and volume of business.[5] Not all establishments were small millinery shops run by women. Over one-third of the 312 businesses which dealt in millinery were run by male merchants and manufacturers. Drygoods merchants sold millinery along with dress fabrics, underclothing, clothing accessories such as umbrellas and gloves, carpets, linens, and other housefurnishings. They also made women's wear, which was sold in their stores, thereby providing work for many milliners and dressmakers who laboured in the workrooms in the back of the shop, or in their own homes. Some drygoods retailers specialized in millinery and mantle, or coat-making, such as Merrick and Bros. of Toronto, 'importers of British, French and American Staple and Fancy Dry Goods, Dress-making, Millinery, Mantles, etc.' Merrick employed twenty-one women and three girls (under sixteen years of age), to make bonnets, hats, and mantles. Their six male employees were likely supervisors, cloth-cutters, and salesmen. By 1871 standards, this was a large establishment, as reflected in its volume of production during that year, valued at $50,000.[6]

Millinery goods were also marketed wholesale. Wholesale merchants imported feathers, ribbon, and millinery fabrics from Europe, to sell to drygoods retailers and milliners. George Goulding was the first millinery wholesaler in Toronto, starting in the 1850s. His long-lasting business (until 1944) was aided by his wife and daughter who were milliners. As well as importing millinery goods from London and Paris, he employed his family and five other women to make hats and bonnets to sell to retailers.[7]

The 1871 census reveals the gendered division within the trade based on the scale and value of business. Men running drygoods stores, wholesalers, and manufacturers were leaders. Of the top one hundred producers of over $5,000 in profit that year, only fifteen were women; men and women were evenly distributed in the middle range of $1,000 to $3,000, and the bottom range businesses, worth $1,000 and less, were almost all women. Most of these women were self-employed, or hired one to four milliners on a part-time basis. With little capital for overhead or stock, they often ran business from their own homes, and were sprinkled throughout the province. Larger towns such as London had five milliners, but at least one milliner was represented in most small towns and rural communities. Typical was E. Susand of Berlin (now Kitchener), Ontario. Mrs Susand engaged a part-time assistant milliner at just over $4 per week, and made $100 on the hats and bonnets of silk and straw she sold in her shop to the ladies of Berlin that year.[8]

Not all female milliners ran such small businesses, however. Mrs Callaway's millinery and dressmaking business in Toronto was the largest owned by a woman, and was in the top one hundred producers for Ontario. When Mrs Callaway opened her own shop in 1867, she was a fifty-two-year-old widow with a daughter and several boarders living in her home. She was ambitious, and one of the few to pay for an advertisement in the *Toronto City Directory*: 'Mrs. Callaway, Milliner and Dressmaker, Bonnets, Mantles, Dresses, etc., procured for Ladies.' She employed nineteen women, one girl, and one boy. She had a large stockroom of cloth for making clothing, bonnets, and hats, worth $6,000, and her production netted $12,000.[9]

A specialized branch of the millinery business was straw bonnet making, which flourished with the introduction of the 'cottage' bonnet early in the nineteenth century and, later, the vogue for straw hats. While straw bonnets and hats made in cottage industries in Europe were imported by Ontario drygoods merchants and wholesalers, women in Ontario also tried their hand at plaiting and sewing imported and domestic straws. One such entrepreneur was Mary Flatt of Flamborough, whose straw-hat workshop produced two hundred hats made from imported straw and locally grown wheat straw, harvested, prepared, plaited, and sewn by hand. She employed two women and one girl. Straw hats could be worn for many seasons with careful maintenance, and some milliners specialized in this service, such as Emma Tomlin in Muskoka, who offered the cleaning, repair, and alteration of straw hats and bonnets.[10]

In 1871 women's headwear was generally made by hand, by milliners who maintained small-scale businesses, or by those working for drygoods stores and wholesalers. There were, however, two large-scale manufactories using steam power, both located in the industrial centre of Toronto. Henderson and Bostwick was the only hat and bonnet factory in the province in 1871, and was the largest producer of all dealers in millinery, with their production valued at $80,000 for that year. Raw materials such as cloth, buckram, and straw plait were made into hats and bonnets by 175 women, twelve men, and fourteen boys.[11]

It did not take long for men with capital to take over straw bonnet production. Joseph Barker, who established a straw bonnet and hat factory in Toronto in 1866, employed eighty women, fifteen men, thirty girls, and five boys by 1871. He had in stock over one million yards of straw braid, imported from the plait-producing centres of Luton, England, Tuscany, Italy, and Switzerland. That year, he made over thirty thousand hats and bonnets, valued at $62,000. Like Henderson and Bostwick, he used a steam engine to run the hydraulic presses for blocking (shaping) the hats that were sewn by hand or machine. Barker was an early entrepreneur in the large-scale manufacture of straw hats. Due to the importance of straw bonnet production in England and on the continent by the mid-

nineteenth century, a race was on to develop machinery to process, plait, and sew together the straw, and then to block the roughly sewn hat into the desired shape. When China and Japan, where labour costs were low, began to export cheaper straw plaits in imitation of the European product, the European small-scale cottage trade suffered, and large factories prospered. Changing fashions which were more suited to factory production also gave impetus to the industry. The straw bonnet, long made by hand, gave way to soft-brimmed straw hats by mid-century, and in the 1880s the straw boater, a sports hat, with hard, straight crown and flat brim became popular. In Ontario, straw bonnet makers quickly fell out of the hand-made straw hat production. By the 1880s the listings for straw bonnet makers had disappeared from the Toronto city directories.[12]

Although the mechanization of women's hat-making was possible at this time, Henderson and Bostwick and Joseph Barker were the only two artificially powered and mechanized millinery factories; the millinery trade consisted mainly of men who imported or produced millinery supplies, and women who made hats by hand. The persistence of the handcraft nature of millinery and other high-end clothing production, such as tailoring and dressmaking, contrasted with other trades such as cabinet making and shoe making, where the transition from artisanal workshops to the modern mechanized factory was well established by 1871.[13]

The Heyday of Millinery, 1890–1910

By the late nineteenth century, millinery had become a very desirable trade for young women, providing one of the few opportunities for women to participate in the commercial sphere. At this time, retailing was essentially a masculine sphere, which allowed women only a small place in running shops thought to be suited to their 'feminine natures.' Millinery shops were the most common of businesses managed by women, but clothing, grocery, and fancy goods (gifts and clothing accessories) shops, and beauty parlours were other choices. Female entrepreneurship was enhanced by the 1880s, when women gained the legal right to conduct business independently of their husbands.[14] Although within a restricted sphere, women were able to convert their domestic skills into lucrative occupations, in a market system dominated by male enterprise.

The story of female entrepreneurship can be discerned in a book published in 1893 describing leading Toronto businesses. Of the approximately seven hundred businesses described in *Toronto Illustrated*, nineteen were run by women. There was only one mention of a seamstress, who specialized in boys' clothing, yet six millinery businesses were featured. The fact that six milliners considered their enterprises worth including in a commercial directory attests to the opportunities

the trade offered to women, not only to become artisans, but substantial and competitive businesswomen as well.

The essential elements of the successful millinery business were echoed in each of the advertisements. The most important attribute was that the milliner be up-to-date. She must be a 'leader in fashion,' connected to the fashion centres of the world, 'among the first to introduce new styles ... in strict accord with the newest Paris, London and New York fashions.' Patrons may rely on her 'exquisite taste and judgement' in making the 'daintiest,' most 'elegant' and 'becoming' hats and bonnets. Not only do these milliners make their own hats, but most, like drygoods stores, 'maintain close business connections with the best foreign houses,' importing 'a varied assortment of straw and felt hats and a large line of fancy trimmings ... ribbons, flowers, plumes, etc.' These stores were located on prominent commercial streets, either in storefronts on the first floor, or on the upper floors, and staff included both millinery-makers and saleswomen.[15]

According to the 1891 census, there were 2,472 trained milliners and fifty-six apprentice milliners in Ontario. There were probably many more working in the trade, as these official figures do not capture the many part-time homeworkers who were overlooked by the enumerator. An apprentice usually worked for six months without pay, and then began her training by sewing in hat linings, progressing to making hat frames, thence to covering the frames with velvet and other materials, when she would be called a 'maker.' If she were artistically gifted, she could then be promoted to the work of a trimmer, or designer. Only large millinery establishments or drygoods stores would have a designer, who would also oversee the work of the department.[16]

By 1890 the bonnet had virtually disappeared, except as worn by older women, but hats were still a very important part of the wardrobe. These pert hats, with vertical bows and decorations, perched straight on top of the head suited the flamboyant female silhouette of the period.

A large metropolitan centre like Toronto could support sophisticated millinery stores, but even in the smallest communities in the province milliners established luxuriously-decorated showrooms, feminine retreats for their customers. In illustration 15, a Midland, Ontario, milliner stands proudly with hands poised on hips, in her fashionable outfit with huge puffed sleeves and lace ruffles. She has festooned her shop front with gauzy net and lace, sumptuous brocade, and gaily printed fabrics. Large floral posies are suspended from the ceiling, and potted plants create a rich and sensual environment. Prominently displayed on ornate metal hat-stands are her model creations: straw and fabric forms overlaid with shirred, draped, and pleated materials of all kinds, silk flowers, lace, ribbons, and feathers. A profusion of yet more flowers and ornaments spill out of paper boxes for her customers to choose their own trimmings.

15 A millinery shop in Midland, Ontario, *c.* 1897. (National Archives of Canada, PA-178835)

By the turn of the twentieth century, small-brimmed hats gradually grew larger and more ornate, with deeply curved brims, culminating around 1910 with gigantic plateaux, precariously floating on top of upswept hairdos, swathed in chiffon, velvet, lace, trimmed with cabbage roses and long, curved ostrich plumes (see colour plate C). These fabulous hats were the apogee of the milliners' art, requiring skill both in constructing foundations to support the huge brims, and in creating highly ornamental trimming.

The millinery trade grew along with the hats during the first two decades of the twentieth century. The number of milliners in 1911 was more than double that of 1891 and keen interest in the trade was reflected in a host of trade manuals that were published during this period.[17] Most were written by experienced milliners who often taught in technical schools, such as Isabella Innes, founder of the Toronto Costumer's Art School, and author of *Scientific Dressmaking and Millinery*

of 1913.[18] These instruction books contained a wealth of information on millinery techniques, as well as on the cleaning and restoration of hats, setting up in business, managing the store, stockroom and employees, and cosmetic advice on matching customer's countenances with suitable millinery colours and styles.[19]

The manuals devoted many pages to the understructure which would support the oversized hats of the era. The two main foundations for hats were wire frames and flat-patterned buckram. Wire, of various weights and covered in tightly wrapped silk or cotton threads, was used to create irregular shaped and wide-brimmed Edwardian hats, such as the 'Gainsborough,' inspired by that painter's eighteenth-century portraits, or the 'Merry Widow,' after Franz Lehar's operetta. Wire foundations were particularly useful for transparent hats made of lace, netting, or loosely woven horsehair, where a foundation should be virtually invisible.

To begin a wire frame, four support wires were crossed and tied in the centre, like the spokes of a wheel. Then circular wires were tied around the wheel at intervals to outline the horizontal planes of the hat. To form the crown and brim, a skilled designer could work freehand, bending the wire in and out at will to create a new shape, but most milliners copied existing hats, possibly introducing subtle variations. The finished frame looked like a skeleton of a hat, and was always overlaid with a material such as crinoline, flannel, or net to prevent the wire or ties from working through the finishing fabric. This technique was fairly laborious, but the suppleness and plasticity of wire allowed the designer an endless variety of crown and brim shapes. Wire frames provided solid foundations on which to crowd all the trimmings popular at this period, making it possible, for example, to bend a turned-up brim a good distance from the crown, so as to create a wide space in which to mass flowers, feathers, or draped material.

The other main method in millinery framing was the sewing or glueing together of pattern pieces made out of buckram or other foundation material, such as crinoline or willow. Unlike wire frames, pattern foundations were usually constructed in two sections, the brim and crown. The crown was cut of two pieces, the side, or stand, and the top, or tip, and sewn together. The brim was snipped about one inch around the headsize, and this was turned up inside the crown to be sewn together. The fabric foundation was usually strengthened before assembly with wire sewn around the edges of the brim and crown. Flat-brimmed hats with straight crowns were simple to assemble, but the patterning of irregular-shaped hats, with turned up 'poke' brims, or 'mushroom' crowns was complex. Likewise, turbans, toques, and berets required elaborate patterns to create an elegant shape.

Although many milliners imported straw hats, the sewing of braid into hats was usually part of their repertoire. Straw was the most common material, but chip (wood shavings), woven horsehair, mohair, ramie, and chenille were also used.

Braid was sewn together on the underside in overlapping concentric circles, starting either from a circle at the tip, or from the edge of the brim. The sewing could be free-hand or shaped over a wire or buckram frame.

The artistic handling of finishing materials was the province of the head milliner. She had to achieve two contrasting looks, depending on the shape of the hat. For plain hats with flat, wide brims and straight crowns, she had to ensure that the fabric lay perfectly smooth and flat. With irregular shaped hats, a variety of techniques were used to drape, tuck, shirr and fold material to create complex and textured effects. Milliners were skilled at working on the bias, to enable them to drape fabric in three dimensions. Draping was an art, as explained by a Parisian-trained milliner: 'the beautiful effects that may be obtained by "draping" a piece of material come under the class of artistic manipulation ... Parisian milliners will take any odd cutting of velvet, silk or lace, drop it over a frame, a few light touches, and behold an arrangement of beautiful curves, graceful lines, and lights and shadows that tempt a painter.'[20]

The head milliner was usually called a trimmer, referring to the most important aspect of hat-making. Trimming was the 'finishing touch given by the artistic milliner, and to which all that has been done before is merely preparatory – a setting, as it were, for the final achievement.'[21] She arranged all the elements – ostrich plumes and other feathers, metal ornaments and handmade ribbon bows, fabric puffs, and artificial flowers – on top of the hat with a deceptively simple result that, at its best, looked effortless and elegant.

The Rise of Wholesale Millinery and the Factory Hat

At the same time as the custom millinery trade was expanding, new developments in wholesale millinery production, marketing, and distribution occurred, which would eventually erode the custom trade. The wholesale business was steadily growing and most firms were located in Toronto. In 1900 the *Toronto City Directory* listed nine wholesalers; in 1910 there were thirteen, and in 1920 the number had jumped to twenty-two. The most prominent and longstanding merchants at this time were George Goulding, already mentioned, and John D. Ivey, originally a drygoods merchant from a small town, who moved to Toronto in 1886 (see colour plate D). As chairman of the Dry Goods Section of the Ontario Board of Trade for several years, Ivey was an influential member of the business community.[22]

The millinery wholesaler initially benefited the custom milliner by supplying the imported materials and trimmings she needed to create increasingly elaborate hats. But by the turn of the century, wholesale firms ventured into the domain of hat-making. As a first step, they imported untrimmed straw hats, factory-made

wire and buckram frames, all of which were sold to milliners to finish and trim. By the late nineteenth century, wholesalers began to manufacture their own hats; for example, Goulding added a millinery workroom to his wholesale warehouse in 1898. Unlike custom millinery work, where each hat was unique, wholesale millinery was mass-produced. Teams of milliners, called copyists, would reproduce 'pattern' hats in huge quantities to sell to retailers. Wholesale firms devoted solely to the manufacture of hats were established, such as the Knox Manufacturing Company, which employed one hundred women in 1901.[23]

Wholesale firms participated in an international fashion system. Many maintained buying offices in Paris, London, and New York, and their representatives would look, buy and send home the latest in millinery design. No article of dress changed in style as much as hats, and the wholesalers prided themselves on being in vogue, as promised in an advertisement for S.F. MacKinnon Co.: 'Fickle fashion keeps us wide-awake in staying right abreast in all the new, natty creations, as they appear in the fashion centres ... Every steamer that crosses carries for us some new thing from Paris, London, or other leading markets, and the trade rely on us for everything that's right to the hour in style.' Wholesalers also sent their head milliners to the foreign centres for inspiration, and to advise on purchasing. While most of the wholesale management was run by men, experienced women trimmers were valued for their fashion sense and understanding of the techniques required to produce new styles.[24]

Because of their connection to Europe, wholesalers were able to disseminate fashion trends to retail milliners. The more retailers were made aware of 'fickle fashion,' the more millinery supplies they bought from the wholesalers. The main method of dissemination was the wholesale millinery opening, which occurred twice a year, well in advance of the spring and fall millinery retail seasons. All the wholesale firms in Toronto agreed on a date for the opening, and invited milliners from across the province. The openings were faithfully reported in the *Dry Goods Review*, a trade journal written by and for commercial businessmen. The *Review* invariably remarked with patronizing humour on the 'influx of pretty milliners,' who 'invade the city as caravans invading Mecca.'[25]

A description of the opening at the John D. Ivey company gives an idea of the size and scale of the wholesale business:

The three upper floors of the John D. Ivey Company, Limited, reveal a brilliant and varied display of the season's most valuable millinery ... The first floor is devoted to flowers, feathers, trimmings and all the numerous materials required in the making up of hats. On the next floor the ready to wear hats, shapes and untrimmed hats are exhibited in huge profusion, while still higher up the trimmed hats are displayed in a large bright showroom.[26]

Promotion and dissemination of wholesale stock and fashion was not limited to the metropolis, however. Not all milliners, especially those operating in rural areas, could afford to go to the openings, and to offset this, the warehouse firms sent out travelling salesman, or travellers, as they were called, armed with samples of stock from which milliners could order small quantities. The S.F. McKinnon Company had twenty travellers who, they claimed, covered the rural areas from the Atlantic to the Pacific. If that failed, wholesalers also sent out fashion plates and catalogues, encouraging their customers to write in for their needs.[27]

An important part of the wholesale openings was the display of model, or pattern hats, bought and imported from Parisian modistes to demonstrate the latest styles of the season. Although haute mode milliners are not as well known as couturiers such as Charles Frederick Worth or Paul Poiret, there were leading hat designers, starting with Caroline Reboux, a fashionable Parisian milliner whose patrons included the Empress Eugénie. Other names were sprinkled throughout the millinery sections of the *Dry Goods Review*, including Mme Pouyane, Linn Faulkner, Julia Delmonte, and later Descat, Agnés, Patou, Le Monnier, and Marie Guy.[28]

With the costs of packing, freight, and duty costs, Parisian model hats were very expensive to import. Profit was made by copying them. The wholesalers made 'reproductions' which were then sold at reasonable prices to milliners, who would in turn use them as models in their own shops. Wholesalers also copied models in large quantities to sell as ready-to-wear hats to the large retailers. Whether they bought pattern hats or not, wholesalers welcomed milliners to the openings to view their models, in the expectation that the milliners would buy the supplies to produce them. John D. Ivey encouraged this practice, by providing workroom space for milliners to copy model hats while at the opening. The *Review* reported that when at an opening, Miss Sorenson, a milliner from Mitchell, Ontario, 'makes pencil sketches of the hats she fancies, always keeping certain patrons in mind. The original model is frequently changed in some way or other to suit the more conservative taste of her trade.'[29]

Parisian styles, although used for inspiration, were usually considered too outré for North American consumers. Consequently, wholesalers also imported model hats from New York and London, where Parisian styles were moderated for more conservative tastes. In addition, large wholesale firms such as George Goulding engaged first-class milliners to create their own model hats that were adapted from European styles, 'to suit the taste and style of Canadians.' These were proudly displayed at their opening, as reported in the *Review*: 'Their show-room was crowded with ... lovely models direct from Paris; but it is only fair to say that the creations made by the firm's own staff of designers and milliners did not suffer by the comparison with that world famous centre of fashion.'[30]

16 The millinery workroom at the T. Eaton Co., Toronto, 1902. (Archives of Ontario, F229-308-0-1819-3)

Millinery fashion news was also disseminated through reciprocal employment between millinery shops and wholesale firms. Often the same women who worked in small millinery shops in rural areas were employed by the wholesale firms during the off-season. They gained knowledge, ideas, and even made measurements of the model hats, which they brought back to the retail shops.[31]

The second great employer of milliners were large department stores, such as Eaton's. In promotional literature, Eaton's claimed that they engaged several hundred young women in their millinery workroom. Photographs from 1908 of the Eaton's workroom show its organization. Milliners sit and work at tables, placed in rows, with each table in charge of a trimmer who supervised makers and apprentices (illustration 16). Some operators are working with wire to create frames, and some with fabric to cover the frames. A few finished hats sit on stands. Like the wholesalers, Eaton's imported hats through their buyers in Paris and London, but their own designers also made models for the showroom. Model hats were sketched for inclusion in their mail-order catalogue.[32]

Custom milliners relied on wholesalers for supplies, fashion information, and even employment in the off-season, but in the end both wholesalers and department stores had a damaging effect on the custom trade. Although ready-trimmed

hats were largely handmade in wholesale and department store workrooms, the production was streamlined so as to save on labour and materials. Wholesalers and department stores were also able to purchase hat frames and trimming directly from manufacturers, thereby eliminating the jobbing costs custom milliners were obliged to pay. Thus, wholesalers and department stores could produce great quantities of hats cheaply, to be sold to customers way below the custom rate.

The trend in fashion toward 'tailored' or 'outing' hats further undermined the custom trade. These hats were modelled on masculine fashions of the sailor, homburg, tricorn, and Alpine, in stock shapes, with modest trimming (illustration 17). Made from stiff felt or straw, these hats were very durable, and able to withstand rain and other hazards from the elements which would ruin a finely trimmed velvet-covered hat. They were promoted for use while camping, sailing, and other outdoor activities, in response to the increasing demand for leisure and recreational activities that came with Edwardian affluence. Originally designed for sporting informality, they soon came to be widely worn everyday. Also called walking or shirtwaist hats, they complemented the new fashion for suits and tailored blouses.[33]

These sports hats were made in straw and felt factories, largely by machine, much like men's hats. All the heavy machine processes of pressing, blocking, and finishing were performed by men, creating a gender division of labour. Women were employed to do simple handwork such as sewing on bands, lining, and simple ornaments. Women did, however, sew straw plait by machine, which was highly skilled work with commensurate pay, but still not comparable to male operators' wages. Sewing-machine operators would dampen imported braid so that it could easily be manipulated and quickly sewn together by industrial lock or chain-stitch machines. Plaster moulds, derived from Parisian, American or domestic models, were used to guide the formation of the hat.[34]

By 1910, straw 'body' hats appeared – that is, hats in which the straw is woven, rather than sewn together, beginning with the panama, first appearing in the Eaton catalogue in 1913. A remarkable variety of fancy imitation and combination materials were developed expressly for women's hats, such as a wool and visca (lustrous, artificial straw), and bakou soie (palm fibre and silk).[35]

Like straw, felt hat making was a separate trade, and highly industrialized by this time. Throughout the nineteenth century the felting industry was generally devoted to the men's market, although ladies' felt hats became popular in the 1880s. But the until the advent of the tailored hat, felt forms served essentially as a foundation for millinery trimming. Felt emerged as the premier material for women's hats in the 1920s, both for informal and formal wear. Parisian designers were willing to relinquish the traditional wire and buckram foundations for direct modelling with felt. The modistes would take a standard blocked shape, and fold

THE . . .

JOHN D. IVEY CO., Limited

Our Travellers are out with their Fall Samples. Wait until you see them before placing orders. They will interest you. We cover the Dominion.

Order anything you require through our Letter-Order Department.

"Brighton"

"Highland"

"Alpine"

Outing Hats

for Midsummer.

"Outing"

They come in Grey and Castor. The "Highland" and "Brighton" have the new Corrugated Crowns. Write for sample lot and prices.

THE . . .

JOHN D. IVEY CO.

TORONTO MONTREAL LIMITED

17 Advertisement for ladies' hats from the John D. Ivey Co. (*Canadian Dry Goods Review*, June 1901, 31)

or cut the brim and crown into new, sculptured shapes. The model hats would then be reproduced into a wood block, or mould, and used in factories in the same way men's hats were made. There were many different grades of felt used in ladies' hats, depending on the material used (wool and fur felts), and the method of finishing (velour and plush).[36]

Although many straw and felt hats were imported, Toronto factories which were already making men's hats, such as the Dominion Hat Works in Toronto, began a line of women's tailored hats after 1900. Unlike men's hats, in which styles slowly evolved, women's hats, although tailored, were susceptible to fashion changes, and the Dominion Hat Company dealt with this by importing wooden hat blocks direct from New York as soon as the new styles appeared.[37]

Tailored hats were far less expensive than custom hats, as remarked upon in the *Dry Goods Review*: 'factory processes are so much less expensive than the work-room methods, that hats can be produced under the former for a trifle more than what the materials cost under the usual form of millinery work; so the ready-trimmed hat and ready-to-wear plain tailored hats have multiplied themselves into the hundreds of thousands.' Even tailored cloth-covered hats were made by machine. A method for mechanically pressing velvet or other materials directly onto buckram or willow frames containing glue was invented around 1910. Machines could now do the work of making foundations and draping with velvet which was traditionally the province of the milliner.[38]

Tailored hats were heavily marketed by drygoods and department stores. Eaton's first offered 'walking hats, fedoras, sailor and outing caps,' made of felt or straw, in their 1900–1 mail-order catalogue. Women could also order sporting fedoras, caps and tams from boys' department. With the availability of inexpensive hats, women began to purchase more than the customary two hats a year, creating a greater and greater demand which drygoods and department stores were eager to fill. Even custom millinery shops were obliged to carry some versions of the ready-to-wear, although they were expensive to order in the small quantities required by their limited clientele. Women who formerly went to the small millinery shop began to patronize the millinery department in large stores, with their greater selection of reasonably priced tailored hats. The trade magazine, the *Canadian Milliner*, conducted a survey to find out why the ladies in the village of Middletown, Ontario, went to the city to buy their hats, and concluded that the attraction was the lower prices and larger selection available in the urban department stores.[39]

Eaton's presented a further challenge to the custom trade. In addition to hats made in their workroom, the company offered a wide selection of untrimmed hats and trimming supplies such as feathers, flowers, buckles, and other ornaments. With the fashion for simpler trim for all but formal hats, customers were confident that they could adequately do the work which was otherwise the domain of the

highly skilled milliner-trimmer. In 1924 Eaton's initiated a new marketing strategy, and 'caused a panic in buying' when they filled their shop windows with buckram frames, at 85 cents each. They claimed the frames were accurately copied Parisian models, which customers could purchase, along with the trimmings required.[40] Eaton's encouraged women to trim their own hats, and this must have worried custom milliners and wholesalers alike.

By 1920 the heyday of the handmade hat was waning; ready-to-wear hats had captured the market as everyday wear. Custom workrooms in retail stores were disappearing. The decline of custom millinery work at Eaton's is clear from changes in the millinery sections of their catalogue over time. In the 1893 catalogue, Eaton's offered to both make up hats according to the illustration, or create a unique hat to a client's specifications, claiming that: 'We can make your hat specially to your order if you desire. Just send us the picture of any hat you like ... Tell us the colors and materials you like and we will quote you prices.' The catalogue continued to advertise custom and ready-to-wear hats until the 1920s, after which they no longer offered personal services. In 1923 a new millinery section called the 'Lady Fair Hat Shop,' invited women to 'shop' for a hat, rather than 'confer' with a milliner (albeit by mail).[41]

A year later Eaton's advertised brand-name hats, called 'Bob-O-Link – The New Hats for Bobbed Hair' (illustration 18). These hats were the first true cloches, popularly worn by young women. Until bobbed hair, hats were virtually unsized, as they sat on top of bulky hairdos; now the closely-cropped pageboy of the 1920s required that the cloche be adjusted to individual headsizes. The precursor to the cloche was a small hat with deep, bell-shaped crown, which appeared in Toronto advertisements and the Eaton's catalogue just before the First World War. The crown of the hat actually fit over the head, the slightly flared or turned-up brim just above the eyebrows. Along with these styles, large-brimmed picture hats, toques, and turbans proliferated, and all sat low on the head. With the advent of the 'Bob-O-Link,' Eaton's featured the characteristic tight-fitting helmet of the 1920s, with dome-shaped, deep crown, worn so low as to partially conceal the eyes.[42]

The simplicity of the cloche suited a new feminine image and a modernist aesthetic evident in the arts and clothing design. The cloche, made of a straw, felt or buckram cone, and lightly blocked, contrasted with the complicated wire-frame structures of the massive Edwardian hats, floating on top of mounds of hair. Likewise, the heavily corseted, voluptuous S-shape of the dress silhouette gave way to a soft, lean and streamlined shape. The exuberant, three-dimensional trimming characteristic of Edwardian hats was abandoned; trimming became restrained and flat so as not to distract from the shape of the hat. Appliqué, embroidery, and simple ribbon treatments were the usual decoration. The cloche was the culmination of the trend toward the factory hat. In both shape and materials, it was perfect

18 Eaton's catalogue advertisement for 'Bob-O-Link' hats. (Eaton *Catalogue*, Fall/Winter 1924–5, 104; Archives of Ontario, F229-1-74, AO S906)

for factory production. Machines could easily reproduce the simple dome-shaped crowns with minimal brims in one piece, especially with felt and straw materials.

A collection of five hundred hats from Miss Newton's hat shop in Sarnia, Ontario, most dating from the 1920s, attests to the inroads that the factory hat had made in the custom millinery business, even outside the large urban centres. Katherine Newton opened a millinery shop in her home town of Petrolia in 1918, and the next year another one in Sarnia. She prospered through to the 1920s, with two milliners and one apprentice on her payroll. But by 1930 she was 'seriously embarrassed financially,' and closed the Petrolia store. It is likely she overstocked during the previous few years and could not sell the hats, which eventually found their way to the Canadian Museum of Civilization.[43]

This rich collection includes some hats Miss Newton may have made herself, but by far the majority were purchased ready-made. Miss Newton's hat shop was far from parochial; several of the hats have makers' or distributors' labels, and hand-written price tags, making it possible to establish the origin of these hats and their prices. Miss Newton ordered from a total of forty establishments, mostly Toronto firms, but also from Vancouver, Montreal, and New York. These were ready-to-wear hats, but made by skilled hands in millinery workrooms. They show a surprising high quality of work, made of solid construction, precise detailing, good design and quality materials. Many of these hats carry labels from millinery wholesalers.[44]

The three examples in colour plate D were made by the John Ivey Company, from which Miss Newton ordered many hats. Made of lightweight felt, the cloches are decorated with velvet motifs appliquéd to the crown by means of metallic chain-stitch embroidery, achieved by a steady hand at the chain-stitch machine. They all display a excellent design.

Both machine and handworked details are evident in the ready-made hats in the collection. Hand-blocked hats, indicated by the visible indentation from the cord used to hold the hood on the wood block, were often more subtle in shape, the brims sometimes sewn on separately, or partially cut and sewn to the brim in decorative ways (in vogue in the late 1920s). Machine-blocked hats were often simple in shape. The pressing machine created a crease at the headsize, as well as a shiny, sometimes crinkled, finish from the pressure. Even the hats made by the traditional method of buckram foundation exhibit much handwork, but also machine chain stitching.

On the whole, the hats that Miss Newton ordered through travellers, by catalogue, or during trips to Toronto were of good quality. No doubt department stores sold shoddy hats in their 'basement' millinery departments, but among this collection there are few inferior hats. Miss Newton may have sold cheap hats in her shop, but clearly she also supplied quality ready-made hats as well. This material

evidence supports the claim in a 1916 study of the millinery trade in Cleveland that wholesale firms 'set the standard for millinery models and for high grade workmanship.'[45]

The Milliner's Last Stand, 1920–1930

With so much competition from department stores and factory hats, custom milliners had to create new marketing techniques. Some shops gave up their workrooms and concentrated on selling ready-to-wear. A reverse strategy was to market 'exclusivity.' Exclusive shops offered their 'discriminating' customers the personal attention they would not find in a large store. The decoration of custom millinery shops emphasized elegant comfort and the mystique of the handmade, such as Reynola Salon, founded by Mrs Ola E. Reynolds in Toronto in 1919. An article in the *Dry Goods Review* reported that the Reynola showroom was decorated in rose, delft blue, and grey, with upholstered sofas and chairs, two private fitting rooms and a select display of four or five model hats. Mrs Reynolds served tea at her openings, to which personal invitations were sent. She claimed that 90 per cent of her hats were made in the shop for select patrons.[46]

Not many millinery shops were as exclusive as the Reynola Salon. Especially in smaller towns, the milliner had to supply the demand both for tailored hats and handmade hats. Young women generally favoured the simpler, ready-made styles, leaving the custom part of the milliner's work to providing wedding and mourning headwear and hats for older women. The Newton hat collection includes an example of a 'matron's' bonnet. It is highly conservative in both style and construction, made with a wire frame, draped with silk velvet.[47] It resembles a late-nineteenth-century bonnet, except that the large headsize was meant to fit over a 1915 bouffant hairstyle. While they continued to make hats from scratch, milliners also took advantage of the machine-made buckram forms that were available in the 1920s. One of these pressed forms in the Newton hat collection is made of very stiff two-ply buckram.[48] The one-piece dome-shaped crown and curved brim has wire binding sewn at the brim edge by zigzag chain stitch. Miss Newton would have covered this form in various ways to please her customers. She also purchased several series of untrimmed straw hats in a variety of colours, as well as plaited crowns to which she would have attached a brim, probably made of buckram and trimmed with some material specified by her customer.

Remodelling of old hats occupied a large part of the milliner's trade during this period. Some felt hoods in the collection appear to have been taken apart, cut, and restitched, as described in the *Dry Goods Review*: 'an expert modiste cut[s] and pin[s] the hat right on the head, shearing away the brim here, tucking down the crown there, adding a chic feather or pin.'[49]

With the enormous popularity for the felt cloche, milliners had to change their techniques. The traditional millinery methods of wire and buckram framing continued, but milliners added direct moulding to their repertoire. They adapted what was really an industrial skill performed by men to their own workroom. Directions for blocking hats began to appear in millinery instruction manuals after 1925, but most manuals concentrated on wire and pattern framing until 1930, when explicit directions for hand-blocked felt crowns dominated, and wire-framing technique virtually disappeared.[50] A 1939 report on the millinery industry in the United States commented on this change: 'Recent years have witnessed a revolutionary change in millinery. The felt body has replaced the frame and fabric hat of the past.'[51] By 1944 one millinery manual claimed the wooden hat block was 'as useful to a milliner as an eyeglass to a jeweller, a forge to a blacksmith, or a dummy to a dressmaker.'[52]

Blocking was a simple, but painstaking process, especially for a novice. A straw or felt hood was steamed and stretched over the block, ensuring that all was smooth and even. The milliner would then tie a cord around the base of the crown, tack, pounce and press. The moulded hat was then carefully removed and trimmed.[53] She would also use the mould to reshape old hats.

Although milliners could handmake all the new styles, they were unable to compete with the factory hat. Custom millinery shops continued well into the twentieth century, especially in downtown Toronto and Montreal.[54] However, the numbers of women employed in the trade dropped dramatically after the First World War. Even wholesalers producing handmade hats were going out of business. Millinery wholesaler Joseph Leone of Montreal regretted the trend toward the cheap factory hat. His advertisement in the *Canadian Milliner*, entitled 'Conditions of the Millinery Trade To-Day,' illustrates a man shovelling a pile of cloches in front of a department store shipping and receiving door. In a later article Leone 'sees the virtual end of the milliner ... The millinery trade would then principally run by departmental stores. ... As an old millinery man, I would not like to see the end of the many milliners who are striving for a decent living.'[55]

The 1921 census reported about one-fifth the number of women engaged in millinery as there had been a decade earlier. In Toronto the number of milliners dropped from 1,215 to 441; in London, from 200 to 30; in Hamilton, from 299 to 38. The trend was explained in an Ontario Department of Labour vocational study of 1920: 'In 1911 over three per cent. of all women wage earners were classed under the heading of milliners. Just as in dress-making, the proportion of women workers required in this occupation to the entire number of women in the Province has been greatly reduced since that year by the increase in the use of factory made hats.'[56]

The years 1871 to 1920 were the most profitable for the millinery trade in Ontario. Milliners took advantage of the increasingly diverse and elaborate milli-

nery fashions to hone their techniques and open businesses for themselves. These years also marked the transition in Ontario's economy from agrarian to urban, industrialized commerce. Manufacturers with increasing access to capital and facilities set up factories to mass-produce hats to suit the growing taste for tailored headwear. Wholesalers expanded their business to include the importation of foreign factory hats, as well as their own large-scale millinery workshops. Department stores mass-marketed the ready-made hats. The custom millinery' trade responded by devising new hatmaking techniques and marketing strategies. But while the trade was not completely destroyed after 1920, it was no longer the viable opportunity for young, ambitious women that it had been decades before.

NOTES

1 *Toronto Illustrated*, reprint of 1893 ed. (Toronto: Ontario Genealogical Society, 1992), 180.
2 Gamber, *The Female Economy*.
3 On millinery fashion, see Bolomier, *Cent ans de chapeaux, 1870–1970* (Chazelles sur Lyon: Éditions Association – Tradition Innovation du Musée du Chapeau, 1993); Clark, *Hats*; Ginsberg, *The Hat*; Mildred Doris Lintner, 'The Height of Fashion: The Construction of Ladies Fashion Headwear, 1830–1914' (PhD diss., University of Michigan, 1979), Nicole Le Maux, *Modes de Paris: Histoire du chapeau féminins* (Éditions Charles Massin, 2000); and Florence Muller and Lydia Kamitsis, *Les chapeaux: Une histoire de tête* (Paris: Syros Alternatives, 1993).
4 *Toronto City Directory* (Toronto, 1856), 273–3; ibid. (1861), 325.
5 An invaluable computerized database, the *Canadian Industry in 1871 Project* (CANIND71), containing the full data for some 45,000 industrial firms which were enumerated in the 1871 census, was created by Elizabeth Bloomfield and G.T. Bloomfield at the University of Guelph Geography Department in 1981. For this paper, Elizabeth Bloomfield and Peter McCaskel kindly printed out all the establishments in which millinery appeared in the description of the type of business or product.
6 Advertisement in the *Toronto City Directory* (1856), following page 192; CANIND71, Census District 47, Sub-district A-1.
7 CANIND71, District 47, Sub-district B-2; *Illustrated Historical Atlas of the County of York* (Toronto: Miles and Co., 1878), 63; National Archives of Canada (NA), RG1, Schedule 6, Census District 47, Sub-district B-2, 36; *Toronto City Directories*, 1856–1944.
8 This analysis was based on a report from the CANIND71 database, in which the 312 establishments which produced millinery were arranged in descending order of

volume and value of the business. CANIND71, District 32, Sub-district D-1. On the subject of women and manufacturing in general, see Elizabeth Bloomfield, *Canadian Women in Workshops, Mills, and Factories: The Evidence of the 1871 Census* (Guelph, ON: Department of Geography, University of Guelph, 1991).

9 NA, RG 1, Schedule 6, Census District 46, Sub-district B1, p. 70; CANIND71, District 46, Sub-district B-1; *Toronto City Directory* (Toronto: Robertson and Cooks, 1870), facing p. 96.

10 CANIND71, District 23, Sub-district D-1; ibid., District 85, Sub-District I.

11 Ibid., District 46, Sub-District A-1.

12 Aiken, *The Millinery Department*, 8-51; CANIND71, District 47, Subdistrict A-1; Joleen Gordon, *Handwoven Hats: A History in Straw, Wood and Rush Hats in Nova Scotia* (Halifax: Nova Scotia Museum, 1981); Harry Inwards, *Straw Hats: Their History and Manufacture* (London: Sir Isaac Pitman and Sons, 1922).

13 Gregory S. Kealey, *Toronto Workers Respond to Industrial Capitalism, 1867–1892* (Toronto: University of Toronto Press, 1980), 18–34; Gerald Tulchinsky, 'Hidden among the Smokestacks: Toronto's Clothing Industry, 1871–1901,' in David Keane and Colin Read, eds., *Old Ontario: Essays in Honour of J.M.S. Careless* (Toronto: Dundurn Press, 1990), 257–84.

14 David Monad, *Store Wars: Shopkeepers and the Culture of Mass Marketing, 1890–1939* (Toronto: University of Toronto Press, 1996), 45–6. See also Peter Baskerville, 'She Has Already Hinted at "Board": Enterprising Urban Women in British Columbia, 1863–1896,' *Histoire sociale / Social History* 26, no. 52 (1993): 205–27; Susan Ingalls Lewis, 'Female Entrepreneurs in Albany, 1840–1885,' *Business and Economic History* 21, no. 2 (1992): 65–73. On the millinery trade, see Christie Dailey, 'A Woman's Concern: Millinery in Central Iowa, 1870–1880,' *Journal of the West* 21, no. 1 (1982): 26–32; Gamber, *The Female Economy*; Janet I. Loverin and Robert A. Nylen, 'Creating a Fashionable Society: Comstock Needleworkers from 1860 to 1880,' in Ronald M. James and C. Elizabeth Raymond, eds., *Comstock Women: The Making of a Mining Community* (Reno: University of Nevada, 1998); Glendyne R. Wergland, 'Designing Women: Massachusetts Milliners in the Nineteenth Century,' in *Textiles in Early New England: Design, Production and Consumption* (Boston: Boston University Press, 1999).

15 *Toronto Illustrated*, 113, 145, 189, 189, 207, 209.

16 *Third Census of Canada, 1890–91* (Ottawa: S.E. Dawson, 1897), 2: 164–67; *Vocational Opportunities in the Industries of Ontario: A Survey, Bulletin 3: Dressmaking and Millinery* (Toronto: Ontario Department of Labour, 1920), 11. On millinery training, wages, standard of living, and the seasonal nature of the trade, see Bates, 'Creative Abilities and Business Sense.' The most thorough treatment of the trade in the eastern United States is Gamber, *The Female Economy*.

17 *Fifth Census of Canada, 1911* (Ottawa: J. de L. Tache, 1915): 6: 166–7; 264–464.

18 The millinery manuals consulted for this study are Florence Anslow, *Practical Millinery* (London: Sir Isaac Pitman, 1922); L.M. Babcock, 'Employments for Women: Millinery,' *Delineator* (New York), October 1894, 50–2; Ben-Ysuf, *Edwardian Hats*; Julia Bottomly, *Practical Millinery Lessons* (New York: Illustrated Millinery Co., 1914); Brand and Mussared, *Millinery*; Carlotta M. Brown, *Millinery Processes* (Boston: Ginn, 1930); Emma Maxwell Burke, *A Perfect Course in Millinery* (New York: Illustrated Milliner, 1925); Agnes Campbell, *Lesson in Millinery* (Manitoba Farmers Library, 1920); Carolyn Countess, *Hat Making Simplified* (Chicago: B.W. Cooke, 1928); *Guide to the Trade: The Dress-maker and the Milliner* (London: Charles Knight, 1843); Clara Hill, *Millinery Theoretical and Practical* (London: Methuen, 1900); M.J. Howell, *The Handbook of Millinery* (London: Simpkin, Marshall, 1847); Innes, *Scientific Dressmaking and Millinery*; *The Ladies Self Instructor in Millinery and Mantua Making* (Philadelphia: Leary and Getz, [1860]); Jane Loewen, *Millinery* (New York: Macmillan, 1925); Ortner, *Practical Millinery*; Virgina C. Patty, *Hats and How to Make Them* (Chicago: Rand McNally, 1925); Vee Walker Powell, *How to Make and Trim Your Own Hats* (New York: Journal of Living, 1944); *Practical Millinery Lessons* (New York: Grosvenor K. Glenn, 1905); Marion M. Pullan, *Beadles Guide to Dress-making and Millinery* (New York: Beadle, [1860]); Madame Rosée, *The Handbook of Millinery* (London: L. Upcott Gill, [1895]); Weiss, *How To Make Hats*; Woman's Institute of Domestic Arts and Sciences, *Millinery for Mature Women*; *Millinery for Misses and Children* (Scranton, PA: Woman's Institute, 1923). For a compete bibliography, see Bates, 'Women's Hats and the Millinery Trade, 1840–1940: An Annotated Bibliography.'

19 This analysis of millinery techniques is based on millinery manuals from 1890 to 1920. For other interpretations of techniques, see Bolomier, *Le chapeau*; Denise Dreher, *From the Neck Up: An Illustrated Guide to Hatmaking* (Minneapolis: Madhatter Press, 1981); Lintner, 'Height of Fashion'; Muller, *Les Chapeaux*; Mary Elizabeth McClellan, *Felt, Silk and Straw Handmade Hats: Tools and Processes* (Doylestown, PA: Bucks County Historical Society, 1977); Musée du Chateau Ramezy, *Les Chapeaux féminins d'hier et d'aujourd'hui / Women's Hats Yesterday and Today* (Montreal: La société d'archeologie et de numismatique de Montréal, 1989); T.J. Rendell, 'Millinery Techniques in the 1920s,' *Costume* 10 (1976): 86–94.

20 Ben-Ysuf, *Edwardian Hats*, 166.

21 Ibid., 177; Woman's Institute of Domestic Arts and Sciences, *The Millinery Shop* (Scanton, PA: Woman's Institute, 1923), 34–5.

22 *Canadian Dry Goods Review* (Toronto), February 1893, 8 February 1896, 9.

23 Ibid., January 1898, 64, August 1901, 58; *Report on the Wages of Women in the Millinery Industry in Massachusetts* (Boston: Wright and Potter, 1919), 17; *Vocational Opportunities*, 11; *Millinery Shop*, 35–6.

24 *Dry Goods Review*, October 1898, 37, April 1999, 48; *Vocational Opportunities*, 11.

25 *Dry Goods Review*, September 1892, 8, August 1894, 39.

26 Ibid., September 1902, 89.

27 Ibid., February 1903, 104, February 1895, 139.

28 For example, *Dry Goods Review*, August 1896, 22, and *The Canadian Milliner* (Toronto), January 1929. Although many Paris fashion designers were women, the most well-known couturiers were men. This was not the case in millinery, where virtually all designers were female. Valerie Steele, *Paris Fashion: A Cultural History* (New York: Oxford, 1988), 72–73; 254–60. On designers, see Dilys E. Blum, 'Ahead of Fashion: Hats of the Twentieth Century,' Philadelphia Museum of Art *Bulletin* 89, nos. 377–8 (1993): 6–15; Bolomier, *Le Chapeau*, 82–91; and Maureen Reilly and Mary Beth Detrich, *Women's Hats of the Twentieth Century* (Atglen, PA: Schiffer, 1997), 19–50.

29 *Dry Goods Review*, February 1900, 83, September 1924, 78. Many hats bearing Parisian model labels 'never saw Paris,' and were actually made by copyists. There was no legislation against reproducing patterns until much later in the century. Ben-Yusuf, *Edwardian Hats*, 238–39; Blum, 'Ahead of Fashion,' 9–10.

30 *Dry Goods Review*, March 1895, 42, March 1894, 151.

31 Bryner, *Dressmaking and Millinery*, 51–2; *Vocational Opportunities*, 11.

32 Eaton's advertising stereoscope card, showing the 'Millinery Work Room,' *c.* 1905 (author's collection); *Millinery Industry in Massachusetts*, 17.

33 Bryner, *Dressmaking and Millinery*, 48.

34 Aiken, *Millinery Department*, 46–51; Inwards, *Straw Hats*, 100–10; *Millinery Industry in Massachusetts*, 14–15.

35 *Eaton's Catalogue*, Spring/Summer 1913, 41; *Canadian Milliner*, November 1929, 21.

36 Henry Bennett, 'Millinery – Wholesale and Retail' in William S. Murphy, ed., *Modern Drapery and Allied Trades* (London: Gresham, 1914), 2: 73, 80, 27–31, 105; Muller, *Les Chapeaux*, 105.

37 Aiken, *Millinery Department*, 52–62; Bennett, 'Millinery,' 80–1; *Dry Goods Review*, January 1901, 156.

38 *Dry Goods Review*, April 1901, 10. Aiken, *Millinery Department*, 6; Bryner, *Dressmaking and Millinery*, 48.

39 Bryner, *Dressmaking and Millinery*, 49; *Canadian Milliner*, July 1929, 25. The battle between small retailers and the department stores was made public by the largely male retailers of drugs, groceries, hardware, etc., who voiced an organized protest against mass merchandisers such as Eaton's. The millinery shop, considered a marginal 'female' retail business, was not included in this revolt. See Monod, *Store Wars*.

40 *Dry Goods Review*, February 1924, 45.

41 Betsey Baldwin, 'The Millinery Tradition in Decline, 1900–1930: The Displacement of Hat-Making as a Professional Art at Eaton's,' report on file, History Division, Canadian Museum of Civilization, 1999; *Eaton's Catalogue*, Fall/Winter 1899–1900, 31; Spring/Summer 1925, 3.

42 Clark, *Hats*, 52–4; *Eaton's Catalogue*, Fall/Winter 1924–5, 104.

43 *Advertiser-Topic* (Petrolia, Ontario), 2 December 1946 and 30 May 1968; author's correspondence with Lyn and Dave Dennis, Petrolia; Lambton County Archives and Library (Wyoming, Ontario), Newton Hat Shop File 6DF (letters), 9ED-JDF (account book); Edward Phelps, *Petrolia 1874–1974* (Petrolia: Petrolia Print and Litho, 1974), 10, 25, 95; *Sarnia Observer*, 14 March 1919.

44 Ruth Mills, 'Miss Newton Hat Collection Report: An Analysis of Fabrication Techniques,' report on file, History Division, Canadian Museum of Civilization, 1999. Ruth Mills is a historical millinery specialist; her report includes detailed cataloguing, analysis of techniques, glossary, and material samples.

45 Bryner, *Dressmaking and Millinery*, 52.

46 *Dry Goods Review*, March 1924, 80.

47 Canadian Museum of Civilization collection, D-6703.

48 Ibid., D-6751

49 For example, ibid., D-6929 a-e, D-6834, D-6624, and D-6996. *Dry Goods Review*, October 1927, 27.

50 Brown, *Millinery Processes*, 179; Brand and Mussared, *Millinery*, 42; Muller, *Les Chapeaux*, 27, 31, 105; Rendell, 'Millinery Techniques,' 89.

51 United States, Federal Trade Commission, *Report to the President of the United States on Distribution Methods in the Millinery Industry* (Washington: U.S. Printing Office, 1939), 14.

52 Powell, *How to Make and Trim Your Own Hats*, 7.

53 Weiss, *How to Make Hats*, 7–23.

54 On the millinery trade later in the twentieth century in Montreal, see Jacqueline Giroux, *Yvette Brillon, femme de coeur et femme de têtes* (Longueuil, QC: La société historique de Marigot de Longueuil, 1989); Christine Godin, 'Les Femmes au chapeau' and 'Créer des chapeaux,' *Cap-aux-diamants* 4, no. 2 (1988): 25–8 and 51–4; and Chateau Ramezy, *Les Chapeaux féminins*.

55 *Canadian Milliner*, July 1929, 95; *Dry Goods Review*, December 1932, 32.

56 *Sixth Census of Canada*, 1921 (Ottawa: F.A. Acland, 1929), 4: 224, 406–7, 424–5, 538–39; *Vocational Opportunities*, 10.

SELECTED BIBLIOGRAPHY

Aiken, Charlotte Rankin. *The Millinery Department*. Department Store Merchandise Manuals. New York: Ronald Press, 1918.

Bates, Christina. 'Creative Abilities and Business Sense: The Millinery Trade in Ontario.' In *A Century Stronger: A History of Women in the Twentieth Century*, edited by Sharon Anne Cook, Kate O'Rourke, and Lorna McLean. Montreal: McGill-Queen's University Press, 2001.

- 'Wearing Two Hats: An Interdisciplinary Approach to the Millinery Trade in Ontario, 1850–1930.' *Material History Review* 51 (spring 2000): 16–25.
- 'Women's Hats and the Millinery Trade, 1840–1940: An Annotated Bibliography.' *Dress* 27 (2000): 49–58.

Ben-Ysuf, Anna. *Edwardian Hats: The Art of Millinery, 1909*. Reprint, Mendocino, CA: R.L. Shep, 1982.

Bolomier, Éliane. *Le Chapeau: Grand art et savoir-faire*. Paris: Musée du chapeau and Somogny éditions d'art, 1996.

Brand, Violet, and Beatrice Mussared. *Millinery*. London: Sir Isaac Pitman and Sons, 1935.

Bryner, Edna. *Dressmaking and Millinery*. Cleveland, OH: Survey Committee of the Cleveland Foundation, 1916.

Clark, Fiona. *Hats*. The Costume Accessories Series. London: B.T. Batsford, 1982.

Gamber, Wendy. *The Female Economy: The Millinery and Dressmaking Trades, 1860–1930*. Urbana: University of Illinois Press, 1997.

Ginsburg, Madeleine. *The Hat: Trends and Traditions*. Hauppauge, NY: Baron's Educational Series, 1990.

[Godin, Christine]. *Les Chapeaux féminins d'hier et d'aujourd'hui / Women's Hats Yesterday and Today*. Montreal: La société d'archeologie et de numismatique de Montréal, 1989.

Innes, Isabella. *Scientific Dressmaking and Millinery*. Toronto: I. Innes, 1913.

Ortner, Jessica. *Practical Millinery*. London: Whittaker, 1897.

Weiss, Rosalind. *How to Make Hats*. New York: McGraw-Hill, 1931.

'The Work Being Chiefly Performed by Women': Female Workers in the Garment Industry in Saint John, New Brunswick, in 1871

PETER J. LAROCQUE

Like other Canadian urban centres during the late Victorian era, Saint John, New Brunswick, had a large concentration of women working in the garment industry. Although female textile workers weaving cloth at home and in factories have been the focus of numerous studies, women producing clothing for the garment industry have received less attention from Canadian historians. Yet the garment industry provides an ideal setting for an investigation of the degree to which industrial capitalist production may have reinforced distinctions of age and gender. Some of the association between job and gender can be attributed to the invention and manufacture of a practical sewing machine, and especially to its successful merchandising. Annually, between 1870 and 1880, between 220,000 and 380,000 sewing machines found their way into homes and factories in North America. As one of the first mass-marketed products for industry, the sewing machine may be credited with, or criticized for, providing a significant impetus for women to move from the domestic sphere to the factory floor.[1]

The sewing machine also reinforced the association of the female industrial worker with one of her traditional domestic duties, sewing. Female education, both at home and in school, most often included instruction in the skills necessary for practical and fancy needlework. In the early part of the nineteenth century, before public schools became common, young girls often learned their alphabet and biblical verses by sewing them in a variety of stitches in elaborate samplers. In schoolhouses by the mid-nineteenth century, plain and fancy sewing were listed among the subjects taught, in most cases by young female teachers, to their younger female charges. The skills that were learned would then form the practical basis for putting the sewing machine to use in a domestic setting later in the century. In fact, by 1871 the use of the sewing machine, which required a high level of manual dexterity, may have also helped to produce a Canadian garment industry where more than 95 per cent of the labour force working outside the

19 This boldly striped dress, made and worn in Saint John, New Brunswick, retains the full skirt and close-fitted bodice fashionable in the 1860s. The fullness of the skirt is gathered at the back and the hoop skirt support is no longer in evidence. Fringed epaulettes and whitework cuffs appear to be the only trimmings. (Woodburn & McClure, *A Female Member of the Merritt or Magee Family*, *c.* 1870, albumen print carte-de-visite 10.1 × 6.2 cm, Merritt, Magee Family Photograph Album, New Brunswick Museum)

TABLE 1
Occupations of female garment workers, Saint John, in 1871

Occupation	No.	%	Average age	Median age
Dressmaker	254	31.6	25.7	22
Tailoress	241	30.0	23.2	20
Seamstress	181	22.5	26.2	20
Milliner	79	9.8	26.5	22
Vest maker	9	1.1	29.6	20
Cap maker	7	0.9	22.9	20
Sewing machine				
operator	7	0.9	19.6	20
Straw milliner	6	0.7	31.0	23
Mantle maker	5	0.6	27.6	20
Coat maker	4	0.5	19.0	17
Cape maker	2	0.2	20.5	18
Collar maker	2	0.2	17.5	14
Pants maker	2	0.2	17.0	15
Bonnet maker	1	0.1	25.0	25
Hat maker	1	0.1	25.0	25
Cutter	1	0.1	41.0	41
Hoop skirt maker	1	0.1	32.0	32
Total	803	99.6	25.1	

home was female.[2] It is also possible that there are other factors behind the increased numbers of women who found their way into the wage-earning workforce. This study begins to explore one component of the paid labour force, the female workers of the garment industry, by using the data found in the manuscript returns of the 1871 census of Canada for the eight wards of the city of Saint John.[3]

In the late nineteenth century, Saint John, New Brunswick's principal urban centre, was the primary location for the province's industrial development. This industry was sustained by a steadily increasing population that provided a readily available workforce. In the thirty years prior to the 1871 census, Saint John, like many other eastern seaboard cities, felt the profound effects of assimilating the successive waves of Irish immigrants that had arrived in North America. These new arrivals contributed to a population that had increased by 40 per cent in the thirty years since 1840.[4] By 1871, Saint John was home to 28,805 people, with a slight female majority (52.6 per cent or 15,147 persons). Almost 70 per cent of this female population was under the age of thirty-one.

The 1871 census contains data on seventeen occupations associated with the garment industry and holds information on 803 female garment workers in Saint John (see table 1).[5] These jobs employed almost 6 per cent of the entire female population. The data omitted some female occupations that were not necessarily

associated with the production of clothing, such as laundress or factory worker. There are also indications that women were employed in the boot and shoe industry but their occupation was not listed as such in the nominal return of the census and thus they were not able to be identified or to be included in this study. For the most part, it appears that these women were working outside the home, using traditional gender-related skills to produce garments for men, women, and children. Until the late nineteenth century, men's clothes were usually produced by tailors, and there were still about 230 male garment workers in Saint John during this period. It seems, however, that a new segment of the population, the young, unmarried Roman Catholic women who lived in close proximity to the city's central business district, was engaged in the production of all types of custom and ready-made clothing for both domestic use and export. Employers and workers alike were taking advantage of the practical and easily transportable skills that women had acquired at home as part of their training for their future domestic life.

This study seeks to shed new light on the dramatically changing work experience of these women during the period of early industrialization by focusing on one important sector of the female workforce in what was, in 1871, Canada's fifth-largest city. Elaine MacKay's chapter, '*Three Thousand Stitches: The Development of the Clothing Industry in Nineteenth-Century Halifax*,' provides an excellent overview of the effects of industrialization and merchandizing on one aspect of the garment industry, the tailoring trade, in another major Maritime centre, Halifax, Nova Scotia. In Saint John's industrial sector, wage-earning opportunities for women could be found at about 325 individual establishments, representing about twenty-five different types of enterprise, ranging from bakeries to twine-making. Otherwise, opportunity for employment in the city was limited to non-industrial occupations, the most common being domestic servant, which accounted for the employment of almost 7.5 per cent of the entire female population or 1,124 jobs.

This study will also examine the general characteristics of Saint John's female garment industry workers in an effort to better understand their place within the rapid industrialization that occurred in the late nineteenth century. Did age, ethnicity, or marital status affect a woman's likelihood of earning wages? Did aspects of their typical living situations set them apart from the rest of the population? The results of this examination may prove useful for comparative purposes in analysing similar aspects of the development of female labour forces in other cities throughout North America.

Recounted Lives

The following accounts of New Brunswick women serve to illustrate the particular situations of the everyday lives of innumerable women who laboured in Canada's

20 This dress from the early 1870s, made and worn in Saint John, New Brunswick, sports an overskirt, full sleeves, and bodice trimmed with pleated and ruched bands of trim. A glimpse of a bustle cover is also evident. (Climo's American Gallery of Art, *Mary Peers, c. 1870* albumen print carte-de-visite 10.1 × 6.2 cm, Forrest Williams Family Photograph Album, New Brunswick Museum)

garment industry in the late nineteenth century. In 1871, for nine months of the year, twenty-eight-year-old Emma A. Mace managed a millinery establishment in Carleton, the western district of the city of Saint John. Responsible for her own earnings, as well as employing her two younger sisters, she reported in the 1871 census of Canada that their aggregate annual wages totalled $600. This income maintained a family comprising their blind father (formerly a shoemaker and photographer), their mother, and four younger siblings. Across the harbour, four tailoress sisters, Mary, Edith, Samantha, and Charlotte Black, aged twenty-four, twenty-two, twenty, and eighteen respectively, found themselves inadvertently registered in the 'Return of Industrial Establishments' in the census. Their employment, apparently as outworkers for a tailoring establishment, did not qualify as an industry, and the enumerator eventually crossed their business off the final list. On 6 May 1867, when nineteen-year-old Melissa Covert married John Richard Sherman, she could not have been prepared for the changes that would occur in less than four years.[6] In 1871, widowed and the only female wage-earner listed in her household, her mantua-maker's salary helped to support an extended family that included not only her widowed aunt and mother, but also her married sister, her Norwegian brother-in-law, and her one-year-old nephew.

A century ago, references to women working in the garment industry lamented the adverse conditions facing the defenceless female who, when forced to leave the protection and security of her home, laboured 'sixteen hours of toil unrelieved by a gleam of hope or cheer; the nets result of this ever-accumulating misery being $3.50 a week.'[7] How accurately does this description reflect the employment opportunities available to women in Saint John? In November 1873 Annie Trueman accompanied her sister, Laura, to Saint John to purchase the trousseau for the latter's coming wedding. Annie writes to her mother, Rebecca Wood Trueman, in Sackville, New Brunswick: 'Do you know Miss Styles was sick last week & wasn't here one day. She came yesterday for the first, we are to have her sew for us, tho' after she's done for Eunice. She is coming to the house to sew – isn't that splendid.' In the reply, her mother frets and admonishes:

We shall never get out of Marie's debt if she takes all that trouble to retain a dressmaker in the house for you ... I fear it will be a great tax upon Marie to have her house turned into a workshop. Pa says you must pay Miss S[tyle].'s board ... Couldn't you find out all about how the dresses are to be made & trim or have them started & brought home to finish?[8]

These revealing passages indicate the tenuous position in which many of the female workers in Saint John's garment industry found themselves. Miss Styles's sickness and the prospect of only partially completing a custom order would

certainly have had a profound impact on her ability to survive by her dressmaking skills.

The garment industry, or the manufacture of ready-made and custom clothing, underwent radical changes in the mid-nineteenth century. Niche marketing and cultivation of an elite clientele were some of the measures a successful custom-tailoring enterprise had to adopt if it were to withstand the pressures of competing with industrial production of mass-manufactured ready-to-wear garments. An 1875 promotional publication entitled *St. John and Its Business: A History of St. John, and a Statement in General Terms of its Various Kinds of Business Successfully Prosecuted* hints at some of the enormous transformations that had taken place and sheds some light on a few of the reasons why workers in the garment trade were predominantly female. One of the affected businesses was James McNichol & Son's Ready-made Clothing & Gents' Furnishing Goods;

> When Mr. McNichol, senior came here [1831], a ready-made clothing store was unknown, and only a few imported coarse jackets for sailors and lumpers were kept for sale at dry goods stores. Tailoring, which now depends upon the women and the sewing machine, was then exclusively performed by men. Such are some of the many changes in the trades.[9]

Although somewhat understated, in the interest of promotion of course, the ready-made and imported clothing trade provided a good portion of available garments.[10] Other businesses, such as Thomas R. Jones & Company, an importer of dry goods and a manufacturer of clothing, had diversified trade during the 1860s, from retail to wholesale:

> He commenced the jobbing business in clothing, in connection with his retail trade ... carried on the wholesale business exclusively in dry goods and the manufac-ture of clothing ... In 1873 Mr. Jones erected the substantial and elegant block now occupied by the firm ... the upper stories are devoted to the wholesale manufacture of millinery goods, silk hats and glazed and cloth caps, *the work being performed chiefly by women* ... The firm employs over one hundred hands and in their store workrooms thirty or forty more. This establishment manufactures more clothing for the whole-sale trade than all the lower Provinces.[11]

While these references provide insight into technological advances and changes in marketing strategy, another aspect of the industry, the low-wage jobbing, or piecework, performed by mostly female workers, remains somewhat obscured by the stories of the owners' successes (see illustrations 21 and 22).

During the late nineteenth century, an era of rapid industrialization in urban

21 Millar's Hoop Skirt Manufactory was one of only two in Saint John that supplied this undergarment that was essential for fashion in the 1860s and early 1870s. (Advertisement for David Millar's Hoop Skirt Manufactory, *McAlpine's St. John City Directory for 1871– 1872* [Saint John: David McAlpine, 1871], p. 192)

22 Thomas R. Jones's merchant tailor establishment employed at least fifty women in the manufacture of clothing. (Advertisement for Thomas R. Jones's business, *McAlpine's St. John City Directory for 1871–1872* [Saint John: David McAlpine, 1871], p. 347)

centres throughout Canada, access to readily available, and preferably cheap, labour proved essential for profitable enterprise. The existence of a substantial female labour force with available specialized skills encouraged the development of industries based on work traditionally associated with women's and girls' domestic roles, most especially the production and care of clothing.[12] This development had other implications, not only for women's jobs and wages, but also for the socialization of girls and women as noted by Bradbury, who writes that 'women's role as domestic labourers conditioned their experience as wage labourers. Differential wage rates in turn reinforced gender distinctions both in the family and in the economy.'[13] In effect, working at home for no wages translated into society's acceptance and expectation of lower wages for similar types of work outside the home.

Women's increased involvement in the paid labour force produced major lifestyle changes for the whole population and transformed the very nature of work in industrializing urban areas. Industrial working conditions, as well as wages, shifted to accommodate an increasingly numerous workforce that 'required' fewer wages probably because employers did not consider their salaries essential to the family economy.[14] One of the most salient features of women entering the workforce was an increase in the division of labour by gender. In general, as women moved into the labour market, men moved into supervisory and more highly skilled jobs.[15] To a great degree, 'industrial capitalist production may have reinforced rather than eliminated distinctions of age and gender,' especially among the working classes. Employers and workers alike placed increasing emphasis on appropriate division of labour into male and female jobs.[16] This would appear to be borne out in the male-owned garment industry businesses identified in the 1871 Saint John census. Often only one male over the age of sixteen was employed while two to forty women were working at the same establishment. It is probable that the lone male worker may have had the managerial or supervisory role or was a senior craftsman in the establishment.

Enmeshed in the interrelationship of job and gender is the persistent question of accurately estimating the real value of women's abilities and skills. Even Saint John's clothing advertisers recognized the worth of promoting their garment workers' skills, rather than their numbers. The description of the business of James A. McInnis, a merchant tailor, stated that 'and as only experienced assistants are employed, first-class workmanship can always be depended upon.' Likewise, John E. Conlon's tailoring establishment stressed that 'none but capable and reliable hands are employed, and first-class workmanship, combined with perfect fits, can always be depended on.'[17] It is interesting to note that neither of these descriptions specifically mention women workers, but the ambiguity speaks volumes. Despite this emphasis on the desirability of a high level of skill, women received lower

wages than men, even for what were basically similar skills and tasks. Seemingly, when men performed them, the skills increased in importance, and value, to society. In fact, accounts of labour parades record the participation of various trade associations or guilds that were almost exclusively male. One of the ways that workers, whether female or male, acquired skills was through a combination of on-the-job experience, extensive training, and/or apprenticeship. Unfortunately for women, their traditionally haphazard and sporadic work histories, a result of balancing both domestic duties and labour outside the home, generally resulted in a restriction or denial of the opportunities for the development of skills as well as equitable remuneration for abilities and experience.[18]

During the late nineteenth century the family economy suffered from the increased availability of numerous low-paying jobs for youth, both male and female. This had dramatic effects on the survival of the family and serious implications for wage-earning capability. As industrialization expanded, parental wage contributions, which ordinarily could have supported a family, decreased, and the wage contributions of children became more important to maintain the family even at a subsistence level. Families responded in various ways to ensure an adequate or 'living wage.' In Montreal, for example, French-Canadian married women increasingly went out to work, while the English, Scottish, and Irish women did not.[19] It seems, however, that married women of all ethnic groups sought wage labour only when they could not ensure their families' survival by any other means. Moreover, ascertaining the precise role of women's labour in maintaining the family economy in Canada's industrializing cities of the nineteenth century proves difficult, because women participated extensively in sparsely documented sub-economies that blurred demarcation between formal and informal economies. Their additions to the family economy would often take the form of bartering, non-wage labour, taking in boarders, sewing and laundry, or even tending small gardens.[20]

Within the family, expectations of, and possibilities for, young women also altered dramatically as a result of societal change and industrialization. Increasing access to educational institutions and rapidly expanding technology for manufacturing heralded many new opportunities. No doubt daughters seriously called into question their families' expectations of fidelity and loyalty when faced with choosing between some measure of independence that might come with working out, and the prospect of remaining dependent and simply adding non-remunerative assistance at home.[28] The change from living within family situations to boarding or lodging with non-relatives dramatically affected the expectations and experience of young women. Exposure to new lifestyles and choices in an increasingly diverse and urbanized population would have modified many of these young women's cultural and family traditions.

TABLE 2
Ages of the female population in Saint John, 1871

Age	Total No.	Total %	No. of female garment workers	% of female garment workers	Female garment Workers as % of All Women
11–16	1,654	14.6	48	6.0	2.9
16–21	1,945	17.2	289	36.0	14.9
21–31	2,980	26.3	309	38.5	10.4
31–41	1,817	16.0	86	10.7	4.7
41–51	1,325	11.7	43	5.4	3.2
51–61	912	8.1	22	2.7	2.4
61–71	430	3.8	5	0.6	1.2
71–81	200	1.8	1	0.1	0.5
81–91	58	0.5	0	0.0	0.0
91+	1	0.0	0	0.0	0.0
Not given	1	0.0	0	0.0	0.0
Total	11,323	100.0	803	100.0	0.0

In 1871 women and girls constituted almost one-fifth of the total industrial workforce of Saint John County (18.1 per cent or 1,319 of 7,277 industrial workers).[30] Within the garment industry, the vast majority of female workers were concentrated in three occupations – dressmaker, tailoress, and seamstress – which together constituted 84.1 per cent of the selected group. Saint John's garment industry attracted young women; 83.5 per cent were between the ages of fifteen and twenty-five, and their overall average age was 25.1 (see table 2). Perhaps employers were seeking the attributes of younger workers that would have included stamina, speed, and keener senses. However, they would have had less experience and perhaps fewer skills than older more knowledgeable workers. Nonetheless, the workers ranged from the youngest, Margaret Driscoll, aged eleven, and her elder sister, Mary, aged thirteen, who worked as seamstresses, to the eldest, Mary Sime, aged seventy-five, who was a dressmaker. A widow, she lived with her two daughters, but only she had a recorded occupation. The average occupational age ranges between 41 years for a cutter (Alice McGee, forty-one, who would have held a senior position in a tailoring establishment), and 17 years for two pants-makers (Bridget Butler, nineteen, and Mary A. Mullin, fifteen, who may have held out-work positions). This clearly reflects the hierarchical craft of the trade, with younger, less-experienced hands working on pants that required the least skill in making up. In the occupations with the most number of workers, a three-year difference in average age existed between the 181 seamstresses (26.2

TABLE 3
Female industrial workers in Saint John County, 1871

Industry	No. of businesses	No. workers	No. female workers over age 16	No. female workers under age 16	Annual wage ($)	% female workers
Dressmaking	32	199	173	21	130.36	97.5
Paper collars	1	29	20	6	89.66	89.6
Oil clothing	1	7	6	0	128.57	85.7
Miscellaneous wares	2	15	12	0	193.34	80.0
Tailors and clothiers	44	835	616	18	176.75	75.9
Cotton factories	2	127	56	36	177.17	72.4
Broom/brush making	2	47	27	0	138.08	57.4
Furriers/hatters, etc.	2	49	26	1	262.24	55.1
Wool cloth making	2	68	31	5	191.18	52.9
Match factories	1	27	6	6	111.11	44.4
Patent medicine	2	9	3	1	244.44	44.4
Dyeing and scouring	1	6	2	0	333.34	33.3
Boots and shoes	70	565	160	9	228.05	29.9
Bookbinding	3	14	4	0	227.57	28.6
Photo galleries	7	18	3	0	400.78	22.2
Rope/twine making	4	68	9	4	185.29	19.1
Trunk/box making	3	31	5	0	264.42	16.1
Bakeries	28	106	10	4	256.46	13.2
Sashes/doors/blinds	7	141	10	0	256.52	7.1
Nail/tack factories	4	118	8	0	400.51	6.8
Meat curing	14	32	2	0	125.25	6.2
Printing offices	9	149	9	0	371.07	6.0
Musical instruments	4	18	1	0	438.89	5.5
Carving and gilding	5	21	1	0	306.67	4.7
Jewellery/watchmakers	10	26	1	0	393.46	3.8
Carriage making	12	109	2	0	339.22	1.8
Saw mills	52	2,261	3	1	243.02	0.13
Total	1,391	5,095	1,006	113	244.95	22.0

years) and the 241 tailoresses (23.2 years). The 254 dressmakers (25.7 years) averaged half a year younger than seamstresses and a year and half older than tailoresses. The ninety-four millinery (and associated trades) workers ranged in average age between 31.0 for straw milliners to 22.9 for cap-makers, with milliners averaging 26.5 years of age. The age differences associated with each of primary occupations of the female garment workers should indicate varying levels of skill based on years of experience, but records indicate otherwise (see table 3). Age and wage do not necessarily correlate. One would anticipate that the more senior workers, because of their increased experience (and perhaps skill), should have received the higher wages. However, dressmakers, including milliners (whose

TABLE 4
Birthplace of female garment workers in Saint John, 1871

Birthplace	Total No.	Total %	No. garment workers	% garment workers
New Brunswick	19,718	68.5	563	70.1
Ireland	5,251	18.2	154	19.2
Nova Scotia	1,136	3.9	28	3.5
England/Wales	1,005	3.5	19	2.4
Scotland	610	2.1	12	1.5
USA	548	1.9	14	1.7
Other	537	1.9	13	1.6
Total	28,805	100.0	803	100.0

median age was twenty-two) received on average $130.36 a year, while tailoresses and seamstresses (whose median age was twenty) received on average $176.75 a year (although this estimate may be affected by the number of tailors and clothiers who were included in this grouping in the census statistics). In comparison, the 7,277 workers in Saint John County earned $1,796,491 or an average of $246.87 per annum. Workers in the city of Saint John, on average, made slightly more money, $263.23 per annum each (4,103 workers earning $1,080,248).[22] Women garment workers therefore generally received, at most, only 53 per cent to 67 per cent of the wages of the average industrial worker in Saint John or Saint John County. This provides additional evidence that the female garment workers were more likely to be contributing to a family wage.

The 803 women workers identified in the 1871 manuscript census constituted the core of Saint John's thriving garment industry. But who were these women? Like the general population, the majority were native-born New Brunswickers (see table 4), but in many other ways they did not represent a typical cross-section. Those of Irish descent, almost seven out of ten workers, were over-represented, while those of English descent, only two out of ten workers, were under-represented (see table 5). Statistically, Roman Catholic women proved more likely than their Protestant counterparts to enter the workforce (see table 6) although the former were in the minority in the general population. These women also were more likely to be living with a widowed parent, while Protestant female garment workers were more likely to be working heads of households. Roman Catholic women also tended towards over-representation in the tailoress category, while the same was true for English and Scottish dressmakers.

In general, the garment industry attracted young unmarried women. In fact, these young single women comprised only 32.4 per cent of the entire population of Saint John and 61.5 per cent of its total female population; yet 86.4 per cent of

TABLE 5
Ethnicity of female garment workers in Saint John, 1871

Origins	Total No.	Total %	No. female garment workers	% female garment workers
Irish	15,605	54.2	546	68.0
English	8,557	29.7	164	20.4
Scottish	3,284	11.4	78	9.7
German	445	1.5	7	0.9
African	368	1.3	1	0.1
Other	546	1.9	7	0.9
Total	28,805	100.0	803	100.0

TABLE 6
Religion of female garment workers in Saint John, 1871

Denomination	Total No.	Total %	No. female garment workers	% female garment workers
Roman Catholic	9,999	34.7	349	43.5
Church of England	6,691	23.2	159	19.8
Wesleyan / Methodist	3,826	13.3	98	12.2
Baptist	3,143	10.9	69	8.6
L.P. / Presbyterian	2,546	8.8	67	8.3
Church of Scotland	957	3.3	20	2.5
Free Will Baptist	784	2.7	17	2.1
Other	859	3.0	13	3.0
Total	28,805	99.9	803	100.0

the female garment workers were unmarried women.[23] Widowed women made up 4.7 per cent of the total population, 8.9 per cent of the female population, and 8.0 per cent of the female garment workers. Married women, who made up 15.5 per cent of the general population and 29.6 per cent of the female population only accounted for 5.6 per cent of the female garment workers[23] (see table 7). Young unmarried women tended to embark on their careers in the garment industry somewhat later than their counterparts who went into domestic service. Of the 694 unmarried female garment workers, less than 7 per cent were under the age of sixteen, but almost 72 per cent were between the ages of sixteen and twenty-five and another 10 per cent of the unmarried women were aged between twenty-six and thirty-one. In contrast, in Saint John in 1851, 25 per cent of sixteen-year-old females were servants, and by age twenty approximately 42 per cent of single women were involved in domestic service. By the age of twenty-five only 25 per cent were in service and by age twenty-nine roughly 14 per cent of single women

TABLE 7
Marital status of female population in Saint John, 1871

Marital Status	No. female population	% of total population	As % of female (28,805)	No. female garment workers	As % of female garment workers
Married	4,476	15.5	29.6	45	5.6
Widowed	1,348	4.7	8.9	64	8.0
Single	9,323	32.4	61.5	694	86.4
Total	15,147	52.6	100.0	803	100.0

were still working as servants. While these figures record substantial rates of employment for single women, they also indicate that these careers were short-lived and were usually abandoned upon marriage. Thus, it follows that less than 1.5 per cent of married women in any age group were employed in the garment industry. In fact, many of these women, like thirty-two-year-old Rebecca Saunders of Guys Ward, were apparently not responsible for the support of children, or like forty-six-year-old Mary Boyd, a dressmaker in Queens Ward, had children old enough to be working in the garment industry as well. However, one in ten widowed women between the ages of twenty-one and forty-one began, or re-established, their garment industry careers (see table 8). Married or widowed women after the age of forty-one were also less likely than any other age group to be involved in the garment industry. Not surprisingly, 17.8 per cent of the married women who were listed as working in the garment industry were living apart from their husbands and more than likely found it necessary to enter the paid labour force in order to survive. What is unrecorded are the outworkers and those who undertook mending.

The variety of family situations indicated in the census reveals that female garment workers were very likely contributing to an overall family wage (see table 9). The classification of family types of the garment workers is based upon the perceived relationship of the garment worker to the head of the household. In total, thirteen differing types of living situations were found. The vast majority of these women, 71.6 per cent, lived in nuclear family situations with parents and siblings, their husbands and children, or as the head of household with children or relatives. Boarding situations (workers living with an apparently unrelated head of household or the worker being listed as the head of household with a lodger) also figured prominently, more than two of every ten households.[24] While there seems to be some correlation with other studies that show nuclear families as the clear

TABLE 8

Ages of married and widowed women, and their participation in garment trade, Saint John, 1871

Age	Married					Widowed				
	No.	% of age group	No. garment workers	% garment workers	Garment workers as % of all women in group	No.	% of age group	No. garment workers	% garment workers	Garment workers as % of all women in group
16–21	112	2.5	0	0.0	0.0	1	0.1	0	0.0	0.0
21–31	1,396	31.2	18	40.0	1.3	95	7.0	9	14.1	9.5
31–41	1,325	29.6	14.0	31.1	1.1	200	14.8	20	31.3	10.0
41–61	1,436	32.1	12	26.7	0.8	613	45.5	33	51.6	5.4
61–71	166	3.7	1	2.2	0.6	231	17.1	1	1.6	0.4
71–81	36	0.8	0	0.0	0.0	159	11.8	1	1.6	0.6
81–91	3	0.1	0	0.0	0.0	48	3.6	0	0.0	0.0
91+	1	0.0	0	0.0	0.0	1	0.1	0	0.0	0.0
Unknown	1	0.0	0	0.0	0.0	0	0.0	0	0.0	0.0
Total	4,476	100.0	45	100.0	1.0	1,348	100.0	64	100.2	4.7

TABLE 9
Household types of female garment workers, Saint John, 1871

Type: perceived household situation	No. female garment workers	As % of total female garment workers	As % of total household types	% with more than one female garment worker
Living with parents/siblings	283	35.2	35.5	50.5
Living with widowed parent/siblings	180	22.4	24.3	54.4
Boarding	106	13.2	12.9	49.1
Boards with sibling	52	6.5	9.9	76.9
Head of household with children	44	5.5	3.2	29.5
Living with parents/siblings/others	31	3.9	4.7	61.3
Head of household with other relatives	23	2.9	3.7	65.2
Living with husband and children	23	2.9	1.5	26.1
Living with husband, children and others	14	1.7	1.2	35.7
Independent	21	2.6	0.0	0.0
Head of household with boarders	12	1.5	1.7	58.3
Living with widowed parent/sibling and others	10	1.2	0.7	30.0
Boarding with other relative	4	0.5	1.0	100.0
Total	803	100.0	100.3	50.2

majority of households,[25] the complex issue of defining boarding or lodging remains. Nonetheless, dressmakers made up 36.3 per cent of the women in boarding situations, and in 44.2 per cent of the cases they boarded with siblings. In the latter case, 76.9 per cent had at least two workers in the garment industry. Obviously, these women were combining their pay to provide a satisfactory living wage. In total, just over half of the households reported more than one garment industry worker, with half of the most prominent family type, the nuclear family, reporting more than one garment industry worker. Those who boarded with siblings, lived with a widowed parent, or headed a household with other relatives or boarders were also more likely to live with another garment industry worker in contrast to women with children who headed a household, or lived with their husbands and children.

Just as the nature of family life differed for these women, so, conditions of work also varied according to the size and nature of the business in which they were employed. A business-by-business examination of the Schedule No. 6, 'Return of Industrial Establishments,' for Saint John provided a working list of thirty-seven businesses associated with the garment industry (see table 10). While these businesses account for only 46.4 per cent of the female garment workers (412 out of a possible 887), they adequately represent the composition of the Saint John garment industry. Some sources, describing the garment industry as it operated in many urban areas, refer to extensive 'putting-out work' or piecework done in the home. The only evidence that this type of arrangement operated in the Saint John area is the previously cited error in Schedule No. 6 and literary sources. However, this does not mean that it did not exist, only that it is difficult to document and evaluate this contribution. These sources confirm the existence of 'putting-out work' or 'jobbing,' but insufficient data exists to substantiate the extent of 'home work' situations.[26]

The total value of wages paid by each business is provided in the schedule; thus the average wages for female workers in the garment industry can be estimated. The majority (twenty-two of the thirty-seven businesses located) were owned and operated by women. These female-owned businesses averaged 3.7 workers and showed a slightly lower annual wage; a worker earned $136.22 compared to $141.17 for all businesses and $148.43 for businesses owned by men. It also seems that there was an advantage to the owner in the merchant tailoring businesses in Saint John. Employees in these businesses could expect to earn, on average, $176.00 in annual wages, while in Halifax workers earned on average $203.57, and in Ontario workers earned $201.25. A comparison of the wages paid to the value of product reveals that for every dollar spent on wages in Saint John, $4.48 worth of product was made. This compared favourably with $4.25 in Halifax and $4.31 in Ontario. Saint John's tailors and clothiers (the vast majority of whom were female) earned less and produced more valuable merchandise.

The size of the business, as well as the nature of ownership, influenced the work environment. The specific thirty-seven garment industry businesses identified in Saint John (see table 11) fall into the following categories based on the size of the workforce: artisan craftshops (one to five workers), craftshops (six to twenty-five workers), small manufactories (twenty-six to fifty workers) and large manufactories (more than fifty workers).[27] The distribution of business types within the garment industry differs substantially from the provincial averages for all industrial establishments. The percentages of artisan craftshops and small manufactories in Saint John's garment industry were more than twice as high as both the provincial and national average for overall industrial establishments (56.8 per cent in Saint John as compared to 26.4 per cent in New Brunswick and 27.2 per cent in

TABLE 10
Garment industry businesses in Saint John, 1871

Name of business	Type of business	Female owner	No. men employed	No. women employed	No. males <16 years employed	No. females <16 years employed	Total workers	Aggregate annual wages ($)	Average annual wage per worker ($)
Armstrong	Dressmaking	Yes	0	5	0	0	5	800	160.00
Stewart	Dressmaking	Yes	1	12	0	2	15	625	41.67
Dunlop	Dressmaking	No	0	4	0	0	4	416	104.00
Sharp	Dressmaking	Yes	0	1	0	0	1	182	182.00
Wilsons	Dressmaking	Yes	0	3	0	0	3	150	50.00
Ross	Dressmaking	Yes	0	3	0	0	3	260	86.67
Groom	Dressmaking	Yes	0	1	0	0	1	150	150.00
Smith	Dressmaking	No	0	1	0	0	1	160	160.00
Magee	Dressmaking	No	1	40	0	0	41	6,240	152.20
Donald	Dressmaking	Yes	0	2	0	0	2	400	200.00
Wilson, M.	Dressmaking	Yes	0	2	0	0	2	500	250.00
Gunn	Dressmaking	Yes	0	1	0	0	1	130	130.00
Swift	Millinery	Yes	0	5	0	0	5	1040	208.00
Collins	Millinery	Yes	0	4	0	3	7	416	59.43
Sharp, A.	Millinery	Yes	0	2	0	2	4	200	40.00
Mace*	Millinery	Yes	0	3	0	0	3	600	200.00
Starr	Millinery	Yes	0	0	0	2	2	363	181.50
Flood	Millinery	Yes	0	2	0	0	2	75	38.50
Yandell	Millinery	Yes	0	4	0	0	4	400	100.00
Trefry	Hoop Skirts	Yes	0	2	0	0	2	400	200.00
Pengilly	Oil Clothing	No	1	6	0	0	7	900	128.57
Wilson, M.	Tailoring	No	7	7	0	0	14	1040	74.29
Johnson	Tailoring	No	2	5	0	0	7	1000	142.86
Taylor	Tailoring	No	4	25	0	0	29	3000	103.45

TABLE 10 (concluded)
Garment industry businesses in Saint John, in 1871

Name of business	Type of business	Female owner	No. men employed	No. women employed	No. males <16 years employed	No. females <16 years employed	Total workers	Aggregate annual wages ($)	Average annual wage per worker ($)
Roark/Geddes	Tailoring	Yes	0	2	0	0	2	370	185.00
Farrell	Tailoring	No	2	12	0	0	14	2,400	171.42
Staples	Tailoring	No	2	7	0	0	9	2,000	222.22
Johnson, A.	Tailoring	No	1	1	0	1	3	400	133.33
Rogers	Tailoring	No	2	12	0	0	3	600	200.00
Butt	Merchant/Tailor	No	6	10	2	0	18	5,000	277.78
Jones, T.	Merchant/Tailor	No	70	50	0	0	120	10,000	91.67
McDonough	Merchant/Tailor	No	4	30	0	0	34	4,160	122.35
Youngclaus	Merchant/Tailor	No	4	2	2	0	8	1,000	125.00
Manson	Millinery/Dressmaking	No	0	14	0	2	16	2,000	125.00
Barbour	Millinery/Dressmaking	No	0	8	0	0	8	1,250	156.25
Montgomery	Dressmaking/Millinery	Yes	0	10	0	0	10	1,100	110.00
Campbell	Millinery/Dressmaking	Yes	0	2	0	0	2	300	150.00
Total	n/a	n/a	106	290	4	12	412	n/a	n/a

*Mace operated 9 months of the year, whereas all other businesses operated for the full 12 months.

TABLE 11
Garment industry business types in Saint John County, 1871

Type of business	Total No.	% of garment industry	Average wage	Average no. of workers per business
Artisan craftshop	21	56.8	142.80	2.6
Craftshop	12	32.4	136.21	11.1
Small manufactories	3	8.1	126.00	34.7
Large manufactories	1	2.7	91.67	120.0

Canada). By 1871, more than 3 per cent of the industrial labour force, both in New Brunswick and Canada as a whole, worked in large manufactories.[28] In Saint John, female proprietors of businesses tended to concentrate in the artisan craftshops (nineteen of the twenty-one garment industry artisan craftshops). Only three of the businesses run by women had more than five full-time employees. In these businesses the average annual salaries were only $70.37, or half the average wage for garment industry workers.

Although this study looks at a very specific time frame and location, it provides detailed insight into important features relating to a significant portion of the industrial workforce during the initial stages of women's wage-earning in Canada. It is most likely that the garment industry in Saint John developed because of the availability of young Roman Catholic women of Irish heritage, such as Mary (aged nineteen) and Hannah Jane (aged seventeen), the eldest of the seven children of fisherman Patrick Dawson and his wife Charlotte. As well, the occupations associated with industry were equated to tasks that mirrored socially acceptable roles or spheres of interest for women during the era.

In 1871 a typical Saint John female garment worker was drawn into the workforce out of necessity and her salary contributed to the total family wage. The survival of these garment workers often necessitated finding a livelihood in the small, temporary, and usually female-owned artisan craftshops that required little capital to maintain and that were unlikely to withstand the pressures of difficult economic times. Otherwise they laboured in larger factory situations for a relatively higher wage but where they could also be readily replaced or displaced in a large impersonal operation. Jobs were not only dependent upon the general economy but also on the whims of fashion; an entire industry could be decimated by change in demand for one item of apparel. Despite these women's experience and abilities, they continued to exist on the fringe of the industrialized workforce in terms of salaries and job opportunities. An initial investigation shows that the

FANCY STORE,
59 GERMAIN STREET, SAINT JOHN, N. B.
A. STEWART,
DEALER IN
Ladies' and Children's Underclothes,
Millinery, Trimmings, Furnishings, Hosiery, Berlins, Yarns,
Stamped Work, Laces, Frilling, Flowers,
Jewellery, and Perfumery.
All of which will be sold low for Cash.

23 Agnes Stewart was one of the few female-owned businesses to advertise in the city directory in 1871–2. (Advertisement for Agnes Stewart's Store, *McAlpine's St. John City Directory for 1871–1872* [Saint John: David McAlpine, 1871], p. 256)

garment industry, which employed almost 20 per cent of single women between the ages of sixteen and forty-one, was in steep decline in Saint John only a decade later. By 1881 the city had undergone massive change: a devastating fire on 20 June 1877 laid waste the central business district where many garment-related businesses were located. Many owners did not rebuild, most probably as the result of having lost their competitive edge as compared with the larger and more efficient factories in the American cities south of the border. In fact, the industrial returns of the 1881 census list only 240 dressmakers and milliners, as compared to 634 a decade earlier. Unfortunately in 1871, unbeknownst to these women and girls whose livelihoods depended on their meagre earnings, their working situations were about to become even more tenuous and difficult.

NOTES

1 Jenson and Davidson, eds., *A Needle, a Bobbin, a Strike: Women Needleworkers in America*, 30–41.
2 Bloomfield and Bloomfield, *Canadian Women in Workshops, Mills and Factories*, 38.
3 Microfilmed copies of the 1871 census of Canada were used. Unfortunately Division 1 or Kings Ward in Saint John is missing. The population for this division totalled 1,184 persons, so a population of 27,621 (95.9 per cent) was examined.
4 Acheson, *Saint John: The Making of a Colonial Urban Community*, 252.

5 Unless otherwise indicated, all data in the tables and text come from microfilmed copies of the manuscript Schedule 1 and Schedule 6 of the *1871 Census of Canada for the City of Saint John, New Brunswick* and *Report of the Census of Canada 1870–1871*, vols. 1–4.

6 Johnson, *Vital Statistics from New Brunswick Newspapers 1867*, 21, and *Vital Statistics from New Brunswick Newspapers 1869–1870*, 116. Mellisa Covert's husband, John Richard Sherman, died on 3 December 1869.

7 Campbell, *Prisoners of Poverty*, 111. Campbell sympathetically chronicles the arduous lives of a variety of garment workers in the early 1880s in New York.

8 Provincial Archives of New Brunswick (PANB), Wood Family Papers, 1800–1942, MC 218. Typescript copies thanks to Dr Gail Campbell of the History Department, University of New Brunswick.

9 *Saint John and Its Business*, 68.

10 Numerous advertisements in Saint John's *New Brunswick Courier* indicate that second-hand clothing and ready-made clothing were widely available. (Information thanks to Dr Beverly Lemire and Dr Gail Campbell of the History Department, University of New Brunswick.)

11 *Saint John and Its Business*, 64 (my emphasis).

12 Cross, 'The Neglected Majority,' 211–12 and graph 2, 223. Cross estimates that in 1871, in Montreal, 42 per cent of female industrial workers were involved in the garment industry and associated trades.

13 Bradbury 'Women and Wage Labour in a Period of Transition,' 116.

14 Bradbury, *Working Families*, 80. Bradbury affirms that in the late nineteenth century social convention took it for granted that the role of a man was to support his wife and family on his earnings.

15 Abbott, *Women in Industry*, 224.

16 Bradbury, *Working Families*, 31.

17 *Our Dominion: Cities, Towns and Business Interests (St. John and Environs)*, 80, 56.

18 Busfield, 'Skill and the Sexual Division of Labour in the West Riding Textile Industry,' 153–70.

19 Cross, 'The Neglected Majority,' 212–14. This is most probably the result of the establishment of the *salles d'asiles* in Montreal by Roman Catholic nuns. These provided care for children aged two to twelve, which would have allowed women with young children to seek wage labour.

20 Bradbury, *Working Families*, 171, 153.

21 Bloomfield, *Canadian Workers in Workships*, 11. Bloomfield found that the female population of industrial workers amounted to under 16 per cent of the total industrial workforce in Canada in 1871.

22 Figures are based on the recapitulations of Schedule 6 in the *1871 Census of Canada*.

23 Bradbury, *Working Families*, 1993, 169–72. The stresses of family management

meant that wage labour for married women was more casual and may have been under-enumerated by census takers.

24 Defining these household types proved difficult. Included are workers who had no apparent relationship to the head of household (their surnames, religion, and origins frequently differed), or who lived with a sibling or relative (other than parents or husband) as the head of household. Without completing a family reconstitution, ascertaining the number of boarding garment workers who were actually living with remarried mothers or other relatives remains problematic.

25 Darroch and Ornstein, 'Family Coresidence in Canada in 1871,' 36 (table 1).

26 Bloomfield, *Canadian Women in Workshops*, 14, and Cross, 'The Neglected Majority,' 211.

27 Bloomfield and Bloomfield, *Patterns of Canadian Industry in 1871*, 37–46. The work environment and the manner in which it was powered were categorized by B. Laurie and M. Schmitz, 'Manufacture and Productivity: The Making of an Industrial Base, Philadelphia, 1850–1880,' in T. Hersberg, ed. *Philadelphia: Work, Space, Family and Group Experience in the Nineteenth Century* (New York, 1981), 43–92.

28 Bloomfield, *Patterns of Canadian Industry*, 39.

SELECTED BIBLIOGRAPHY

Primary Sources

1871 Manuscript Census for the City of Saint John. Government of Canada, 1871. (Microfilm, New Brunswick Museum).

Abbott, Edith. *Women in Industry: A Study in American Economic History*. New York: Arno Press, Inc., 1969. (Reprint of D. Appleton and Company, New York, 1910).

Campbell, Helen Stuart. *Prisoners of Poverty: Women Wage-workers, Their Trade and Their Lives*. Westport, CT: Greenwood Press, 1975. (Reprint of original Roberts Brothers, Boston, 1887).

Our Dominion: Cities, Towns and Business Interests (St. John and Environs). Saint John[?], 1887.

Report of the Census of Canada 1870–1871, volumes 1–4. Submitted by J.H. Pope, Minister of Agriculture. Ottawa: I.B. Taylor, 1873.

Report of the Census of Canada 1880–1881, volumes 1–4. Submitted by J.H. Pope, Minister of Agriculture. Ottawa: MacLean, Roger & Co, 1882.

St. John and Its Business: A History of St. John, and a Statement in General Terms of Its Various Kinds of Business Successfully Prosecuted. Saint John: H. Chubb & Co., 1875.

Willett, Mabel Hurd. *The Employment of Women in the Clothing Trade*. New York: AMS, 1968. (Reprint of No. 42 Columbia Series in the Social Sciences, 1902).

164 Peter J. Larocque

Secondary Sources

Acheson, T.W. *Saint John: The Making of a Colonial Urban Community*. Toronto: University of Toronto Press, 1985.
Beattie, Betty. "'Going Up to Lynn': Single Maritime-Born Women in Lynn, Massachusetts, 1879–1930.' *Acadiensis* 22, no. 1 (1992): 65–86.
Blewett, Mary H. *Men, Women, and Work: Class, Gender, and Protest in the New England Shoe Industry, 1780–1910*. Urbana and Chicago: University of Illinois Press, 1988.
Bloomfield, Elizabeth, and G.T. Bloomfield. *Canadian Women in Workshops, Mills and Factories: The Evidence of the 1871 Census Manuscripts* (Research Report 11). Guelph, ON: Department of Geography, University of Guelph, 1991.
– *Patterns of Canadian Industry in 1871: An Overview Based on the First Census of Canada* (Research Report 12). Guelph, ON: Department of Geography, University of Guelph, 1990.
Bradbury, Bettina. 'Surviving as a Widow in 19th-Century Montreal.' *Urban History Review* 17, no. 3 (1989): 148–60.
– 'Women and Wage Labour in a Period of Transition: Montreal, 1861–1881.' *Histoire sociale Social History*, 17, no. 33 (1984): 115–31.
– 'Women's History and Working-Class History.' *Labour/Le Travail* 19 (Spring 1987): 23–43.
– *Working Families: Age, Gender and Daily Survival in Industrializing Montreal*. Toronto: McClelland and Stewart, 1993.
Busfield, Deirdre. 'Skill and the Sexual Division of Labour in the West Riding Textile Industry, 1850–1914.' In *Employers and Labour in the English Textile Industries, 1850–1939*, ed. J.A. Jowitt and A.J. McIvor. London and New York: Routledge, 1988.
Cross, D. Susan. 'The Neglected Majority: The Changing Role of Women in 19th Century Montreal. '*Histoire sociale / Social History* 6, no. 12 (1973): 202–23.
Darroch, A. Gordon, and Michael Ornstein. 'Family Coresidence in Canada in 1871: Family Life-Cycles, Occupations and Networks of Mutual Aid.' Canadian Historical Association, *Historical Papers / Communications historiques* (1983): 30–55.
– 'Family and Household in Nineteenth-Century Canada: Regional Patterns and Regional Economies.' *Journal of Family History* (Summer 1984): 158–77.
Jenson, Joan M., and Sue Davidson, eds. *A Needle, a Bobbin, a Strike: Women Needleworkers in America*. Philadelphia: Temple University Press, 1984.
Johnson, Daniel F. *Vital Statistics from New Brunswick Newspapers, 1867*, vol. 25. Saint John: The author, 1988.
– *Vital Statistics from New Brunswick Newspapers, 1869–1870*. Vol. 28. Saint John: The Author, 1989.
Johnson, Laura C., with Robert E. Johnson. *The Seam Allowance: Industrial Home Sewing in Canada*. Toronto: Women's Press, 1982.

Kessler-Harris, Alice. *Out to Work: A History of Wage-Earning Women in the United States.* Oxford: Oxford University Press, 1982.

LaFleur, Ginette. 'L'Industrialization et le travail remunéré des femmes. Moncton 1881–1891.' In *Feminist Research: Prospect and Retrospect*, ed. Peta Tancred-Sheriff. Kingston: CRIAW and McGill-Queen's University Press, 1988, 127–140.

McCallum, Margaret E. 'Separate Spheres: The Organization of Work in a Confectionary Factory, Ganong Bros., St. Stephen, New Brunswick.' *Labour/Le Travail* 24 (Fall 1989): 69–90.

McLean, Lorna R. 'Single Again: Widow's Work in the Urban Family Economy, Ottawa, 1871,' *Ontario History* 83, no. 2 (1991): 125–50.

Medjuck, Sheva. 'Family and Household Composition in the Nineteenth Century: The Case of Moncton, New Brunswick, 1851–1871,' *Canadian Journal of Sociology* 4 (1979): 275–86.

Morton, Suzanne. 'Separate Spheres in a Separate World: African Scotian Women in Late-19th-Century Halifax County.' Pp. 185–210 in *Separate Spheres: Women's Worlds in the 19th-Century Maritimes*, ed. Janet Guilford and Suzanne Morton. Fredericton: Acadiensis Press, 1994.

Muise, Del A. 'The Industrial Context of Inequality: Female Participation in Nova Scotia's Paid Labour Force, 1871–1921.' *Acadiensis* 20, no. 2 (1991): 3–31.

Stein, Leon, ed. *Out of the Sweatshop: The Struggle for Industrial Democracy.* New York: Quadrangle / New York Times Book Company, 1977.

Turbin, Carol. *Working Women of Collar City: Gender, Class and Community in Troy, New York, 1864–1886.* Urbana and Chicago: University of Illinois Press, 1992.

Three Thousand Stitches: The Development of the Clothing Industry in Nineteenth-Century Halifax

M. ELAINE MacKAY

Halifax, Nova Scotia, may seem like an unlikely setting for an important clothing industry that rivalled any in the country.[1] However the maelstrom of industrial change that arose during Victoria's reign affected the clothing industry in Halifax, much as it did in other manufacturing centres. In an effort to supply a growing middle class with affordable, ready-to-wear clothing, tailors adopted the most modern cutting and sewing techniques. Small, individually run shops expanded into factories that employed hundreds of hands. This chapter traces the economic and social impact of the wave of industrialization in Halifax that crested at the end of the nineteenth century. In particular it highlights the work and social pressures that many young women faced when they entered this trade.[2] Scholars exploring the impact of John A. Macdonald's National Policy of 1879 tend to focus on the iron and steel works, railways, and textile production. Social historians tend to group the garment factories with other industries that also profited from cheap labour, often female. By exploring the tailoring and clothing trade in Halifax, a rich and unacknowledged history is revealed that illuminates the lives and difficulties faced by a large group of Eastern Canadian women striving to profit from the opportunities offered by the new clothing industry.

The clothing industry in Halifax had humble beginnings early in the 1800s. There was little need for custom clothing since the large number of military personnel posted to the city was outfitted in Britain. Much of civilian clothing was also imported from Britain, or made at home with coarse, homespun fabric. The tailor who did offer custom work had gone through a system of apprenticeship followed by years of experience under a master tailor. His success depended on his skill in fitting time-honoured patterns to 'bestow a good shape where Nature has not designed it; the Humpback, the Wry shoulder must be buried in Flannel and wadding; he must study not only the shape but the common Gait of the Subject.' His tools were simple: needles, scissors, chalk or soap for marking fabric, and an iron. To measure his client, the master tailor used a strip of paper or parchment

upon which he would mark important measurements. The handful of tailors who did offer bespoke tailoring were among a group of small local manufacturers who depended upon shipping and the seasonal trade with Britain to provide the staples to the Halifax citizenry.[3]

When the spring or fall shipments arrived, advertisements flooded local newspapers. John Fraser, in the *Acadian Recorder* in May of 1820, 'Returns his sincere thanks to a generous public, and respectfully informs them, that he has now received his Fall supply of CLOTHS, which will be made up in the neatest stile [*sic*], at reduced prices for cash or short credit.' By mid-century a *Nova Scotian* journalist noted: 'Our Streets are beginning to assume quite a lively aspect in consequence of the arrival of the Fall ships, and the stores of our Dry Goods Merchants are being thronged with inquiries after the latest fashions for dress &c.' Local merchants responded to the public's demands by stocking all manner of cloth from England, including cotton shirtings, Irish linen and lawn, hats and bonnets, broad and narrow cloth, ribbons and notions, and even ready-made waistcoats and waistcoat patterns. When tailors received shipments of fine wool for London and the west of England they invariably promised to make up made-to-order clothing that was second to none, at the shortest possible time.[4]

Between the seasons tailors faced long periods of inactivity. In order to sustain their livelihood on an annual basis they began to take advantage of the growing demand for ready-to-wear clothing. They stockpiled large quantities of fabric from which they produced and sold clothing throughout the year. At the time, sizes were not standardized, and fit varied with each tradesman. The newly invented measuring tape, and the tailors' square with divisions in inches, helped tailors as they competed to perfect drafting methods. Some tailors saw the body as a proportional ideal from which all points of reference could be attained from one or two measurements. Others mapped every conceivable body measurement with the use of clever and complicated measuring devices. Eventually a combination of both methods was used. John G. South, of 15 Hollis Street, seemed to prefer the mathematical approach:

> The subscriber respectfully informs the Tailors of Halifax, that he will ... open a school for teaching a self-varying mode of delineating, for the Cutting of Coats, Wrappers, and Vests. The System proposed to be taught, is totally different from any heretofore introduced into the Province. It is not like the system in use here now, founded on the application of breast or shoulder measure divisions, to suit the various parts of the body ... but is on the correct application of whole measures, taken, with the assistance of an elastic square.[5]

The open discussion of cutting patterns led to greater efficiency in the trade but did not, in itself, increase the speed of production.

Without question, the introduction of the sewing machine in the middle of the century set the pace for the clothing industry during the second half of the century. In 1860 the well-known publication, *The Tailor & Cutter*, estimated that a shirt was constructed with approximately twenty thousand stitches. By hand, a sewer could average thirty-five stitches per minute. The machine worker could average between one thousand and two thousand stitches per minute. A reasonable estimation concluded that the machine could potentially increase production some 500 per cent. After a short period of experimentation, professional businesses as well as the general public embraced the sewing machine. The new technology improved and became more specialized throughout the Victorian period and by the end of the century the machine produced work that was sometimes superior to that done by hand. Ultimately this made many skills obsolete and the traditional male artisan was replaced by a multitude of working men and women. During the 1860s a number of sewing machine dealers set up shop in Halifax. As the popularity and practicality of the new machines increased so did the number of local dealers. There were six local sewing machine dealers in 1869. By 1870, production and distribution of the sewing machine had increased on a massive scale.[6]

Concurrently, members of the tailoring community in Halifax were busy establishing their businesses, building partnerships, and defining their places within the maturing trade. Many were now registered as merchant tailors, suggesting that as well as making custom clothing they also sold ready-to-wear garments. Others were listed as clothiers who also sold ready-to-wear garments. In 1858 there were nineteen tailors listed in the city directory. Ten years later there were only eight tailors listed, but twenty-one merchant tailors, some of whom were registered as clothiers as well. Some drygood merchants, who were traditionally wholesalers of non-perishable groceries, hardware, and imported British fabrics, also began manufacturing men's and boy's garments during this time. Advertisements in the city directories stressed the particular strength of the business. Daniel M. Walsh of 164 Granville Street was a 'Tailor and Clothier, Wholesale and Retail, ... The Ready Made Clothing in this house is of very superior Quality, of the latest and most approved styles, and warranted equal to any Custom work in the Province.' The style-conscious Mr H.G. Laurilliard of 231 Hollis Street was an 'Agent for New York Fashion Plates.' Mr H.G. Tracy claimed expertise as a 'Tailor & Clothier & Cleaner, Cleans and Renovates Gentlemen's Garments of all colors, in the neatest manner; removes Paint, Tar, Pitch, Grease, and all impurities, without injury to color or garment, and gives the original shape, gloss, and softness.'[7]

Doull & Miller were drygoods merchants who also manufactured clothing. They had offices in both London and Manchester and a special buyer travelled from Britain to Halifax twice a year. When a huge fire on Hollis Street destroyed

their original building in 1857, they moved to larger premises on the corner of Hollis and Prince streets. The manufacture of ready-made clothing occupied a large part of the fourth floor and two upper flats of a neighbouring building. By 1876 the company employed 128 females and 22 males, year-round. They boasted a large and varied stock of men's and boy's wear that was either manufactured on the premises or given out to hands who 'find it more convenient to work out of their own homes.' Doull & Miller became one of the largest clothing companies in Halifax.[8]

Doull & Miller's largest competitor for the ready-to-wear men's and boy's wear industry was Clayton & Sons. Edward Clayton was a young man when he established a small tailoring shop on Argyle Street in 1869. He began his business in the traditional mould and at first produced very little ready-made clothing. Soon, however, he moved to the modern factory system and business flourished.

The factory system utilized another crucial innovation in the clothing industry: the division of labour. This was the process of dividing the highly skilled construction of clothing into many small tasks for which little training was necessary. It was a system that had started to develop since early in the century. The Elizabethan statutes that had ensured that tailors follow a strict apprenticeship were repealed in 1814, thus opening the door for the employment of thousands of unskilled workers. Those tasks which required training and skill, such as pattern-making, cutting, and inspecting, were done on the premises by a master tailor. But now simpler tasks, such as stitching trousers and the straight seams of coats and jackets, could be performed by untrained workers or non-apprentices, often away from the owner's premises. In England and America these outworkers, as they were called, were largely female and often new immigrants. Many enlisted the help of their children and family. At the beginning of the century, a jacket was constructed entirely by hand by a single journeyman. By century's end, it was divided into at least twenty-five complete and separate tasks, constructed by as many people, with the aid of a variety of specialized machines. Women now moved into the labour market as men were directed into supervisory roles.[9]

By 1871, the Halifax clothing industry used $111,950 worth of raw materials and produced $200,000 worth of goods. It paid $48,450 per year in wages to approximately 238 adults and children. The census of 1871 listed tailors and clothiers as second only to the boot and shoe industry in terms of the number of people employed in the city of Halifax.[10]

These employment figures are impressive, but the clothing industry was but a small part of the Halifax economy, which was still based upon shipping and trade. However, a worldwide depression in the 1870s, and a constricted British market for Nova Scotian built ships in 1873, created a serious economic crisis. In the midst of this depression, John A. Macdonald was re-elected prime minister in

1878 on a platform of economic nationalism. He sought to stimulate Canadian manufacturing by means of imposing high tariffs of up to 35 per cent on foreign manufactured goods. However, many raw goods such as cotton and hemp were admitted into the country free of any duty. Manufacturing machinery was also admitted duty free. This national policy gave established industries a chance to expand and gave new industries, like the Nova Scotia Cotton Company, a welcome boost.[11]

The Clayton establishment grew throughout these years. 'The National Policy is a benefit to our business. The work is done in the country, which was the case previously only to a very limited extent. Prior to the adoption of the National Policy nearly everything was imported from England,' claimed the Clayton company. Caught in the wave of expansion, Edward and his brother and new partner, William, bought one of a collection of small wooden buildings on the northern edge of the city and moved the factory there in 1879. They were soon cramped, so they bought neighbouring buildings, tearing down the wooden structures and erecting large brick ones until they occupied almost the whole block between Poplar Grove and Barrington Street. Tariff-free, steam-powered sewing machines were bought and installed in the new buildings. Between 1879 and 1884 the Claytons hired over one hundred employees, most of them women. Some of these women mastered the new sewing machines, and many more were employed as outworkers. All of them contributed to the expanding ready-to-wear department.[12]

One clear indication of the effect of the National Policy is a comparison of the number of people employed by clothiers in 1874 and 1884. In 1874, thirty-five men, two boys, and 188 females were employed in Halifax. This number grew in 1884 to forty-four men, two boys, and 280 females. Almost all of the new employees were hired by the Clayton company. Wages were reduced slightly for men, from $10.42 to $10.00 per week, but changed rather more favourably for females, from $2.48 to $3.50 per week during this period. Three factors are evident from this comparison. The most noteworthy is that the percentage of females employed increased significantly more than did the percentage of men over the five years. This indicates that the ready-to-wear trade also grew significantly. Many of the women worked out of their homes using their own sewing machines that had by this time become both practical and inexpensive. The second factor is the huge wage discrepancy between the men and the females, confirming and reinforcing the convention that work done by women was unskilled and therefore worth less money. The third factor, though not as obvious, is equally significant. Men and boys are listed separately. Females, however, are both women and girls. Presumably, men and boys were listed separately because their wages were expected to change as the boys grew to men and took on supervisory

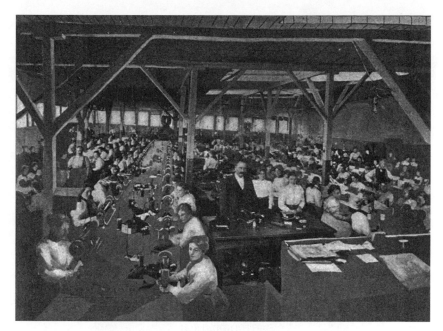

24 Workroom at the Clayton & Sons factory, 1900. Young women used specialized sewing machines for the production of custom and ready-to-wear garments in one of the spacious assembly rooms of Clayton & Sons. These rooms boasted fresh air and good lighting from hundreds of windows as well as the use of electric lights. Women worked exclusively in the production line and outnumbered men in the factory by eight or ten to one. (From the Jean Holden Collection, Nova Scotia Archives and Record Management)

positions. Girls and women, however, continued to work on the machines, staying within the same wage frame so there was no need to distinguish age.[13]

The clothing industry grew at an astonishing rate, and within the decade the number of people it employed tripled. The percentage of money spent by the working class on clothing had increased from 6 per cent in 1845 to 10 per cent by 1889. The census of 1891 acknowledged tailors and clothiers as the largest single employer in Halifax. Of the 878 employees in the industry, 716 were women and 7 were girls. By 1895, 40 per cent of all clothing sold in Canada was ready-to-wear.[14] (See illustration 24.)

The increase of females in the workforce was a phenomenon of the last quarter of the nineteenth century. Most of these women were young, between the ages of

seventeen and twenty-five. Some were spurred on to work by a growing sense of independence and a desire for personal income. Many were searching for much needed additional income for their families. A tide of young women from across the Maritime provinces left their rural homes in search of employment in the cities. Many travelled farther, to what was known in the Maritimes as the Boston States, in search of domestic or factory work. By 1880, 4,374 Maritime women were employed in Boston alone. Of this number 1,232 were employed as either dressmakers or tailors. This outmigration contributed to a stagnation of the population growth in Nova Scotia and caused a serious void in the workforce of the province. Newspapers used techniques of persuasion and fear-mongering to encourage the young to remain in the Maritimes with headlines such as the following:

NO PLACE LIKE HOME ...
AND YET BOSTON is the HUGE PULP MILL INTO WHICH
NOVA SCOTIA THROWS MANY of HER SONS AND
DAUGHTERS. BETTER a CANADIAN COT-
TAGE THAN an AMERICAN
CASTLE in the AIR
WITH INDUSTRIAL
SLAVERY

Later, in the same article, the editor asks:

Why is it so many of our young people go to the States?
'They get higher wages,' say the parents in quiet farm house or village homes.
'Jamie and Susie got restless and went to Boston.'
And what became of Jamie and Susie?
'Well Susie came home and died of consumption – there is her picture – but Jamie is getting on well, though he has to stick to business from morning till night.'
So Susie died –
WAS WORKED TO DEATH IN A BOSTON FACTORY

Some articles reflected genuine concerns for 'a bevy of our fair maidens' who were leaving the wholesome influences of home. Using images of cramped and undesirable conditions the editors appealed to girls to first seek employment at home before leaving on the weekly boat to Boston. In July 1891 the *Critic* lamented that girls 'start off with high hopes and great expectations, only to find on arriving in Boston and having obtained employment, that to live they must huddle in

crowded second-class boarding houses, and even then pay almost all they earn for board.'[15]

Among the industries that were deemed appropriate businesses for young working women were the clothing and cotton industries. Mr. Morriscey, the manager of the Outside Work Department for Clayton & Sons, said there were opportunities for year-round employment for girls with all levels of skill. He claimed that girls could earn from $2 to $5 per week working out of their homes, and though wages were higher in the United States, their money could be spent more advantageously in Nova Scotia. Appeals to young women to stay at home, though often rich in imagery, did not abate the tides of change.

Today, these appeals may seem at best quaint, and at worst paternalistic. There were, however, real grounds for concern. Outworking had the potential to exploit workers. The system of passing goods from the manufacturer to a subcontractor and then to one or more outworkers was, by this time, known as sweating, a term synonymous with unsanitary, dirty surroundings, and with long hours and low pay. It was well known that by mid-century most London tailors lived in squalor; sweating themselves, their families, and neighbours. It is estimated that one-quarter to one-half of all the women in the ready-to-wear industry there resorted to prostitution in order to survive. Given the industry's reputation, it is understandable that there was serious concern about the possible physical and moral dangers inherent in factory work.[16]

Across Canada, a number of community organizations offered help to the 'working girl,' including the National Council of Women, the Fédération nationale Saint Jean-Baptiste, and a number of Christian groups. In Halifax, a committee of ladies from different Protestant denominations obtained and furnished a house, 'for the comfort and protection of young women seeking employment in this city, ... who, often on their first arrival in the city, or when destitute of situations, are likely to be exposed, without such a place, especially if of an unsuspecting disposition, to many perils and temptations.' Within the first year of operation, 140 girls passed through the doors, usually staying a few days before they found more permanent accommodations.[17]

There was concern for the factory worker at the national level as well. In an effort to exorcise the 'evils which accompany the factory system,' the Canadian government investigated factories and outworking systems across the country with respect to working conditions and pay. For the 1889 *Report of the Royal Commission on the Relations of Labour and Capital in Canada* interviews were conducted by W.J. Clayton and W.H. Gibbon of Doull & Miller. The *Report upon the Sweating System in Canada 1896* was recorded by Alexander Whyte Wright and conducted in factories across the country between 29 October and 6 November 1895.[18]

Through the report of the Royal Commission we can glean an insight into the city's factories. In Halifax, like factories across the country, nine- or ten-hour days with a half-day on Saturday were common. Clayton's doors were closed at precisely 8:00 a.m. and a late arriver would lose half a day's pay. Determining the average wage was difficult because so much of the work was piecework. Clayton & Sons and Doull & Miller had similar pay scales, though Clayton's wages were slightly higher. The average weekly salary for custom tailors, all of whom were men, was from $9.00 to $12.00 per week in the Clayton shop. The supervisors, who were also men, made slightly more. Boys, whose salary started at $1.50 per week, did not stay long, according to William Clayton: 'Our trade is rather unpopular with boys,' he said. The women working on the factory floor, who outnumbered the men from eight to ten times, on average earned between $3.00 and $4.00 per week.

Given these low rates of pay, it is hardly surprising that the government also investigated the employee's ability to pay for accommodation. In his evidence, Mr Clayton knew of none of the men in his employ that owned their own houses. At the time, most boarders could expect to pay between $2.50 and $4.00 per week, and few women who worked in the factories could afford to pay this rent. Mr W.H. Gibbon of Doull & Miller believed that the girls lived with their parents and therefore did not need to pay for board. When pushed further by the interviewers, he admitted that the company neither ascertained nor cared where the girls they employed lived. The responses from both companies were in sharp contrast to the public image they fostered of being responsible employers who provided adequate remuneration for approved work.

The morals of the late nineteenth century were reflected in some of the questions put to the leaders of the industry. There was concern that there should be seats for the shopgirls so they need not stand all day. This was because of a belief that standing all day could damage a woman's reproductive organs. Cleanliness and propriety was also important. The government interviewers questioned whether separate lavatories were available for men and women. Clayton's facilities were completely separate, while Doull & Miller conceded that the one room had only a dividing partition and there was nothing to prevent the men from seeing the women entering the facilities.

Neither company hired very young children. Clayton & Sons made it a practice to hire no children under fifteen years of age. It did, however, offer training to little girls and one can deduce that they may well have been younger than fifteen years.

Fire was always a danger to the garment industry and the government queried both companies as to their level of fire safety. W.J. Clayton acknowledged that there were no fire escapes at the factory, but the doors opened out, the stairs were

wide, and there were steel doors between the buildings that would prevent any fire from spreading. This proved effective in containing a devastating fire that destroyed two floors of one building in 1897. W.H. Gibbon, of Doull & Miller, conceded that although there were no fire escapes at their factory, there were doors leading to adjoining warehouses and ladders leading to the roofs that provided the means for escape in the event of a fire.[19]

The bigger problem with the *Report of the Royal Commission on the Relations of Labour and Capital in Canada* was that none of the women on the factory floor were interviewed, leaving an incomplete picture of the situation. The interviews with male supervisors provide little insight to working conditions of the factory because the men reiterated the statements of their employers, so their answers must be taken with some level of scepticism. Nevertheless, they supported the employer's claims that the workspaces were well ventilated, that wages were fair, and that there were no labour problems.

Another government report, *The Report Upon the Sweating System in Canada 1896*, reflected the workers' position more clearly. It investigated the extent of the sweating system in Canada and found that while contracting outwork was common, subcontracting was not, and sanitary conditions were usually good across the country. None of the deplorable conditions that were common in the British, and to a lesser extent, the American industry, existed in Canada, it concluded.

While clothing companies used both production methods, workers invariably preferred the factory system to outworking. Halifax fared rather better than the rest of the country as a place to work because there were proportionally more factory workers. Workers felt that the factory was exposed to public scrutiny and therefore the owners were less likely to abuse their workers. Also, even though garment workers were too fragmented to work cohesively to form unions, it was felt that within the factory, workers were free to compare wages or hours of work, thus preventing any lowering of wages. Outworkers were at a disadvantage because they were even more fractionalized than factory workers. They tended to work longer and less regular hours; they spent more unpaid hours travelling to and from the factory, and if their work did not pass inspection, their transportation time was doubled. Outworkers also used their own equipment. Even though both factory and outworkers did piece work, outworkers actually did more than one job since they had to both sew and press. Clayton & Sons actually recognized that those women who worked out of their homes had more to do and, unlike most owners, compensated them with the slightly higher wage of approximately $4 per week.[20]

Clayton & Sons emerged throughout the government interviews as the preferred company in Halifax for which to work. In an effort to present themselves as exemplary employers, the Claytons opened their doors to the public and themselves to public examination.[21] (See illustration 25.)

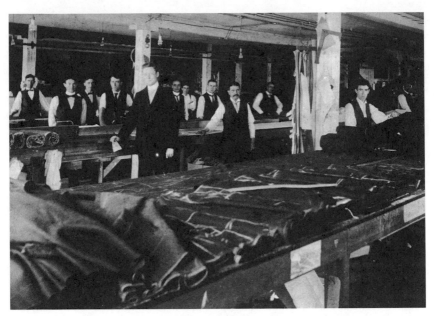

25 Wholesale stockroom at the Clayton & Sons factory, 1900. Men occupied supervisory positions, did the fine custom work, made patterns, and worked in sales. In this stockroom, piles of ready-to-wear trousers are readied for shipment to neighbouring Atlantic Provinces, the Northwest, and the Yukon. (From the Jean Holden Collection, Nova Scotia Archives and Record Management)

The spirit and commitment to the newest technology that had characterized the Clayton family business during its developing years continued into the twentieth century. The main factory had grown into a huge composite of buildings in Halifax and there were plants in the surrounding areas of Bear Cove, Ketch Harbour, Portuguese Cove, Richmond, and Dartmouth. It was the largest clothing company in the Dominion, employing between four hundred and five hundred workers, many of whom were outworkers living within a fifty-mile radius of the city.

Clayton & Sons still purchased British cloth twice a year but they also used locally produced wool. Although they had always offered custom clothing along with ready-to-wear, the 'Acadian Proud Homespun' trousers and overalls became their best-selling line. These were made entirely with locally produced homespun wool. They were worn by labourers in Nova Scotia, the neighbouring Maritime provinces, and part of Quebec, and they were shipped five thousand miles away to

the Yukon Territory, where they no doubt kept many a sourdough warm as he moiled for gold in the muck of the Klondike gold rush.

Modern ways replaced old methods. Bright white-painted walls, electric lighting, and 10,500 separate pieces of glass in the skylights and windows and on each floor created a lofty, well-lit workspace. The company used the most advanced technological innovations; three electric cutters; the English band knife for cutting heavy fabric and cottons; the 'Fenno,' which was a circular knife; and the 'Eastman,' a motor and knife that could move all over the table. When combined with eighteen hand cutters, up to 1000 pairs of pants or 250 suits could be cut in a day. Electric pressing irons had replaced old-fashioned furnaces. There were ninety-seven sewing machines, including six Union special sewing machines, the most complete in their line in North America, each worth $200. These machines strengthened seams from 25 to 45 per cent and achieved three thousand stitches per minute. This serious investment in machinery increased the production and brought down the prices of the ready-to-wear overalls and pants. The cheapest pants were constructed entirely by machine; even the application of buttons and buttonholes.

Even though the company was a model of mechanization, it was also personally involved in the welfare of the workers. Following the fire of 1897, an employees' lunch and recreation area was furnished with a new piano as part of the renovations. The company provided a savings bank, which accepted deposits of as little as five cents and gave 4 per cent interest. If they wished, employees could contribute to a medical insurance plan that paid wages in the case of illness and, in the case of death, paid the funeral expenses. There was even a profit-sharing system available to all hands of two years standing. The Claytons stated: 'We consider that it is good business for us to share the profits as we do, for we and our hands are then working together to gain a common end, our interests and aims are made completely mutual and our trade is that much better than it would otherwise be.'[22]

No doubt some of this altruism was in a deliberate attempt to disassociate themselves from other garment industry sweatshops. But it also demonstrated a strong sense of a duty to the community. The Claytons followed the distinctly Victorian viewpoint that their girls must be protected. The women in the factory were, after all, local girls, many of them from the rural communities of Nova Scotia. Had they been immigrants, as were many of the garment workers in Britain and the United States, one wonders if the same level of concern would have been shown. Nevertheless, the newspapers of the city expounded on the virtues of this socially progressive and successful company and painted a portrait of a contented family of workers with a benevolent guardian.[23]

These were the days of good fortune for the Clayton family business. For the next couple of decades they continued to prosper and make their city proud.

However, the National Policy that had been such a help in the early 1880s had actually created an unnatural economy that had trouble withstanding market fluctuations. Also, the devastating Halifax explosion of 1917 destroyed the Richmond plant and damaged the main factory. This calamity was followed by the Depression, which came early to Nova Scotia, and the next Clayton generation could not maintain the momentum of the founders. The company finally closed in the 1950s. In the 1960s, the massive factory was demolished to make way for a modern shopping complex during an urban renewal project. The only reminder today of this huge industry is found in the name of a subdivision that was built on land once owned by William Clayton.

The wave of industrialization in the nineteenth century had transported Halifax from the age of shipping and trade into the manufacturing age, and the clothing industry led the way. Halifax had lost its dependence on Britain for materials and fashions as the trade routes shifted from shifted from transatlantic to the eastern seaboard of the United States. Technological advances such as industrial sewing machines, cutters, and production techniques continued to transform the garment industry with efficiency and speed. By the century's end, the master tailor had become a businessman whose skill lay not in his ability to manipulate and fit fabric to the individual client, but rather in providing huge quantities of sized, ready-to-wear clothing to a growing consumer base. Tailoring patterns, that were once 'Cherished and highly valued possessions ... bequeathed as legacies from father to son,' now numbered in the thousands in the Claytons' factory and were changed twice a year according the New York fashion plates. Though the pay was poor and rarely resulted in positions of authority, the ground swell had given work to hundreds of young women finding their way in the world. Along the way, it helped lay a strong familial bond between the Maritime provinces and the area that Maritimers still call the Boston States. It can be argued that their ability to take on the roll of wage-earner carried the industry into the twentieth century. The flexibility and initiative they exhibited in seeking out employment in their homes or in factories, in Halifax or Boston, quell any image of the weak and fragile Victorian woman. Also, as they travelled afar looking for work, they helped lay a strong bond between the Maritime provinces and the eastern seaboard. The clothing industry was a vital part of Halifax history that was the result of poorly paid work of young women who were caught between the new opportunities the garment industry offered and the social constraints of the late nineteenth century.

NOTES

1 Poirier, *My Acadian Tradition* 12; Blakeley, 'Margaret Marshall Saunders the Author of "Beautiful Joe,"' *Nova Scotia Historical Quarterly* (September 1971), 229.

2 The story of the ready-to-wear clothing industry in Halifax contrasts markedly with
 the story of the custom tailors in Montreal told by Gail Cariou elsewhere in this
 book. By the middle of the eighteenth century, artisans had to choose the direction of
 their future. In Montreal the Gibb family secured an elite clientele who gladly paid
 the price of custom-fitted and hand-sewn garments. The industry in Halifax appealed
 to a mass market with less expensive ready-to-wear clothing.

3 Pedde, 'Halifax Citadel National Historic Site Labourers Costume Manual,' 44;
 Kidwell and C. Christman, *Suiting Everyone: The Democratization of Clothing in
 America*, 25. Additional information about the tools and techniques of historic
 tailoring is examined in Waugh, *The Cut of Men's Clothes, 1600–1900*, 34–35.

4 *Acadian Recorder*, 6 May 1820; *Nova Scotian*, 1 October 1849; *Acadian Recorder*, 29
 April 1820.

5 *Nova Scotian*, 5 January 1837. Many sources place the invention of the measuring
 tape and tailors' square early in the nineteenth century but none that I consulted
 point to any specific date. Wyatt, *The Tailor's Friendly Instructor*, uses the tailors'
 square with division in inches for drafts of various garments. This technical guide was
 available in Nova Scotia at the time.

6 Schmiechen, *Sweated Industries and Sweated Labor: The London Clothing Trades,
 1860–1914*, 9; Hutchinson, *Hutchinson's Nova Scotia Directory for 1864–65*, 217;
 McAlpine, ed., *McAlpine's City Directory for 1869–70*.

7 Hazen, *The Panorama of Professions and Trades*, includes a chapter devoted to a
 description of the tailor's trade. 'It is usual for persons who carry on this business,
 in cities and large towns, to keep a stock of cloths and other stuffs adapted to the
 season, which they make up into garments, to the order of Customers. In such cases,
 they are termed *merchant tailors*'; Nugent, ed., *Nugent's Business Directory of the City
 of Halifax 1858–59*; *Hutchinson's Nova Scotia Directory*, 217, 601, and 602.

8 White, *Halifax and Its Business*, 127–28.

9 Schmiechen, *Sweated Industries*, 9, 28.

10 McKay, 'The Working Class of Metropolitan Halifax, 1850–1889,' 14; *Census of
 Canada 1871*, vol. 3, table XXVIII–LIV 290.

11 Reid, *Six Crucial Decades*, 129.

12 *Halifax Herald*, 24 October 1903; 'House of Commons Sessional Papers 1885,' 60.

13 See the chapter by Peter J. Larocque for a discussion of the relative amount of skill
 needed to operate the sewing machine.

14 Schmiechen, *Sweated Industries*, 13; *Census of Canada*, 1891, vol. 3, tables I & II;
 Wright, *The Report Upon the Sweating System in Canada 1896*, 13.

15 Margaret Conrad, *Recording Angels*, 14; *Halifax Herald*, 10 August 1895, section 2;
 The Critic, 24 July 1891.

16 Schmiechen, *Sweated Industries*, 18, 61.

17 White, *Women and Unions*, 4; *Morning Chronicle*, 14 April 1870.

18 See *Report of the Royal Commission on the Relations of Labour and Capital in Canada*

for evidences of W.J. Clayton (pp. 1–3), and W.H. Gibbon of the Doull & Miller company (pp. 6–7). See also Wright, *The Report Upon the Sweating System.*

19　It is significant that the Canada government was concerned with fire safety and was making inquiries into fire escapes in factories. Twelve years later, on 25 March 1911, 154 people, most of whom were young girls, died in the Triangle Shirtwaist fire, an American disaster. The deaths were largely the result of unsafe conditions that included locked doors and nonfunctional fire escapes.

20　Wright, *Sweating*, 1–13; *Royal Commission on the Relations of Labour and Capital*, 3.

21　*Halifax Herald*, 24 October 1903. Page 12 is a full page dedicated to the Clayton factory. Much of the following information comes from this source, but similar information is found in the following articles: *Halifax Herald*, 31 August 1901; *The Critic*, 24 July 1891, 'Employment for our Girls'; *Halifax Herald*, 11 March 1895, 30 December 1896; 24 May 1897; 19 June 1897; see also the Clayton & Sons 30th Anniversary, 1869–1900 advertisement, Public Archives of Nova Scotia.

22　*Halifax Herald*, 24 October 1903.

23　During the First World War, Edward Clayton's commitment to the community was demonstrated when he loaned out his house as a military convalescent home.

SELECTED BIBLIOGRAPHY

Primary Sources

Census of Canada, 1871. Vol. 3. Ottawa: Queen's Printer, 1871.
Census of Canada, 1891. Vol. 3. Ottawa: Queen's Printer, 1891.
House of Commons, Sessional Papers, vol. 10, no. 37, 1885.
Hutchinson, Thomas. *Hutchinson's Nova Scotia Directory for 1864–65*. Halifax: Thomas Hutchinson, 1864.
McAlpine, David ed. *McAlpine's Halifax City Directory for 1869–70*. Halifax: David McAlpine, 1869.
Nugent, R.P. *Nugent's Business Directory of the City of Halifax 1858–59*. Halifax: Richard P. Nugent Publishing Ltd., 1858.
Report of the Royal Commission on the Relations of Labour and Capital in Canada. 6 vols. Ottawa: Queen's Printer, 1889.
White, G.A. *Halifax and Its Business: Containing Historical Sketch and Description of the City and Its Institutions*. Halifax: Nova Scotia Printing Co., 1876.
Wright, Alexander Whyte. *The Report upon the Sweating System in Canada 1896*. Ottawa: S.E. Dawson, 1896.
Wyatt, J. *The Tailor's Friendly Instructor*. London: Harris, 1822.

Secondary Sources

Blakeley, Phyllis R. 'Margaret Marshall Saunders the Author of "Beautiful Joe,"' *Nova Scotia Historical Quarterly* (September 1971).

Conrad, Margaret. *Recording Angels: The Private Chronicles of Women from the Maritime Provinces of Canada, 1750–1950*. Ottawa: Canadian Research Institute for the Advancement of Women, 1982.

Hazen, Edward. *Panorama of Victorian Trades & Professions or Every Man's Book*. Philadelphia: Uria Hunt; Watkins Glen, NY: Century House, 1970.

Kidwell, Claudia, and Margaret C. Cristman, *Suiting Everyone: The Democratization of Clothing in America*. Washington DC: Smithsonian Institution Press, 1974.

McKay, Ian. 'The Working Class of Metropolitan Halifax, 1850–1889.' Honours thesis, Dalhousie University, 1975.

Pedde, Anne. 'Halifax Citadel National Historic Site Labourers Costume Manual.' Halifax Citadel, 1994.

Poirier, Leonie Comeau. *My Acadian Tradition*. Hantsport, NS: Lancelot Press, 1985.

Reid, John G. *Six Crucial Decades: Times of Change in the History of the Maritimes*. Halifax: Nimbus Publishing 1987.

Schmiechen, James A. *Sweated Industries and Sweated Labor: The London Clothing Trades, 1860–1914*. Urbana and Chicago: University of Illinois Press, 1984.

Waugh, Nora. *The Cut of Men's Clothes, 1600–1900*. London: Faber and Faber, 1977.

White, Julie. *Women and Unions*. Hull: Canadian Government Publishing Centre, 1980.

Enduring Roots: Gibb and Co. and the Nineteenth-Century Tailoring Trade in Montreal

GAIL CARIOU

In 1774 Benaiah Gibb, an ambitious young tailor from England, arrived in Montreal. Ten years later he had formed a partnership with Peter McFarlane, a well-established Montreal merchant tailor. McFarlane retired in 1790, leaving the business in Gibb's hands. The subsequent fortunes of the firm are a fascinating case study of a custom-tailoring business that survived for nearly two hundred years. The company founded by Benaiah Gibb finally closed its doors in 1968, its reputation as a custom-tailoring establishment to Montreal's elite still intact.

Benaiah Gibb was born in England in 1755 to a family of Scottish origin. Trained as a tailor, he arrived in the province of Quebec in 1774. By 1784 he was working in full partnership with Peter McFarlane, a well-established Montreal draper. After McFarlane's retirement, Gibb formed a brief partnership with Thomas Prior in 1797. Gibb prospered, having developed an elite clientele for his services. He enjoyed a comfortable lifestyle, with a stone house in the city and a China summer house. Gibb died in 1826, leaving a flourishing business to his sons.[1]

In 1989 Benaiah Gibb's descendants donated the Gibb company records from 1800 to 1945 to the McCord Museum Archives in Montreal. The firm was known variously throughout its long history as McFarlane and Gibb, Gibb's and Kollmyer, Gibb's and Company, and from the 1830s into the twentieth century as Gibb & Co.[2] These records are wonderfully rich in their extent and variety and bring to life details of the daily activities of the custom-tailoring trade that are seldom available. The Gibb family papers include documents as varied as apprenticeship and business partnership agreements, land transaction documents, ledgers, orders for supplies, and dunning letters to customers who had not paid their bills. More unusual are the cutters' books listing customers' measurements and the details of the garments they ordered, and literally dozens of letters in the year 1852–3 from customers outside Montreal who ordered garments or complained about slow

service, lost parcels, or the style or fit of their new clothes. Although the records are by no means complete, this archive is an unparalleled record of a Canadian custom-tailoring firm that persisted for almost two centuries.

This chapter is a preliminary investigation of the early business established by Benaiah Gibb and the strategies adopted by succeeding family members that were crucial to the survival of the company as a custom-tailoring establishment beyond the first generation. It examines how and why Gibb's firm was able to adapt to the challenges of competition from ready-to-wear clothing manufacture during the transitional phase of the garment industry to industrial production.

Under Benaiah Gibb the company enjoyed the initial advantages of family and personal connections. Gibb was a shrewd entrepreneur as well as a tailor. Numerous documents for various land transactions, lease agreements, property improvements, and efforts to collect outstanding rents demonstrate his considerable talent for building capital and investing outside his tailoring business. For Gibb, however, tailoring was the basis of his prosperity and he ensured that the tailoring business was passed on to his sons intact, carefully managing the transition from his ownership to theirs. Throughout the nineteenth century Gibb and Co. negotiated the onslaught of competition from the ready-made garment industry, continuing to cultivate and serve an elite clientele rather than the mass market, providing made-to-measure clothing rather than ready-to-wear. The company responded to the early challenges of the industrialized marketplace by adopting new approaches to management and production.

Scholarship on the garment industry in Canada has concentrated largely on the post-1870 period, for which census data are available. Existing studies, with few exceptions, have focused on the path that led to large-scale mass manufacturing in the post-industrial period of the late nineteenth and early twentieth centuries, and, in the case of the garment industry, to studies of ready-to-wear manufacture. Until recently, custom-tailoring establishments have been all but ignored, in part because the assumption has been that such firms clung to archaic craft practices and did not engage fully in the industrial revolution that transformed the ready-to-wear side of the garment trade. However, according to Michael Bliss, the growth of industry in Canada, not only that of the garment industry, was characterized by unevenness and its evolution was not 'simply the transition from household to factory manufacture.' N. Maurice Davidson and Michelle Payette-Daoust, in their studies of the garment industry in Montreal, and Gerald Tulchinsky, in his work on the Toronto industry, have all concentrated on the period after 1870, and on mass manufacturing rather than custom-tailoring.[3] According to Tulchinsky, unlike many other manufacturing sectors which emerged during the nineteenth century, clothing production as a whole did not become converted completely, or

even mostly, to mechanized factory production but continued to exhibit an astonishing variety of modes of production.[4]

One of the few studies to examine the pre-industrial period is Mary Anne Poutanen's work on Montreal's garment trade from 1820 to 1842, the period of 'transition from feudalism to capitalism.' Poutanen concentrates on the factors that differentiated men's tailoring establishments from those of dressmakers, including the accumulation of capital, modes of production, and division of labour within the workshop.[5]

Michael Zakim's recent studies of both the ready-to-wear and the custom-tailoring trade in the United States are especially relevant to Gibb's situation. Zakim refutes the notion that equates custom tailoring with pre-industrial practices. He asserts, on the contrary, that 'the made-to-measure trade was that branch of the clothing business that underwent the most far-reaching industrial transformation in the middle of the nineteenth century.' Of particular significance to the case of Gibb and Co. are Zakim's questions regarding the means by which markets were developed, served, and expanded.[6]

Robert Lewis, in his recent work on the geography of Montreal's manufacturing districts between 1850 and 1930, identifies three distinct types that characterized the city's clothing firms. The first was the small, unmechanized custom-tailoring shop that catered to a local elite or working-class market. The second route 'consisted of firms performing in-house production, featuring extensive mechanization, a highly developed division of labour, and a sophisticated system of distribution.' The third Lewis identifies as the large wholesale manufacturer whose labour force consisted of rural outworkers who sewed garments cut out in the owner's premises.[7]

Looking at the picture Lewis paints, one might wonder where Gibb and Co. fitted in. While at the outset the company may have conformed to Lewis's first classification, as the firm matured it did not mutate into either of Lewis's other two categories. Instead, it evolved into another variant – that is, a sturdy hybrid that still catered to the cream of Montreal society by producing custom-made clothing, while simultaneously adopting the strategies of the large-scale garment manufacturers who pursued a wider market.

By the time Benaiah Gibb handed the reins of the company over to his sons, the firm's foundations and strategies for survival were well established. In the first fifty years after his arrival in Montreal, Gibb had established his market for high-quality tailoring and had amassed sufficient capital to withstand the vagaries of the marketplace. The basis of Gibb's early prosperity was already confirmed by 1804, not only as a result of his earliest Montreal business connections and his initial partnership with McFarlane, but probably as a result of timely military and fur-trade connections and his speculations in real estate. Gibb's assets when his first

wife, Catherine Campbell, died in 1804 were £8,820. 17s. 11d., while his debts were only £2,499. 16s. 10d.[8]

Like many of those who arrived in Canada during this period, Gibb's early business successes profited from family and personal connections. Gibb's family had a business in London, England, which, according to differing accounts, was either a tailoring shop or a firm specializing in ready-to-wear clothing. No invoices or letters from the London branch appear in the McCord papers until 1817, when a letter from Benaiah Gibb, Taylor and Draper, of Ratcliffe Highway, England, gave power of attorney to Benaiah Gibb of Montreal. This suggests that early in the firm's history the connection was perhaps not only a family one, but was of distinctly commercial advantage to Gibb of Montreal, at least as a source of fabrics and haberdashery, if not capital. Beginning in 1851, invoices and letters show that Gibb of Montreal depended on Gibb of London to supply a wide variety of haberdashery and fabrics until the end of the century, despite later tariffs which could have inhibited the connection. In addition, Gibb of Montreal referred debts of clients who returned to Britain without paying their bills to Gibb of London for collection.[9] The close relationship with the English branch of the firm endured and the company eventually passed into the hands of the London branch of the family.

Gibb's successful partnership with Peter McFarlane was formally dissolved in 1791, when McFarlane bought out Gibb's share of the partnership for £400. This was an unusual arrangement, considering that McFarlane had brought Gibb into his own business as a young man who may have originally contributed little capital to the enterprise.[10] However, McFarlane was by this time elderly, and without any apparent intention of continuing the business under his own name. Undoubtedly, the arrangement proved mutually agreeable to both Gibb and McFarlane. When the partnership ended, Gibb had substantial capital in hand, and an existing clientele. McFarlane paid Gibb out, the reverse of what might have been expected, but he lived in Gibb's home in his old age. Gibb's marriage to Catherine Campbell in 1790, less than a month prior to McFarlane's retirement, suggests that he may have decided to marry on the strength of his business prospects.

In 1795 Gibb contracted a brief partnership with his wife's brother-in-law, Thomas Prior, who was also a tailor. Under this agreement, which was originally contracted for three years, Gibb was to hold two-thirds of the shares and manage the business and the account books while Prior, holding the remaining shares, was to manage 'the works part,' presumably meaning the hands-on tailoring aspect of the business. It appears that the arrangement was less than satisfactory. Blood may be thicker than water, but not thick enough to cement a business relationship that neither party found satisfactory. Barely two years after its inception, the partnership dissolved. Gibb retained the business and bought out Prior's share.[11]

Gibb made a significant connection with Joseph Kollmyer in 1813 when he was

fifty-eight and his sons had not yet reached the age of majority. Gibb's relationship with Kollmyer ensured the successful transfer of the business to his sons and the future of the firm as a family business beyond his lifetime. At the same time, Benaiah Gibb made sure that his sons became proprietors of a tailoring firm, not tailors.

Kollmyer was a tailor who originally apprenticed to Gibb in 1802, completing his apprenticeship in 1808.[12] Gibb must have regarded him highly to have offered him such a significant opportunity with the company only five years after Kollmyer had completed his apprenticeship. Gibb understood that Kollmyer's tailoring skills and his abilities as a foreman were essential to the firm's success, since none of Gibb's sons became tailors. Instead, Gibb had his sons educated as businessmen, not tradesmen, with the clear intention of making them proprietors rather than craftsmen. It appears that Benaiah Jr was sent to England in 1813 for two years to study the clothing business with the Gibb firm in England, but he does not appear to have learned the art of tailoring. James Duncan Gibb had been apprenticed to a bookkeeper and was to keep the accounts for the firm. In these circumstances, in order to continue to satisfy the company's profitable elite clientele, Gibb needed a highly competent tailor to fill the role of master tailor and shop-floor manager. The agreement with Kollmyer took the form of a temporary partnership which was to have been cancelled when James Duncan Gibb came of age in 1817. The document spelled out the conditions of the agreement with regard to shares in the company, financial responsibilities related to wood to heat the shop (and the tailor's pressing irons), and candles to light it. It also evaluated the goods already owned by the firm. In particular, the agreement discusses the stock of military goods on hand that had been devalued because peace had recently been declared. A series of subsequent copartnership agreements, dating from 1815 and 1818, gradually transferred the business to Kollmyer and to two of Gibb's sons, Thomas and James Duncan.[13] According to the 1818 agreement, Kollmyer was to continue in his capacity as foreman, Benaiah Gibb Jr was to 'settle old business,' and James Duncan Gibb was to act as bookkeeper. Although Benaiah Sr was entering a phase of semi-retirement, he was to advise on the business and draw an income.[14] By 1821 the long-standing relationship between Gibb and Kollmyer had ended. Sadly, after establishing himself independently, Kollmyer went bankrupt, in spite of his long association with the Gibb name, which would have been a positive recommendation of his services.

Gibb publicly announced his official retirement and the transfer of the business to his sons on 22 August 1822 in a notice in the *Montreal Gazette.*

Whereas Benaiah Gibb, the elder, considering his advanced age, and wishing to substitute, and vest the whole management and administration of his affairs and

Estates in THOMAS GIBB and JAMES DUNCAN GIBB, his Sons, hath solicited their legal appointment as his Counsel, which appointment was homologated by the Hon. J.C. Goucher, one of the Justice [*sic*] of the Court of King's Bench for this District, on the second day of March instant.

Gibb's strategic decision to bring Kollmyer into the company as a partner and foreman ensured the eventual and successful transfer of the company to the next generation. As a result of Benaiah Gibb's early and careful plans, responsibility for the management of the firm returned fully to the Gibb family when his sons reached the age of majority and it would eventually pass into the hands of future generations and branches of the family. Thomas Gibb died in 1832, while still in partnership with his brothers. James Duncan Gibb withdrew from the partnership in 1841, leaving the business in the hands of the youngest son, Benaiah Gibb Jr, who retained control of the business until 1862, when it passed into the hands of James Duncan Gibb of the English branch of the family.[15]

Just prior to his death in 1826, Gibb was still instrumental in ensuring the well-being of his firm. During the general economic down-turn of 1825–6, Gibb and Co. was able to sustain losses of £1,775 in 1825, and to endorse promissory notes totalling more than £2,550 in 1826, for Gibb's son George (Thomas Gibb's twin), who was a partner in the merchant grocer firm of Ware & Gibb, which subsequently went bankrupt that same year.[16] So that Gibb and Co. did not suffer as a result of George's business and personal losses, Benaiah revised his will so that his son's debt would be paid out of his father's legacy and that he would receive only interest payments on the remaining portion of his inheritance.[17]

Building and Maintaining a Reputation

From the beginning, Benaiah Gibb cultivated the most profitable of clients – the elite of Montreal. His arrival in Montreal had coincided with the influx of a second generation of up-and-coming young merchants, tradesmen, and clerks who hoped to gain a foothold in the developing colonial economy. Although a tailor could ply his trade with little equipment or capital, Gibb's advantageous partnership with McFarlane established his capacity to attract and serve a wealthy clientele, which necessitated continued investment in a large and varied stock of high-quality fabrics, and in the case of military officers, costly military accoutrements. In addition, this clientele expected to pay on credit and Gibb would have needed sufficient capital to carry the business until the invoices were paid.

The post-mortem inventory of the tailoring shop's contents taken after Catherine's death in 1804 records literally hundreds of yards of fabric and other goods in the shop and storehouse. Included were 163 yards of 'superfine' wool fabric, the most

costly of the fabrics in stock (at 20 shillings a yard); workshop supplies such as thread, shears, and beeswax; ready-made coats and vests; a large stock of hose and gloves; and three 'mahogany travelling writing desks' at 45 shillings each. Although the conclusion to the inventory claims that the stock was of 'the greatest part consisting in remnants of pieces which would never fetch any more nor higher price,' its value totalled £1,392. 1s. 15d., a substantial investment well beyond the capacity of any but the most well-established and successful of tailoring firms.[18]

By 1804, Gibb's regular customers included the so-called merchant princes of Montreal who came to him for high-quality clothing that suited their elevated social status. Among these early clients were important figures in the fur trade, such as the founders of the North West Company, Joseph Frobisher and Simon McTavish, William McGillivray, who became the company's chief director in 1804, as well as other socially prominent Montrealers.

Tailors like Gibb, who catered to military officers, profited from the increased demand for uniforms during the War of 1812. Rank-and-file soldiers were supplied with uniforms, but officers had to supply their own. After the war, Gibb and Co. continued to stock a variety of military accoutrements required by officers, such as gold and silver braid, buttons, gold bullion epaulettes and 'other articles which will enable [Gibb] to compleat [sic] most all orders for Military Officers Dress.' Somewhat surprisingly, Gibb and Co. also sold 'Rich Gilt Sabres, according to his Majesty's late regulation for the Army.'[19] Though it would certainly have been advantageous, it is not known whether Gibb expanded his production capacity during the war in order to bid on lucrative military contracts to supply ordinary soldiers' uniforms.

Unlike the practice of the ready-made retailers, who touted 'Unparalleled Low Prices' designed to attract 'Gentlemen desirous of economizing in clothing,' Gibb and Co.'s newspaper advertisements were not calculated to lure bargain hunters.[20] Instead, they emphasized the reputation of the company and the superiority of Gibb's products, although early in the century, while in partnership with Kollmyer, Gibb was not above mentioning that 'goods having been advantageously laid in, enables them to be sold at a low rate.'[21] A mid-century newspaper advertisement for Gibb and Co.'s new premises epitomizes the delicate art of appealing to the superior tastes of the client by reminding the readers of the superiority of Gibb's establishment, the goods it had on offer, and the elevated and long-standing reputation the firm enjoyed.

The Subscribers having removed from their old place of Business, Notre Dame Street to the New and Elegant Shop adjoining the Bank of British North America, built expressly for their use, avail themselves of the occasion gratefully to acknowledge the long continued and extensive patronage of the Public, both in the city of Montreal

and throughout the Province generally. The superior accommodation of their new premises has enabled them greatly to increase their Stock of GENTLEMEN'S HABER-DASHERY, to which they invite special attendance.

Their supply of PLAIN & FANCY GOODS will be all of the best quality and of the most recent styles. In this way they hope to maintain the reputation which the Firm has had for the last 70 years for keeping the best articles, made up in the best manner.'[22]

By continuing to cultivate an elite rather than a mass market, Gibb and Co. side-stepped some of the competition from the ready-to-wear retailers. Fortunately for highly skilled tailors, the superior qualities of tailor-made clothing – perfect fit, fine fabrics, and high-quality craftsmanship – over the factory-made item were evident to anyone accustomed to wearing them. For those who could afford custom-made clothing, early ready-to-wear was notable mainly for its poor fit and construction, the hallmarks of garments produced by low-end custom tailors. The McCord Museum contains two men's garments that highlight the differences between custom-made and mass-manufactured garments. Two frock coats from the latter part of the nineteenth century, one made by Gibb and Co. and the other, bearing a Morgan label, are superficially similar in style, fabric, and colour. But the qualities that differentiate these garments become evident upon handling them. The Gibb coat is pliable, the fabric supple, and the cut elegant. On close examination, the workmanship is refined. By contrast, although Morgan professed to sell high-quality ready-to-wear goods and also operated a custom-tailoring department, its coat feels weighty and rigid and the stitching and style are strictly workmanlike and serviceable.

From its earliest days Gibb also sold ready-to-wear clothing, primarily in the haberdashery line, much of it imported from England. Invoices and inventories list a wide variety of ready-made items of this type but relatively few tailored garments. Most tailors, including Gibb, kept a few such garments on hand for clients who needed to be dressed on short notice. In 1817, for example, Gibb and Kollmyer advertised that they had 'received some Garments, from the most approved Taylor in the west of London, which are of the most recent Fashions.' Another advertisement from the same period announces that 'a few gentlemens [sic] rich trimm'd surtouts, London made coats, Vests, Webb pantaloons, & drawers, shirts & c.' are for sale.[23] Reductions for cash payments or the single prices offered as an inducement by other merchant tailors and retailers were probably not much of an incentive for Gibb's customers, who were accustomed to operating on credit, and paid their bills only when due. Gibb and Co. offered credit to new customers on the basis of reputation or personal recommendations from clients already known to the firm. Until the quality of ready-to-wear tailored clothing improved to the point that Gibb's customers were prepared to accept the

hustle and bustle of the fashionable retail establishments that offered cut-rate cash prices but little in the way of personal service, Gibb's competitors for tailored garments were likely to be other custom-tailoring firms, not ready-to-wear purveyors.

The nature of the needle trades was such that sewing machines were not an immediate threat to traditional hand skills that are used even today in the production of finely-made tailored menswear.[24] Tailors were a proud lot; they considered the fit and construction of factory-made garments to be vastly inferior to custom-fitted and hand-sewn garments. They believed machine stitching to be both inflexible and weak, making garments not only rigid and uncomfortable, but less durable as well. Even at the end of the nineteenth century, a tailoring manual claimed that by comparison with hand-sewing, machine sewing 'fails in every quality except regularity of appearance' and described in detail the repertoire of about twenty distinct hand stitches used by traditionally trained tailors, each suited to the various parts of a tailored garment, and none of which could be precisely duplicated by machine. Among these were the back-stitch (considered the most important stitch), the back-and-fore stitch, the side-stitch, the button-hole stitch, stoating or felling.[25] Traditionally trained tailors, who thought of themselves as highly skilled artisans, were slow to accept machine stitching, both in spite and because of the increased rate of production sewing machines allowed. Sewing machines that speeded up production were quickly adopted by the clothing industry, but were not perfected until the 1870s. Steam or water power, which concentrated production processes in one location, did not have much effect on the use of sewing machines, which were not only cheap and portable, but could be powered by foot or hand whether at home or in a factory setting. In some ways, mechanization was not an issue, since by expanding production, with or without the use of sewing machines, a tailor could become a 'manufacturer.' In the same way, tailors did not automatically become manufacturers simply because they used sewing machines.

Gibb's clients visited the premises to be measured carefully, to have their posture and bearing observed discreetly by a skilled tailor, to select fabrics from a range that included the finest, to choose styles based on the advice of a knowledgeable staff, and to have their clothing carefully fitted and made by tailors skilled in the traditional arts. A clientele already persuaded by the superiority of custom-made, hand-tailored garments over factory-made ones would continue to pay for them even when ready-made, machine-stitched garments in well-fitting standard sizes and of increasingly sophisticated make, became an attractive alternative.

Until the 1830s the Gibb Co. followed the usual practice of hiring journeyman tailors who were likely proficient in most, if not all, branches of the trade, including pattern-making and sewing. Apprentices were expected to learn the 'art

and mystery' of the trade under the tutelage of an experienced journeyman or master tailor, with a view to becoming independent business owners and operators themselves. It became increasingly common for apprentices to learn only the sewing side of the tailoring profession, and for tailors to be hired to sew but not to make patterns. During the period between 1820 and 1838, Gibb and Co. is known to have formally engaged four workmen and eight apprentices, but other skilled workmen were hired on a contract basis, as business demanded. In 1834 Gibb regularly advertised for 'Journeyman Taylors [sic] wanted immediately, a number of good hands to whom constant employment and good wages will be given.'[26] Presumably the foreman was to supervise the work of skilled tailors hired on a casual basis, not a number of apprentices, who earlier would have been viewed as a source of cheap labour. At one point between 1835 and 1842, Gibb and Co. hired a foreman when only one apprentice was engaged.

Dilution of the tailor's skills put individual tailors at a disadvantage. Without having mastered all branches of the trade, few of them were in a position to establish their own workshops independently, even if they had the necessary capital, unless they could also afford to hire journeymen whose skills complemented their own. From the point of view of the employer, increased specialization on the part of tailors did not necessarily translate into a diminished quality of workmanship. If anything, the more specialized the worker, the more refined the workmanship. In the context of the custom-tailoring shop, one tailor may have specialized in making coats while another exclusively made waistcoats or trousers, all with the help of less skilful apprentices or workers who basted garments or clipped threads.

The Gibb and Co. payroll records from 1865, by which time the traditional apprenticeship system was practically obsolete, show that the pay scale for fourteen salaried employees ranged from a high of $70 per month to a low of $6. The wide range of salaries reflected varying degrees of responsibility, expertise, and skill among the employees. Robert Darling, who received the highest rate of pay in 1865 ($70 per month), was made a partner in the business two years later, a relationship which lasted for the next ten years. In the hierarchy of the trade, cutters who made patterns and cut fabrics were considered the most highly skilled workers. In light of his high salary, Darling may have been a cutter or a foreman who managed the shop floor. By the 1860s, the employees receiving the lowest rates of pay would not have been apprentices, but more likely errand boys. On the payroll also were clerks who took care of the voluminous correspondence required in order to communicate with customers, collect accounts, and order goods and supplies.[27]

No documents have yet surfaced to suggest that Gibb directly hired outworkers or sub-contractors, as did the even larger ready-to-wear manufacturers, although given the large number of clients the company served and the small number of

employees on the in-house payroll, this seems plausible. Gibb and Co.'s continued dependence on the London branch of the firm and on wholesalers for a wide variety of ready-made goods would have made the need to hire local outworkers less critical to the success of the business. Gibb would have been able to supply its clientele with goods it did not have a direct hand in manufacturing. However, as the chapters by Peter Larocque and M. Elaine MacKay in this volume demonstrate, women would undoubtedly have played a significant role in the production of garments made off the premises.

Cultivation of an elite clientele involved providing more than beautifully sewn and fitted garments or a well-appointed showroom. The client expected from his tailor the degree of deference he considered appropriate to his social status, and perhaps a little flattery as well. An amusing account of a tailor's relationship with a client that is probably representative of those of the Gibb Co. are found in the letters of Juliana Ewing, the wife of a British military officer posted to Fredericton in the late 1860s.

> We had a most amusing interview yesterday with Buckmaster & Co. i.e. the head of that eminent tailor's firm, who is making a tour of Canada to get orders. He is Rex's tailor, & very thankful we were that he arrived, for R. was in sore need of some things & I grudged his getting them of the wretched tailors here. The old fellow was such a regular specimen of the army tailor. ... It was awful fun to hear him discussing one officer after another. ... 'I met Mr. Batsford just now Sir. We made for him years ago, Sir. He had on clothes, Sir – (measuring rapidly) they looked – (continuing to measure) as if they had been made by a blacksmith Sir.?!!!'[28]

The Gibb family's own rising social status likely encouraged the cultivation of an elite clientele. As Benaiah Gibb Sr's prosperity increased he gradually lost his tradesman's demeanour, disengaging himself from the tailor's workroom and joining the ranks of Montreal's prosperous shopkeeping aristocracy. His sons maintained this distance from the tailor's workshop, becoming part of Montreal's elite and rubbing shoulders in social and business settings with the same people whose business the company attracted. Gerald Tulchinsky, in his study of Montreal businessmen, mentions an incident in which Benaiah Gibb Jr, who had long since curtailed his active participation in the trade of tailoring, stood up at a public meeting with John Molson, a wealthy Montreal industrialist, to oppose the St Lawrence and Atlantic railway. At the time John Molson may not have been one of the Gibb and Co.'s clients (though his descendants numbered among them), but it would not have harmed Gibb's already respected reputation to be mentioned in the same breath as one of Montreal's most prominent entrepreneurs, despite the ridicule Molson and Gibb suffered for their stand on the issue.[29]

The firm's continued success in attracting an elite clientele is borne out by orders from such eminent customers as Lord Elgin, governor general from 1846 to 1854, Sir George Simpson, the governor of the Hudson's Bay Company from 1821 to 1860, and Sir Wilfrid Laurier, Canada's prime minister from 1896 to 1911. Gibb's claim to an elite clientele continued to climb into the twentieth century when, in 1925, the company was awarded a royal warrant and could boast of their 'appointment to his excellency the Lord Byng of Vimy,' Canada's governor general from 1921 to 1926, whose official residences were in Ottawa and Quebec City.[30]

Expanding Markets

Despite the challenges posed by transportation and communication, the firm made consistent efforts from its earliest days to diversify and expand its market far beyond the Montreal environs, responding to the demand for clothing that existed outside the major urban centres. Throughout the century many customers depended on direct written communication with Gibb rather than contact with a company agent, placing their orders by mail and, later in the century, by telegraph. Gibb advertisements in the *Montreal Herald* in 1817 and 1818 promised that 'All orders from town or country will continue to meet with the strictest attention and punctuality.'[31] Clients submitted their orders along with their measurements, sometimes on forms supplied by Gibb (see illustration 26.) Charles Oakes Ermatinger of Sault Ste Marie, a trader connected with both the North West Company and the Hudson's Bay Company, was one of Gibb's early long-distance clients.[32]

Gibb and Co.'s later expansion into provincial markets coincided with improvements in transportation and communication routes. The growth of the railway system during the1840s, concurrent improvements in the postal system, and the establishment of the telegraph allowed the company to tap into markets far beyond Montreal and accept and fill orders from provincial customers as well as from the United States. In 1852, the year after the Champlain and St Lawrence Railway connecting Montreal to New England's rail network was completed, a surprising number of orders were received from major American cities, including New York, Boston, and Philadelphia. When a Boston customer ordered a coat from Gibb in May of 1852, after the rail connection had been in operation for less than a year, he noted that 'there is so much intercourse now that no difficulty can exist for so small a package.'[33]

In an effort to further develop and serve markets outside Montreal, as early as 1848 Gibb and Co. began to send company representatives on the road. This manner of conducting a roving tailoring business was not uncommon. The familiarity of the rural population with the traditional practice of tailors travelling

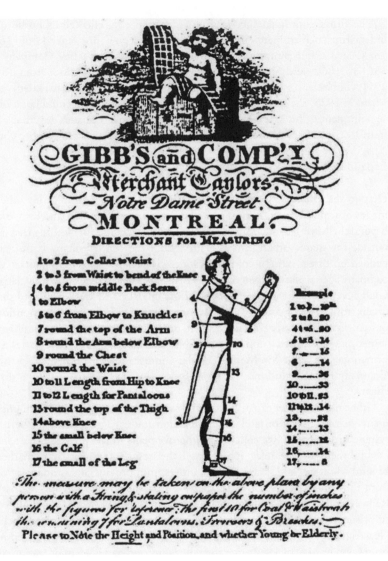

26 These elegant 'directions for measuring', dated 14 November 1827, would not have been used in professional tailoring workshops. Instead, tailors recorded the customer's measurements in a prescribed order without the benefit of a printed form. Clients from outside the Montreal area would have filled out a measurement form like this one and sent it to Gibb and Co. along with other particulars of their clothing order. (Thomas Benson Papers, Archives of Ontario)

with the tools of their trade, known as 'whipping the cat,' paved the way for more sophisticated incursions by established urban firms into the rural and small-town markets.[34] Gibb and Co. was already well known throughout Upper and Lower Canada and small-town customers were likely attracted not only by the big city prestige of the Gibb name but also by the patronage of local leading lights.

Nevertheless, despite its competitive advantages, Gibb and Co. was not without rivals for the provincial market. In the summer of 1834 Joseph Prior, 'Merchant Tailor' of Quebec, announced in the *Montreal Gazette* that he intended to conduct business in conjunction with Mr James Lane of London. The two would solicit orders for 'Ready-made wearing apparel of the first style and description from the London establishment' as well as clothes 'made-to-measure, and guaranteed to fit.'[35] At the time the advertisement appeared, Mr Lane was on his way to Upper Canada to take orders, which would be delivered in the fall. Buckmaster and Co. of London served both military and civilian clients and regularly sent representatives to solicit business in Canada. In July 1852 Buckmaster announced the 'periodical business visit to North America' of their representative and requested from their customers 'the honor of their commands.'[36]

In the spring and fall of 1852 and 1853, James Duncan Gibb made extensive journeys on behalf of Gibb and Co. through Upper Canada, soliciting new orders and collecting outstanding debts for orders taken on previous trips. His travels in the spring of 1852 extended to Buffalo, New York. Among the clients who placed orders with him in the fall of 1852 were John A. Macdonald, then a prominent young Kingston lawyer and politician, and John Counter, the mayor of Kingston.[37]

According to the correspondence, there seems little doubt that the bulk of orders recorded by J.D. Gibb on his travels were for coats, waistcoats, trousers and overcoats, made to customers' individual measurements and personal specifications, not ready-to-wear clothing. Gibb dealt directly with clients, recommending fabrics and styles. Extensive measurements were taken and recorded in prescribed order to be used by the pattern cutter in the Montreal workshop. In addition, the customer's build was described in the language of the tailor: 'high shouldered and knock kneed' or, even more descriptively, 'requires very long pitch to neck his head is very forward.' The fabrics selected for the garments were described by name: a 'rich fancy watered silk' for a waistcoat or a 'fine bottle green cloth' for a coat, while the exact fabric choice was specified by number. Some of the letters included minute drawings of garment details and described the precise requirements of fussy customers. For example, J.D. Gibb noted that one customer, a Mr Richard Miller of St Catharines, specified 'the old fashioned side pockets to his trousers that is a slit in the sideseam and not cross cut thus,' followed by a drawing no bigger than a fingernail. From Hamilton, he directed that a pair of trousers be made for another customer 'as nattily as possible he is very particular.'[38]

J.D. Gibb also sold ready-to wear clothing on his travels, primarily haberdashery. The records from 1848 and 1851 of the goods he took to Canada West included an array of shirts, collars, stocks and neckties, cambric and silk handkerchiefs, night caps, drawers, gloves, and hats, but little in the way of coats, waistcoats, or trousers. The February 1851 inventory of goods taken to Canada West did include a small assortment of ready-made frock, dress and shooting coats, fancy dressing gowns, and three dozen wrappers (a type of loose overcoat), some of them waterproof, 'sent to Toronto for Smith,' who may have been the agent for the company in that city.[39] Obviously, not all customers' needs could be satisfied with the goods J.D. Gibb carried with him. Along with the orders he took for custom-made clothing on the 1852 and 1853 journeys were orders for ready-made shirts, socks, neck cloths, hats, and other accessories.

At each stop, from Brockville to Goderich, Gibb sent the orders and accumulated payments back to Montreal by post. The completed orders were then forwarded from Montreal to the customers via various steamers, stages, and express companies. There is a constant note of irritation in J.D. Gibb's correspondence and his letters are full of complaints: the roads were poor, money impossible to collect, and previous orders were unsatisfactory or never received. But given his regular remittance of funds to Montreal, his trips must have been profitable, at least for a time, and the company continued to build up its provincial clientele.[40]

Adapting to New Demands

Among the Gibb Papers are customers' direct correspondence with Gibb and Co. for the 1852–3 period that coincided with James Duncan Gibb's trips. Some of these communications were from customers whose orders had been taken by Gibb on his journeys or from customers who had already dealt with Gibb and Co. in person while in Montreal, and for whom a record of personal measurements taken by the firm's tailors were already on file. Others were sent by customers located beyond J.D. Gibb's circuit who may not have had any previous personal contact with the company. This form of mail order did not always prove satisfactory. Just as Gibb found his trips an ordeal, a high proportion of the letters included complaints from dissatisfied customers, highlighting the difficulties inherent in doing business from a distance. Orders were misinterpreted or went missing; confusion arose regarding delivery time or destination. Complaints also arose from conflicting expectations of urban and rural clients; Mr Halliwell's lengthy tirade sent from St Catharines confirms that fashions considered stylish in urban Montreal did not necessarily suit small-town or rural life. Halliwell charged that

A Julie Papineau and her daughter Ezilda. This 1836 portrait shows sumptuous garb, once common to nobles of both sexes, but increasingly a female prerogative during the early nineteenth century. The piano further emphasizes the ornamental role now seen as the province of the lady. A matching portrait of Julie's husband, politician Louis-Joseph Papineau (not shown), presents him dressed in his black robes of office. New codes of masculinity laid stress not on a man's good breeding but his work. (Painting by Antoine Plamondon, National Gallery of Canada)

D Three hats, late 1920s: felt, velvet appliqué with metallic chain-stitch embroidery, silk lining, tip of lining printed 'Ivey. Granard Registered.' (Photographer: Harry Foster, Canadian Museum of Civilization, D-6708, D-6708, D-6717)

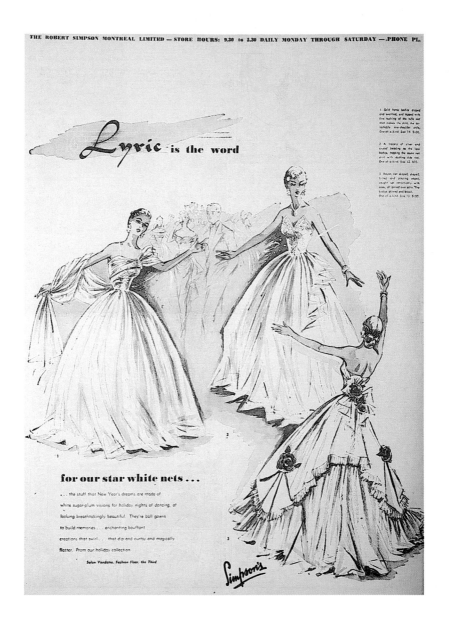

E This 1950 ad for Robert Simpson's depicts figures in the expressionist style of fashion illustration popular at the time. (Copyright and used with permission of the Hudson's Bay Company)

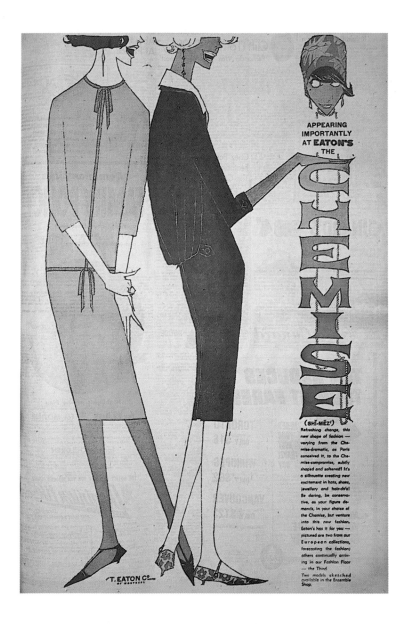

F An early award-winning fashion illustration from 1958, this ad conveys the strong sense of design and composition that would become synonymous with Eaton's 'new style.' (Used with permission, Sears Canada Inc.)

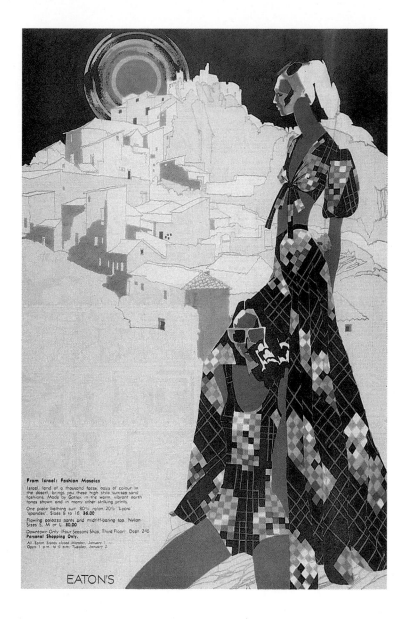

Within the advertisement image:

From Israel: Fashion Mosaics

Israel, land of a thousand faces, oasis of colour in the desert, brings you these high style sun-sea-sand fashions. Made by Gottex in the warm, vibrant earth tones shown and in many other striking prints.

One piece bathing suit 80% nylon, 20% Lycra 'spandex'. Sizes 8 to 16. **36.00**

Flowing palazzo pants and midriff-baring top. Nylon Sizes S, M or L. **80.00**

Downtown Only (Four Seasons Shop, Third Floor), Dept. 246
Personal Shopping Only.

All Eaton Stores closed Monday, January 1 —
Open 1 p.m. to 6 p.m. Tuesday, January 2

EATON'S

G Designed by art director Harriet Santroch and illustrated by Georgine Strathy, this 1972 Eaton's ad, entitled 'Fashion Mosaics,' shows the artists' clever integration of a second, smaller figure into the folds of palazzo pants. (Used with permission, Sears Canada Inc.)

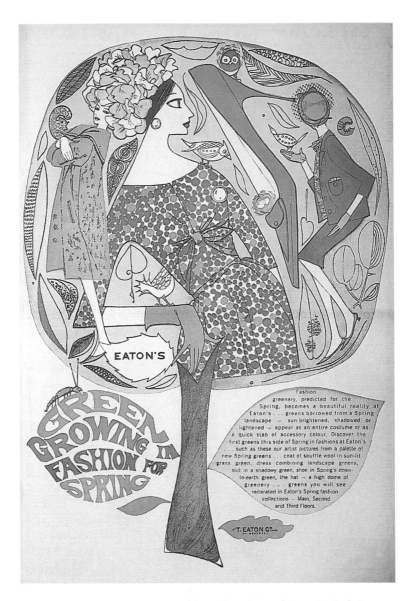

EATON'S

GREEN GROWING IN FASHION FOR SPRING

Fashion greenery, predicted for the Spring, becomes a beautiful reality at Eaton's . . . greens borrowed from a Spring landscape — sun-brightened, shadowed or lightened — appear as an entire costume or as a quick stab of accessory colour. Discover the first greens this side of Spring in fashions at Eaton's . . . such as these our artist pictures from a palette of new Spring greens . . . coat of soufflé wool in sun-lit grass green, dress combining landscape greens, suit in a shadowy green, shoe in Spring's down-to-earth green, the hat — a high dome of greenery . . . greens you will see reiterated in Eaton's Spring fashion collections — Main, Second and Third Floors.

T. EATON C°

H This whimsical 1960 image created by Jack Parker and Eugenie Groh incorporates three fashion figures into the silhouette of a tree. Note the presence of various other living creatures reminiscent of those found in the Japanese ukiyo-e. (Used with permission, Sears Canada Inc.)

the business coat does not suit me at all the collar comes too high up the neck altogether and the sleeves are half an inch too long and much too wide for one, now this is a great nuisance as should I send them back it will be a month before they are returned and I shall have to do without a coat to wear all that time, the trowsers [*sic*] I intend returning as they are made with a great *snobbish* looking stripe down the side and I told you when here that I did not want it and also that I did not wish the coat collar made so large even if it is the fashion and it is an infernal nuisance that when you deal with people 500 miles away that they will not make your clothes as they are ordered.'[41]

Among the most frequent complaints were those from customers whose clothing, when it arrived from Montreal, was found not to fit. In order to placate unhappy customers and avoid the expense of returning unsatisfactory goods to Montreal, the Gibb company made arrangements to have ill-fitting garments altered by local tailors at Gibb's expense. Although this strategy of subcontracting alterations was calculated to appease customers quickly, it could also have undermined Gibb's relationship with its long-distance customers. Already dissatisfied with Gibb's products, and in the hands of a local tailor who could demonstrate the obvious advantages of having garments made closer to home, some customers may have abandoned their mail-order relationship with Gibb or turned to the obvious alternative – ready-to-wear clothing. The continued uneasiness inherent in the firm's relationships with its competitors is confirmed in correspondence with a client during the 1870s. Gibb and Co, in response to an order by mail, warned the client that his measurements are 'to be taken by any other than a tailor as such might try to mislead us.'[42]

Success in the provincial market depended on the ability of the company to fit customers acceptably well without having the customer try on the garments, a step normally considered essential to the production of custom-made menswear. Without having the customer fitted carefully by the tailor, how could Gibb and Co. expect to satisfy a clientele paying for a made-to-measure product? Michael Zakim posits that the use of systematized pattern-drafting systems, which came into common use in the 1830s, was critical to the success of the custom-tailoring trade in its competition with ready-to-wear, especially as firms like Gibb penetrated provincial markets. Although no evidence has been found to connect Gibb directly with the use of these published systems, they are known to have been in circulation in Quebec as early as the 1830s and evidence suggests that they were used by Gibb and Co.'s competitors during the first half of the century. Although the company's continued focus was on satisfying the unique needs of individual customers, Gibb and Co. did not necessarily cling to archaic methods of production associated with artisanal practices and may well have adopted the new methods of pattern-

making. In 1837 the *Tailors' Magazine*, an American trade journal that regularly published pattern drafts for novel styles in men's garments, had reprinted, 'through the kindness of Mr. J. Prior of Quebec,' portions of *Hearn's Rudiments of Cutting*, a drafting system originally published 1819.[43] Mr Prior was likely the same Prior who had set himself up in business with Mr Lane in 1834. The *Tailors' Magazine* also listed agents for the magazine in both Upper and Lower Canada, though Gibb was not among them.

Monthly editions of *The Mirror of Fashion*, another New York tailoring periodical, also included pattern drafts for the latest styles in menswear. Its editor, Genio C. Scott, was also the co-author of his own system of pattern drafting, *A Treatise on Cutting Garments to Fit the Human Form*. In 1848 the list of Canadian agents who sold the magazine and the pattern-drafting system included Joseph Boulonget of Montreal, a tailor whose advertisements in the *Montreal Gazette* had appeared next to those of Gibb and Co. some dozen years previously.

As company records show, despite the encroachment of ready-to-wear, at mid-century Gibb and Co. was still producing custom-made clothing for hundreds of customers, many of them far from the company's workshops. The company continued on a course of expansion and contraction, opening branches and closing them in response to market demands. In 1861 efforts were made to sell Gibb and Co.'s haberdashery in Montreal, which apparently operated separately from the rest of the business. Not until 1864 is there any evidence that the company had stopped its itinerant solicitation of trade. In the meantime, a branch house was established in Toronto, possibly on the strength of the trade that had been so successfully generated during James Duncan Gibb's trips. No records have yet been located relating to operation of the Toronto branch. However, in March 1858 hundreds of letters were sent to clients informing them of the branch's closure and asking them to remit outstanding payments to the Montreal house. As yet, the reasons for the closure of the Toronto branch are not known. The company also established an agent in New York City, at least as early as 1864, who was still active in the 1890s. It is not yet known whether this agent operated continuously throughout the period.

Surviving the Challenges

During its early years, Gibb and Co. conformed to the prevalent pattern of business development in Montreal. Gibb the elder occupied a niche, and while it may have differed from that of other better-known, perhaps even more successful, early Montreal tradesmen-turned-businessmen, it was a pattern he shared with many Montreal-based entrepreneurs of the early nineteenth century. He used his family and business connections to advantage; he diversified into other profitable activities such as real estate speculation to expand his capital base; and he took

advantage of lucrative opportunities offered by the fur trade and military garrisons headquartered in Montreal during those early days of his career.

The course Benaiah Gibb set for his firm in its early days continued to play a part in subsequent generations' management of it. The company survived the nineteenth century by building on the sterling reputation of its founder. Benaiah Gibb's descendants dabbled in other enterprises and adapted to evolving business operations, but did not abandon the custom-tailoring trade upon which the original family fortune had been built. Gibb and Co. exemplifies the forgotten niche identified by Tulchinsky. Although a tailor might evolve into a businessman, the transformation did not necessarily entail a complete break from traditional artisanal production of clothing for individual clients to the manufacture of ready-to-wear based on large-scale industrial practices. There does appear to have been some middle ground. Although the traditional nature of the business probably limited the growth of the company, the niche it occupied was a profitable one. By adapting to opportunities in the marketplace and shifting to new modes of production, while retaining its original focus on custom tailoring, Gibb and Co. secured its own stability throughout the nineteenth century. In contrast to the dramatic changes that some sectors of the garment manufacturing industry under-went, and despite the far-reaching changes that the firm itself experienced, Gibb and Co.'s endurance is a tribute to the tenacity of a sector of the trade in which service to individual customers remained central to the business, and quality was as important as quantity.

NOTES

1 Burgess, 'Benaiah Gibb,' 284–5.
2 The company will be hereafter referred to as Gibb and Co. or Gibb.
3 Bliss, *Northern Enterprise: Five Centuries of Canadian Business*, 235; Davidson, 'Montreal's Dominance of the Canadian Men's Fine Clothing Industry'; Payette-Daoust, 'The Montreal Garment Industry, 1871–1901.'
4 Tulchinsky, 'Hidden among the Smokestacks.'
5 Poutanen, 'For the Benefit of the Master.'
6 Michael Zakim, 'Customizing the Industrial Revolution,' 41.
7 Lewis, *Manufacturing Montreal*, 71.
8 Archives Nationales du Québec-Montréal (ANQ-M), Delisle NP, #4569 'Inventory of the property belonging to the community between Benaiah Gibb and his late wife, Catherine Campbell,' 24 April 1804.
9 McCord Museum Archives, McCord Museum of Canadian History (McCMA), Gibb papers, #201, #362, #601, letter to Sir James Elphinstone in Aberdeenshire, Scot-land, 1 July 1864.

10 ANQ-M, Beek #680. Dissolution of copartnership between Peter McFarlane and Benaiah Gibb, 26 January 1791; ibid., #82. 'Peter McFarlane and Beniah Gibb. Articles of copartnership for three years,' July 10, 1784.

11 Ibid., #980. 'Benaiah Gibb and Thomas H. Prior, Merchant Tailors, Articles of Coppartnership,' July 1795; ibid., #1142, 'Benaiah Gibb to Thomas Hill Prior, Notice of the Dissolution of the Partnership of Gibb & Prior,' 2 June 1797; ibid., #1157, 'Benaiah Gibb and Thomas H. Prior late Copartners in Trade under the Firm of Gibb and Prior, Agreement of the Dissolution of the said Copartnership,' 31 July 1797.

12 ANQ-M, Gray NP, 'Articles of Apprenticeship, Joseph S. Kollmyer to Benaiah Gibb,' 30 July 1802.

13 ANQ-M, Griffon NP, #986. Articles of Copartnership agreement between Thomas Gibb, James Duncan Gibb and Joseph S. Kollmyer under the firm of Gibb and Kollmyer, 25 May 1815.

14 McCMA, Gibb Papers, #201.

15 Meng, 'The Gibb Family: A General History, 1774–1877,' 30.

16 McCMA, Gibb Papers, #111.

17 Poutanen, 'For the Benefit of the Master,' 63.

18 ANQ-M, Delisle, NP #4569.

19 *Montreal Herald,* 15 June 1815; 17 July, 1819; 4 November 1820; 19 June 1822.

20 *Morning Chronicle,* September 1848.

21 *Montreal Herald,* 2 November 1816.

22 *The Pilot,* 18 April 1854.

23 *Montreal Herald,* 4 November 1820, 15 June 1815.

24 Thanks to Mr Michael Samuelson of Samuelsohn Ltd. of Montreal, manufacturer of high-quality hand-tailored men's made-to-measure and ready-to-wear clothing, for a tour of his premises.

25 Williamson, *Garment Making,* 16.

26 *Montreal Gazette,* 27 May 1834.

27 McCMA, Gibb Papers, #369.

28 Blom and Blom, *Canada Home,* 202.

29 Tulchinsky, *The River Barons,* 160. Benaiah Jr was also secretary and treasurer of Montreal's prestigious Turf Club in 1851. He is probably best known for his partici-pation in the founding of the Montreal Arts Association, later donating the site of the present-day Montreal Museum of Fine Arts (Gibb papers, #254, 360, 422m 424).

30 The royal warrant appears on a handkerchief (M991.35.1) in the collection of the McCord Museum printed by the firm to commemorate its 150th anniversary in 1925.

31 *Montreal Herald,* 21 June 1817, 21 February 1818.

32 Reid, *Mansion in the Wilderness,* 7. Among Ermatinger's papers are invoices from the Gibb Co. for the period between 1808 and 1823, while Ermatinger was living in

Sault Ste Marie. He likely continued as a client of the company after he retired to Montreal in 1828.

33 McCMA, Gibb Papers, #386, #387, #395.

34 S.S. Rathvon, 'Technical Terms of Tailoring,' in *The American Tailor and Cutter* (New York: Jno. J. Mitchell Co.), November 1899, 111. 'Cat-Whipping is said to be an itinerant kind of tailoring, in which the "crook," with his journeymen and apprentices, goes from house to house, especially in the rural districts, and cuts out and makes up the farmers' or mechanics' home-made webs of cloth or Linsey woolsey into clothing for the head of the house and his sons. November and December, and March and April, were principally the months in which the cat-whipper found his chief employment. Cat-whipping was looked forward to with lively anticipations, especially by the apprentices, for it was to them a season of sumptuous feeding. As the customer boarded and lodged the master and his men while employed in his service, the master was exonerated from the expenses of boarding, lodging, and additional light and fuel at home, and therefore, although his wages may have been small, yet all he made was clear gain.' In the same dictionary of terms, 'crook' is defined as a 'pure tailorism,' and means a practical tailor in the trade.

35 *Montreal Gazette*, 17 June 1834

36 *Morning Chronicle*, July 1852.

37 McCMA, Gibb Papers, #386.

38 Ibid., #392, letter from James Duncan to Gibb to Gibb and Co., Montreal from Hamilton, 6 April 1852; letter from James Duncan Gibb to Gibb and Co., Montreal from Chippewa, 27 March 1852; letter from James Duncan Gibb to Gibb and Co., Montreal. Order for Mr O'Brien of Hamilton, 5 April 1852; letter from James Duncan Gibb to Gibb and Co., Montreal. Order for Mr Alexander Kirkpatrick of Chippewa, 27 March 1852; letter from James Duncan Gibb to Gibb and Co. Montreal, from St Catharines, 29 March 1852; and letter from James Duncan Gibb to Gibb and Co. from Hamilton, 5 April 1852.

39 Ibid., #362.

40 Ibid., #386, #387, #392.

41 Ibid., #429, letter from Mr Halliwell of St Catharines to Gibb and Co., 18 September 1853.

42 Ibid., #605, Letterbook, 7 October 1875.

43 *Tailors' Magazine*, January, February, and March, vol. 2, no. 5., 1837 (Thos. P. Williams & Co., New York).

SELECTED BIBLIOGRAPHY

Bliss, Michael. *Northern Enterprise: Five Centuries of Canadian Business.* Toronto: McClelland and Stewart, 1987.

Blom, Margaret Howard and Thomas E. Blom. *Canada Home: Juliana Horatia Ewing's Fredericton Letters, 1967–1969*. Vancouver: University of British Columbia Press, 1983.

Burgess, Joanne. 'Benaiah Gibb,' *Dictionary of Canadian Biography*. Volume 6. Toronto: University of Toronto Press, 1987.

Davidson, N. Maurice. 'Montreal's Dominance of the Canadian Men's Fine Clothing Industry.' MA thesis, University of Western Ontario, 1969.

Fraser, Steven. 'Combined and Uneven Development in the Men's Clothing Industry.' In *Business History Review*, 57, no. 4 (1983): 522–48.

Lewis, Robert. *Manufacturing Montreal: The Making of an Industrial Landscape, 1850–1930*. Baltimore: Johns Hopkins University Press, 2000.

Meng, Mark. 'The Gibb Family: A General History, 1774–1877.' Unpublished paper, McGill University, 1994.

Palmer, Alexandra. 'Lloyd Bros. Ltd.: Custom Tailors.' *Ars Textrina* 10 (December 1988): 167–91.

Payette-Daoust, Michelle. 'The Montreal Garment Industry, 1871–1901.' MA thesis, McGill University, 1986.

Poutanen, Mary Anne. 'For the Benefit of the Master: The Montreal Needle Trades during the Transition, 1820–1842.' M.A. thesis, McGill University, 1985.

Reid, C.S. *Mansion in the Wilderness: The Archaeology of the Ermatinger House*. Toronto: Ontario Ministry of Culture and Recreation, Historical Research and Planning Branch, 1977.

Roy, Catherine L. 'The Tailoring Trade, 1800–1920: Including an Analysis of Pattern Drafting Systems and an Examination of the Trade in Canada.' M.Sc. thesis, University of Alberta, 1990.

Tulchinsky, Gerald. 'Hidden Among the Smokestacks: Toronto's Clothing Industry, 1871–1901.' Pp. 258–84 in *Old Ontario: Essays in Honour of J.M.S. Careless*, ed. David Keane and Colin Read. Toronto: Dundurn Press, 1990.

– *The River Barons: Montreal Businessmen and the Growth of Industry and Transportation, 1837–1853*. Toronto: University of Toronto Press, 1977.

Williamson, John J. *Garment Making: A Treatise Embracing the Whole Subject of Practical Tailoring*. London: John Williamson Co. [1887].

Zakim, Michael. 'Customizing the Industrial Revolution: The Reinvention of Tailoring in the Nineteenth Century.' *Winterthur Portfolio*, 33, no. 1 (1988): 41–58.

Montreal's Fashion Mile: St Catherine Street, 1890–1930

ELIZABETH SIFTON

> This street is becoming the great business center of the city ... immense business stores
> rear their heads ... The English Cathedral was the first large structure erected and now
> it is difficult to count the number of grand stores, churches, dwellings, theaters and
> other places over its whole length.[1]

These words were written in 1897, as merchants moved to St Catherine Street
transforming it from a street where residences, churches, and small businesses
existed side by side into what was to become Montreal's leading retail artery. In the
late nineteenth century, Montreal's major retailers were Henry Morgan, John
Murphy, Samuel Carsley, James A. Ogilvy, and Henry Birks. Their stores were in
the long-established commercial area, centred on Notre Dame and St James
streets. This area was near the busy harbour and prone to spring flooding, its streets
were narrow, noisy, dirty, and crowded with traffic, and it was no longer a pleasant
environment for shoppers. In 1891 Henry Morgan, acknowledged as the city's
leading retailer, led the move uptown, to a palatial new building more suitable to
the fine imported merchandise for which his store, Colonial House, was famous.
Within a few years, the major retailers and most specialty shops had relocated to
new premises along St Catherine Street, creating the fashion mile where Montrealers
shopped for the next sixty years. Within the next decade, most of these stores
underwent more transformations, both physical expansions and changes of mer-
chandising strategy, keeping pace with retailing trends in the United States and
Europe. Advertising, too, was in a period of change and development. Nineteenth-
century advertisements were factual, detailing the arrival of imported merchandise
for the coming season, and politely requesting the ladies of the city to favour
the merchants with their trade. In the twentieth century the merchant took on the
role of fashion director – for example, the customer was invited to select her
wardrobe where 'a Parisienne of discriminating taste caters to the woman who

would make of her toilette a subtle harmony.'[2] Stores also offered new services, entertainments, and restaurants where shoppers could meet for lunch, hear informal concerts, and see fashion shows.

The creation of Montreal's fashion mile will be documented by excerpts from newspaper advertisements published for the major Montreal retailers. From these advertisements we learn about the development of the Montreal department stores, and about the evolution of fashion retailing. The newspaper advertisements are as close as we can get to interviewing those bygone merchants.[3]

From its founding in 1643 until the early years of the nineteenth century, Montreal was a small, fortified settlement nestled at the edge of the St Lawrence River. Both life and commerce were concentrated at the harbour, where ships with essential manufactured goods from Europe off-loaded their cargoes into the riverfront stone warehouses. Both wholesale and retail trade was carried on in these warehouses, a single counter being adequate to serve the local retail trade. As the city grew in population, it expanded beyond the city walls, which were finally demolished in the 1820s. Retail activity moved away from the harbour front and relocated along Notre Dame Street. In 1839, a proud Montrealer compared this new retail area to the old : 'The modern shops ... are much better furnished with windows giving every facility for the exposure of articles intended for sale. A great number of the shops are elegantly, and some of them splendidly fitted up.'[4]

Commercial activity spread beyond the confines of the harbourfront, and the desirable residential areas moved up towards Mount Royal. While the dwellings of the labourers remained clustered around the river front, comfortable greystone houses, occupied by the middle class, appeared on the streets at the crest of Beaver Hall Hill, and spacious new homes with large properties were built along Sherbrooke Street. During the final decades of the nineteenth century, the southern flank of Mount Royal became the favoured location for the opulent mansions built by the wealthy industrialists and financiers who controlled most of the capital of the new dominion. The affluent lifestyle and glittering social activities of these favoured few earned this area the name 'The Golden Square Mile.'

In the early years after its founding, Montreal's retail trade supplied only the necessities of life, but soon fashionable goods and luxury products were imported to supply the demand of the growing population. The arrival of the year's first ships, usually in May, was eagerly awaited, as much for the season's new fashion fabrics and accessories as for essential manufactured goods. Shortly after he opened his first store in 1845, Henry Morgan wrote to his brother in Scotland, asking him to select only the season's most fashionable goods for the store's stock: given 'our proximity to the United States, where neatness of dress is proverbial and from whence new fashions are continually coming in, it requires good taste to select for our market.'[5] Montrealers may have been remote from the fashion centres of

Europe, but they made every effort to remain au courant. Many buildings specifically designed as retail stores were constructed along Notre Dame Street as the city expanded. A visitor to Montreal in the 1860s described Notre Dame as 'flashing with plate glass and displays of jewellery and brocade.'[6] By the late 1880s, however, these palatial store buildings had become cramped, difficult to alter, and impossible to expand. Contemporary photographs of this area show the narrow sidewalks and the congestion of commercial traffic. It was no longer an atmosphere pleasant enough to encourage women to linger over their shopping. In 1891 this changed when the Henry Morgan Company relocated to St Catherine Street.

Henry Morgan had established his first shop on Notre Dame Street in 1845, and as his business grew he moved and expanded his premises at least twice. In 1866 he constructed a large store on St James Street at Victoria Square. This store, described as a 'solid and substantial business structure,' was too small by the late 1880s to accommodate its ever-widening variety of merchandise.[7] Increasingly, stores were expected to offer their goods in an atmosphere of opulence and luxury, with modern conveniences such as elevators and rest rooms. Dry-goods retailing was changing, and no one knew it better than Morgan's nephews, James Jr and Colin, who had been made partners in the business in 1877. Colin brought with him retail experience gained at Swan and Edgar's in London, and James had an insider's knowledge of Montreal society. The new partners instituted a department system whereby individual managers had the responsibility for inventory, sales, and profits of groups of related merchandise. These managers were accountable to Colin and James and, through them, to Henry Morgan. This was a new concept in merchandising and it put the firm in a position to further develop its merchandise assortment.

The site selected for the new store was on St Catherine Street at Phillips Square, an area still considered residential. Many Montrealers were shocked: the store would be immediately to the east of Christ Church Cathedral, facing Phillips Square, which was a grassy park, and on nearby Sherbrooke Street were the large homes of well-to-do Montrealers. However, there was already commercial activity along St Catherine Street. Lovell's 1895 City Directory lists a variety of small shops and businesses among the residential addresses in this area. To the west of the cathedral, on the site of the present Eaton building, was the Queen's Block, housing a theatre, and W.H. Scroggie's dry-goods store. When the project was announced, an architect's sketch published in the *Montreal Daily Star* gave some tantalizing preliminary information about the new store, which was to be three and a half times larger than the old store (illustration 27). Projected to cost between $350,000 and $400,000, the structure was to be constructed of imported Northumberland red sandstone, its architecture echoing that of Renaissance palaces. Noteworthy were the seven large plate-glass show windows, twenty-two

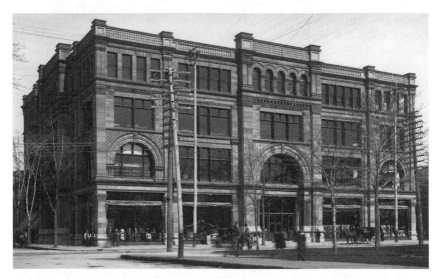

27 Henry Morgan's Colonial House, the first major department store on St Catherine Street. Opened in 1891, its dignified red sandstone façade is still an imposing presence. Since the early 1970s it has been the Hudson's Bay Company. (View-2540, Notman Photographic Archives, McCord Museum of Canadian History, Montreal)

feet in width, the passenger elevators, and the 'ladies parlor.' A central lightwell would give illumination to the interior of the building, and electric light was to be provided by the firm's own generator.[8] This building had within its impressive architecture all the features of nineteenth century Palaces of Commerce. The inclusion of electricity was innovative and forward-looking.[9]

Colonial House opened on 21 April 1891, and newspapers were immediately lavish in their praise. 'A Dry Goods Palace,' said the *Montreal Gazette*; 'A Palatial Store' was the headline of *Montreal Star* article, which commented on 'the sight-seeing and purchasing public ... [that] ... thronged the building all day long ... wandering at their leisure through ... an endless variety of beautiful goods.'[10] The *Gazette* was impressed by 'the light well extending from the roof to the ground floor [which] imparts a cheerful appearance to everything and from the upper floors one can enjoy a fine view of all going on below.' Both articles commented on the novel system by which cash was conveyed to the main cashier's office in metal containers which travelled on an overhead system of cables operated by an electric motor. One writer commented that the system was as intriguing to men as it was to little boys. Again Morgan's was a leader: the use of electricity as a source of

power as well as of illumination was innovative – in fact, the first efficient electric motor had been patented by Nikola Tesla only two years earlier in 1889.

Another feature which warranted comment were the fitting rooms for the selection of evening gowns; these were lighted only by electricity so that the customer could determine the effect of artificial illumination on colour. During the opening week, Morgan's kept their new building 'lighted up ... that the public may see what we are doing.'[11] Clearly Morgan wanted the new store to be seen as more than a source of a wide variety of fine merchandise. The building itself provided the customers with facilities and luxuries on a scale that had not been previously seen in Montreal. Shopping as a pleasurable activity was encouraged by such welcoming surroundings.

As part of establishing the new store, Morgan's broadened its assortment of goods to include new merchandise lines. An advertisement in the *Gazette* reads 'we feel justified in stating that our Present Stock is not surpassed in Richness and Variety by that of any single Dry Goods House in the Dominion.'[12] The advertisement then lists the usual repertoire of dress goods, silks, satins, shawls, ladies' dressmaking and fashion accessories; it also proudly describes the 'departments which have only been added to our list at the Present Time ... everything being in the Latest Style and Best Quality.' These new departments included Furniture, China and Glassware, Boots and Shoes ('The best American Make'), Books and Stationery, and Ready-Made Clothing for youths and boys. Thus Colonial House, having set a precedent in terms of location, was preparing to offer its customers an assortment of quality merchandise unequalled by any other merchant in Montreal. The *Gazette* article concluded by quoting a visitor from New York who 'expressed the opinion that there was nothing in Gotham to equal Messrs Morgan's new store, except perhaps A.T. Stewart's.' This might be considered a back-handed compliment, since the Stewart store was already thirty years old, but it demonstrated that Stewart had been a leader, well ahead of his competition, and that his customers remained loyal and appreciative.

Following Morgan's move, the retail trade gradually moved uptown, leaving St James Street to become the financial heart of Canada and the site of many new bank and insurance buildings. There was also much construction activity along St Catherine Street as retailers competed for good sites on this street. Of particular importance was the new store of Henry Birks and Sons, jewellers and silversmiths. Located on the west side of Phillips Square, it was a close neighbour of Colonial House, as it had been on St James Street. Designed by the noted Montreal architect, Edward Maxwell, the elegant and imposing building was 'Renaissance in feeling ... of buff coloured Miramichi sandstone, the trimmings and cornices being richly carved,' Birks's store occupied the ground floor and part of the second floor of the five-storey building, while the rest of the building was rented out as office

space. The new store opened with little fanfare on 10 May 1894. A very small advertisement in the *Star* stated simply 'Henry Birks and Sons Have Removed to their new building ... the public are cordially invited to inspect – without any intention to purchase.'[13]

In 1894 John Murphy, whose dry-goods store was established in 1869, announced the relocation of his store to St Catherine Street, citing 'a desire on the part of the public for an "uptown" movement. Convenience demands it and common sense endorses the claim ... that is why we are moving up.' Murphy's new building was described as 'Byzantine in general design, and massive and substantial in structure ... the five stories and the basement will be light and airy, magnificently upholstered and beautifully finished and fitted up in every detail ... as well as equipped with the latest facilities for the dispatch of business.'[14] Murphy achieved a public relations coup within a week of opening his new store when the Countess of Aberdeen, wife of Canada's governor general, opened the special shop sponsored by the Irish Industries Association, which promoted the cottage industry of hand-made laces, linens, and tweeds. The event was 'like a society function, Montreal ladies ... attend in large numbers.' Following the speeches of the dignitaries, the countess went behind the counter, 'acting the saleswoman for an hour or so.' This action would have entailed no loss of dignity for Lady Aberdeen, who, by all accounts, was a woman of great energy with a well-developed sense of humour; rather, it would have enhanced, even briefly, the status of the Murphy saleswomen. The countess also purchased a 'magnificently rich garment' in the store's Mantle Department, a fact that was exploited in an advertisement, which emphasized both the fashionable assortment and the good values offered by Murphy's.[15]

The last major retailer to move to St Catherine Street in the 1890s was James A. Ogilvy. Founded in 1866, his store had an established reputation for fine quality household linens and dress goods. The description accompanying the architect's sketch of the new store was very detailed, including technical references and tantalizing information about the 'modern dry goods building, having every device known at the present time for the convenience of the public, the comfort of employees and economy in time.' The impressive exterior was of granite, with ornamental carving in 'the Renaissance style,' and plate-glass show windows lining both street façades. A light well opened up the centre of the building from the roof to the ground floor, and 'around this well on each floor there will be an ornamental guard railing for exhibiting hanging goods of every description.'[16] The light well had become a focal point as merchants realized the dramatic possibilities of staging merchandise displays which were visible from many locations within the store. An additional convenience that Ogilvy planned for his customers was a 'ladies' sitting room ... furnished with writing tables and chairs, complete with electric heating apparatus, and detailed throughout in cherrywood with Italian Renaissance deco-

ration.' By providing conveniences and luxuries not generally available in every household, merchants not only welcomed their customers as if into their own homes, but ensured that the customers would be relaxed and comfortable, thus encouraging them to linger longer in the store.

When Ogilvy opened his St Catherine Street store in early September of 1896, he immediately made a statement regarding his merchandising policy. In contrast to Morgan's, who five years earlier had expanded their assortment of goods, Ogilvy announced: 'We came up to St. Catherine Street and mean business – a Dry Goods Business – only Dry Goods. A number of persons have asked us if we are going into departmental store work. This we have positively refused to do. Our business is dry goods.'[17] The location selected by Ogilvy would prove to be the western limit of the fashionable shopping mile of St Catherine Street, as the eastern limit was at Phillips Square.

Within a few years of Morgan's move uptown in 1891, the old retail area of Notre Dame Street had lost all its major merchants except one – Samuel Carsley. Carsley had expanded his original 1872 shop by taking over adjacent properties until his store was the length of a city block. While expanding, Carsley tried to keep pace with the customer services offered by the St Catherine Street merchants. 'Every Comfort to make Shopping a Pleasure, Ladies' Dressing Room, Refreshments and Reading Rooms, Waiting Gallery to Meet Friends, Telephones, etc ...' reads one 1895 advertisement. Carsley frequently referred to his store as the 'Universal Provider' of Montreal, so vast was the merchandise assortment it offered.[18] However, a comparison of the Carsley's merchandise assortment with those of other Montreal merchants during this decade conveys the impression that this was a big general store, with a vast conglomeration of merchandise. At Carsley's, 'Opera Cloaks received from Europe' could vie for attention in the same advertisement as 'The Electric Health Shoe ... with a battery in the sole ... if the current is maintained ... it is impossible to catch cold.'[19] As his neighbouring retailers moved, Carsley kept up a stubborn advertising campaign with the continuing theme 'It is well known that Ladies do not like shopping at stores immediately in the neighbourhood of their residences.'[20]

> Why will ladies go to Wanamakers? Why will ladies go to Whiteley's? Why will ladies go to Au Bon Marché in Paris, not because the stores are situated on the fashionable promenade streets, or handy near their homes ... for this reason – that the largest and best assorted stocks are found there ... for that same reason they come to Carsley's.[21]

In this comparison, Carsley ignored the fact that William Whiteley established his London store in 1866 in a location convenient to a newly developing residential area, but as this area became rundown in the late nineteenth century, his business

faltered. Carsley also ignored the fact that in New York City, the fashionable shopping area was shifting uptown along Fifth Avenue from Fourteenth Street to Thirty-Fourth Street and beyond, closely following the development of new residential areas.

Carsley kept emphasizing that his store's assortment included more and more fashionable and quality goods, but it would seem that Carsley's was attempting to be all things to all people, a dangerous concept in merchandising. Finally, in April 1906, more than a decade after the retail heart of Montreal had moved uptown, Carsley's announced the purchase of a property on St Catherine Street for a forthcoming move. Carsley's purchase included adjacent properties in order to provide for future expansion and renovation. The major tenant at this location was W.H. Scroggie, a dry-goods retailer, who had been at this site since the late 1880s. However, Scroggie's lease was in force until May 1910, so Carsley's had to be content with maintaining their business at the Notre Dame Street location while publishing artists' sketches of the planned St Catherine Street building.[22]

By 1900 St Catherine Street was well established as *the* retail shopping street of Montreal; the handsome buildings of Colonial House, Henry Birks's, John Murphy's, and James Ogilvy's were strategically spaced along this new retail mile. Between these stores, on both sides of the street, was a variety of smaller businesses, many of which had also been part of the uptown move. These smaller stores included the dry-goods merchants Henry and N.E. Hamilton, R.J. Tooke, a quality haber-dasher, and the Paris Kid Glove Store. There were also some newcomers to the Montreal retail scene, among them Fairweathers, that opened a shop near Peel Street in 1910, and Holt Renfrew in a location near McGill College Avenue.

The early years of the twentieth century saw a number of major changes in merchandising direction and management in Montreal stores, as the first genera-tion of department store merchants disappeared from the scene. Henry Morgan and his brother James had died within a few months of each other in 1893, leaving Colonial House under the creative direction of Colin Morgan and his cousin James. John Murphy retired in 1905 when he sold the controlling interest in his business to the Robert Simpson Company. In 1908 Samuel Carsley died suddenly, leaving his merchandising empire to his sons, and James Ogilvy died in 1911. Morgan's and Ogilvy's, under continuing family management, grew and strength-ened their positions as quality fashion stores, and they would continue as such until the middle of the twentieth century. Henry Birks, with the active involve-ment of his sons, continued to enhance the reputation of his jewellery store in Montreal and across Canada. By 1910, however, dramatic changes at Murphy's and Carsley's redefined fashion retailing in Montreal. These two stores changed from what were, in reality, large general stores with diffuse and ill-defined stock assortments into stores with clear merchandising strategies which emphasized

fashion in moderate and better-priced ranges, offering assortments which would complement those of Colonial House, where the appeal continued to emphasize higher-priced goods.

The Robert Simpson Company of Toronto acquired control of the John Murphy Company in February 1905, but the Murphy name remained on the store and in the advertisements for some years, giving a feeling of familiarity and continuity in spite of the major changes to come. The new direction in management and merchandising was immediately evident. In the advertisement that announced the retirement of John Murphy, the new management also stated that 'There is room in Montreal for a store devoted exclusively to women's needs, and with this in mind ... we must at once clear out all the Crockery, Tinware, Hardware, Gent's Furnishings and Men's Clothing.' Throughout February, Murphy advertisements kept offering bargains on all lines throughout the store, while frequently hinting at better things to come. 'Our policy of nothing but new goods for spring makes it necessary for us to offer nearly all the goods we have in now at prices very, very much less than you have been accustomed.'[23] Soon the Murphy advertisements took on a new look. Each had a single fashion message, and featured a charming fashion illustration. For example, in March 1905, a 'Talk on Dress' is particularly lavish in describing the store's new merchandise assortment:

> We have imported some of the newest and most exquisite frocks and wraps made by Beer, Callot Soeurs, Redfern, Doeuillet and others ... The head of our Dressmaking Department [has been the] première couturière with Laferrière ... We promise to supply our patrons with the most exclusive style not later than fifteen days after it makes its first appearance in Paris.[24]

The promise to supply the latest fashions from the leading couture houses of Paris was a bold step and helped to establish Murphy's as an important fashion retailer in Montreal. There had been no previous indication in the store's advertisements that its buyers were in a position to offer such merchandise to their customers. There is rarely any direct reference to the Robert Simpson Company in any of these Murphy advertisements, but the change in them is so dramatic that the influence of the Simpson buying organization is evident. Indeed, Murphy advertisements take on the style of Simpson advertisements published in Toronto at the same time. One of the few times the two names are linked is in a January 1909 advertisement featuring a special purchase of white wear (ladies' underwear and sleepwear): 'Purchasing Power brings prices down ... The Robert Simpson Company Limited of Toronto, and the John Murphy Company, Limited of Montreal are organically the same. We are one. The purchasing power is ours.'[25]

The change to an emphasis on fashion merchandising seems to have had the

desired result for Murphy's. Sales improved to such an extent that in April 1909, they announced the start of construction to 'double the store in size, and duplicate our present premises.' The general manager of Murphy's during this time was W.H. Goodwin, who had been transferred from Simpson's in Toronto. An established retail executive, Goodwin's prior experience had also included a period as manager of the advertising department of the T. Eaton Company. By 1911, when Goodwin left Murphy's, the store had taken on a completely different personality and vitality. The store building had doubled in size, and the sales reportedly had tripled in volume. W.H. Goodwin had made an impact on Montreal's retail scene, he would soon put his creative talents to work in developing another fashionable department store.

The changes at Carsley's were much more complex. Although Carsley had purchased the property at the corner of University Street in 1906, W.H. Scroggie was to remain there as tenant until May 1910. Four years is a long time in the retail business, and Carsley's must have become impatient. In April 1909 they announced their imminent arrival on St Catherine Street: 'Our uptown store will open with an entire new stock of merchandise.' In spite of optimistic statements, the opening was not achieved without some major disturbances. Scroggie's refused to vacate the premises, and had to be evicted by force. Grudgingly, they moved their business west along St Catherine Street to a store vacated by another retailer, the Henry and N.E. Hamilton Co. Scroggie's advertisements of early May 1909 give a step-by-step description of their move with a number of spiteful allusions to Carsley's. Samuel Carsley seems to have had a long-standing vendetta with a number of his competitors. He regularly used his advertisements to criticize the practices of commerce in general and other retailers in particular; in fact, many of the 'Carsley Columns' contain more indignant editorial comment than merchandise offering.[26]

It was Carsley's stated intention to maintain 'Two Separate and Distinct Stores,' with the uptown store carrying 'all classes and qualities of merchandise from the medium up to the very best, supplying everything required in everyday life.' Carsley's-Uptown opened to the public on 2 June 1909. The merchandise featured in the opening advertisements cannot be called very enticing, surely only a naive customer would have been attracted by featured specials such as 'Gentlemen's Dollar watches at 79 cents ... only 50 can benefit from this offer.'[27] It would seem that Carsley's aggressive, if irascible, spirit had died the previous fall with Samuel Carsley Sr. Indeed, only three months after arriving on St Catherine Street, when other stores were advertising their new fall assortments, the Carsley name suddenly disappeared from the Montreal retail scene. The company, comprising the uptown building, the merchandise in both uptown and downtown locations, and the 'goodwill of the Carsley business' had been purchased by a syndicate headed by A.E. Rea, a Toronto whitewear manufacturer.[28] During September, Carsley adver-

tisements featured only merchandise clearances, and at the end of the month both uptown and downtown stores closed for stocktaking. When the St Catherine Street location reopened, it was as the A.E. Rea Company. For the month of October the advertisements continued to feature clearances of Carsley stock of every description. One advertisement read in part: 'The Price-cutting knife has been in every Department. Never before in the history of Canadian retailing have such remarkable reductions been made on high-grade seasonable merchandise.'[29] This advertisement puts a positive spin on what must have been the daunting task of clearing out the massive accumulation of Carsley merchandise, much of it, one suspects, quite out of date.

Gradually the Rea advertisements began to feature new, fashionable merchandise. In November, Rea's proudly announced. 'This morning two of our buyers sailed in on the R.M.S. Corsican. One goes to London, the other to Paris – to keep in touch with the happenings at Fashion Centers.' By January 1910, Rea's seemed to offer an appealing variety of well-priced fashion goods, as well as large-scale promotions such as a 'White Sale ... the result of concentrated effort, judicious planning, and forethought of a two million dollar corporation.'[30] Rea's also renovated and expanded its building, possibly implementing the plans that had been previously made by Carsley's, in September 1910 they opened a portion of the new building. With up-to-the-minute information from European fashion centers, expanding premises, and substantial financial backing, Rea's seemed to be positioning itself as a full-line department store featuring fashions in middle price ranges. In their basement Rea's opened 'Sample City.' Organized like a large bazaar, Sample City housed booths where manufacturers demonstrated their products, giving the customers information, and in some cases free samples. A March 1911 advertisement lists over thirty companies there, among them McLaren Imperial Cheese, Imperial Oil, Berliner Gram-o-phone, Canadian Shredded Wheat, Jell-O and Bell Telephone. An additional feature was regular live entertainment featuring the Sample City Orchestra, with invited guest artists such as the 'Psychic Demonstrator Angell' and the popular local pianist, Billy Eckstein. A visit to Rea's Sample City could be both informative and entertaining.

However, customers soon had to adjust to the arrival of yet another retailer at this location. In April 1911 the announcement that

> a new store, under a new name, will formally, and we trust completely pass into the possession of the Montreal public ... 'The New Store' is to be a new possession ... to which every Montrealer may point with pride and say 'That's Ours.' It is to be a new influence that shall work to the all-round advantage of all those whom it touches ... 'The New Store' to be known hereafter as Goodwin's Limited (owning and operating A.E. Rea & Co.).[31]

Describing the beauty, comfort, and service to be enjoyed by the customer in the new store, the advertisement read: 'All yours. ... Retiring Rooms, Rest Rooms and Silence Rooms in a fire-proof building, with a new staff, new Directors and new ideas. You will wonder when you really learn all that has been done solely for your comfort and safety.' As previously noted, W. H. Goodwin came to Montreal as a Simpson executive in 1905 when that company took over Murphy's. The burst of civic chauvinism evident in this announcement probably served two purposes: to excite customers at the prospect of a new fashion store, and to give notice to Simpson's that there was a lively new competitor on St Catherine Street. Goodwin's advertisements immediately emphasized higher-priced fashions, noting that 'the new French Room [has] a very large assemblage of Paris Frocks, Robes, Gowns and Dress Novelties.' An early September advertisement featured sketches of a suit by Paquin at $125 and more moderately priced ensembles styled by Drecoll and Poiret. 'Goodwin's have searched the Old World and America for the models of the hour and Goodwin's have succeeded in securing them.'[32] At this time, the couture houses of Paquin and Drecoll were among the most important in Paris. They had established reputations for elegant fashions, and their clients were from the wealthiest families of Europe and the United States. Paul Poiret, on the other hand, had broken with the tradition of the elaborate costume, offering his clients sleek linear designs embellished with many subtle details. His colour palette emphasized primary colours, frequently in startling combinations. He also claimed to have freed women from the tyranny of the corset. Goodwin's reference to Poiret's designs indicated that the store intended to have a contemporary fashion appeal. The retail location at St Catherine and University streets was now occupied by a merchant whose name would become familiar to a new generation of Montreal shoppers.

In April 1912 Ogilvy's opened another store. Again designed by David Ogilvy, it was a more elegant version of the existing store, described as a 'four storey, fireproof structure, designed in simple and admirable taste' (illustration 28). The *Star* article stated that the opening was an 'event of much interest to the public and especially to the ladies of Montreal.' The article described in much detail the efficient use of space within the store, and the organization of the departments, planned to provide shopping convenience, 'closely allied departments are placed in near proximity to each other.' New fixtures had been made especially for the store; they were low, for good visibility, and with shelves that were adjustable to suit many types of merchandise. In addition, 'the accommodations are such that 1,100 people can be standing at the counters at one time and still have the aisle space for a couple of thousand people more.' Ogilvy's was preparing for the kind of customer traffic that is the dream of every merchant! This Ogilvy building marks the end of an era, it was the last St Catherine Street store to be designed in the Renaissance palazzo style.[33]

28 This advertisement celebrates the opening of James Ogilvy's second store on St Catherine Street in 1912. Still known as Ogilvy's, this building now houses a variety of high-priced boutiques. (*Montreal Daily Star*, 27 March 1912)

Modern architecture influences were introduced in 1913, when W.H. Scroggie, having survived the eviction by Carsley's, opened its huge new store. Constructed of brown brick, it was designed in an un-ornamented industrial style, a term that was proudly used in the opening advertisements. The new Scroggie's, built at a reported cost of $4,750,000, was located just to the east of Colonial House, and had 'the largest frontage on the continent ... 360 feet.' In what was anticipated to be 'not only a commercial, but a civic event,' this 'Store of Wonders' opened on November 25, 1913. 'Shop Here. Dine Here. Be Entertained Here' read a line in an early advertisement.[34] Indeed, F.A. Scroggie seemed determined to take his department store beyond traditional merchandising activities. The newspaper article which was published a few weeks before the opening noted only that the store would sell 'everything from the cradle to the grave,' then listed over forty features that were considered to be novel and of benefit to both customer and employee. The long list of features in the seven-floor building included an 'undertaking establishment,' a nurse to care for babies while the mothers shopped, cafeteria facilities capable of serving two thousand people at lunch hour, an animal show with a real lion, a barber shop and hairdressing parlour, and 'the largest soda water fountain in Canada, seating 56 people, one of three in the building.' There were also facilities for the comfort of customers, including a 'Silence Parlor where customers indisposed or tired may rest at their ease.' Conveniences for the reported twelve hundred employees included separate dining rooms for men and women, literary and debating societies, a school offering business training to young employees, and a service to locate suitable boarding houses for female employees. F.A. Scroggie's philosophy, stated in an early advertisement, was:

> We have come to view the function of distribution as a social service – a public utility of the highest order ... The new store for all the people will have more real novelties and attractions than any other store in the world ... and while it revels in beauty and novelty, it will cater to the material welfare of man and please his pocket [with] economic selling under the happiest possible conditions for all concerned.'[35]

Scroggie was attempting to be benevolant employer, educator, impresario, and social reformer as well as merchant.

Scroggie's advertisements had never given any indication that the store was a fashion leader – indeed, the store seemed to have concentrated on low to moderate priced family apparel, likely filling the niche vacated by Carsley's and Murphy's as they had changed their merchandise profiles. However, one feature of the opening activities was indeed novel: a fashion show with live models, one of the earliest in Montreal.[36] The scope of the expansion, and the ambitious in-store activities, apparently must have put a severe strain on Scroggie's finances. The company

declared bankruptcy in January 1915, and the business was taken over, on a much less expansive scale, by Almy's Limited.

During these years, Morgan's Colonial House continued to prosper, as it catered to Montreal's fashionable clientele. The advertisements of this era are rather pompous in their praise for both the quality of the merchandise and the discriminating taste of the Morgan customer. This March 1912 statement is typical: 'The completeness and wide diversity of merchandise, the wealth of variety and the high standard of excellence ... that constitutes a perfectly appointed stock finds this store in absolute readiness for the increasing demand of a discriminating public.'[37] Colonial House kept its fashion statements very low-key, emphasizing 'taste, distinction and refinement' when advertising its imports from Paris, London, and New York. Couture names are not featured in any advertisements of this era; instead the copy features phrases such as 'the most skilled of Parisian designers contributed largely toward making this exhibit one of the more than ordinary excellence in the matter of correct and fashionable dress.'[38] Morgan's was confident that its customers would rely on its merchandise being not only of outstanding quality, but also a reflection of the best taste in the newest fashions.

Morgan's had had a men's tailoring department since 1866, but menswear was never a particular feature in its advertisements, yet about 1909 the company started to advertise itself as having 'A Store Devoted to the Needs and Requirements of Men ... Today it is considered a valued asset to be well dressed. Eventually it will be a necessity.' Another advertisement tells its customers that its assortment is 'rich in suggestion ... [which] emphasizes strongly the ability of our Men's Section to meet the most exacting requirements ... men should visit these Sections which are conveniently grouped together in the Annex of the store.'[39] Morgan's offered men the convenience of having all their apparel needs met in a defined shop, away from the dominantly feminine atmosphere of the department store itself. This was a novel concept on St Catherine Street, as neither Murphy's nor Ogilvy's had a menswear department. As an additional appeal to the male customer, Colonial House expanded its sporting goods department. By 1912, for example, there was a 'large new showroom containing six model Motor Boats and forty model Canoes,' with a demonstration tank for the watercraft. The merchandise assortment included all required necessities for a camping trip. As part of an expanding range of services, which were clearly intended to appeal to Morgan's established customers – that is, people of comfortable means – Colonial House offered house decorating and repair services. This expansion into services beyond the traditional dry-goods business grew to include the Dominion Car Company, and the Colonial Real Estate Company.[40]

Henry Birks and Sons also continued to prosper. By 1907 the Phillips Square building had expanded, and according to a newspaper article, had 'the largest

ground area covered by any jewellery store in the world, the next largest being in New York with an area of 16,300 feet, while Birks building has 18,000.' The firm had also opened a store in Ottawa in 1901, followed by Winnipeg, Toronto, and, in 1907, Vancouver. Birks designed and manufactured much of its own merchandise: 'In the factory itself are several hundreds of men ... gem setters, silversmiths, goldsmiths, watchmakers and stationery printers.' Many of these artisans were European, bringing old-world skills to the young country. Henry Birks stated that when he had first opened his store in 1879, only 10 per cent of the merchandise was made in Canada, the rest being imported, but by 1907 the Canadian-made merchandise represented 90 per cent of the stock.[41]

Murphy's had expanded in 1909 when they had constructed 'an important addition to the store that will give us much needed room and facilitate business in every way.' By 1913 the company had 'a direct Fashion News Service ... between our Paris office and this store ... for direct reports from our Paris office on the leading fashions as exhibited at the important social functions held in Paris, Vienna and other important social centers ... for the guidance of women in the city.'[42] This served as an added feature to the store's 'Little Paris Shop' which was already frequently featured in the Murphy advertisements.

Murphy's and Goodwin's seem to have become direct competitors for the attention of the fashionable consumer. The spring and fall fashion openings in particular offered great opportunities for flattering and ingratiating statements. Goodwin's wrote that 'No city in Europe and yet no center in America can boast a quicker following of Fashion than Montreal.' Murphy's stated that its fashion assortments 'would meet the expectations of you who have grown to rely largely on our judgement in the matter of dress.'[43] In spite of the terrible events of the 1914–1918 war in Europe, the regular cycle of season openings continued, with few references to any shortages. In February 1915, in a burst of patriotism, Almy's (the successor to W.H. Scroggie's) mounted a 'Made in Canada Exposition ... Bargains for you ... Employment for others.'[44] This event included in-store activities and demonstrations of manufacturing techniques. In September 1918, in a newspaper where lists of Canadian soldiers killed or wounded in France had regularly appeared, this same company advertised their 'Fall Fashion Show ... a most comprehensive collection of new styles which will be appropriately displayed by professional models from New York.' At the same time, Murphy's published an elegantly designed advertisement which included a sombre note: 'here are lovely modes in original adaptations in which Parisiennes, no longer gay, but serious, dress as witchingly as ever not withstanding war's disturbances.'[45] Fashion merchants were anxious to maintain their image of leadership inspite of the exigencies of wartime manufacturing.

The 1920s was a decade of change. The economy was on an upward spiral, and

consumer products such as cars, radios, and other new household appliances were available in great quantities. Women, who had enjoyed a new degree of freedom from traditional roles during the war, were now expressing their desires as consumers more actively than ever. In 1923 Morgan's expanded its store, trebling the size of the existing building. Multi-page sections in the local newspapers proudly documented this expansion, giving details of construction techniques and engineering innovations.[46] It was about this time that the name Colonial House finally disappeared from advertisements, which now simply bore the name Henry Morgan and Company Limited.' This change was likely a response to the growing sense of national identity which had been awakened in the First World War. Proudly opened in November, just in time for Christmas shopping, the opening specials included 'A Radiant Array of Evening Gowns [and] Dance and Dinner Gowns of Exotic Beauty.'[47]

In early March 1925, Goodwin's ran a ten-day anniversary sale, celebrating 'The fourteen years which we have been in business ... a Grand Celebration ... the greatest merchandising event we have ever attempted.' The event included 'A Last Minute Sensation Just in from France, 565 Beaded and Embroidered Dresses for Evening, Afternoon or Street wear worth $35.00 to $54.75 for $14.95.'[48] However, while this grand celebration went on, secret negotiations were in progress that would change the Montreal retail scene once more. On 19 March the front page of the *Daily Star* carried the banner headline, 'Sale to Toronto Firm of Famous Montreal Departmental Store, The T. Eaton Company Buys Goodwin's Ltd.'[49] For a few weeks, the Goodwin advertisements continued unchanged, with the usual offerings of spring merchandise, then on April 14, a full-page advertisement carried a message from the presidents of both companies.

> Timothy Eaton commenced business in Toronto in 1869, and it was in 1871 that Carsley and Company opened in Montreal the shop from which the Goodwin Store has developed. Thus for over half a century these two establishments have played a leading role in the mercantile life of Canada's two largest cities.[50]

This statement was a graceful acknowledgment of Montreal merchandising history. Eaton's certainly already had a clientele in Montreal, since their catalogue was a familiar presence in most Canadian households. The Montreal customer was to learn that, in addition to the popular-priced fashions for the entire family, Eaton's was a store where the fashionable customer could shop with confidence. Eaton's advertisements immediately started to feature 'Eatonia' brand merchandise which 'stands for good value in good merchandise.' By the fall, the store's advertisements incorporated elegant fashion messages. A feature was the Ensemble Shop, 'The Shop of the Complete Costume – From hat to shoes, coats to gloves and lingerie,

embroidered shawls and brocade evening wraps – The Ensemble Shop will equip madame and mademoiselle for the social fray.'[51]

Plans were quickly under way to completely rebuild the store; indeed, an architect's drawing of the new building was published the day after the formal announcement of the sale.[52] Reconstruction was completed in stages over a period of two years, and resulted in the familiar St Catherine and University street facades of today. The renovation culminated in January 1931, when Eaton's proudly opened its ninth-floor restaurant. The headline of the *Star*'s feature article reads: 'New Eaton Restaurant is Unique in Artistic Beauty. Foremost Modern Architect and Leading Mural Artist Achieve Masterpiece in Local Store.'[53] The architect, Jacques Carlu, coordinated the design of every detail (including the staff's uniforms), while his wife, Natacha Carlu, painted the rooms only figural decoration, two large murals. The restaurant embodied all the characteristics of Art Deco design, echoing the design of the most luxurious transatlantic liner of the 1920s – the *Île de France*. Fortunately this restaurant is the one part of the store which has been preserved unchanged. Recognized as one of the jewels of Art Deco design in Montreal, if not in Canada, it has recently been declared a heritage site by the Quebec government.

The spirit of competition along St Catherine Street seemed to heighten in the spring of 1925, as Eaton's was introducing itself to its Montreal customers. Murphy's presented the 'Murphy-Simpson Spring Fashion Revue,' an elaborate production that was staged in the Capitol Theatre. Twice daily the show presented 'models from Jenny, Drecoll, Worth, Patou, Bernard, Lanvin and other Parisien modistes as well as from noted London and New York designers [in addition] the Wedding Dress of Empress Josephine of France – as copied by Jeanne Lanvin of Paris expressly for the Murphy-Simpson Fashion Revue ... is the center about which the elaborate wedding scene is staged.'[54] Morgan's, making a special effort to entertain its customers and to attract new ones, presented a week-long 'Brilliant Fashion Pageant,' which featured 'Mlle Marceline d'Alroy, The Renowned Parisien Fashion Interpreter With Her Own Specially Trained Mannequins.' Activities climaxed in the grand finale when the show made its 'special appeal to the teacher, the business woman and the college student.'[55] Morgan's was reaching out to new customers, independent women, with their own source of discretionary income. By that fall Eaton's, too, was offering its customers the latest in Paris fashions, one advertisement featuring fashions by Lelong, Molyneux, and Vionnet. These are illustrated and described, but very discreetly; no prices were mentioned.

The fashion advertisements of the next few years demonstrate considerable rivalry among the St Catherine Street stores for the attention of fashionable customers. This is best seen in the *Montreal Daily Star* fashion sections, which were

regularly published to coincide with the start of each new season. These multi-page sections in mid-March and mid-September featured both advertising and editorial content, and the careful reader could learn about every aspect of the season's fashions, in house furnishings as well as apparel.

Spring 1929 was particularly exciting for the fashionable St Catherine Street shopper. Eaton's was expanding into its new facilities, Simpson's announced the construction of a new store to replace the old Murphy building, and Ogilvy's, under the direction of a new president, Aird J. Nesbitt, seemed suddenly to reinvent itself. In early March 1929 a series of teaser advertisements ran in the *Star*, on the theme 'Ogilvy's and Montreal grew up together.' These advertisements described the evolution of the store from its founding in 1866, and culminated in a description of the new Ogilvy's. The construction of an additional storey allowed the store to reorganize its second floor into a 'group of thrilling fashion shops ... in which the latest fashions of Paris, London and New York are displayed.' A new feature was the oak-panelled Tudor Hall, with a pipe organ, whose music could also be enjoyed by the patrons of the store's new Adam dining room 'built and decorated by the same man who decorated the home of Henry Ford.'[56] In September, Ogilvy's offered a 'Fashion Show by Candlelight' in the Adam Room. The full-page advertisement is elegant, featuring a 'Collection of French Originals by the creators of fashion themselves – Molyneux, Vionnet, Lanvin, Chanel, Worth, Louiseboulanger, Lucille, Paray, Maggy Rouff, Paquin, Augustabernard.' At the same time, Eaton's announced its readiness for the fall season with an elegant, almost abstract line drawing of '*Tomorrow,* an original by Patou ... one of the most outstanding fashions that the Autumn Paris Openings produced.' Equally elegant and understated was Morgan's advertisement, which relied more on poetic copy than names of couturiers to describe the 'elegance and brilliancy of its Fall Collection.'[57]

In March 1929 Simpson's proudly announced a new building for their Montreal store: 'The John Murphy Company, owned and operated by the Robert Simpson Company will begin construction of their new store building early in May.' In design the store was to be similar to that in Toronto, and was planned for a final height of ten stories, to be built in stages. A full-page advertisement described the building as a 'New Structure, worthy Addition in Beauty and Efficiency to Montreal's Architectural Wealth.'[58] The timing of this ambitious scheme could not have been worse, six months later the Stock Market collapsed, and the Great Depression undermined business everywhere. The Simpson building was finished, but on a much reduced scale. Fall 1929 marks the final appearance of the Murphy name, as advertisements now bore the heading 'The Robert Simpson Company formerly the John Murphy Company.' The construction of the new Simpson

building, the last major department store to be built on St Catherine Street, marks the closing of an era of development that started in 1891 with the construction of Colonial House.

The fashion merchants of Montreal had established their territories on St Catherine Street. Over the years they built and rebuilt their stores, always incorporating the latest in customer services and display techniques, and they stocked these stores with assortments of merchandise carefully selected to appeal to their clientele. But ultimately it was the customer who made St Catherine Street a fashion thoroughfare. The customers came, enticed by the large airy stores, where in pleasant surroundings they experienced the pleasant activity of shopping. The customers came, as St Catherine Street became an arena of activities, with store-wide sales, special events, and fashion openings, and from this the merchant benefited both from immediate trade and from the development of customer loyalties. St Catherine Street was no longer an uptown novelty, but the downtown heart of Montreal's retail activity. At the end of the twentieth century the era of the immense business stores described in the opening quotation had gone, but the development of St Catherine Street's Fashion Mile left Montreal with a rich architectural legacy which reflects a unique period in the history of Canadian retailing.

Epilogue

It is interesting to note that all the buildings discussed here still play an important role in Montreal retailing. The 1912 Ogilvy building houses a retail operation of the same name and Tudor Hall is still the venue for recitals and receptions. Across Mountain Street, the 1896 Ogilvy building, almost unaltered, houses a variety of retail tenants. Simpson's 1930 store stood untenanted for a number of years following the withdrawal of the company from Montreal in the late 1980s. Having undergone extensive alterations, the building reopened in spring 1999 with Simon's, a long-established Quebec City fashion store, located on the lower floors. The upper stories have been converted into Famous Players Paramount Theatre with twelve screens, an Imax theatre, and integrated entertainment centre. The Eaton building underwent interior renovations during the summer of 1998 as part of that merchant's major restructuring. The building itself was washed, revealing the elegant golden-beige stone, as it had originally appeared in the late 1920s. In October 1999 Eaton's closed its doors for the last time, but the building re-opened in August 2002 with a new retail concept developed by Les Ailes de la Mode. Henry Birks and Sons has changed ownership, but the 1894 building still houses one of the city's finest jewelry stores in its original opulent interior, and Birks's traditional blue boxes still hold eagerly anticipated gifts. Henry Morgan's 1891

Colonial House, expanded significantly in the 1920s and 1960s, has housed the Montreal flagship store of the Hudson's Bay Company since 1972. The Scroggie building has been put to less glamorous use. Known for some years as the Belgo Building, the street floor is occupied by a variety of small stores, while the upper stories, which were used for some time by the wholesale garment trade, are now used as offices, and as gallery space for independent artists.

NOTES

1 Rev. J. Douglas Borthwick, *History of Montreal, Including the Streets of Montreal* (Montreal, 1897), 178. The English cathedral referred to is Christ Church, located on St Catherine at the corner of University Street. When the original English cathedral, located on Notre Dame Street, was destroyed by fire in 1856, the congregation decided to move closer to the developing residential area uptown. Christ Church Cathedral is still on this site, although recently an underground urban shopping mall, 'Les Promenades de la Cathédral,' was constructed underneath it.

2 *Montreal Daily Star*, 16 September 1925.

3 The part of St Catherine Street studied in this paper is limited to the mile between Bleury Street to the east and Mountain Street to the west. There was another nucleus of large retail stores farther to the east, most prominent among these was Dupuis Frères. Founded in 1868, this small dry-goods store developed into a large department store, its growth paralleling in many respects the development of the stores discussed in this paper.

4 Bosworth Newton, *Hochelaga Depicta* (Montreal: Wm. Greig, 1839), 212.

5 Henry Morgan Papers, McGill University Archives, MG 1082, C4 file, 2443/10, 28 January 1847.

6 Quoted in Kathleen Jenkins, *Montréal: The Island City* (New York: Doubleday, 1966), 386. Plate-glass windows were increasingly used after 1850 as more buildings were built with cast-iron skeletons, and they not only provided improved lighting, but also gave retailers a showcase on the street. A Montreal merchant advertised plate glass in 1844 (*Montreal Gazette*, 16 May 1844) and by 1853, Peter Redpath advertised that as sole agent for the Union Plate Glass Company of Liverpool, he was 'prepared to take orders for ... plate glass of any size' (*Transcript*, 3 May 1853).

7 *Commercial Sketch of Montreal* (Montreal: Chisholm and Dodd, 1868) 20.10.

8 *Montreal Daily Star*, 11 January 1890.

9 See also articles on A.T. Stewart by Harry E. Resseguie in the *New York Historical Society Quarterly* 48, no. 2 (1964: 131–62, and in *Business History Review* 39 (1965): 302–22. The prototype for all nineteenth-century retail buildings was A.T. Stewart's Cast Iron Palace. Built in 1862 in New York, it introduced plate-glass show windows,

used the lightwell as a feature, and introduced a 'retiring room' for customers. An enthusiastic description of Stewart's building in *Godey's Lady's Book* of May 1863, written when the store opened, also described the luxurious assortment of shawls, dress fabrics, and fashion accessories (p. 431).

10 *Montreal Gazette*, 21 April 1891; *Montreal Star*, 22 April 1891.

11 *Montreal Star*, 28 April 1891.

12 *Montreal Gazette*, 25 April 1891.

13 *Montreal Star*, 25 March 1893, 10 May 1894.

14 Ibid., 10 March, 13 September 1894.

15 Ibid., 21 September 1894. Both the advertisement and the report appeared in this issue.

16 Ibid., 9 March 1894.

17 Ibid., 7 September 1896.

18 Ibid., 11 September, 23 November 1895. Carsley is comparing his store to William Whitely's merchandising empire in England. See Richard Lambert, *The Universal Provider* (London: Geo Mariapo, 1938).

19 *Montreal Star*, 10 April 1891. Note that the date of this advertisement coincided with the move of Colonial House.

20 Ibid., 7 September 1894. Note that this date coincided with the move of Murphy's.

21 Ibid., 17 August 1896. Ogilvy's moved at this time.

22 Ibid., 3 April 1906; *Montreal: The Imperial City of Canada, The Metropolis of the Dominion* (Montreal: Montreal Board of Trade, 1906), 81.

23 *Montreal Star*, 1 and 9 February 1905.

24 Ibid., 17 March 1905. The fashion designers mentioned in this and other quotations in this paper are discussed in McDowell, *McDowell's Directory of Twentieth Century Fashion*.

25 *Montreal Star*, 9 January 1909.

26 Random examples of these columns demonstrate Samuel Carsley's crusading spirit. A column headed 'Church Debts' details irregularities in the bookkeeping of various Montreal congregations. Another, published a few weeks later entitled 'Baits,' inveighs against business tactics he considered unscrupulous. During the smallpox epidemic of 1885 he published many household hints, and advertised that his store 'disinfected' all money circulated on the premises. In 1891 he complained about other stores blocking the sidewalks with their delivery vans. See, for example, *Montreal Daily Star*, 7 February 1880, 13 March 1880, 22 September 1885, 25 July 1891.

27 Ibid., 24 April, 3 June 1909.

28 *Montreal Gazette*, 14 September 1909. The sale of the business that followed so closely the move to St Catherine Street suggests that a Carsley presence on that street was a condition of the sale.

29 *Montreal Star*, 2 October 1909.

30 Ibid., 19 November 1909, 7 January 1910.

31 Ibid., 20 April 1911.
32 Ibid., 5 September 1911.
33 Ibid., 25 March 1912.
34 Ibid., 13 October, 25 November 1913.
35 Ibid., 22 November 1913.
36 Ibid., 27 November 1913. It was at this time that the French couturier Paul Poiret was creating a sensation in Europe by using live mannequins to present his revolutionary fashions. While Scroggie's show itself was a novelty, it would be safe to assume that it presented few radical fashions to Montreal customers.
37 *Star*, 26 March 1912.
38 Ibid., 14 September 1909.
39 Ibid., 11 February 1910, 8 April 1911.
40 Ibid., 27 March 1912.
41 Ibid., 20 November 1907.
42 Ibid., 21 April 1909, 8 November 1913.
43 Ibid., 16 September 1911, 8 March 1913.
44 Ibid., 6 February 1915.
45 Ibid., 7 September 1918.
46 Ibid., 13 November 1923; *Montreal Gazette*, 13 November 1923.
47 *Montreal Star*, 12 November 1923.
48 Ibid., 3 and 13 March 1925.
49 Ibid., 19 March 1925.
50 Ibid., 14 April 1925.
51 Ibid., 15 September 1925.
52 Ibid., 15 April, 1925. The architectural and mechanical details of the construction are fully described in an article in *Construction* 21 (December 1928).
53 Ibid., 24 January 1931.
54 *Montreal Star*, 21 March 1925. An article in the same paper commented on the 'Gorgeous Effects' of the show (24 March 1925).
55 Ibid., 9 and 15 September 1925.
56 Ibid., 11 March 1929.
57 Ibid., 9, 10, 14 September 1929.
58 Ibid., 7 March 1929.

SELECTED BIBLIOGRAPHY

Architecture commerciale. Vol. 3. *Les magasins les cinemas*. Montreal: La Communauté urbaine de Montréal, 1985.
Burton, C.L. *A Sense of Urgency: Memoirs of a Canadian Merchant*. Toronto: Clarke, Irwin, 1952.

Leach, William. *Land of Desire: Merchants, Power and the Rise of a New American Culture.* New York: Pantheon, 1993.

Macleod, Ken. *The First Century: The Story of a Canadian Company.* Montreal: Henry Birks and Son, 1979.

McDowell, Colin. *McDowell's Directory of Twentieth Century Fashion.* Englewood Cliffs, NJ: Prentice Hall Trade, 1985.

Miller, M.B. *The Bon Marché: Bourgoise Culture and the Department Store, 1861–1920.* Princeton: Princeton University Press, 1981.

Monod, D. *Store Wars: Shopkeepers and the Culture of Mass Marketing, 1890–1939.* Toronto: University of Toronto Press, 1996.

Morgan, David. *The Morgans of Montreal.* Toronto: n.p., 1992.

Santink, Joy L. *Timothy Eaton and the Rise of His Department Store.* Toronto: University of Toronto Press, 1990.

Sifton, Elizabeth. 'Retailing Fashion in Montreal: A Study of Stores, Merchants, and Assortments, 1845–1915.' Master's thesis, Concordia University, 1994.

Weisman, Winston. 'Commercial Palaces of New York, 1845–1875.' *Art Bulletin* 36 (December 1954): 285–302.

FASHION AND TRANSITION

Dress Reform in Nineteenth-Century Canada

BARBARA E. KELCEY

It was undoubtedly a courageous and liberated Clara Graham who wrote to the editor of *Public Health Magazine* in 1877 about her new underwear and the subsequent emancipation of her limbs and lungs.[1] With unbridled enthusiasm for the new dress reform, Graham chided the magazine's female readers for squeezing their bones into 'strong little cases' which pushed the natural female form into a more finished appearance. She considered it strange the Creator did not provide women with a proper figure in the first place, and concluded His error was rectified when 'God created great whales.'

Clara Graham referred *Public Health Magazine* readers to a 'cheap little book' entitled *Dress and Health*, which had convinced her that the tight lacing of her corsets, and an unhealthy load of heavy skirts falling from the waist, had compressed and depressed the very vigour and life from her body.[2] Dress reform was not nonsense, she explained, even though it would be a very bitter pill for Canadian women to swallow, and she wondered whether it might be expedient to exterminate all the whales. It was Graham's opinion that there was no suitable substitute for whalebones, so women would be forced to resort to using their own bones to support their backs.

Technology and the development of fine steel ribs eventually replaced whalebone in some corsets, but, as *Dress and Health* lamented, any radical change in the way women dressed was 'too much to be hoped for,' even though making those changes was one reform which could have been effected without resorting to political action.[3] It was certainly a reform which was both medically necessary, and socially worthy, yet, as a movement for women reformers, it was essentially overlooked. In fact, between the time Clara Graham's testimonial appeared and the end of the century, fashion changes did not reflect any real reform aimed at health and safety, and women in Canada continued to allow Victorian attitudes towards women's roles and feminine appearance to dictate what they wore even as

they fought for political emancipation and against social evils. In effect, the restrictive nature of their corsets epitomized their continued position in society.

While there was some move towards clothing which reflected the new consciousness of women's need for emancipation in the late nineteenth century, fashion still projected the ideal of the fragile, feminine, delicate woman. The way women dressed not only represented their own social status but, more importantly, signified the success of fathers and husbands, and the ideal impression of refinement and dignity was maintained by rigid boning and snug-fitting bodices. Even though styles changed dramatically over four decades, this ideal remained a constant.

In the mid-1860s, fashionable Canadian women wore bodices buttoned to the neck. Sleeves were open, with an undersleeve that was tight at the wrist. Skirts were rigid, gored, and pyramidal in shape. These skirts were supported by cage-like crinolines or hoops which were extremely difficult to manoeuvre. There was also some real physical danger because the lightweight fabric from which these skirts were made was highly flammable. One British journal reported in 1867 that in England, three thousand women were burned to death annually because of these skirts, and up to twenty thousand women a year suffered related injuries as a result of the crinoline.[4] In an age when open fires were used for cooking and heating in Canadian homes, there is no reason to believe that similar statistics would not apply to Canada.

By the 1870s, the skirt had become smooth and straight at the front, but was larger and supported by a modified crinoline which allowed for a fullness at the back that later evolved into a train. It was during this period that tight lacing became popular in order to project the image of a tiny waist and large hips. The decade also saw skirts change from those with simple fullness to those with an overskirt draped up and over the thighs. The bunching at the back caused by the drape eventually developed into bustles of all shapes and sizes. This tied-back skirt was referred to by a contemporary writer as the 'painful spectacle of the whole female race more or less tied into narrow bags.'[5]

By 1895, skirts were less complex, but sleeves were enormous and puffy. These were stiffened with fibre chamois or haircloth, and the absurdity of the size was noted by feminist Flora MacDonald Denison, who later suggested in a speech to suffragists that if they doubted the stupidity of fashion of the time, they should 'look at the old family album and see where the photographer had to put [them] crossways on the card to get [the] sleeves in the picture.'[6] Tailored suits also became popular by the 1890s, but simplicity was deceptive, for complex construction was necessary to maintain the smooth, sleek lines.

On the surface, it might appear that these fashions were significant only for middle- and upper-class women able to afford the luxury of constant changes to

their wardrobes. The dictates of fashion, however, had far deeper implications: for those who wore the unhealthy and unsafe garments, for those who struggled to achieve the ideal when it was beyond their means, and for those who laboured to produce and maintain those clothes. Admittedly, dress reform was probably not an issue for immigrant and homesteading wives who lived in a sod shack on the open prairie, yet the question has to be raised as to why Canadian feminists did not pursue more actively the issue of dress reform in the nineteenth century.

Dress reform first surfaced as a cause in North America about 1851 with the introduction of a bifurcated garment designed by Elizabeth Smith, a cousin of American feminist Elizabeth Cady Stanton. The costume consisted of full-cut trousers gathered in at the ankles with elastic. These were covered by a tunic-like dress which fell to just below the knee. The outfit came to be known as a bloomer after Mrs Amelia Jenks Bloomer, the editor of the feminist publication *The Lily*. Mrs Bloomer promoted the garment and wore it in public for five or six years. The bloomer reflected typical modesty and conservative attitudes, but was still a vast improvement over the voluminous skirts supported by twenty pounds of petticoats and ridiculous hoops that were worn by women of the period.

The concept of hygienic and comfortable dress was advocated by a small revolutionary group of American feminists, some of whom formed the Dress Reform Association in 1856.[7] Dress reformers defended the radical approach to dress by explaining the bloomer was not only healthy, neat, and modest, but that healthier women were more productive workers. They also maintained that current fashion was morally evil, and bloomers were more suited to those engaged in social reform. The final argument was patriotic. It seemed that wearing a bloomer costume was the 'American way,' and epitomized the American standards of taste, utility, comfort, and economy. Bloomers were well suited to the peculiarities and habits of American society. That the trouser style used in the costume was Turkish in origin was dismissed on the grounds that the bloomer was an outgrowth of American wants, the product of American skill and a sign of American independence.[8]

Since the object here is only to provide a brief historical background, it must suffice to say that the bloomer did not enjoy enduring success. However, arguments raised both for and against the costume would surface again in another era north of the border, and therefore are important to this discussion. It is also essential to remember that while the bloomer was often considered the garment which represented advances in women's costume, it was not typical of dress reform and was simply one element in the movement for change.

Women in the United States did not adopt the bloomer for a number of complex reasons, not the least of which was its acceptability as fashion. The garment was decidedly unfashionable, and as Flora Denison pointed out, it was

only 'two floppy skirts still trying to hide the fact that a woman really had more than one leg.'[9] The real issue was that the bloomer offended the contemporary ideals of womanhood, femininity, and women's role. Not only was it a visible affront to the established norms, but the costume contradicted the distinctions between men and women. The women who wore bloomers in public were suddenly conspicuous and notorious, and therefore disruptive to society. Ironically, the unfeminine bloomer was also blamed for fanning the fires of passion in men who were aroused by the sight of ankles, feet, and legs which had hitherto remained covered. In the same vein, bloomers were accused of heating the lower half of a woman's body; as a consequence, the elevation of body heat encouraged sexual desires. (It would be another forty years before Canadian men made the same discovery in Toronto when women needed two legs to ride a bicycle.)

While the bloomer enjoyed little public acceptance, progressive women still continued to wear some form of this garment in their homes, and the dress reform movement in the United States did not die with the bloomer. Interest in reform was revived in the 1870s, with the advent of tightly laced corsets which were necessary to provide the hour-glass shape of the current fashion. Then the focus became health and safety.[10]

Early reforms aimed at changing prevailing dress in Great Britain were more concerned with perspiration and the importance of good ventilation for the body. British women had dismissed the bloomer costume out of hand. They were both shocked and amused by the garment, and British society attacked it in both song and word, and in the pages of *Punch*. Ridicule focused on the mannish style of the pantaloons.[11] What is more important about this British attitude towards early American dress reform is that until the mid-1870s, Canadian women were more likely to follow English fashion trends, so it is not surprising that bloomers did not seem to be an issue in Canada. The 1860s and 1870s also marked a period of transition for women's clothing in Canada. The rise of the middle class meant a demand for more fashionable garments from women whose financial and social position became more comfortable. Add to this stratification a new availability of all kinds of domestically produced fabrics, as well as the national costumes of recently arrived immigrants, and Canadian women must have presented quite a diverse picture. But with the shift toward north-south communication, and the appearance of women's journals published in Canada with considerable American content, Canadian women soon adopted the popular modes from New York and Boston.[12] (See illustration 29.)

It was from Boston that the first organized efforts against unhealthy dress emerged, and it was this literature which had such an impact on Clara Graham. *What to Wear* by Elizabeth Phelps appeared in 1873. It was a collection of works first published in the *Independent,* and included a paper presented to the New

29 Bloomers on Canadian women: a commentary from the *New Dominion Monthly*, September 1869.

England Women's Club. Phelps dramatically pinpointed all the problems associated with current styles. Unlike *Dress and Health*, which faulted women for the problems caused by fashion, *What to Wear* laid the blame for unhealthy and dangerous dress squarely at the feet of men. Elizabeth Phelps declared that the problem 'in a beechnut-shell' was that 'woman was made for man ... for his attraction,' and that 'heaven gifted her with peculiar graces and beauties of person for his attraction ... Devotion to the art of dress was a sexual duty.'

Phelps concluded that the majority of women did not consciously dress to be attractive to men, but if they *were* conscious of it, they would not do it. It was simply that the ideal was 'too well transmitted and the lifelong habit too fixed, to attract their distinct attention.' She countered the contemporary premise that women naturally possessed more physical grace and elegance than men. If that were true, she suggested, women 'did not need to depend on their clothes to say so.' But when she suggested that 'there was never a serpent that did not hide and crawl underfoot,' Phelps might well have added that it was easier for serpents to hide and crawl under lengthy and voluminous skirts, and for women to use those skirts to hide behind.[13]

There is no evidence that *What to Wear* received any attention in Canada, but *Dress and Health* was published in a Canadian edition, and was reviewed by both the *Public Health Magazine* of Montreal, and the *New Dominion Monthly* of Toronto. Edited by Mrs Abba Goold Woolson, this book consisted of a series of lectures made by a number of prominent female physicians from the Boston area. The focus of the volume was underwear, and women were advised to change the way they wore their underclothes to preserve their health.

Corsets were the first concern of dress reformers, and these garments were blamed for all manner of medical evils because they compressed and lifted the chest and upper abdomen while forcing internal organs and muscles downwards, a position which caused the heaving bosom so common in Victorian literature. In order for the garment to do its job it had to fit snugly, with rigid stiffness in the centre body, and so the options were to wear a properly fitted corset, or not bother. Tight lacing – made possible by the introduction of steel-reinforced eyelets – took this fitting one stage further. Although the self-induced torture of tight lacing was by no means the normal practice, the most popular and recurring argument against the discarding of stays was that without them, it was impossible to remain neat and tidy; so the correctly dressed woman wore a corset.

That the wearing of corsets was foolhardy and unhealthy was widely known, and questions were often raised as to why women would continue to submit themselves to such discomfort. As one author asked, 'does not the highly cultivated and highly refined lady, who knows all that can be said against the custom, place herself on a level of the squaw who sticks a bone through her lip to make it

hang down below her chin? A cynic might ask on which side the savagery [was] greater.'[14]

The Eaton's fall and winter catalogue of 1893-94 announced unabashedly that, while doctors claimed the corset as their best friend, women still wanted to buy them, so Eaton's was prepared to sell corsets of every description and style, and to suit all budgets. As the catalogue noted, Canadian doctors were well aware of the dangers of the corset and blamed the garment for every ailment from gallstones to deranged menstruation. Yet the doctors also were concerned about why women trussed themselves up like turkeys in whalebone, steel and laces.

In 1880 the *Canada Medical Record* recorded the views of an British researcher who concluded that the 'miserable imprisonment' was not due to a desire for a small waist, or because of a need to be fashionable. Women wore corsets because mothers confined the figures of young girls at an early age, so women became gradually accustomed to some degree of constriction. More significantly, women's muscles and spines became used to the support provided by corsets. This opinion was also proffered by Dr Mary Safford-Blake in *Dress and Health,* but was exemplified by Clara Graham, who described how difficult it was to walk without her corsets when she first discarded them, and that it took several months of dress emancipation to rectify the situation.[15]

Another Canadian physician wrote that he did not think 'that women [were] alone to blame for wearing tight corsets. They only [tried] to meet a demand. If men admired women of natural shape more than thin waisted girls, the supply of the latter would soon cease to come on the market. So that we should educate our male acquaintances to understand the probable sickliness and costliness of corset-laced wives. Dr Smith obviously viewed women as commodities, and hoped to appeal to men's sense of economy. Nevertheless, his intent was at least pointed in the right direction. He also made some medical observations about the reaction that was setting in against the corset. It was, he noted, 'becoming generally admitted that the great increase in abdominal pressure which [the corset caused was] to be blamed for a great many diseases to which women were victims.[16]

It was generally admitted that corsets interfered with respiration which, Dr Smith explained, led to the deterioration of the blood. Poor blood weakened muscles and produced a flagging brain, although there was no scientific evidence to sustain this notion. In reality, weakened muscles, chronic shortage of breath, and compression of the internal organs also meant constant fatigue, fainting spells, headaches, digestive problems, and general debility, lending credence to the image of the fragile and delicate Victorian female unsuited to any physical or mental enterprise.

Corsets were also blamed for difficult childbirth and for damaging the capacity of women to bear strong, healthy children. In a chapter dramatically entitled

'Slaughtering the Innocents,' *Dress and Health* assumed that the agonies of child-birth were compounded by weakened muscles, and that delicate women would eventually produce female children who would inherit small pelvic bones. This would lead to babies with smaller heads, and less intelligence. Mothers would transmit lower and lower vitality to their offspring if the babies survived tight lacing during pregnancy. There was, the authors concluded, little hope for the future. One later eugenics-oriented manual was more blunt: 'if the murderous practice [continued] another generation, it [would] bury all the middle and upper classes of women and children and leave propagation to the coarse-grained, but healthy classes.'[17]

This elitist view is important in understanding the context of arguments, but evidence suggests that while dress reform was very much a part of the eugenics program, eugenics was not necessarily the driving force behind the motivation for dress reform, it was simply one part of the debate. The idea that a healthier lower class might overtake the middle and upper classes because of tight corsets must also be considered with the understanding that poor women wore corsets too, although not perhaps for the same reasons as middle-class women.[18] One physician wrote in the *Canada Medical Record* that, based upon observations, he believed that corsets were an essential article of clothing for a poor woman because they added a layer of warmth close to the body.[19] There is also no reason to assume that poor women did not want to appear neat and tidy in public; poverty does not necessarily mean a lack of pride in appearance.

There was some irony to the contention that corsets damaged the childbearing capacity of middle- and upper-class women. Doctors believed that the compression and restriction caused congestion in the 'lower regions' of women, which in turn caused 'amative desires' and encouraged immoral behaviour and the sexual aggression of men. In addition, bustles, trains, hoops, and other parts of fashionable skirts were designed to create the illusion of a larger pelvis and greater fecundity, so although corsets distorted women's bodies, they emphasized women's reproductive function.[20]

Skirts and petticoats which fell from a waist already traumatized by a tightly-laced corset were also attacked by dress reformers. There were really only three points of contention, even though changes in skirt design were numerous over the last half of the century. Problems developed because of weight, cleanliness, and a lack of freedom in movement.

Imagine the waist of a fashionable woman of the 1870s. The 'finished' measurement was as close to an ideal eighteen inches as possible. Under the corset was a chemise of fine cotton or linen. The stays were topped by a corset cover. Each garment which hung from the waist had a binding or waistband of double thickness; *Dress and Health* listed garments which might add up to sixteen

thicknesses, all bound and buttoned to be unyielding. Because corsets and bands forced pressure downward on to the hip, all the weight of the dress skirt, overskirt, petticoat, skirt protectors, bustles, ruffles, and linings dragged on the hip and pelvic bones, adding further pressure on an already compressed lower abdomen. It was believed that it was this dragging down on the organs and muscles which produced the most damage. There was also a view that there was no balance to the amount of clothing which covered the extremities. Arms and necks, for example, were comparatively bare. Legs often went uncovered under the skirts, and women complained of poor circulation in the feet and legs.

Dress and Health doctors advocated four principles of healthful dressing which addressed these concerns. These were:

1. *Allow the Vital Organs Unimpeded Action*
This requires the removal of all tight-fitting waists, and of all unsupported waist-bands, whether tight or loose – the latter, for this reason, if tight, they compress the ribs; if loose, they slide downwards and depress the abdomen.

2. *Suspend the Clothing from the Shoulders*
This requires the attachment of all the lower garments to the upper or to suspenders passing over the shoulder.

3. *Reduce the Weight as much as Possible*
This involves careful calculation to render the skirts as few and short and light as possible.

4. *Preserve a Uniform Temperature of the Body*
This involves, theoretically, that every thickness of cloth which covers the trunk should furnish sleeves and drawers for the limbs; practically, however, especially so far as the arms are concerned, less than this will be found sufficient.[21]

These recommendations still assume that even those women wearing reformed dress would remain well covered, and would accept the ideals of the fashion of the day within these guidelines. Reformers may have operated under the assumption that women might be convinced to adopt new designs of underclothes because no one saw them, and besides, underclothes did not assume any sexual connotation until the late 1890s when they became known as 'frillies.' Outer garments were another matter.

Skirts with long trains were cumbersome, dangerous, and collected dirt. As early as 1884 the *Ladies Journal* told its Canadian readers that it was 'scarcely too much to say that the wearing of such amounts to stupidity in those who [did] not know the consequences (for over and over again warning [had] been given) and to wickedness to those who [did].' One article which appeared in *Wives and Daughters*, another Canadian women's magazine, suggested that the awkward train was

'evidence of a weakness or lack of intelligence,' and that those who wore trailing skirts through mud and water should know better. The article further professed that 'no woman can be dignified who [was] compelled to make frantic dashes to lift her dress skirt to escape some suddenly discovered nastiness ... and no woman of clean habits will let her dress skirts drag through the mud and filth of our streets.'[22]

These were streets where horses provided the principal means of transportation, and where men spat tobacco juice on the sidewalks. The solution, according to *Wives and Daughters*, was for all women to wear short walking skirts when outside of their homes. This created something of a dilemma. In the interests of cleanliness, hygiene, and common sense, women had to display a certain degree of immodesty by wearing short skirts in public.

Short skirts (which, it should be noted, means *shorter* skirts which were ankle length), constructed along simple lines with relatively little yardage were unthinkable in the 1870s and 1880s. The fashion of the day upheld the conviction that the less women were able to stoop, bend, pick up, or otherwise perform any physical movement, the more it suggested that someone else was doing it for them. The longer the train, the more help a woman needed to manoeuvre in her own front parlour, much less a carriage or a shop.

Less cumbersome skirts and less restrictive underclothes became an undeniable necessity when the daughters of these same middle- and upper-class women entered universities, colleges, and the professions. As the doctor who offered the theory of the flagging brain commented, 'it would seem strange that anyone should care to pour into herself intellectual food at the same time that she carefully shuts off the draft of her furnace and so prevents its utilization.'[23] Nevertheless, these women were still dragging around long skirts which became damp when it rained or snowed, and which became dirty after the precipitation stopped. Women were seated in draughty lecture halls with damp hems without even the luxury of being able to complain to decidedly unsympathetic male students. This was not as bad as standing all day in wet, poorly fitting shoes and boots, and with skirts heavy from moisture, however. That was the lot of factory workers, shop girls, and teachers.

Women who worked were not concerned about elegant trains, although shop girls, domestic servants, and teachers were expected to appear in clothing acceptable to their employers. Factory workers might spend hard-earned wages on 'finery.' It is not that these women were concerned with what to wear that was the issue with dress reformers so much as it was the labour involved in the production of fashionable clothes.

Ready-made, factory-produced clothes for women were not widely available until the 1890s, so most middle-class women's clothing was made by dressmakers.

Some of those dressmakers were fortunate enough to own a treadle sewing machine, which was invented in the 1860s and was available to Canadian homes which could afford them by the middle of the decade. But even with sewing machines, making the clothes of the period was time-consuming and expensive. In fact, the sewing machine provided little relief for busy dressmakers and piece workers because women wanted more ruffles and frills, which could be produced faster with a machine. Domestic servants had to maintain these elaborate garments for their employers without the benefit of electricity and easy-care fabrics.

Middle- and upper-class women, however, were not at all concerned with the plight of their servants or the lives of working women forced to labour in sweatshops and factories, any more than they were about deadly corsets, at least not when their own appearance was at heart. In 'Gentle Lady,' an essay published in *In Times Like These*, Nellie McClung described how one such woman begged not to hear how factory workers who made women's clothes were treated. She did not want to know, for the last time she had 'heard a woman talk about the temptation of factory girls, [her] head ached all evening, and [she] could not sleep.'[24]

At the annual meeting of the National Council of Women of Canada in May 1895, one report dealt with the length of working hours for women and children in factories. A resolution was moved to petition the legislature to limit the legal hours of work for female employees. When she rose to address the other middle-class women at the meeting on the matter of what she called 'the wonderful pathos of the question,' Mrs Edwards of Ottawa asked:

Why have women to work so hard and get so little pay? Is it not, ladies, because we want things so cheap? (applause) – and that we want such a variety of things? ... Even to-day, looking around, we all appeared in one costume in the morning, then some of us went again and changed in the afternoon, and some of us will have something new this afternoon and a fresh costume this evening. (Laughter.) Some of us, ladies, in order to get our gowns ready to come up here, pushed those girls to work late and urged our dressmakers. Are we willing to go back and to dress plainly and to live simply, that our sisters may have more time to do what their duty is to do – to have good, healthy bodies, to rear and bear good healthy children?[25]

Mrs Edwards was apparently not concerned that she was overwhelmed by the 'coarse-grained' classes, but her sentiments indicated that fashion was interfering with feminism in Canada. This is significant because while feminists did not actively pursue a program of dress reform in Canada, dress reform was a feminist issue.

There are instances which illustrate that Canadian women were not completely

30 Advertisement for rainproof bicycling dress with bloomers from *The Winnipeg Tribune*, July 1896.

unaware of the conundrum. In 1896, for example, a Mock Parliament of Women passed a resolution which prevented men from wearing knickerbockers when riding bicycles.[26] This was in reaction to comments about women riders who were wearing divided skirts so that they would not get tangled in chains and spokes. Alongside resolutions which dealt with more political issues, such as suffrage and equal pay for women, this resolution appears almost ludicrous, but it did stab at the root of the problem. There is a sense that these feminists were able to equate any small challenge to the status quo with sex equality. Indeed, the bicycle became a true symbol of women's emancipation. For dress reformers, the bicycle provided a vehicle for the future in more ways than one. (See illustration 30.)

In August of 1895 the *Ladies Journal* reported that Bloomers had begun to 'bloom' on Toronto streets, much to the horror of some men in the city who had to face the fact that women who wore bloomers had two legs. The *Ladies Journal* suggested other women would have to follow, albeit wearing divided skirts of good taste. This was assuming that ladies would know what good taste actually was, without need of the fashion advice offered by *Chatelaine* sixty years later during the Second World War, which dictated the need for good fit and faultless drape over the hips. 'How [could] they hold to the fast fading delusion that they are one-legged, when their emancipated sisters, mounted on steeds of rubber and steel [went] skimming over the asphalt, clothed in bloomers?' asked the *Ladies Journal*, demonstrating the changing role of women meant a change in fashion styles.[27] Before any erroneous conclusions are drawn about the sudden popularity of bifurcated garments at this time, however, this item should be viewed

within the context of another report which appeared in *Saturday Night* one month later.

In this article, *Saturday Night* announced that women were wearing breeches in Toronto. These were not the metaphorical kind, which were antithetical to Victorian values; these were made of cloth and were machine-stitched. Investigation had discovered that some women were wearing Syrian trousers, or modified 'gymnasium suits' in their homes.[28] There was the startling revelation that 'AT LEAST THREE HAD APPEARED ON THE STREETS!' 'Keep calm, my prejudiced friends,' the author wrote, 'two wore stylish street suits with abbreviated skirts, one with a skirt reaching to the boot tops, and the other with a skirt a couple of inches shorter. The third lady wore – dare I tell it – trousers, not of a manly cut, but of a voluminous flowing character.'[29]

Reformed dress did not appear in Toronto until 1895, but that does not mean that pressure for change had been dormant, although there is little evidence to suggest anything other than quiet activity by a few feminists. This may have been due, in part, to the lack of organization of Toronto feminist groups during this period. Between 1884 and 1889, for example, the women of the Toronto Women's Suffrage Association suspended their activity.[30]

Women in Canada were offered a fashion alternative about this time when the Empire style was revived in 1891-2. This style employed a high waist just under the bustline, and allowed for the use of a new foundation garment which was the forerunner of the modern brassiere. These 'short stays' did not compress the waist or abdomen. Patterns were available for the Empire dress and the necessary petticoat and short stays from *The Delineator*, an American fashion magazine which had Canadian circulation. But it seems that Canadian women were unimpressed with the costume.[46]

Women's magazines in Canada were usually Canadian editions of American periodicals, and it is probable that American journals such as *Godey's Ladies Book* influenced Canadian women about dress reform.[31] Canadian magazines such as the *Ladies Journal*, *Wives and Daughters*, and the *Canadian Queen* only mentioned dress reform and associated concerns on rare occasions, if at all.[32] As early as 1877 Clara Graham had prefaced her testimonial by suggesting that the *Public Health Magazine's* readers were probably sick to death of the issue and she would like a final word. Where all this discourse occurred remains a mystery, unless Graham was referring to American periodicals. The *Saturday Night* item on dress reform began by saying that the progress of dress reformers was seldom reported in Canada, leaving the impression that there was little thought on the subject. One conclusion might be that Canadian dress reformers simply stayed out of the public limelight; indeed, *Saturday Night* suggested that while 'our American cousins are given to much talking, and delight in publicity, it is the way of Canadian women

to say little, work quietly, and in the end accomplish just as much.'[33] And as Barbara Freeman notes in 'Laced In and Let Down' in this volume, Canadian female journalists were loathe to pursue the issue on any scale in the conservative Canadian press, which was probably another reason that the debate did not appear in Canadian women's periodicals.

Early in 1892 a well-known American dress reform advocate lectured in Toronto to an estimated crowd of one thousand. The *Globe* offered editorial comment by both male and female reporters. The male reporter described the men in attendance as 'the investigative types ready to be astonished at almost anything.' After listening to Elizabeth Jenness-Miller, he concluded that all men should encourage their wives, mothers, grandmothers, future wives, and daughters to become advocates of dress reform. Instead of an opportunity to ridicule the speaker, which was undoubtedly anticipated by some of the 'investigative types,' the men probably received a good dose of common sense.

Madge Merton, the female reporter, noted that most of her women readers had heard of Jenness-Miller, and observed that as they dragged their long skirts through the mud and snow they must have considered her 'brave and altogether lovely,' even if she 'looked a fright.' Jenness-Miller, however, wore dress that was pleasing to the eye, and fashionable in every sense. She had discarded corsets, and wore a divided skirt under a conventional dress. Toronto women who were in attendance were pleasantly surprised to discover that Elizabeth Jenness-Miller was not a radical, and that she was respectable in every way.[34] This was because Miller's style of reformed dress was inconspicuous.

Advocates of dress reform, of course, had a reputation for being extreme – a reputation caused in part by the shameful bloomer, which was an affront to modesty. Women who wore bloomers were trying to dress like men, and as a consequence, women who wore trousers threatened to tear apart the very fabric of society. Women who advocated dress reform so that they would be better able to work outside the home were also a threat to working-class men and professionals. These apparent threats may be the key to understanding why middle-class Canadian feminists were ambivalent about dress reform, even though there is every indication that they were aware of the consequences of wearing fashionable clothes.

Fathers and husbands may have tolerated and even encouraged wives and daughters to participate in temperance and suffrage associations, but it is highly unlikely that these men would have had the same attitude toward women wearing any form of radical dress to the meetings. For example, in 1895, six out of nineteen Toronto School Board trustees voted in favour of a motion 'that inspectors be instructed to report at the next meeting the names of all female teachers who have

been riding bicycles in male attire.'[35] It is important to note that the trustees were not only offended because the female teachers were riding bicycles, but also because the bicycle was condemned as a vehicle of passion since the women rode about unchaperoned and open to the most horrendous of temptations, no doubt fed by heated lower bodies and subsequent sexual desires. The trustees were equally scandalized because the women were wearing 'men's' clothing, and the female teachers were therefore trying to usurp the position of men through adopting male attire.

The Toronto teachers had the support of Dr Augusta Stowe-Gullen who was the first woman elected to the Toronto Board of Education, and who fought for the 'right of women teachers to dress according to their own preferences, free from the priggish dictates of a stiff-necked Board.'[36] But middle-class men wanted their women to be modestly and fashionably dressed, and it would have been a rare financially and emotionally independent woman who could thumb her nose at the house rules. Those who held the purse strings and enjoyed patriarchal privilege considered radical dress as a mockery to their dignity. This was one reason why Canadian doctors felt it necessary to influence men about dress reform. Some historians who have documented dress reform contend that the movement died because women were not willing to risk public ridicule, but this view fails to recognize the extent of pressure exerted in the private sphere. It may well have been that it was not Canadian feminists who were conservative as much as it was that their fathers, husbands, and employers were. And dress reform was always presented to Canadian women with that continued sense of respectability and outward appearance as the underlying theme.

The way women dressed exemplified their sexual subjugation to men and emphasized their reproductive role. The lack of freedom created by ostentatious dress displayed women's economic dependency upon men, and ensured women's secondary status. Dress reform was a motherhood issue, yet even for maternal feminists to embrace it would have meant in some ways a public denial of that very subjugation, status, and reproductive role which society saw as women's place, and with which most women were comfortable. The fashionable trappings of the period reinforced the tenets of maternal feminism, and provided visible evidence of submission to the physical and philosophical limitations. This and women's slavish concerns about fashion, modesty, and appearances were an effective barrier to any true emancipation. Until women themselves broke the actual and figurative chains associated with Victorian dress, there could be no real freedom.

Elizabeth Phelps explained in *What to Wear* that dress reform would not be achieved until women recognized that they had 'mistaken the outpost for the enemy and the skirmish for the battle.' Nellie McClung echoed the same senti-

ment when she argued that 'the physical disabilities of women which have been augmented and exaggerated by our insane way of dressing has had much to do with shaping women's thought.'[37] Both comments presented an interesting paradox. Emancipation depended on a greater understanding about women's condition in a patriarchal society, yet such thoughts depended on real physical freedom, which would not happen without more dynamic thought by the women themselves.

This raises one final point. It is relatively easy for feminist historians in the twentieth century to attribute reasons to nineteenth-century behaviour, but it is also important not to assign contemporary feminist premises and goals to Victorian women. Judgmental conclusions serve no useful purpose. While second-wave feminists of the twentieth century rallied around bonfires to burn their bras, it is impossible to imagine nineteenth-century feminists carrying banners made of scorched corsets as symbols of their subjugation. After all, the women of the 1960s and 1970s had freedoms that Victorian women struggled for and could only dream of. Perhaps dress reform was among those dreams of social and political change that earlier feminists hoped to achieve with the vote; but, for the moment, it was too much to be hoped for.

NOTES

1 Graham, 'Dress Reform,' 308–10.
2 Woolson, ed., *Dress and Health*. The price of this volume was 30 cents.
3 Ibid., 9.
4 Roberts, 'The Exquisite Slave,' 557.
5 Mrs Margaret Oliphant, *Dress*, quoted in ibid., 557–58.
6 Denison, 'Reform in Women's Dress.'
7 Russell, 'Survey of the American Dress Reform Movements of the Past,' 8.
8 *Springfield Republican*, 12 June 1851, quoted in Lauer and Lauer, *Fashion Power*, 249–50.
9 Denison, 'Reform in Women's Dress.'
10 This move toward changing how women dressed should not be confused with the simple dress of women involved in communal living, especially in those settlements which espoused equality of the sexes and free love. There was often a religious basis to these communities, and women wore simple dress because their Christian ideals opposed ornamentation and ostentation. In Great Britain there were similar societies, such as that described by Canadian feminist Alice Chown in her autobiographical account, *The Stairway*. At Garden City, Chown discovered that how women dressed was a matter of personal choice, but there was no effort to effect true reform.

11 Newton, *Health, Art and Reason*, 4, 5. There was one music-hall song which had
 twenty-two verses and which ended:
 > Yankee Doodle Doo,
 > Rolling in the ditches,
 > Married men prepare,
 > To buy your women the breeches.
12 Brett, *Women's Costume in Ontario*, 8.
13 Phelps, *What to Wear*, 25.
14 Watts, 'On Taste in Dress,' 56.
15 *Canada Medical Record* (1880), 216; Woolson, *Dress and Health*, 27; Graham, 'Dress
 Reform,' 310.
16 Smith, 'Gynecology and Obstetrics,' *Canada Medical Record* (1889).
17 Shannon, *Nature's Secrets Revealed*, 177.
18 Since poorer women were more likely to suffer from the debilitation caused by
 annual pregnancies, malnutrition, and overwork, it was improbable that they were
 healthier.
19 *Canada Medical Record* 8 (1880), 216.
20 One radical feminist had an ideal solution to the problem of immoral dress. Since
 clothes were so provocative, she suggested nudity should be encouraged (Reigel,
 'Women's Clothes and Women's Rights,' 397); Green, *The Light of the Home;* 121–2.
21 Woolson, *Dress and Health*, 116–17.
22 'Dumpy Women,' 9; 'A Dangerous Introduction,' 4.
23 Smith, 'Gynecology,' 73.
24 McClung, *In Times Like These*, 63.
25 National Council of Women of Canada, Report of the Annual Meeting, May 1895,
 182.
26 Roberts, 'Rocking the Cradle for the World, 21.
27 'The Bloomers, Long May They Bloom,' 8.
28 Syrian trousers were the same as Turkish-style bloomers. This name was often used by
 the Rational Dress Society of Great Britain who promoted this type of costume.
29 'Dress Reform in Toronto,' 7.
30 Cleverdon, *The Woman Suffrage Movement in Canada*, 24.
31 See Kunciov, *Mrs. Godey's Ladies*, 54. Kunciov notes that *Godey's* carried letters
 alternately attacking and defending corsets and fashion.
32 The real difficulty is availability. Microform copies cover the period only from 1884
 to 1896 for the *Ladies Journal*, 1890 to 1892 for the *Canadian Queen*, and 1890 to
 1892 for *Wives and Daughters*.
33 'Dress Reform in Toronto,' 7.
34 *Globe*, 7 January 1892, 4. The newspaper incorrectly reported her name as Elizabeth.

Sisters Mabel Jenness and Annie Jenness-Miller were both active reformers who lectured and wrote extensively on physical culture and dress. The author probably confused the name with Elizabeth Smith Miller, an American feminist who wore trousers.

35 Quoted in Lenskyj, 'Physical Activity for Canadian Women,' 208.
36 Roberts, 'Six New Women,' 148.
37 McClung, 'Gentle Lady,' 62.

SELECTED BIBLIOGRAPHY

Primary Sources

'The Bloomers, Long May They Bloom.' *Ladies Journal* (Toronto), August 1895, 8.
Chown, Alice A. *The Stairway*. Toronto: University of Toronto Press, 1988 (first published, Boston, 1921).
Cobbe, Frances Power. 'The Little Health of Ladies.' *New Dominion Monthly*, April 1878, 443–58.
'A Dangerous Introduction.' *Wives and Daughters* (London, ON), May 1891, 4.
Denison, Flora MacDonald. 'Reform in Woman's Dress.' From lectures given at suffrage meetings, *c*. 1913, box 2, Papers of Flora MacDonald Denison, Thomas Fisher Library, University of Toronto.
'Dress and Health.' In Literary Notices, *New Dominion Monthly*, December 1875, 451–56.
'Dress and Health: or How to Be Strong.' Review, *Public Health Magazine* 1, 1875, 172–73.
'Dress As It Is.' *New Dominion Monthly*, August 1876, 296–300.
'The Dress of Girls.' *New Dominion Monthly*, April 1876, 154–55.
'Dress Reform,' *Wives and Daughters* (London, ON), September 1892, 1.
'Dress Reform in Toronto.' *Saturday Night*, 7 September 1895, 7.
'Dress Reform at the World's Fair,' *Review of Reviews* (New York), 7, 1892, 312–16.
'Dumpy Women.' *Ladies Journal* (Toronto), August 1884, 9.
'Folly and Extravagance in Women's Dress.' *Saturday Night*, 7 December 1918.
'Frances Willard on Dress Reform,' *Wives and Daughters* (London, ON), September 1891, 2.
'The Glass of Fashion.' *Wives and Daughters* (London, ON), June 1891, 4.
Graham, Clara. 'Dress Reform,' *Public Health Magazine* 2, 1877, 308–10.
McClung, Nellie. 'Gentle Lady.' In *In Times Like These*. Toronto: University of Toronto Press, 1972.
'Modern Mannish Maidens,' *Blackwood's Magazine* 147, February 1890, 252–64.

'A New Dress Reform.' *Ladies Journal* (Toronto), August 1891, 11.

Paget, W. 'Common Sense and Dress in Fashion,' *Nineteenth Century* 13, March 1883, 458–64.

Phelps, Elizabeth Stuart. *What to Wear*. Boston: James R. Osgood and Company, 1873.

'The Petticoats Must Go,' *Ladies Journal*, (Toronto), October 1890, 9.

Russell, E. 'Survey of the American Dress Reform Movements of the Past.' *Wives and Daughters* (London, ON), September 1892, 8.

Shannon, Professor T. *Nature's Secrets Revealed: Scientific Knowledge of the Laws of Sex Life and Heredity or Eugenics. (Together With Important Hints on Social Purity, Heredity, Physical Manhood and Womanhood.)* Reprint of 1917 edition. New York: Doubleday, 1970.

Smith, A. Lapthorn. 'Gynecology in General Practice.' *Canada Medical Record* 19, 1891, 73–76.

Smith, Goldwyn. 'Woman's Place and the State.' *Forum* (New York) 8, 1889–1890. (CIHM 33516).

'Tight Lacing,' *Ladies Journal* (Toronto), December 1895, 8.

Watts, J.F. 'On Taste in Dress,' *Nineteenth Century* 13, January 1883, 45–57.

Woolson, Abba Goold, ed. *Dress and Health: How to Be Strong*. Montreal: J. Dougall 1876. (Canadian Institute for Historical Reproduction, CHIM No. 06242).

Secondary Sources

Bacchi, Carol Lee. *Liberation Deferred? The Ideas of the English Canadian Suffragists, 1877–1918*. Toronto: University of Toronto Press, 1983.

Brett, K.B. *Women's Costume in Ontario, 1867–1907*. Toronto: Royal Ontario Museum, 1966.

– *Modesty to Mod: Dress and Undress in Canada, 1780–1967*. Toronto: Royal Ontario Museum, 1967.

Cleverdon, Catherine L. *The Woman Suffrage Movement in Canada*. Toronto: University of Toronto Press, 1974.

Cook, Ramsay, and Wendy Mitchinson, eds. *The Proper Sphere: Women's Place in Canadian Society*. Toronto: Oxford University Press, 1976.

Gorham, Deborah. 'Flora MacDonald Denison: Canadian Feminist,' in Kealey, ed., *A Not Unreasonable Claim*.

Green, Harvey. *The Light of the Home: An Intimate View of the Lives of Women in Victorian America*. New York: Pantheon, 1983.

Kealey, Linda, ed. *A Not Unreasonable Claim: Women and Reform in Canada, 1880s–1920s*. Toronto: Women's Press, 1979.

Kunciov, Robert. *Mr. Godey's Ladies: Being a Mosaic of Fashions and Fancies*. Princeton: Pyne Press, 1971.

Lauer, Janette C., and Robert H. Lauer. *Fashion Power: The Meaning of Fashion in American Society.* Englewood Hills, NJ: Prentice Hall, 1981.

Lenskyj, Helen. 'Physical Activity for Canadian Women, 1890–1930: Media Views.' In J.A. Mangan and Roberta J. Park, eds., *From Fair Sex to Feminism: Sport and Socialization of Women in the Industrial and Post-Industrial Eras.* London: Frank Cass and Company, 1987.

Macdonald, Anne L. *No Idle Hands: The Social History of American Knitting.* New York: Ballantine, 1988.

Mitchinson, Wendy. 'Causes of Disease in Women: The Case of Late 19th Century English Canada.' In S.E.D. Shortt, ed., *Medicine in Canadian Society: Historical Perspectives.* Montreal: McGill-Queen's University Press, 1981.

'Mrs. Bloomer, Her Bid for Dress Reform,' *Saturday Night,* 10 September 1927, 30.

Newton, Stella Mary. *Health, Art and Reason: Dress Reformers of the 19th Century.* London: John Murray, 1974.

Reigel, Robert E. 'Women's Clothes and Women's Rights.' *American Quarterly* 15, no. 3 (1963): 390–401.

Roberts, Helene E. 'The Exquisite Slave: The Role of Clothes in the Making of the Victorian Woman.' *Signs* 2, no. 3 (1977): 554–69.

Roberts, Wayne. 'Rocking the Cradle for the World: The New Woman and Maternal Feminism in Toronto, 1877–1914.' In Kealey, ed., *A Not Unreasonable Claim.*

– 'Six New Women: A Guide to the Mental Map of Women Reformers in Toronto.' *Atlantis* 3, no. 1 (1977): 145–64.

Rush, Anita. 'Changing Women's Fashion and Its Social Context.' *Material History Bulletin* (Spring 1982), 37–46.

Simpson, Valerie, ed. *Women's Attire.* Saint John: New Brunswick Museum, 1977.

Strong-Boag, Veronica. 'Canada's Women Doctors: Feminism Constrained.' In Kealy, ed., *A Not Unreasonable Claim.*

Wilson, Elizabeth. *Adorned in Dreams: Fashion and Modernity.* London: Virago Press, 1985.

Fashion and War in Canada, 1939–1945

SUSAN TURNBULL CATON

Popular slogans from the Second World War epitomized the mood and intentions of the Canadian people: 'Shoulder your share,' 'If YOU waste THEY want,' 'She serves that men may fly,' and 'Eat it up, wear it out, make it do.' The nation was encouraged to set aside individual concerns and issues, to work for the overall good and the common cause. Sylvia Fraser's history of *Chatelaine* magazine points out that both Canadian men and women 'projected their energies and anxieties overseas.' Women were encouraged to serve their country in some way, as part of their patriotic duty. The campaign to mobilize women to do their share in the war effort had a strong effect, as illustrated in a September 1942 issue of *Saturday Night* magazine, where one woman commented, 'Like most other school-teachers I often wish that my daily routines were a little more obviously connected with the great conflict that is involving the whole world.'[1] In Ruth Latta's collection of Canadian women's wartime memories, Pat Boreham Vaisey recollected that 'I felt a crying need to do more ... There must be a way for me to be a more effective person to serve my country in its fight to restore freedom and democracy in Europe.'[2]

Thousands of hours of volunteer work were given. Many women joined the paid workforce for the first time, in commerce, agriculture, industry, and war production, where they filled the gap caused by men going overseas. They also became members of the women's branches of the Army, Navy and Air Force, and groups such as the Canadian Red Cross.

In light of the critical nature of the work, some aspects of daily life, such as fashion, might be considered frivolous or of lesser importance. Why would people be concerned about their personal appearance when the war overseas was brought so frighteningly close to home through the daily press and radio broadcasts? Fashion is profoundly affected by war. The relationship may not be a direct one: the social upheaval resulting from war is frequently cited as the outcome of war that in turn affects fashion. James Laver, who wrote extensively about the effects of war on fashion, described a main factor as one of 'drastic simplification.'[3]

For some time, theorists and writers on fashion have argued that because of the immensity and importance of the larger concerns of war, fashion concerns fade in importance, and may even disappear. Earlier histories of the Second World War support the premise of the absence of fashion: some authors tell us that fashion was non-existent during the war years. Some blamed government regulations as being responsible for 'no real fashion changes in the period.' Quentin Bell believed that the 'New Look' of 1947 was very similar to the styles of 1939, describing it as a 'natural continuation of the pre-war styles.'[4]

Fashion has often been described as having skipped over the war years to carry on afterwards as if there was no gap in time. In the United States, the General Limitation Order L85, which limited the amount of fabric and style details manufactured, 'effectively froze the fashion silhouette.'[5] The prevailing point of view from fashion historians is illustrated in their own words: Dorner believed that during the Second World War, 'fashion [was] halted ... until the war was well and truly over'; 'fashion implies freedom of choice,' wrote Ewing, and this was non-existent under the influence of government controls; and Murray, in *Changing Styles in Fashion* noted that there was 'not much time for fashion. Pure function was the rule of the day.'[6]

Similar examples can be drawn from Canadian literature. Canadians were described by *Chatelaine* as 'a warring people away from the war' and were told to expect 'simple and quiet clothes, ... for the clothes women wear are, and have been for generations, the barometer of the times.' In a January 1942 issue, *Maclean's* Magazine reminded its readers that clothing and cosmetics were made of commodities that ranked high on the war priorities list, implying that other end uses were more critical. Important clothing-related materials such as rubber, metal, and silk were being either redirected to the war effort or reaching the end of supply stocks due to trade restrictions and import closures. Others items were to follow. Initially, 'girdles, garters ... and bathing caps' would be in short supply, while only metal zippers and garter clips were allowed in apparel production. With greater limitations of supplies, the public was being prepared for the inevitable slowing of fashion changes and their likely 'disappearance.'[7]

It would seem from these references that fashion and war did not coexist during the Second World War. However, more recent scholarship has countered this assumption, maintaining that fashion continued with its ever-changing face, through the duration of the war and beyond.[8] In France, the very heart of international fashion, nearly sixty couture houses continued to operate during the Nazi occupation, and the German resolve to move the fashion industry to Berlin was thwarted.[9] At the same time, New York grew in stature, and fashion pundits began to question whether it might take over as the fashion centre. The English government asked the Incorporated Society of London Fashion Designers to

develop styles for the Utility Clothing program, made from Utility fabrics, that met the restrictive requirements of government regulations. Hardy Amies, Digby Morton, Victor Stiebel, and Norman Hartnell, among others, submitted designs to the Board of Trade, and the selected models were mass-produced. The outcome posited English clothing as fashionable and attractive, even while operating under wartime controls.[10] The Canadian experience did not differ dramatically from that of the other Allies.[11] A cursory glance at Canadian newspapers and other periodicals of the wartime period reveals many fashion features and fashion columns. If fashion stopped for the duration of the war, what was the purpose and content of these writings? Do the columns and features provide evidence that fashion did exist throughout the war years? These questions form the basis for this inquiry, which seeks to explore the trail of Canadian fashion in the print media during the Second World War.

To establish the existence of fashion during the 1939–45 years, it is important to identify the characteristics and factors that mark its presence. The word 'fashion' is understood to be either an object or a process. As an object, fashion is commonly defined to be a style that is accepted by a large group of people at any one time. This differentiates it from clothing styles that appeal to a small group of people, which are quickly adopted and abandoned, and are known as fads. Fashion as a process refers to the social forces that constantly create new styles and cause styles to be accepted, then eventually rejected for yet newer offerings.[12] It encompasses the creation and development of new ideas, the transformation of ideas into tangible garments, the offering of several options to the buying public, and the somewhat vaporous selection of the styles chosen that then become fashion. Understanding the definition of fashion is helpful. However to ascertain the presence of fashion, its notable components should be examined.

General descriptions and reports of fashion are common. They include narration of new lines, collections, and seasons, or accounts of designers themselves. The language used frequently includes words such as 'new' to describe fashion images.

Fashions, singularly or as a group, are also concrete objects. Here, the elements of description include the style (for example, the length of skirt), garment details (such as a preponderance of side zippers), the design (a specific combination of style and detail), fabrications (as velvet versus polished cotton) and, perhaps most importantly, colour (for example, khaki versus forest green).

We understand, of course, that none of these factors describe truly new objects. Rather, they represent fashions with features that differ, or are presented in different combinations, from those already available in the fashion world. Dior said it succinctly: 'We invent nothing, we always start from something that has come before.'[13] In this way, fashion as process continues. In both general descrip-

tions and specific detailing, fashion is written about, referred to, and often heralded as a welcome and desirable change in our lives.

During the war years, the Wartime Prices and Trade Board (WPTB) was responsible for the control of all goods and services in Canada. Its control embraced supply allocation, manufacturing capacity, and labour allotment; product design including prohibition of some design details; product change regulations; product and service distribution; and prices.[14] Working under the terms of the War Measures Act, the WPTB was formed immediately upon Canada's declaration of war in September 1939. It was feared that a high rate of inflation, similar to that of the First World War, would occur as the Canadian labour force and resources were rapidly mobilized. The board chairman, Donald Gordon, reported directly to the federal minister of finance, and the board had the ability to promulgate its own administrative orders and regulations. Spence notes that the WPTB 'control[led] the price, supply and distribution of the necessaries of life.'[15]

The WPTB developed a two-part strategy to deal with the war shortages of labour, production, and material: controls on both prices and supply.[16] The price controls were particularly critical for the garment trade, as it is an industry where styles constantly change. In 1941, a three-week period in September/October, known as the Basic Period, was selected as a measuring benchmark when prices were recorded. All consumer prices, including those for clothing, were held constant to prevailing levels at that time. A second period in the spring of 1942 was used to mark the prices of new seasonal clothing fashions. In this way, fall/winter and spring/summer fashion price ceilings were set.

A system of economies and simplifications was also instituted in an attempt to reduce production costs and help stem the supply shortage problem. Some garment categories such as coats, jackets, and pants were in direct competition with military clothing requirements for manufacturing capacity and fabric supply. The standardization of garment styles, and limits on line variety, design details, and amount of fabric per garment were all part of the simplification program. According to the WPTB's administrator of women's coats and suits, more economical production practices and clothing design simplifications were responsible for providing thousands of additional garments by ensuring year-round production and reducing the apparel industry's inherent risk of lessened production in some periods of a year.[17]

The effect of these measures was to reduce the number of available styles, silhouettes, and colours, and control garment dimensions. For example, new men's suits lost their trouser cuffs and double-breasted jackets were replaced by single-breasted designs. The measurements of women's skirt hem's depth and circumference were limited.[18] The conservation and simplification measures were justified by the WPTB as steps necessary to eliminate wasteful or dispensable clothing

features in terms of material shortages.[19] The WPTB further noted that 'freezing of styles and other limitations on styling have been applied as general simplification measures which assume importance because of the traditionally seasonal fluctuations in certain branches of the textile industry.'[20]

In the later years of the war the Canadian controls became especially troublesome to apparel manufacturers who wanted to sell garments in new styles. In 1944 the style-freezing orders had just been lifted by the WPTB and the buying public was expecting to see substantial fashion changes. However the WPTB was still not allowing Canadian manufacturers to produce styles that were significantly different from those in the basic comparison period of 1941–42. The Manufacturers Council of the Ladies' Cloak and Suit Industry for the Province of Quebec cited the problem of wanting to add embroidered trim on women's coats: 'furs have been eliminated [by the WPTB] on account of high prices. [However] substituting embroideries for fur, thereby reducing prices to consumer, eg. $30 fur collar, replaced by $7 embroidery [is prohibited]. The WPTB does not permit the use of embroidery on a new style if the cost of such embroidery is greater than on a similar garment authorized in the basic period, or, where no embroidery was used before on a garment indicated for comparative cost.' The Cloak and Suit Council wanted permission to develop cost sheets for new styles that could be trimmed with embroidery. They also wanted to 'include buttons, braiding, ornaments, or any other embellishment ... [that] will enhance the style-value of ladies' coats and suits.'[21] Unfortunately, no reply to this request is filed in the National Archives of Canada. Clearly the WPTB was moving cautiously as its control was slowly being lifted from Canadian life.

To understand Canadian fashion during the Second World War, references to both general and specific fashion reports and descriptions have been considered. Fashion topics can be found in different public media, including all manner of periodicals and, where they exist, radio transcripts. Newspapers and magazines offer visual and textual records of the times. Dailies provide us with the quickly changing nature of news, while monthlies or bi-weeklies are more likely to offer evidence of building trends and general movements. This essay draws from *Chatelaine* magazine as the foundation for extensive analysis. The material found there was supplemented with features and information from additional Canadian primary sources.[22]

Chatelaine was chosen because throughout the war years it was a nationally read magazine that dealt directly with issues of concern to Canadian women. In November 1939 editor Byrne Hope Sanders noted the magazine's intention was to offer a periodical that would give some 'dramatically interesting' and 'entertaining' content for its readership and to offer some diversion from the war itself. However, she also hoped to provide helpful advice, to 'grapple with ... problems' to be faced

during the war years. In the 1939–45 period, the content of the magazine included general articles, fiction, and regular departments. Feature articles included ones on Canadian women in the three military branches returning to the workforce, and recruitment for volunteer Red Cross activities. The regular departments usually encompassed the subjects of foods, housing, clothing, child rearing, and personal health.

As a typical woman's magazine, *Chatelaine* was not centred on fashion, but importantly it has always included fashion in its regular offerings. From the start of the war until the middle of 1943, the department called 'Beauty Culture' contained fashion information. It also offered information on such topics as skin care, but was mainly fashion-focused. The section title changed to 'Fashion and Beauty' in June 1943, to 'Fashion' in November of the same year, and by January 1945 returned to 'Beauty Culture' again. While the section title changed, fashion continued as an inherent part of the magazine.

Chatelaine never published an issue during the war without a fashion column or feature. Clearly the magazine was interested in continuing its coverage of fashion and its subscribers were keen to read it. Fashion editor, Carolyn Damon, often by-lined two or three articles per issue, while from New York, fashion writer Kay Murphy kept readers abreast of American fashions in her 'Fashion Shorts' column. Fashion did not lose its international flare and was of keen interest to Canadians.

If fashion ceased during the war years, as many authors would have us believe, then what purpose would these fashion columns serve? Interestingly, many magazine and newspaper section titles included the word, and the concept, of fashion. Women's magazines, newsmagazines, and newspapers alike continued with their regular fashion columns throughout the war years. They also featured fashion stories, such as the style restrictions set out by the WPTB. Sketches of new designs, suggestions of how to wear them, and detailed descriptions of accessories were continuously evident. Included in this study were reports of new fashion lines, collections, and seasons; accounts of designers; and language indicating new or different fashions. New styles, details, designs, fabrications, and colours were sought out, in image or text form. *Chatelaine* provided a suitable field in which to search for fashion evidence.

The actual word 'fashion' was continuously used, in titles, captions, and text: 'Fashion Shorts,' fashion forecasts, the new fashion, *Chatelaine* fashions, fashion trends, the fashion picture, fashion news, fashion fabrics and fashion colours. Sometimes the concept of change, that inevitable fashion process, was directly tied to the word. In January 1940, the *fashion cue* was determined to be the shift from working woman to evening's 'lovely lady ... during this strange new year of grace and gravity.'[23] Murphy wrote that there was 'a new attitude toward fashions' in January 1941, reflecting the longer life of fashion designs already in the wardrobe.

Articles and advertisements frequently mention fashion news for the upcoming season, such as the 'spring fashions,' 'new for fall,' or in fashion 'this summer as never before.' There were 'new clothes,' 'gay new Canadian designs for '43,' and 'the new fall look.'

While the word 'fashion' was consistently sprinkled throughout features and advertisements, the context changed to reflect the war. 'Today we think more seriously, and so we dress more seriously.' In February 1942 the Simplicity Pattern Company declared that 'simple clothes are smart clothes.' With that philosophy, one might expect fashion change to slow considerably. In contrast, fashions were seen as a 'relief from the soberness of today's world.'[24]

The ability of clothing to influence mood and attitude was not forgotten. Kay Murphy's 'Fashion Shorts' column referred to more than new fashion trends. She made a case for the importance of fashionable dress in the May 1942 column by offering the opinion that women must be 'prettily dressed' for their own morale and that of the service men. And, with a nod to the ever-increasing percentage of women working, 'women won't work their best unless they look their best.' This belief was echoed by those wearing uniforms. 'It has always been perfectly understood by a woman that her morale can be raised or lowered by the clothes she wears.'[25]

L. Dempsey, a writer for *Chatelaine*, dealt directly with the impact of the war on fashions in February 1940. She predicted that Canadians would follow the lead offered by the 'allied sisters' in the adoption of conservative clothes, and at the same time reminded Canadian women to offer as attractive an image as possible for the men going off to war. In February 1941 four points were listed as influencing the style forecast for the year ahead: reduction in imports, proliferation of uniforms for men and women, the increased practice of home sewing, and the general attitude toward the war.[26] And in September 1942, an article entitled 'Fashion's New Code' listed the main WPTB design restrictions or eliminations next to Simplicity pattern sketches that illustrated the regulations in practice. *Chatelaine* offered the conviction that designers 'take less to work with and do more with it than we've seen in many a moon.' 'Ration-Fashion or The Buttonless Vogue' was the title of a delightful poem portraying the impact of the clothing restrictions, printed in April 1942 by Carolyn Damon. In the second verse she wrote: 'And a zipperless outfit with swagger and dash, is the Spanish bolero tied up with a sash.'[27] Even clothing that followed WPTB decrees could be fashionable.

Conservation crossed many elements of Canadian life. In clothing, it was described as the fashion watchword. Murphy underscored the conservation theme, noting that 'whatever is available is fashionable.' Citizens were told not to stock up on extra clothing. It was a very practical point: why bother with clothing 'put aways' – when one pulls them out of the closet to wear, 'they'll be as old-fashioned

as rats in your hair.' Readers of *Saturday Night* magazine were exhorted to buy judiciously, as it was 'more important than ever because none of us can afford to regard lightly the 'little mistakes' that used to be shoved far back in the clothes closet and piously forgotten.'[28]

Fashion designs from the Simplicity Pattern Company's were featured on one or two pages each month, a firm sign of the popular swing to sewing. Canadian women were making clothes, sewing and knitting for themselves, for soldiers, and for refugees overseas. Remaking old clothes was a critical part of the conservation thrust in Canada. The 'Make-Over and Make-Do' campaign of Great Britain was echoed in Canada as 'Sew ... Save ... Serve,' and the popularity of the WPTB-sponsored remake centres across Canada was tremendous.[29] In dozens of Canadian cities the centres were flooded with applications to enrol in the free classes, taught by qualified dressmakers and designers, to learn the art of transforming old, unused garments into new fashionable styles. Both material and labour were conserved by this move to increased home production. Women set to, making new fashions out of old: old housecoats, suits, and coats. *Chatelaine* offered many before and after examples for its readership, including the something-for-nothing approach of transforming household textiles such as tablecloths or draperies into clothing. Men's suits in particular became targets for the make-over scissors, for they held enough material for new dresses, blouses, vests, and many items of children's apparel. *Chatelaine* was the first magazine on the continent to publish patterns for remaking a man's suit into one for a woman.[30]

The language of war also transferred itself to the world of fashion: 'Canada's busy woman of today needs clothes that *register for service*' in October 1940; 'we've *joined the navy* for spring' in February 1941; and '... our clothes are *on the alert*' in April 1944. The military influence in womenswear was constantly referred to, with buttons, braid and *furlough fashions* in abundance (November 1942). The *patriotic touch* was the description of the printed fabrics featured in May 1940, along with the *bravest* colours you ever saw (March 1944). Designers were offering *front line* autumn smartness (August 1941). Spring coats were said to *advance to a new front line* in February 1944.

Duration clothes on this side of the Atlantic were defined as fashions that would last over several seasons of wear, such as quilted outer garments, and wind and water resistant cotton poplins (November 1942). Even individual designs were named, such as the 'Wartimer' (April 1943), a British designed, straight-lined overcoat (see illustration 31). A phrase that seemed to last throughout the wartime was that of *blackout fashions*. They were primarily white accessories, such as gloves, socks, hats, umbrellas, or light-coloured jackets and outwear that allowed one to be seen in the street during blackout conditions. They were described as being worn in England, Paris, and New York at various times during the early 1940s.

31 The 'Wartimer' – a raglan-sleeved coat model designed for the duration. (Courtesy of *Chatelaine* magazine, April 1943 © Rogers Media)

In the early months of the war, readers wrote *Chatelaine* to ask whether Parisian fashions were available in North America, and the answer was yes. Prior to the fall of Paris in June 1940 the new fashions were seeping through and, according to Kay Murphy, 'they tell me that the French Government is chartering ships to see that America still gets her share of the wartime fashions.'[31] Following the German occupation of France, the Nazis planned to move French haute couture to Berlin and Vienna, however this did not happen. While some French designers continued to work in Paris, others closed their doors in the face of collaboration with the enemy, German textile manufacturing restrictions, and fabric rationing. In the early months fashion news still trickles through, but, not long afterwards it was reported that 'Today Paris is blacked out as a style centre, with the news that comes from couturiers there ominously by-lined "via Berlin."'[32]

There were reports of many English designers who managed to continue to produce new collections of their designs. The works of Digby Morton and Norman Hartnell were part of the 'exciting influx of trunkfuls of that beautiful tailoring only London can do.' Hartnell, who became one of Queen Elizabeth's favourite designers, continued to design throughout the war and Canadians continued to learn about his work as discussed in an article that read: 'Hartnell of London, still amazing us with his marvellous fashions ... this year sequins on tweeds.'[33]

As direct news of European designers and their seasonal collections lessened, two things of importance happened in North America. First, New York took on the larger role of fashion leadership; American designs were welcomed as the newest news in fashion. In September 1940 Canadians read that 'with Paris out of the fashion picture, we're going North American in a big way.' Columnist Kay Murphy wrote: 'All the fighting is not taking place "Over There." Here in New York various fashion schools of thought are waging bitter battle over the theme we should follow for the coming season (fall 1941).' She felt that the fashions would not be completely plain and stark, but 'we will cut out most of the fripperies.' Two years later she continued her observations about American designs with: 'this war has put the fashion designers on their mettle.'[34] New York was seen as the central stronghold of American fashion due to the existing size and longevity of the garment industry in that city. In 1944 *Chatelaine* was wondering whether Paris could ever regain its position as international fashion capital, given the growing strength of New York. But by the December 1944 issue, there were references to the Paris openings once again.

As a second result of the war, recognition and optimism for the future of Canadian fashion was growing. 'The French influence in Canada should contribute much toward carrying on the french tradition of French couture in the Western Hemisphere.'[35] The textile industry also came in for praise, with 'lots of lovely fabrics in Canada' (February 1941). Absence of sourcing from abroad

benefited Canadian textile print designers: 'one of those good things that happened when we couldn't get the designs and colors we wanted from abroad.'[36] Canadian designers and manufacturers were written about and their designs were featured in *Chatelaine*. The magazine predicted that 'the Dominion was going to stop following Paris and New York slavishly, and formulate some of her own ideas for clothes, the kind that Canadian women need and like.'[37] The fashion columnist of *Saturday Night* agreed:

> Until the beginning of the recent war, Canadian buyers and consumers chose fashions designed in New York, Paris or other world fashion centres. It was not until wartime restrictions on imports forced Canadians to fall back on their own resources that the ingenuity of native designers came to the fore. Wartime dresses had to use only as much material as the WPTB would allow, but Canadian textiles were second to none in quality and the designer produced many variations within the scope of the regulations.'[38]

In general, the fashion features and columns of *Chatelaine* tended to be prescriptive in their treatment of the subject: this is what is happening in the fashion world, this is what will be considered fashionable, and these are the influences on the trends. The writing emphasized the relationship between fashion and the war, with fashion serving as a symbol of patriotism. Canadian women were seen to be fashionable, and patriotic, by wearing styles that incorporated the restrictions of the Wartime Prices and Trade Board. Women could support the war effort by conserving labour and materials, and support the Canadian economy by being judicious in purchases of new garments. They were considered fashionable in their desire to look efficient and capable, to work on the home front, and, at the same time, to recognize the importance of looking their best for the boys overseas and at home.

Also in *Chatelaine* were numerous examples of individual fashions, manifested in varying styles, design details, fabrics, and colour. In general, examinations of fashion over time target changing styles and silhouettes. Even during the Second World War, these changes are quite visible. In the months leading up to the war, fashion experts were predicting two different looks: a strong hourglass figure shape and, in contrast, a long line effect. However, the war intervened and made its mark on all consumer products, including fashion. Women's fashions changed course. Initially, they were rather sombre in line, to indicate that those left at home were as concerned about the conflict as those in the midst of it.

Women's styling mirrored the influence of uniforms, a reflection of the surrounding culture. Ruth Pierson suggests that the uniform for the Canadian Women's Army Corps (CWAC) was viewed with a certain fashion envy, citing

several sources that described it as the smartest of the women's uniforms.[39] Women's civilian clothing was described in January 1941 as 'cleverly tailored [for] military slimness' and phrases such as 'military precision' and 'as jaunty as any soldier' were used. The styles clearly projected the military influence. There were capes on suits and coats, strong square shoulderlines, large useful pockets, and rows of centre front buttons.

Clothes for women reflected their working roles, whether busy in the massive volunteer movement or in paid employment in business, government, or industry. The uniform's ability to unite people in a common cause was mirrored in civilian clothing, as many manufacturing firms developed their own uniforms for their workers. Comfort and safety were paramount. Styles for these working women included comfortable low heels, short-sleeved blouses, slacks, and some kind of hair bandanna or snood.

Fashions were 'gracefully feminine' throughout the summer of 1940, and moved into a very narrow silhouette for the fall. Frivolity was passé, as a more tailored look became popular. By the spring of 1941, the hard shoulder padding was decreasing, and the suits offered a 'feminized tailoring.' Skirts narrowed and shortened slightly. That August the well-dressed woman would sport 'slim hips, a softer shoulder, lower heels, ... [with] skirts a teeny bit longer.' Lapels narrowed somewhat, and a collarless line was popular for dresses and some jackets, reflecting economy of cloth. After clothing restrictions were introduced, less fabric was being used, resulting in fewer gores in skirts, no extra pleats, an A-line silhouette, and less fabric overlap in bodice cuts. As summed up by Damon in October 1942, 'The silhouette ... is slimmer, narrower, shorter.'[40]

Suits represented a big wartime fashion story (illustration 32). They were practical, offered several mix-and-match possibilities, and could be easily changed from a day to an evening look. Suits, and their jackets, were described as being a Canadian tradition. The suit established itself as the major clothing staple, and blouses came into their own. The popularity of spring suits even overtook that of coats and dresses in 1942. The ingenuity of design turned its attention to fashion details such as trim and accessories. The over-all style changed subtly during the next months, as 'suits were holding the attention in New York fashions these days.'[41] Skirts, however, were shortening and jumpers found their way onto the fashion pages.

'We're changing our mind about slacks,' announced *Chatelaine* in April 1942. The growing popularity and social acceptability of slacks was certainly one of the biggest fashion stories of the war. Before the 1940s, slacks for women were worn infrequently, most often in two extreme circumstances: for heavy work such as farming chores, or for leisure, especially in warm weather or for 'down south' exclusive holidays. By 1943 serving members of the Women's Division of the

32 One of the biggest wartime stories: skirt suits became a civilian uniform. (Courtesy of *Chatelaine* magazine, April 1942 © Rogers Media)

Royal Canadian Air Force were given permission to wear slacks to social events on stations, and WREN Helen Hamilton wrote home from her station in Moncton, New Brunswick, that 'I've got so used to wearing pants that I sometimes wonder if I can ever revert.'[42] In June 1943 the *Chatelaine* feature, 'If You MUST Wear 'Em,' offered a point-by-point exploration of the complaints against the wearing of pants by Canadian women, including 'they make you look big,' 'they're sloppy' and 'they're out of place on the street.' Readers were warned about good fit, and the importance of proper ease and drape at the hipline was emphasized. Slacks were cited as being favoured for sports, gardening, workwear and lounging, and more women appropriated this traditionally male garment, the practice paralleling their changing social roles (illustration 33).

With restrictions in garment fabrics, other non-restricted materials were an obvious outlet for fashion fun. Hats were made of everything from paper to shreds of old felt. They often attained bizarre appearance and dimensions, causing Murphy to exclaim: 'hats are downright silly' in January 1943.

In February 1944 the fashion spotlight shifted to the waistline for the first time since the start of the war. Contrasting fabrics or nipped in waistlines drew attention to the midriff area. Narrow skirts with peplums emphasized the figure's back and dresses sported front closures. Women's fashions loosened and more feminine touches were added as the boys were coming home.

The end-of-war fashions gave direction to the changes of the near future. The origins of Dior's New Look of postwar 1947 can be seen in the fashion images and descriptions of 1945, right down to the article title, 'New Year, New Look!'[43] While the fashion silhouette did not alter drastically during the war years, most of the design details did. It was in this category that the individuality of fashion shines through. For example, pockets were both functional and fashionable; by April 1940 they were 'bigger and better than ever.' Gold-coloured buttons were popular for the duration of the war, and the size of buttons altered from quite small to over-size by 1943. Once zippers were restricted, clothing fastened with buttons, bows, and belts. Self-trims and braids could change the look of any outfit and individual creativity was expressed. Time-honoured handwork skills such as crochet, knitting, and tatting were added features of fashions. Collars and cuffs could be changed, creating new looks for staple garments.

Even though fabrics were restricted during the war, nations were trying to clothe their own and at the same time continue to export to other allies. Wool was very limited in supply, since it was an important commodity for military uniforms and was most popular for women's suits and coats. Once the war extended to the Far East, silk stockings could not be replaced; cotton was limited in supply. Nylon was initially utilized for military purposes, but by 1945 it was finding its way back to the civilian markets. The use of rayon expanded greatly, and it was an acceptable fabric for many women's fashions due to its silk-like drapability.

33 Trousers for women were more commonly seen, if not universally popular. (Courtesy of *Chatelaine* magazine, June 1943 © Rogers Media)

Practical, serviceable fabrics were favoured, with corduroy being highlighted in coats, jackets, suits, skirts, and pants as a suitable, warm substitute for wool fabrics. Canadian 'lumberjack blouses' were seen in late 1942 – made of a brushed rayon woven in bright plaids to go with casual wear and pants. In 1943 *Chatelaine* was suggesting that 'snug and cosy' was the trend in fashion fabrics, citing fuel rationing as a good incentive to develop warm fashions. Velvets and velveteens repeated the warm pile theme and these fabrics appeared in every colour and every garment possible. Quilted garments and clothing with quilted components served two needs: they were fashionable, and offered a warm defence against cold weather and cold houses. With the popularity of sweaters, knit fabrics like soft rayon jerseys were shown, along with dress sweater knits in rib stitch. Another popular fabric of the war years was seersucker – a cool fashion for hot summers. Once the fashion silhouette changed to offer a fuller skirt in 1945, crisp fabrics such as taffeta and rayon faille filled the demand.

Prints, stripes, and checks also had their day during the war years. The English influence was strong in shepherd's checks, plaids, and tweeds. In 1943 stripes and checks were popular as trim fabrics and piping accents. Prints changed over time as well. Tiny regiments of soldiers marched across fabrics in early 1940. The motifs were large in 1941 and 1942 and moved back to smaller scale, all-over patterns in 1943. Damon emphasized the importance of the functional quality of prints in the wardrobe, as they 'have become the all-purpose go-everywhere type of dress for Canadian women.'[44]

Perhaps the most varied and extensive of the fashion writing was on the subject of colour. Each and every issue of *Chatelaine* contained copy about the colours of fashion, present or anticipated, and went so far as to write in January of that year that 'the unforgiveable sin of 1941 is to be colorless.' Even the magazine's cover featured colour as 'The Style Note' in October 1941. During the course of the war years, colours naturally changed, although not with the rapidity of prewar times. The WPTB controlled the number of shades manufactured in Canada for many components of the garment and accessory front, limiting the amount of dyestuff used and redirecting it to explosives manufacture. Another outcome of these restrictions was the range of lighter colours in fashion, which required less dyestuff. Hence we find the names of lighter tints, such as frosting pink, lemon snow, apricot glace, and polar white.

Nonetheless, since colour is one of the most visible of all elements of appearance, its importance in wartime fashions cannot be diminished. For November 1939 black was championed from dawn to dusk, and by January 1940 women were reported to be toning down the colours of their day dress, preferring brighter colours for evening. Browns and greys also had a strong showing: a resurgence of all shades of grey and fawn in February 1940, 'brown coffee' in May 1940,

'nutmeg' and russet brown in October 1940, grey silk in January 1941, the 'Bond St. grey' of April 1941. Browns were highlighted as one of the big colours for the fall and winter of 1941, and tobacco browns, saddle leather, and gungreys in September 1941.

The military influence was reiterated in the naming of the new shades of a season. Hence, we find 'smokey blue with a military glamour' and the khaki of the army was described as a 'blithe young color'; there was 'Victory blue,' 'commando red,' and 'Burma ruby.' Ever mindful of the impact of war on the Allies, we read of 'mustard yellow' and the 'shelter shades' of red, wine, and purple. The Allied theme was carried further in May 1941, with British beige, Canadian red, Welsh thyme, Anzac green, and Dover fog. Mexico and South America were also influential. In the summer of 1943, Mexican fashions were stealing the limelight with vibrant colours and colour pairings. It was Mexican pink in the fall that year, and Mexican yellow in the autumn of 1944.

The colour red, long associated with war and human destruction, also has an ability to lift spirits and offer a glamorous image. Not surprisingly, it was popular throughout the war, at different times. Early in 1940 the clear colours of red, white, and blue – the Allied colours – were popular. September 1941 was another time of red's popularity, and London was touting scarlet the following month. In a related colour family, purple was consistently in the fashion news; described as *the* important colour in the winter of 1944, variants of purple included eggplant, grapevine, fuschia, and lilac.

Unusual colour and shade combinations, along with wearing two or three colours at the same time, were also popular. The latter trend was seen as offering a way of using a wardrobe's older pieces in new combinations. Different colour couplings, such as lime green and mauve (April 1941), the then relatively new pairing of yellow and navy (March 1943), and the 'glorious and very daring' purple and pink (July 1943) appeared. Pastel coats over dark dresses presented a new look in February 1941. The two-colour suit was started in London and by the end of the war, dresses with contrasting colours at the midriff were being shown, giving more flexibility to designs limited by fabric restrictions.

Just as writing about the general concept of fashion was continually found on the pages of *Chatelaine*, so too do we find constant examples of particular fashions themselves. The expected images and descriptions of line and silhouette, colours, and fabrications were presented through the 1939–45 period unceasingly. Fashion change was highlighted in smaller, subtler factors. During the war Canadian women shouldered their share of the work; in many respects their societal roles changed with the added burdens. We see a reflection of the essence of the nation in the adopted fashionable styles. From the military uniform came the square shoulders and centrefront line of buttons. From the restrictions of the WPTB came the

slim skirts and elimination of doubled fabric layers. From the limited supplies
came the make-over fashions, home sewn styles, removable collars and cuffs, and
mixed colours in one garment or ensemble. From women's assumption of men's
tasks came the increasing acceptance of slacks. And from the women themselves
came the constant push for changing fashions that made them feel attractive, work
efficiently, and feel good about their contributions to the war effort.

If the existence of fashion can be established with features, articles, and regular
columns about fashion, then there was fashion during the Second World War in
Canada. If the proof of fashion's existence can be evidenced with write-ups and
images of new styles, colours, and fabrics, then fashion was present. If the existence
of fashion is dependent on new and changing language, accounts of designers and
collections, and the telling of fashions worn by women, then fashion was not a war
casualty of the 1939–45 years. As the December 1942 issue of *Chatelaine* stated,
there was 'no blackout in fashions.'

NOTES

1 Fraser, ed. *Chatelaine*, 11; 'The Feminine Outlook: Ladies – To Arms!' *Saturday Night*, 26 September 1942, 27.
2 Myrtle 'Pat' Boreham Vaisey enlisted in the Canadian Women's Auxiliary Air Force, and was awarded the British Empire Medal. Latta, *The Memory of All That*, 83–94.
3 See James Laver, 'War and Fashion,' *The Living Age*, December 1940, 363, and Laver, *Taste and Fashion*.
4 Jeffery Daniels, *CC41. Utility Furniture and Fashion, 1941–1951* (London: Inner London Education Authority for Geffrye Museum, 1974), 33; Quentin Bell, *On Human Finery* (London: Hogarth Press, 1976), 169.
5 Prudence Glynn. *In Fashion* (New York: Oxford University Press, 1978), 56.
6 Dorner, *Fashion in the Forties and Fifties*, 7; E. Ewing, *History of Twentieth Century Fashion*: (London: Batsford, 1974), 141; M.P. Murray, *Changing Styles in Fashion: Who, What, Why* (New York: Fairchild Publications, 1989), 108.
7 Dempsey, 'Will War Affect Our Fashions?' 8; T. LeCocq, 'Fashions for War,' *Maclean's*, 15 January 1942, 9.
8 Turnbull Caton, 'Did Fashion and War Co-exist?' 90–1.
9 This point is addresssed by both M-F Pochna, in *Christian Dior: The Man Who Made the World Look New* (New York: Arcade Publishing, 1996), and Lou Taylor, 'Paris Couture, 1940–1944, 'in *Chic Thrills: A Fashion Reader*, J. Ash and E. Wilson, eds. (Berkeley: University of California Press, 1992), 127–44.
10 C. Breward, 'Exhibition Review. Tanks and Trousseaus: Fashion in the Theater of War – Forties Fashion and the New Look. Imperial War Museum, London,' *Fashion Theory* 1, no 3 (1997): 314–20.

11 Turnbull Caton, 'Fashion Marches On,' 167–9.
12 Broadly accepted definitions have been developed by Kaiser, *The Social Psychology of Clothing* and by M. Kefgen, and P. Touchie-Specht, *Individuality in Clothing Selection and Personal Appearance* (New york: Macmillan, 1986). See also G.B. Sproles, *Fashion: Consumer Behavior toward Dress* (Minneapolis: Burgess, 1979).
13 Pochna, *Christian Dior*, 80.
14 S. Stewart, 'Statutes, Orders, and Official Statements Relating to Canadian Wartime Economic Controls,' *Canadian Journal of Economics and Political Science* 13, no 1 (1947): 99–114.
15 See National Archives of Canada (NA), Wartime Prices and Trade Board, *Report of the Wartime Prices and Trade Board*, 3 September 1941 to 31 March 1943; Waddell, 'The Wartime Prices and Trade Board'; and E.J. Spence, 'Wartime Price Control Policy in Canada,' doctoral dissertation, Northwestern University, 1947, 15.
16 NA, Wartime Prices and Trade Board, *Policy Statement*, mimeograph, 1 February 1942 and K.W. Taylor, 'Canadian Wartime Price Controls, 1941–1946,' *Canadian Journal of Economics and Political Science* 13, no 1 (1947): 81–98. For a detailed explanation of the complete system of controls related to clothing, see Turnbull Caton, 'Government Control and Canadian Civilian Clothing during World War II,' and 'Fashion Marches On,' 167–9.
17 NA, Wartime Prices and Trade Board, RG 64, vol. 36, *History of the Women's Cost and Suit Industry*, 1947, 6.
18 NA, Wartime Prices and Trade Board, *Administrator's Order No. A-474. Respecting the Manufacture of Women's, Misses', and Children's Wear*, 11 November 1942.
19 NA, Wartime Prices and Trade Board, RG 64, *Wartime Controls in Canada*, MDLV, 1942.
20 Ibid., *Report on the Canadian Textile Industry*, XLV, 1944.
21 Ibid., vol. 369, file 6-7-9, vol 3, Letter to WPTB Administrator, Harry Rother in Montreal, *Manufacturers Council of the Ladies' Cloak and Suit Industry for the Province of Quebec*, 13 September 1944.
22 For copies of *Chatelaine* Magazine, 1939–1945, microform texts from the University of Manitoba Dafoe Library, Winnipeg, and original texts from the Victoria Public Library were used.
23 C. Damon, 'Be Dramatic after Dark,' *Chatelaine*, January 1940, 23.
24 C. Damon, 'How Do We Dress from Here?' *Chatelaine*, February 1941, 16; C. Damon, 'There's No Tax on Color,' *Chatelaine*, October 1941, 2.
25 Ziegler, *The Story of the Women's Division Royal Canadian Air Force*, 123.
26 C. Damon, 'How Do We Dress from Here?' 16.
27 *Chatelaine*, November 1942, 26; Damon, 'Ration-Fashion,' 34–35.
28 K. Murphy, 'Fashion Shorts,' *Chatelaine*, November 1943, 53, ibid., October 1941, 29; Bernice Coffey, '"Saving" Graces in Fall Fashion,' *Saturday Night*, 19 September 1942, 23.

29 Consumer Branch, Wartime Prices and Trade Board, *The Miracle of Making Old Things New: A Re-make Revue*, 1943 booklet; and B. Crichton, 'New Clothes,' *Chatelaine*, August 1943, 22–23.

30 Murphy, 'Fashion Shorts,' *Chatelaine*, May 1943, 45.

31 Murphy, 'From 5th Avenue,' *Chatelaine*, April 1940, 29.

32 Damon, C. 'How Do We Dress from Here?' *Chatelaine*, February 1941, 16.

33 'Canadian Woman and Her Fashion Formula,' *Chatelaine*, October 1940, 5. Also in this volume, Sharman tells the story of Montreal couturier Jane Harris, who was able to import fashions from England during the early war years. Murphy, 'Fashion Shorts,' *Chatelaine*, February 1941, 30.

34 Murphy, 'Fashion Shorts,' *Chatelaine*, September, 1940, 26; 'The Fashion Front,' *Chatelaine*, September 1941, 31; 'Fashion Shorts,' *Chatelaine*, April 1943, 33.

35 Murphy, 'Fashion Shorts,' *Chatelaine*, October 1940, 26.

36 'Made in Canada,' *Chatelaine* April 1942, 11.

37 Damon, Carolyn. 'How Do We Dress from Here?' 16.

38 Elspeth Chisholm. 'Canadian Fashions Have Become Major Industry,' *Saturday Night*, 13 April 1946, 4.

39 Pierson, *'They're Still Women After All,'* 138–40. The Canadian Women's Army Corps uniform consisted of a tunic and slightly flared skirt, with pockets, epaulets, and tie.

40 Damon, 'Wear It and Like It,' *Chatelaine*, October 1942, 44.

41 Murphy, 'Fashion Shorts,' *Chatelaine*, March 1943, 29.

42 Ziegler, *The Story of the Women's Division Royal Canadian Air Force*, 124; Helen Hamilton, of the Women's Royal Canadian Naval Service wore 'bells' (bell-bottom pants) as part of her daily uniform. A selection of her wartime letters to family members appear in Ruth Latta's book *The Memory of All That*, 75.

43 A. White, 'New Year, New Look!' *Chatelaine*, January 1945, 8.

44 Damon, 'Print Primer,' *Chatelaine*, April 1943, 29.

SELECTED BIBLIOGRAPHY

Banister, L., ed. *Equal to the Challenge: An Anthology of Women's Experiences during World War II.* Ottawa: Department of National Defence, 2001.

Bruce, J. *Back the Attack! Canadian Women during the Second World War at Home and Abroad.* Toronto: Macmillan, 1985.

Damon, C. 'Ration-Fashion,' *Chatelaine*, April 1942, 34–5.

Dempsey, L. 'Will War Affect Our Fashions?' *Chatelaine*, February 1940, 8–9, 23.

Dorner, Jane. *Fashion in the Forties and Fifties.* London: Ian Allan, 1975.

Fraser, Sylvia, ed. *Chatelaine: A Woman's Place – Seventy Years in the Lives of Canadian Women.* Toronto: Key Porter Books, 1997.

Kaiser, S.B. *The Social Psychology of Clothing: Symbolic Appearances in Context.* 2nd ed. New York: Fairchild Publications, 1997.

Latta, R. *The Memory of All That: Canadian Women Remember World War II.* Burnstown, ON: General Store Publishing House, 1992.

Laver, J. *Taste and Fashion,* London: Geo. G. Harrap and Co., 1945.

Pierson, Ruth R. *'They're Still Women After All': The Second World War and Canadian Womanhood.* Toronto: McClelland and Stewart Inc., 1986.

Pochna, M.F. *Christian Dior. The Man Who Made the World Look New.* New York: Archade, 1996.

Turnbull Caton, S.G. 'Did Fashion and War Co-exist?' *Proceedings of the Ars Textrina International Textiles Conference* (1995): 90–1.

– Fashion Marches On: A Canadian Snapshot of the Second World War.' *Canadian Home Economics Journal* 44 (1994): 167–9.

– 'Government Control and Canadian Civilian Clothing during World War II.' *Ars Textrina,* 22 (1994): 175–92.

Waddell, C.R. 'The Wartime Prices and Trade Board: Price Control in Canada in World War II.' Doctoral dissertation, York University, 1981.

Ziegler, M. *The Story of the Women's Division Royal Canadian Air Force.* Hamilton, ON: R.C.A.F.(W.D.) Association, 1973.

Fashion and Refuge: The Jane Harris Salon, Montreal, 1941–1961

LYDIA FERRABEE SHARMAN

Jane Harris-Putnam (née Van Gelder) was a Second World War evacuee from England who arrived in Canada without material resources and successfully made a place for herself beside Montreal's established couturiers. In the 1940s and 1950s her salons on Sherbrooke Street, a few doors from the Ritz-Carlton Hotel, were a centre of fashion and a meeting place for evacuees and refugees. In 1991 Jane Harris donated her archives to the McCord Museum at the request of Stanley Triggs, at that time curator of the Notman Collection. In 1997 the McGill University School of Social Work honoured Jane's work with evacuees and refugees by giving her name to a graduate scholarship in social work. These events acknowledge the quality of Jane's achievements in two very different areas of accomplishment. They also attest to the strength of her personality and character in creating a new life in a new country for herself and her family while much of the world went to war and then recuperated from the effects.

Much of this essay is taken from interviews I conducted with Jane from 1997 to 1999, and the facts have been verified whenever possible. However, it is not intended to be exclusively an account of the facts. It also attempts to convey her personality, the way she saw and presented herself and her social position, how she responded to her situation, and the efforts she made to shape it to her liking. She was a woman of high energy and strong opinions, and those she came in contact with were seldom indifferent to the impact of her personality.

I met Jane Harris for the first time in 1997 at a book signing for William Weinstraub's *City Unique*, at Montreal's Double Hook Canadian Books. When she learnt that I was a professor in the Department of Design Art at Concordia University, and perhaps because she heard my mid-Atlantic accent, she wanted to talk to me about a project she had in mind. After asking me questions about my professional experience, she asked if I would be interested in writing a book about her career in Montreal. She had an interested publisher. I accepted the project,

which turned out to be very challenging. Later, I learned that I was not the first person she had approached, nor the first who had attempted to write about her work. Although the publisher decided against the book, I continued to have an interest in her story, because it connected to my own early life, and provided a reflection on it. As a very young child, I had been in Turkey when war broke out, and became a displaced person (DP), evacuee, and later a resident alien. From the age of seven to twenty-two, I grew up in England. In 1959 I became a landed immigrant in Montreal when I married into an Upper Westmount family. Although the path of my life and my response to it were very different than Jane's, my experience gave me some understanding of the England she came from, the Montreal society she entered, and the resourcefulness she needed to survive the unexpected situation wartime presented.

Very little has been written about Jane and her company, Jane Harris Limited. The descriptions of her life in this essay have been largely provided by Jane. They do not give the perspective of her clients or employees, with one exception, as I was unable to trace them, or they were no longer living or were very elderly and did not want to be interviewed. Jane read a draft of these descriptions in 1998, and I have included her corrections. I used Jane's archives in 1997 and 1998. Her permission was required for anyone to use them, except her daughter, and I was the only other person to whom she gave that permission. I usually went with Jane to the archives. As this piece was being completed, Jane Harris died on 13 January 2000 while visiting her friends and grandchildren in Santa Monica, California. She was ninety-two, independent, still living on her own and leading an active life, a grandmother of seven and great-grandmother of six.

The interviews and discussions with Jane took place at her apartment on Summerhill Avenue, and often included tea or a Dutch cuisine meal that she would prepare. The discussions continued during visits to her archives at the McCord Museum as she expounded on an item by relating an anecdote, and were followed by lunch in the McCord Museum's coffee shop or at the Ritz-Carlton. Jane was greeted personally at the Ritz, whether it was in the Café de Paris, or in the men's hairdressing salon where she went to have her nails done by the only manicurist in the city she considered knew how to do them properly – a European lady. Although Jane remained very British in her style and mannerisms, she loved Canada. She explained it this way: 'I came to Montreal in 1940 as an evacuee with my small daughter Patricia; it was only to be for a few months until the war was over ... Almost from the day I arrived in Halifax, Canada seemed a wonderland; the train ride through Acadia was a romance. And Montreal was so totally different from anything I had imagined ... I went back to England, but Montreal beckoned me to return ... the people, the place, and the invigorating pace never ceased to enchant me.'

In 1941, when Jane Harris opened her salon on fashionable Sherbrooke Street West, there were already three well-established couturiers in Montreal, a city known as the Paris of the North. These three couturiers were all members of the francophone community, and continued to dominate the Montreal fashion world into the 1960s.[1] Gaby Bernier, who could trace her ancestors' arrival in Quebec to the seventeenth century, had her own salon from 1927 to 1959. Raoul-Jean Fouré began his career in Paris. When he married Margaret Mount, a woman from a long-established Quebec family, he left Paris to open his own salon in Montreal, also in 1927, and continued to be active until 1955. Marie-Paule Archambault Nolan, the daughter of a distinguished Quebec family, went to work for Fouré as a *vendeuse* in the early 1930s and after a year in Paris, opened her own *maison de couture* in 1935 and presented her first collection. She became above all an authority on elegance in fashion. It was not until 1975 that she finally retired.

When Jane Harris was ready to open her own salon, she went about it in her own way. She emphasized her connections with Europe, especially England, and found her clientele primarily in the Anglophone community, who admired and emulated what they perceived as the British aristocracy's approach to fashion. Jane did not consider herself a couturier, whom she referred to as dressmakers; she saw herself as a designer and a fashion entrepreneur. She produced collections, which combined her fashion imports with designs made up from her own sketches, and presented them in unusual and dramatic fashion shows, often on location. She was a small, high-energy woman with a British upper-class presentation, a sharp wit, constant flow of new ideas, and strong opinions on the right way to do things. In Montreal in the 1940s and 1950s this combination earned her a range of supporters and detractors, but her contribution to the fashion industry of the time is generally acknowledged.

Getting Started in Montreal

According to Jane, until she was in her early thirties she was a lively but very proper young woman, who had lead a protected life growing up in England, the daughter of Dutch Jewish parents. Then in 1940 her life changed. Concerned about Hitler's persecution of Jews in occupied Europe, many were leaving England for North America. Jane's father, who did not qualify to leave, as he was over sixty, stayed in London with her younger sister, while Jane left for Canada with her eight-year-old daughter Patricia.[2] Her mother joined her the following month as soon as a place for the crossing was available. These were the kinds of decisions that many families were making at that time, often at very short notice.

In June 1940 Jane and Patricia arrived in Montreal as wartime evacuees. They had crossed the war zone of the Atlantic in convoy on the *Monarch of Bermuda*

with other evacuees, in many cases the wives and children of Britain's social elite, who were leaving the dangers and inconveniences of war-torn England. There were many unaccompanied children on the boat. Their tickets were bought in England, and they were put on the boat to travel alone to Montréal, where they were expected to be met. On board ship Jane, who was looking for companionship for her bored and restless daughter and for diversion from the fear of depth charges and German submarines, organized a children's recital with singing and dancing. For three days of the seven-day journey, the children were occupied and not running around unsupervised. The recital was a success and it earned Jane an introduction to a number of passengers who were travelling first class, including Captain Cunningham Reed, brother-in-law to Lord Louis Mountbatten, who was travelling with his two sons and his mother. After disembarking in Halifax, all the passengers travelled by train to Montréal. When they arrived, a lady from the Refugee Committee asked Jane where she was staying. She burst into tears and so did her daughter. No one was meeting her and she did not know which hotel she would stay in. She followed the advice of Captain Reed, who had said she should stay at the Ritz-Carlton Hotel, commenting, 'You tell them I recommended it and they will have a room for you.' Jane considers she started life in Montréal at the Ritz-Carlton, and she kept this connection throughout her life. When she died in January 2000, a reception celebrating her life was organized by her daughter at the Ritz-Carlton Hotel.

During her first summer in Montréal, Jane visited with other evacuees who were being housed at the Victoria Hall Women's Residence at McGill University. According to Jane, a 'very nice class of women' they were waiting to find homes with elite, anglophone families of Upper Westmount. Jane brought with her to Canada an acutely British sense of social hierarchy and its significance. She respected it, and held on to it very firmly, using it to help her to become established in what she considered her appropriate social milieu. She knew that, as part of a family of three generations, no one would take her in for any length of time, so she would have to find a job. Jane, her daughter, and mother moved many times in their first year in Montréal, first living with families and then in apartments.

In London, Jane had been apprenticed to a French fashion designer by her father, who believed a young woman should have a work skill. For a year she worked from morning until night, learning all about draping material, cutting, and sewing clothes. She then worked for a year in a salon to learn the business side of haute couture. In addition to this skill, Jane had come to Montréal with introductions to several influential people, given to her by Isabelle Adami, a Canadian living in London, whose father was a professor at McGill University. One of the introductions took Jane to Grenville Smith, then Head of CIL, the

paint manufacturer in Montreal. As his company did not employ women at that time, Smith introduced Jane to Mr Pollack, the general manager of Morgan's, which was at that time a most prestigious department store for women's clothing. After discussing which department Jane could work in, Pollack said he would have a place for her in furs in two weeks.

When Jane went back to Morgan's, there was a different job for her. A department had been set up especially for her, with a Canadian flag on one side and an English flag on the other. She was to outfit in uniform all the women who were going into the armed forces. In 1941 manpower shortages were growing serious, so the Canadian government established the Canadian Woman's Auxiliary Air Force and the Canadian Women's Army Corp (CWAC). These were integrated into the Canadian armed forces early in 1942, as the CWAC and the Woman's Division, Royal Canadian Air Force. A year later the Women's Royal Canadian Naval Service was added.[3] Jane was required to coordinate the women's uniforms, shoes, insignia, and so on from different parts of the store. As Jane describes it, members of the 'finest families' were going overseas. She met them and later they became clients in her salon. There was a greater openness at that time with less of the elitism that insulated the upper classes during peacetime. It was a time to lower the barriers and offer to help.

Isabelle Adami had also given Jane an introduction to the private school, Miss Edgar's and Miss Cramp's, for her daughter. Jane had no money to pay the fees because her money had been frozen in the bank in England as a wartime measure two months after she arrived in Montreal. The school agreed that she could repay the fees after the war. In fact, Jane was able to pay the following year when she started her business. Through the school, Jane was befriended by an English woman, Isabelle Fletcher, who was concerned that her long hours working at Morgan's combined with the task of looking after her mother and daughter were exhausting her. She suggested that Jane could bring fashions from London that she could sell in Montreal from Isabelle's flat in the fashionable Linton Apartments on Sherbrooke Street West.

Launching Her Own Salon

Six months after her arrival, Jane left Morgan's. She contacted her father in London, who was a wool merchant and had excellent contacts with manufacturers in England and Scotland, to ask if he could send her some fashion items to sell. He could send them under the Dollars for Britain campaign in which quality goods, unavailable in Britain, were sold abroad to raise funds for the war effort. Jane's clients could afford the imported fashions, and perhaps reassure themselves that

their purchases were helping both the war effort in England and evacuees in Montreal.

The first shipment of clothes that Jane received was a problem, as her father had sent thick tweed suits, knowing that it was very cold in Canada. He had not taken central heating into account, as this was still rare in England at that time. However, Isabelle gave two parties for her women friends and their husbands and Jane managed to sell the clothes. Mrs Alex McKinnon bought a suit and Jane met her husband who was head of Rothschild investments in Montreal. He asked Jane why she did not go into business, and Jane replied that she had no money. Alex introduced her to his client, Mr Mann, who liked small business opportunities. Mr Mann told her if she could find cheap premises, he would finance her and they would divide the earnings equally.

Jane found a basement premises at 1324 Sherbrooke Street West, beside Holt Renfrew and one block west of the Ritz-Carlton Hotel. The basement had low ceilings and had not been occupied before. There was a room in the front, the boiler for the building was in the middle, and Jane used the room behind the boiler for a workshop. Her solicitor, Louis Fitch, incorporated her business, and Jane launched her first salon. She transformed the basement by painting the concrete floor peacock blue and the ceiling a pale pink. She bought furs that were used for rugs in Montreal's calèches from a supplier in the city's East End and, after a thorough cleaning, backed them in purple felt and used them as rugs. City Hall gave her permission for a window to be installed in the front room, but not a lighted sign, so she had a wooden one made using her name Jane Harris with a large dot over the j and i, and painted it purple with grey on the sides to emphasize the depth. A flower box installed above the window had lights built in under it to light the sign. Jane designed the logo, stationery, and business cards for the business. The first shipment from England was placed in its crate in the window with the top open and the clothes spilling out. For Christmas, Frank Jennings made her a replica of the lighthouse he had designed for the St Lawrence River, complete with flashing beacon. Word got around and people came as much to see what she was doing as to buy clothes. Mr Mann never had to put up any money. Jane had six months' credit from her suppliers and her clothes sold out almost as soon as she received them. At that time, anything British was much admired by the anglophone elite of Upper Westmount and the Square Mile. Jane stayed in this location for ten years.

Jane explained her ideas through sketches and letters to British wholesalers who had quality stock which had to be exported for dollars, and could not be purchased in England. Jane met with Mr Peterson from the Montreal Board of Trade, and Arnold Heckle, the UK trade commissioner, who helped her expand her contacts

in England. Immediately after the war, Jane imported fabrics, including Courtaulds, Cellanese, Weatherall, and Horrockses. In 1950, in recognition of her contribution to the Dollars for Britain campaign, Jane was honoured at a reception given by the Board of Trade at Lancaster House in London, and presented to the Princess of Wales, later Queen Elizabeth, and Princess Alice (illustration 34).

Jane was living at the Summerset Apartments on Sherbrooke Street when she got a phone call to say that her business was in flames. A fire in the boiler room had destroyed her salon and all the stock. She went to the Ritz to ask if she could rent rooms for two or three weeks and use the telephone number of her salon. When this was arranged she called her clients to tell them all their dresses had been destroyed. It took three months to repair the damage. The lease for the building belonged to Mrs Zimmerman who, as Madame Jehane Benoit, became the nationally known authority on Canadian cuisine with her own radio and television shows and publications. She lived there and had a restaurant and her cooking school upstairs. She called Jane and said, 'If you want to take over my lease from the Royal Trust, you can have it at the controlled price. I would like you to have it, but you must buy my salad bar.' Jane thought this was a good idea, but Mr Mann did not, so a customer and friend of Jane's, Erminy Jennings, guaranteed a loan for Jane so she could buy the salad bar and take over the lease for the whole building. The salad bar was a success; her customers loved it and Jane, now working twelve hours a day, could eat there too. She paid off the loan in a year, but kept the salad bar until after the war.

Jane moved into the building and Patricia became a weekly boarder at Miss Edgar's and Miss Cramp's School. Jane had a bedroom and dining room at the end of a long corridor and a second bedroom for Patricia when she was home. A Danish girl, who was an excellent cook, lived on the top floor and prepared the food for the salad bar. A French-Canadian girl who had been with Madame Benoit stayed on to waitress. A refugee woman from Belgium came to help with the accounts for two months and stayed two years. In 1943 Alice Robson, a dressmaker who had been trained at Debenham's in London, came on a two-year contract and stayed until the salon closed in 1961. Thus the staff was multicultural, multilingual, and well trained.

Jane Harris was invited to be on the Montreal Refugee Committee. She was the youngest member and the only evacuee.[4] Many members of this committee and their friends and daughters became Jane's customers. Jane also started the Overseas Pony Club, a connection from her pony club days in England, and there met another large group of potential clients. In Britain, riding and the pony clubs were a well-established area of recreation for the landed gentry and required a fashionable wardrobe. The McCord Museum has a pair of dark cavalry twill jodpers which were made in England especially for Jane.

34 Jane Harris and Princess Alice, Countess Althone, Lancaster House, London, England, 1950. (Notman Photographic Archives, McCord Museum of Canadian History, Montreal)

The Refugees

During the war and for a few years afterwards, Jane's salon was not only a centre for fashion, but also a place where European evacuees and refugees could gather. Some would come to talk and tell their stories; some would be looking for work for a few months until they could get established and would find work knitting or sewing for her clients or for her own fashion shows. Jane had twelve 'girls' working for her who spoke nine languages and she put a sign in the window saying, 'We speak, *nous parlons*, English, French, German, Spanish, Italian, Greek, Hungarian, and Arabic.'

As many refugees gathered in her salon, it was always full and busy. This made clients think it was very popular and made them eager to shop there. Jane gave soireés in the evenings for the Refugee Committee. Her clients liked visiting with the Europeans, many of whom were artists and musicians who went on to have successful careers in Canada. A number of these had been among the 2,290 former residents of Austria and Germany, who were classified as enemy aliens and interned in camps in England in 1940, before being sent to internment camps in Canada. The Canadians had been misled by the British and were expecting dangerous prisoners of war. What they received was a very different mix of prisoners, including Nazis, anti-Nazis, and Jews fleeing from Nazi oppression. Their ages ranged from the teens to the seventies and included students, rabbis, and priests. The internees spent the next two years in the camps and were finally released in 1942, but some 952 stayed in Canada.

One of the youngest to visit Jane's evenings was Eric Koch, who became a well-known radio and television producer for the CBC and at one time head of arts and science programming. He was twenty, a former English public school boy and currently a law student at Cambridge studying for his final exams, when in May 1940, two policemen knocked at his door and informed him without notice that he was under arrest. Other detainees Jane remembers were Dr Stern, later the owner of the Dominion Art Gallery, Helmut Blume, and John Newmark. When John Newmark was moved to the Sherbrooke camp there were, according to Koch, 'two great pianists under one roof, Blume, the romantic virtuoso, and Newmark, the elegant, polished chamber-musician.'[5] Helmut Blume became the dean of the Faculty of Music at McGill University, and a CBC broadcaster. John Newmark (previously Hans Neumark before he arrived in Canada) who died in 1991, had a sophisticated appreciation of chamber music and lieder, and an interest in histori-cal pianos long before it was fashionable. Newmark's major contribution was as an accompanist and collaborator with the internationally known contralto, Maureen Forrester. It was through John that Maureen became a client at Jane's salon, and later recommended it to John Diefenbaker's wife Olive, who also became a client.

Jane created a world for herself in her salon. She was the hostess in this world where the Montreal social and business elite, mainly anglophone, met with accomplished Europeans displaced by the war. There was a particular vitality about this time, when these two very different groups endeavoured to become acquainted. The Europeans were struggling to establish a new life in a very different country, often with little more than their talents and the sophistication of the educational, social, and cultural background they experienced back home before the war.

Released from Wartime

The number of women in the workforce in Canada decreased dramatically after the war. By September 1945 nearly eighty thousand women in war industries had been laid off and thousands of service women discharged. Marriage rates soared, especially among younger women. In 1944, at the peak of wartime employment, one-third of all women over the age of fifteen were in the paid labour force, but only slightly more than 10 per cent of them were married. In 1941 only one in twenty-five wives worked; by 1954 this had increased to one in five.[6] This situation had an impact on fashion, first with the surge in demand for ball gowns and wedding dresses, and then the increase in the need for workplace fashions. The Saint Andrew's Ball, the high point of Montreal's anglophone community's social calendar, had been suspended during the war. It was revived in 1945, with more splendour than ever and named the Victory Ball.[7] Over two thousand guests attended, and 183 debutantes were presented to the guests of honour, the Earl of Athlone, governor general of Canada, and his wife Princess Alice. Thus, by the mid-1940s the war was over and Jane could travel again. She claimed that in 1946 she visited every country in Western Europe to buy fabrics. She invited members of seven consulates to a Montreal fashion show launching her collection using these fabrics.

London looked as grim in the first year of peace as it had in wartime. The situation was brightened by the Aschers, owners of one of Prague's largest textile companies who had moved to London, and had the idea of asking famous artists to design head scarves to brighten up a dreary outfit. The artists' head scarves, created by such well-known names as Henri Matisse, Henry Moore, Jean Cocteau, Graham Sutherland, and Ben Nicholson, became collectors items and were exhibited in galleries. The Aschers also recognized a potential market for new fabrics, directed to the young and fashion-conscious. They set up a company, Bourec, with an aggressive approach to foreign sales and in 1949 Joseph Ascher opened a showroom on Sherbrooke Street in Montreal, to introduced the Ascher and Bourec fabrics to local couturiers. These painted scarves and new materials were an inspiration for Jane.

French fashion reasserted itself comparatively quickly after liberation and evening gowns were a focus again. In Paris in December 1946 forty couture houses joined for Les Robe Blanches, a show of evening gowns held at the Théâtre des Champs Élysées. In February 1947 Dior launched his New Look, that was an extravagant and luxurious use of yardage.

Jane Harris was now providing wardrobes for her many clients, and the weddings gowns and debutante ball gowns for their daughters. Influenced by the European New Look, her skirts were full and bodices had pinched waists and off the shoulder necklines. Some debutantes would joined her salon for brief periods for work experience and to learn about fashion. Jane was asked once what the difference was between a salon and a shop. She replied that the salon created a home atmosphere, where women could go with complete confidence for fashion advice and to buy the fashions which would suit their individual personality. Jane also encouraged fashion illustrators, models, and photographers, including David Bier, known for his photographs of ice hockey, who wanted to move into fashion photography.

Fully Established

Following the end of the war, Jane Harris was free to undertake more ambitious projects. She acquired the exclusive Montreal distribution rights for Pierre Balmain of Paris for five years and Nina Ricci for two years. Later Doreen Day, fashion director for Eaton's, took over these rights. Jane said she was the only representative from Canada to be invited to the first Italian fashion show in Florence following the war, and the first to bring European prêt-à-porter, Italian sportswear and separates, and the designs of the Italian, Emilio Pucci, to Montreal. She claims to have been the only Canadian invited by Frances Beamis, fashion editor for the *New York Times*, to a major fashion show in Atlantic City. She became friends with Frances and helped her plan her first visit to London, providing her with introductions and sending her some of the clothes she would need. In her book *Gaby*, Betty Gernsey says Jane 'simply brimmed over with inventive ideas: having well-known artists paint fabric and turning it into skirts; having models dance live on runways; putting her own signature on silk scarves.'[8]

It was not easy to make a success of a salon in Montreal. Marie-Paule Nolan, who opened a Paris-style maison de couture from 1954 to 1956, became so indebted she had to close and move to her home in Westmount. In an earlier location, she had used the French antique chateau-style furnishings with Belgium tapestries and suits of armour as the background for her extravagant fashion shows.[9] Jane Harris, who had rented premises, took pride in the less ambitious décor of her salon. In the caption on a David Bier photograph of the salon from

the garden end looking towards Sherbrooke Street West, she describes the lovely parquet flooring with inlay, and the antique throne chair with its original covering which she bought from an evacuee. The front of the salad bar was studded leather and her office had marble tiles, thereby creating an original and amusing interior.

In 1955, when 1324 Sherbrooke West was sold, Jane moved farther along the street to number 1200, still only one block from the Ritz-Carlton. The salon had a white marble fireplace and a wall mural, the first commission for the daughter of her secretary. Downstairs Jane had furniture from the Iron Cat, a shop in Westmount, the wealthy, anglophone residential district. The shop specialized in the design of wrought-iron furniture, often custom-made, which was very popular for both the town and country houses of their Upper Westmount clients.

In its new location, Jane Harris Ltd. included a Pierre Balmain, Paris, Boutique. At this time, top Paris designers were opening boutiques in an effort to capture a wider market on the North American continent. Originals from named Paris designers were so expensive that $1,000 would not buy very much, but fashions from the same designers' boutiques could be priced under $200 and were seldom over $400. Jane's Balmain boutique carried apparel as well as accessories such as jewelry, belts, 'neckerchiefs,' and knitted shawls. The 1956 collection, called Florilège, consisted of coats, suits, dresses, and separates. Balmain favoured hip-hugging lines, subtle colours, and fabric contrasts. Many of his styles incorporated two, three, or even four textures in one garment, and often emphasized the waist with a wide insert of a crushed or contrasting fabric. He also offered a fitted and pleated cummerbund available in a variety of colours as a boutique accessory. For evening wear there were short dresses, including one that was black taffeta and lace with a bell skirt. Apart from her Balmain Boutique, most of the Jane Harris imported collections were British. From London she imported a Susan Small collection of clothes priced at under $100, which included daytime and after-five garments, and hats from the milliner Madge Chard. Other British imports included classic suits in knit jersey, a line of furs, and a 'couturier corset and bra service' offering custom-made foundation garments.[10] Jane Harris was offering a variety of styles and prices in order to accommodate a range of consumers.

Jeanette Alynak arrived in Montreal from Paris in 1955 with an introduction to Jane Harris. She was looking for a job and became Jane's personal secretary for six years until the salon closed its doors. She came to know Jane well, and considers her number one at a time when there was not much competition for such retailers. Jeanette was probably influenced in her opinion by her European background. Jane was very creative, a strong personality, and an unusual mixture – a romantic who was also an effective businesswoman. Her clients were the wives of corporate presidents and other members of the elite, and they came from as far away as Vancouver and Nova Scotia. Jeanette remembers gowns for Montreal's St George's

and St Andrew's balls that could cost over a $1,000. The McCord Museum costume and textile collection, started in 1957, has a Susan Small evening gown imported by Jane Harris which was worn by Mrs T.H.P. Molson's eldest daughter, Pamela. Tight-waisted with a bouffant skirt, it has layers of pale grey, stiffened net petals with sunburst rays of gold sequins, over a tight, diagonally pleated skirt, and is reminiscent of a Dior model.

In a press release, Jane explained she liked to combine French and English fashions that were suitable for a Canadian way of life. In Toronto, she put together a fashion show, Entente Cordiale, at the Hunter House in Rosedale. This show introduced Paris collections, some by Nina Ricci, which used British textiles, especially wool and man-made fibres, and included some of her own designs. Jane loved to travel and, in her words, 'bring the world back to Montreal.' When she was included in a visit to the British West Indies by the Canadian Board of Trade and Chamber of Commerce, she brought back Jamaican fashions. Jane also designed garments for herself and others by adapting Indian saris which could fold into a very small space.

For her fashion shows, Jane was one of the first in Canada to go on location and her themes often centred around travel, using as her context airplanes, boats, trains, cars, and highways. For the open deck on board ship, she presented mohair coats 'completely uncrushable' and herringbone suits, and cocktail dresses for the glassed-in enclosure. Hand-knitted dresses and skirts that 'would not crush even when you travel day and night' were modelled beside a train. In front of highway signs, models wore wool from Scotland and woven textiles from Switzerland by Madam Zsantos. There were more fashion shows beside a Rolls Royce outside the stately McConnell house on Pine Avenue.

In 1958 Jane launched the Air France Fashion Tours of Europe with a collection of European designs at Dorval airport (illustration 35). The fashions included clothes from London, Paris, Vienna and Switzerland.[11] Michelle Tisseyre, who had her own radio program at that time, gave the commentary for the event on French radio. It was September and the fashions introduced furs from France by Nelly Rouenen, including a dyed ermine suit. For the show, Jane used hats from Irene of Montreal created by the Polish-born Irene Burstyn, who had escaped to Italy from Nazi-occupied Warsaw. When Mussolini joined Hitler, she wandered through seven countries until a British convoy took her from Egypt to South Africa. She finally arrived in Canada in 1944, where she became renowned as a hat designer.

Jane's archives have a number of photographs of the launch of the Air France Fashion Tours, and the handwritten captions on the back show her interest in her models, as well as her love of fashion and the details of textures and materials. She includes references to a model who arrived from France and asked Jane if she could

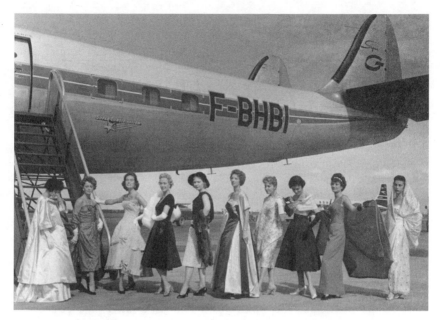

35 Models at the start of fashion tours with Air France, Dorval Airport, Montreal, 1958. (Notman Photographic Archives, McCord Museum of Canadian History, Montreal)

model for her: 'She was wonderful and stayed with me until she opened her own business. I designed this piece especially for her ... It was lined with Kolinsky fur from Russia which I had bought from Madame Rouenen. Her husband was a fashion photographer and took the photographs.' On other photographs she comments: 'A wonderful model who ultimately opened her own modeling school, wearing a Nina Ricci black satin outfit with a pink bodice ... A Dutch girl I had discovered who had been a manicurist. This was her first show. I had trained her.'

Jane saw herself as an entrepreneur whose fashion shows were a major production. For her, every aspect of the fashion business was an opportunity for her creative expression. She connected fashion with her interest in music, art, and theatre. She had an 'Art into Fashion' evening with skirts hand-painted by the artist Michael Forster. One of her events was the subject of an article in the local *Star Weekly* magazine, and *Maclean's* published a four-page article, 'A Fashion Expert Speaks her Mind,' which was an unusual amount of fashion coverage for that time.[12] In a telephone interview Iona Monahan, fashion editor for the *Gazette*, remarked that she remembers Jane as being very visible.

With Gaby Bernier and other Montreal couturiers, Jane designed the dirndl-type peasant skirts for *Le Père Chopin* which had its gala opening at the Saint-Denis Theatre on 19 April 1945. This was the first of eighteen feature films produced in the province between 1944 and 1954. Jane continued to be involved in the Montreal theatre scene, organizing fund-raising fashion shows for the National Ballet and the Montreal Repertory Theatre (MRT). For MRT she presented a fashion show which was a mime play she created and narrated. She described designing the costumes for a Mountain Playhouse production by Norman Jewison, now a successful Hollywood producer/director.

At this time Jane met Brian McDonald, who has become one of Canada's best-known choreographers. Jane asked Brian McDonald's wife Olivia, who was a dancer, to model for her. Olivia accepted and was instrumental in bringing dance movement to Jane's fashion shows. In a press release for one of the MRT fund-raising shows, Jane explained that for her 'fashion and theatre are an integral part of each other. As in life, every woman has her part to play, and the part is always enhanced by the right fashion for the right time and place.'

Through my interviews and conversations with Jane, it was apparent how much she valued and cultivated acceptance by the social and business elite in both her social and her professional life, which were very much connected. Jane's clientele were also her friends and she went on holidays with them to the Quebec country-side, the Caribbean, and Europe. Lively, petite, generous, always elegantly and appropriately dressed, she was a welcome guest for her wealthy and influential clients. In the Notman Collection at the McCord Museum there is a photograph of Jane at a museum gala in 1944. Henry Carr, portrait painter to the British royal family, painted her portrait to 'keep his hand in' between painting Princess Margaret, and the Canadian governor general. A pastel of Jane by the Czechoslovakian refugee Bruno Beran hung for twenty years in the National Portrait Gallery in London. The Swiss artist Hans Ern sketched her in a pencil drawing during a visit to Switzerland.

Closing Shop

The period from 1941 to 1961 was a time of rapid change in the fashion business as it moved from couturiers making individual dresses for their clients to specialized limited editions and imports. This progression suited Jane very well. However, when she was in England in 1960, she saw the work of the British designer Mary Quant, still in her twenties and the originator of the miniskirt.[13] Mary Quant designed for a young market who, like herself, hated the fashions they saw around them, and what they were expected to do to themselves to accommodate them. She designed the kind of bold, colourful, original clothes she liked to wear and found thousands of others did too. Jane knew she would never be able to go in that

direction. Now in her fifties, it was time for a change. With the massive arrival of the baby boomers on the market, 1965 produced what Mary Quant described as the 'youth quake.' England took the lead in responding to the event with the Carnaby Street Look. Fashion was internationalized and democratized with the expansion of ready-to-wear fashions, and in Montreal boutiques shot up everywhere.[14]

Jane's fashion business first enabled her and her family to survive in a war-torn Western world, and then to thrive in the immediate postwar period. Through her fashion business she was able to link her old life with a new one, provide a focus for her love of travel, and find a place within the social elite. For her, fashion was a vehicle through which she achieved all this, and it was an outlet for her passionate entrepreneurial spirit. In 1961 she closed her business and returned to England, where she remarried and went on to direct her energy to another enterprise – the preservation of thatched cottages. She settled there for a while, but was in the end drawn back to Canada to live, while still visiting England for part of each year.

In England, Jane accepted an invitation to direct one last production as part of the three-day Royal Commonwealth Society Centennial Celebration in London in June 1968. She called her event 'Fashion, Folk Dance, Food and Flowers,' and described it as, 'a marriage of ideas through fashion in the family of the Commonwealth. As a time of celebration when family feuds and differences are forgotten. A time when the parent provides the venue and the guests contribute gifts, show off in fashion their ideas, and find they can and do entertain each other, and finally share food, drink and making merry.' The intention of the celebration was to bring together the wealth of ancient crafts creating a common heritage, interpreted through fashion, and the transition from the traditional to the modern in folk dance and music, and the influence and interest in food. There were Maori dancers, calypsos, Indian brocades with gold embroidery, African barkcloth and batiks, and Canadian furs, followed by Canadian whisky, Jamaican rum, curry puffs, and New Zealand lamb chops.[15]

Following Jane's death in January 2000, Nora Hague, of the McCord Museum's Notman Photographic Archive, spoke about her at a reception held at the Ritz-Carlton to celebrate her life. She described Jane as 'a vivacious, energetic and persistent lady ... [whose] discussions over coffee were stimulating and wide-ranging. Her frequent visits to the archives were always tumultuous, involving everyone within her range in a totally absorbing way.' Small as she was, she had presence when she made an entrance, and was often referred to as Lady Jane (the title she acquired through her marriage), which pleased her. Jane Harris was an enthusiast who loved theatre, fashion, and drama, and had the organizational capacity to realize her big ideas. As a wartime evacuee, she had an understanding and sympathy for other evacuees and refugees. She maintained her ability to involve people in her projects to the very end of her life. This was her way of

creating a context for herself in her adopted country and helping others to do the same. She created a unique place for herself in the history of fashion during a cultural and economic boom in Montreal and Canada.

NOTES

1 Jacqueline Beaudoin-Ross. 'Marie-Paule Haute Couture,' 16.
2 This essay is about Jane's career in fashion in Montreal. Jane did not speak about her private life in England before she came to Canada, and so I did not ask about her first husband, the father of her daughter.
3 Tily Crawley, ed., *Canadian Women: A History,* 301.
4 Other committee members included, Senator Karen Wilson, Mrs Nora McDowel, Mrs Cecil McDougal, Mrs Keith Hutcheson and the Reverend George Donald's wife, Adelaide. Mrs McDowel later donated to the McCord Museum a Jane Harris evening dress of heavy corded silk with fitted bodice and a bell skirt trimmed with circular designs in net braid. Mrs. Donald's estate presented an evening dress of purple chiffon with a boned bodice by Susan Small which Jane imported.
5 Eric Koch, *Deemed Suspect: A Wartime Blunder,* 156.
6 Crawley, ed., *Canadian Women,* 311, 312.
7 William Weintraub, *A City Unique,* 147.
8 Betty Guernsey, *Gaby,* 141.
9 Beaudoin-Ross, 'Marie-Paule Haute Couture,' 17; Guernsey, *Gaby,* 140.
10 *Women's Wear Daily,* New York, September 1955; *Montreal Star,* 12 October 1956.
11 *The Montreal Star,* 15 September 1958.
12 Gwen Cowley, 'The Star Weekly Goes to a Fashion Party,' *Star Weekly,* 1 February 1960, 21–3; Jane Harris, 'A Fashion Expert Speaks Her Mind: Women Are Cowards about Clothes,' *Macleans,* 1 July 1961, 22–5.
13 In 1958 one of my earliest jobs as a designer was the window display unit of Mary Quant's first shop, Bazaar, on the King's Road in London. I still have a dress and suit designed and made by her that I bought at that time.
14 Quant, *Quant on Quant,* 52. *Elle Quebec* 35 (July 1992).
15 *Evening Post* (New Zealand), 12 June 1968.

SELECTED BIBLIOGRAPHY

Beaudoin-Ross, Jacqueline. 'Marie-Paule Haute Couture.' *Dress* 18 (1991): 14–25.
Blake, Joan, and Judy Mcdougal, eds. *Montreal Woman's Agenda.* Montreal: Sky Press, 1988.

Crawley, Tily, ed. *Canadian Women: A History*. Toronto: Harcourt, Brace, Janovanovich, 1988.

Dorner, Jane. *Fashion in the Forties and Fifties.* London: Allan, 1975.

Forrester, Maureen, with Marci McDonald. *Out of Character: A Memoir*. Toronto: McClelland and Stewart, 1986.

Guernsey, Betty. *Gaby: The Life and Times of Gaby Bernier, Couturière Extraordinaire*. Toronto: Marincourt Press, 1988.

Koch, Eric. *Deemed Suspect: A Wartime Blunder*. Toronto: Methuen, 1980.

McDowell, Colin. *Forties Fashion and the New Look*. London: Bloomsbury Publishing, 1997.

Palmer, Alexandra, *Couture and Commerce: The Transatlantic Fashion Trade in the 1950s*, Vancouver: UBC Press and the Royal Ontario Museum, 2001.

Quant, Mary. *Quant on Quant*. London: Cassell, 1966.

Tyrrell, Anne V. *Changing Trends in Fashion: Patterns of the Twentieth Century, 1900–1970*. New York: Drama Book, 1986.

Westley, Margaret W. *Rememberance of Grandeur: The Anglo-protestant Elite in Montreal 1900–1950*. Montreal: Libre Expression, 1990.

Weintraub, William. *A City Unique: Montreal Days and Nights in the 1940s and 50s*. Toronto: McClelland and Stewart, 1996.

FASHION AND
JOURNALISM

Laced In and Let Down: Women's Fashion Features in the Toronto Daily Press, 1890–1900

BARBARA M. FREEMAN

> Will the millennium ever arrive, I wonder, when we women can wear easy shoes, larger gowns, less back hair piled up on our craniums, travel about in fact as though we had lungs and hearts and livers, and not do as we now do, push these organs out of place with whalebone and steel and buttons and tight sleeves and neckbands?
>
> 'Kit,' *Daily Mail*, 16 May 1891[1]

During the late nineteenth century, women were taking on new roles in society, and also deciding how to dress for them. Many turned for guidance to the daily newspapers, where a new professional, the woman journalist, was offering news and commentary about the world of fashion and advice for women on how to dress and present themselves. That advice often included encouraging their readers to adopt dress that was healthy, becoming and comfortable, and warning them about the dangers of tight-lacing corsets or other dubious practices. Still, the economics of the newspaper business, which depended increasingly on advertising, ensured that the journalists did not encourage an outright revolution in women's attire. Instead, they established a pattern of fashion reporting still common today, boosting the fashion industry and dispensing practical advice to consumers while lightly treading the line between advertising and journalism.[2]

The fashion features that appeared in Canadian newspapers at the end of the nineteenth century included a broad range of articles, from lavishly illustrated fashion spreads from the American syndicates to brief paragraphs on the latest in spring hats, hurriedly written by the local women's page editor or a freelance journalist. Some newspapers had women's pages, which usually appeared on Saturdays. They consisted of an eclectic mix of articles on many issues of interest to women, both social and political, which testified to the energy, interests, and imaginations of the journalists who wrote them. A typical page might begin with a discussion of the latest fashions available at a local department store, or a serious

essay about the writer's recent visit to a street shelter for women, or a debate about suffrage, or, perhaps, a light-hearted and flowery description of a spring walk. This main feature might be followed by a description of a local society ball, gossip about royalty or famous entertainers gleaned from American or overseas newspapers, recipes, sewing tips, a poem or two, and some book reviews. Some journalists also ran an advice column, a popular innovation of the time, in which they answered readers' questions.[1]

Contemporary cultural attitudes about consumerism, gender, and their work as women in the male-dominated media all shaped the messages that the Toronto writers, discussed in this study, relayed to their readers about fashion and women's place in the world. As journalists writing material for female readers, they were intellectually 'laced in,' separated from the exciting male world of hard-news journalism, and confined to a constraining corset of the mind that was designed to enhance their feminine sensibilities rather than their eclectic curiosity. Their editors and readers expected them to be upright, matronly, and moralistic advice-givers to the hundreds of people who wrote in seeking guidance. These journalists traversed this narrow world of women's furbelows and fripperies carefully, however, aware that loosening their intellectual stays or letting down their hair might be interpreted as a serious threat to the commercial interests of the newspapers for which they toiled.

Despite any frustration that they felt about this state of affairs, the journalists did enjoy, at least with their eyes, the dresses, hats, mantles, and coats that were the mainstay of their fashion features. They were consumers, too. But they also knew that too much intellectual or moral rebellion might cost them paid work, public recognition, and even the modest freedoms that their journeys into the everyday work world afforded them. Consequently, their columns about fashion were multi-textured and often contradictory, reflecting their conflicting feelings of resentment, frustration, and enthusiasm. Although they encouraged their readers to experiment with healthy reform dress, and to clothe themselves less restrictively than most fashion plates allowed, they also tended to draw the line at any perceived masculinity in women's dress, especially anything resembling trousers.

Scholars have written many articles and books on the vexing question of what constitutes and influences fashion. In recent years, they have been shifting their focus from sociological analysis towards cultural analysis and postmodern perspectives.[2] The influence of gender, ethnicity, and class on consumerism as it has been expressed in the media constitutes overlapping areas of that debate. In her work on two American magazines, which were also read by Canadians, the *Ladies' Home Journal* and the *Saturday Evening Post*, Helen Damon-Moore argues that these publications 'aided in the creating, development and sustaining of the commercialization of gender, and the gendering of commerce,'[3] but also points out that

the interplay among editors, advertisers, and readers must be understood in historical and cultural context.

While we now have a few substantial American studies on consumerism and nineteenth-century magazines, there are no scholarly articles on fashion features in Canada's daily newspapers during this era, nor on their role in promoting consumerism among Canadian women of all classes. We need a fuller history of consumer culture in Canada that also includes an understanding of what women desired but did not have the money to buy. An American media historian, Susan Henry, has urged researchers to consider women media workers as producers of women's culture, and to explore their everyday tasks as journalists and their relationships with their readers.[4] Such analysis, I believe, should include the work of women journalists who wrote about fashions for other women, and were consumers themselves. This article addresses these issues.

Women's fashion features of all kinds were an expression of the growing consumerism of late nineteenth-century Canada, which was partly fuelled by the growth of department stores and fostered in turn by the advertising which financed the newspapers. The advertising industry was still young, and most newspaper editors were not fully aware of the advantages of what we would identify today as niche marketing – in this case, a ready-made female audience.[5] Consequently, their approach to having a women's page, with its own woman editor, could be serendipitous. Sometimes, newspapers would carry plenty of advertising but no women's page as such, or would publish occasional articles from anonymous writers using feminine pen-names. In 1893, for example, the *Toronto Evening News* was publishing only a regular fashion illustration called 'Our Daily Fashion Plate.' Finally, in 1899, it introduced 'The Woman's Page,' edited by 'Donna' and featuring contributions from 'Ikabel,' 'Irene,' 'Gretchen,' 'Cleo,' and finally, 'Isadore,' who went on to become the editor of the same page, while most of the other writers disappeared.[6] The use of pen-names came from an earlier literary tradition and served several functions. It allowed a writer to be anonymous, to freelance for competing publications, and to create an attractive public persona with whom readers could identify.[14]

The Canadian newspaper writers examined in this article were prominent women whose real identities and personal politics were generally known, and who worked on various Toronto newspapers for several years during the last decade of the nineteenth century. They were Kathleen Blake Coleman, writing as Kit of the *Toronto Daily Mail*, Alice Fenton Freeman, writing as Faith Fenton of the *Toronto Empire*, Emily McCausland Cummings, writing as Sama of the *Toronto Globe*, and Elmira Elliott Atkinson, who wrote under her own name, and also as Madge Merton or Ella S. Atkinson for the *Globe*, and the *Toronto Star*, among other Canadian publications. These four journalists were all middle class and well

educated, which was the norm for women working on the daily newspapers at the time.

Kathleen Blake Coleman was the editor of 'Woman's Kingdom' for the *Toronto Daily Mail* from October 1889 to February 1911, staying on after the *Mail* merged with the *Empire* in 1895 and became a Conservative party organ. An Irish immigrant, she became a journalist in Canada in order to support her two children. She was a loner by nature and, although she believed in equal pay and was a late suffrage supporter, she was not a feminist activist. She did, however, help to establish the Canadian Woman's Press Club to advance the professional status of women journalists and writers.[7]

Toronto-born Alice Fenton Freeman produced 'Women's Empire' in the *Toronto Empire* every Saturday from 1888 to 1895, losing her job to Kit when their two papers merged. Faith, who was also a school teacher, had a reputation as a 'graceful' and 'thoroughly womanly'[8] woman, given to philosophizing about nature and life in general. Best known for her later travels in the Yukon, she sent the first press dispatch from Dawson in 1901. She was a suffrage activist and probably the most outspoken feminist of the four journalists, despite the fact that she worked for a Conservative newspaper.[9]

Emily McCausland Cummings was from Port Hope, Ontario. During 1893 and 1894 the widowed Cummings earned her living writing and editing 'From a Woman's Standpoint' in the Saturday *Globe*, a newspaper generally associated with the Liberal party. Later, she became the newspaper's Ottawa correspondent. The daughter of an Anglican rector, she was active in church missionary societies and, like Faith, was a leading member of the National Council of Women of Canada. Her pen-name, Sama, was the Japanese word for lady, which suggested that she wanted to project a conventionally feminine image that was also exotic and alluring.[10]

Elmira Elliott (Atkinson), born in Oakville, Ontario, wrote 'Women's Work and Ways' for the *Globe* during 1891, and subsequently contributed freelance articles to the same newspaper, which also used American syndicated writers. Madge married a newspaper editor, Joseph Atkinson, and moved with him to the *Montreal Herald* in 1896, and then to the *Toronto Evening Star* (later the *Daily Star*), a newspaper aligned with Liberal and progressive causes. A somewhat reserved maternal feminist, Madge was also a supporter of temperance and women's suffrage, but did not approve of women running for public office or becoming directly involved in politics.[11]

These writers, like many other middle-class women, were taking on new challenges in the work world outside the home. While Kit, Faith, Sama, and Madge generally supported the advancement of women, one of their primary duties as women's page editors and writers was to explore the world of fashion and

encourage their readers to become enthusiastic consumers of various modes of dress. Fashions reflected those changing roles for women and measured the cautious one-step forward, two-steps-back rhythm of public acceptance. Thus, the extravagant bodice of the 1890s, for example, could signal either businesslike efficiency with stiff, high collars, and ties, or feminine charm, with ruffles and lace. It was the journalist's job to guide her readers on the importance of taste and personal style, and to interpret and comment on the latest trends. She was supported in this endeavour by the advertising copy and the syndicated articles that helped fill the space on her pages.

Almost 50 of Canada's 119 newspapers subscribed to American wire services and also bought American features and advertising as pre-set type forms called boiler-plate. Canadians read American newspapers and magazines avidly, and much of the fashion material the journalists ran on their pages focused on the latest trends from New York, and other international fashion centres.[12] Canadian dailies regularly carried features accredited to *Harper's Bazaar* and other fashion magazines and various U.S. newspapers, including fashion letters describing the latest attire worn by society leaders in London, Paris, Vienna, and even Dublin.[13] But the Toronto woman journalist was clearly expected to originate some fashion material of her own by investigating what was available to local consumers in their own stores, and keeping up to date by making the occasional trip to New York.

The journalists actively spread fashion's influence in these ways partly because this industry was closely linked with advertising, which financed the newspapers. By the 1890s Canadian dailies were still aligned with the major political parties, but were relying less on those allegiances for their survival and more on business practices. During this period they began consolidating their newspaper holdings into chains, increasing display (pictorial) advertising and lavish illustrations, and dividing their newspapers into sections that would appeal to different kinds of readers.[14] By 1900 two-thirds of the typical Canadian newspaper consisted of advertisements. Historian Mary Vipond notes that the advertising dollar was the 'principle motive for the stylistic changes that popularized and diversified the contents of Canadian newspapers in the late 19th century.' Those changes included the establishment of the women's pages, which were dotted with ads for products that appealed primarily to women. Small pictorial ads from local or national companies touting items that ranged from riding habits, to patent medicines, to useful items for the home sewing market, were placed on the women's pages, and in other sections of the newspapers as well. Many women still made their clothes at home, so that boiler-plate ads for sewing machines, and for dry goods such as fabrics, threads, linings, skirt bindings, and fasteners, were common.[16]

The content of these advertisements reinforced what newspaper editors and advertisers assumed were the typical female reader's primary interests: her personal

appearance and conduct, her family's health, and the upkeep of her home. Similarly, the woman journalist was expected to appeal to these same consumer interests in the articles she wrote, the fashion notes she ran, and even the advice she gave to the readers who wrote to her. It was her duty to do so.

The journalists must be understood in the context of the professional expectations placed on them in their workplace as much as for the contents of the articles that they wrote. As women writing primarily for women, they were metaphorically assigned to the private or domestic sphere reserved for middle-class females in late Victorian culture, much like the dressmakers and milliners who produced the fashions about which they wrote. This gendered separation between public and private was arguably more myth than fact, however, for these journalists ventured into the world at large every day, as did most other women. Nevertheless, they worked in the women's department, a physically separate area of the newspaper building from the newsroom where the male journalists and editors produced news stories that were considered vastly superior and far more weighty than the 'gossip and chit-chat' that belonged to the women's realm.[17] In keeping with the value placed on their work, the women were paid less than the men,[18] and they were not encouraged to aspire to anything more challenging. Contemporary advice books counselled fledgling women journalists to write light articles about feminine beauty and domestic concerns, rather than substantial work on business or politics, because that was what the public expected of them.[19] Their work reflected a distinct female culture that was less valued than the male business of hard news, but was designed to contribute to the overall financial health of the newspaper concerned.

A journalist's relationship with her female readers, especially their responses to her, was one measure of her popularity, and an important factor in attracting lucrative advertisements. But whether audiences played an important role in the contents of these pages is difficult to assess in historical context, especially a century after the fact. While fashion features, like other news copy, tended to stress the exotic or sensational, it was an emphasis which may have been quite out of proportion with the public's actual acceptance of those trends. It does appear from the journalists' own advice columns that readers did influence the content of the women's pages to some degree, although we cannot know for certain who these readers were, how they chose their favourite newspaper, or how much attention they really paid to the articles they read.

The advice columns gave readers some opportunity to make a direct connection with the journalists, who answered their queries about a wide range of topics, including 'politics, polemics, physiology and pimples,' as Kit of the *Mail* once put it.[20] Few of these letters were actually published. The journalists chose only the ones they wanted to use, identified the readers by their pen-names, quoted

excerpts or gave the gist of their questions or comments, and selectively answered them. Occasionally, however, they would run an original letter in its entirety, especially when a reader wanted to make a point about a contentious issue, such as whether or not women should go into business. The journalists may even have made up some letters themselves, again to attract readers, or reused them from time to time to make their workloads lighter.[21] Much of the advice the journalists offered their readers had to do with the ways in which women could improve their appearance, including what they should wear.

Because both readers and advertisers desired news of the latest fashions, newspaper editors insisted that their women's page writers introduce these trends as full-length articles outside of their advice columns, and accommodate matching advertisements on their pages as well. This directive frustrated the journalists when they wanted to write about other issues. Faith of the *Toronto Empire*, who preferred writing about national affairs and women's work over fashions, mentioned wrangling with the foreman of the composing room, where the galley of her page was set, over ad space. She wanted to keep as much of her five-and-a-half column page as possible for her own writing and resisted his attempts to insert a big ad which, she wrote, 'must go on our page by promise to the advertiser.'[22]

In addition to having to give up their editorial space, the journalists were also expected to act as uncritical agents for Toronto businesses, endorsing new fashions or products available to local consumers. Faith, for example, went to Murray's department store, a prominent Toronto establishment, two or three times a year to learn about the latest fashion trends. In January 1894 the store's various department heads gave her a list of tips, including the following, which she passed on to the *Empire*'s readers:

- Dress skirts are of walking length and full.
- Pearl lace is expensive, but is extensively used for evening gowns.
- Sleeves are much puffed.[23]

The connection between the women's page editor's role and the advertiser's product was not lost on readers. When 'A Business Woman' wrote Faith an unpublished letter that was no doubt critical, the journalist replied in print that she was 'not under orders. This is not an advertising page.' She explained that she was simply acknowledging the courtesy of the people at Murray's who helped her write about fashions.[24]

Kit, like Faith, also regularly discussed consumer products or services in her columns. She insisted to her readers that she did not get paid for her endorsements. One of her toughest and most exhausting assignments was to judge fifteen hundred entries to an ad writing contest, sponsored by the *Mail* and local

businesses, which were anxious to understand what kind of ad copy appealed to women. She sent the twenty best entries to the sponsors, who chose the top three winners and awarded them with generous prizes: a fashionable mantle worth $45, an ostrich feather fan worth $25, and a folding bamboo silk screen worth $20.[25]

While the local stores undoubtedly provided the busy journalists with handy copy, it was, perhaps, important for both Faith and Kit to assert their independence, given the growing professional trend toward writing objectively – that is, accurately and without bias. But they definitely wanted more say in what they should write about, other than fashion, including the social issues and other interests close to their hearts.[26] Of the four journalists, only Sama complained that she would like to write more about fashions, as many of her readers requested. But, she wrote, 'even if it were possible ... I am afraid there would arise a perfect howl throughout the office concerning "want of space."'[27] She seemed to be saying that the requested fashion features would have to be added to her other material and the advertisements, not replace them, and her editors already begrudged the space given over to women's interests.

Advertising copy, direct or disguised, was not the only material that superseded the features about other matters that the women wanted to write. Drawings were a common component of the nineteenth-century newspaper, and were often used to illustrate the topics explored in the accompanying article – for example, Kit's investigation of Charles Dickens's London and its still apparent social ills.[28] Believing, with reason, that fashion-conscious women felt obliged to measure up to a certain image of natural beauty, the newspaper editors increasingly replaced the more sober drawings with lavish pen-and-ink fashion illustrations depicting the latest modes. Faith used more and more fashion features and illustrations, which took up half of her page in the *Empire*. The *Toronto Globe*, which carried columns by Sama and Madge, often featured drawings with brief descriptions, such as the various styles of ball gowns for 1893 (illustration 36). The *Empire* and the *Globe* were competing with each other and with Kit in the *Mail*, which also carried prominent fashion plates.[29]

Of the four journalists, Kit seemed the most unhappy about having to run so much fashion material, especially after the merger of the *Mail* with the *Empire*. She had always preferred more intellectual topics, arguing that imported women's fashion magazines already provided readers with ample coverage of the subject. She complained that she was being pressured by her male editors at the *Mail and Empire* to do more fashion articles than she had before, and she asked her readers what they wanted. One respondent, 'Mary E. Duncan,' felt that a woman's page without fashions was like a farmer's page with nothing about farming. But a reader who called herself 'Another Kit' argued against too many fashion features, observ-

36 'A New Ball Gown' like this one was de rigeur for elite gatherings. (*Toronto Globe*, 14 January 1893)

ing that editors did not understand the woman's market and were not very successful with it:

> I suppose men editors, as a rule, consider that women are not capable of appreciating much else than fashion and receipts [*sic*], and no doubt that is why a woman's page edited solely by men seems so flat to the average woman. I have heard men say that a woman's paper cannot, as a general thing, be made to pay, and no wonder, if that is the way men editors seek to please us.

That same day, Kit claimed that most readers who wrote in response to her appeal did not want 'Woman's Kingdom' turned into a fashion page and gleefully ended the debate, writing:

> Well, I think that's enough girls. We have worsted the editor, and the next time he approaches me with 'What about a fashion page now, for the ladies?' I shall trot him off to the file and make him read every one of these letters over again and defy him with a triumphant 'Now!'[30]

Her victory was short-lived, however. Her editor had no doubt noticed that her advice column had always been peppered with readers' questions, so much so that Kit had sometimes complained about the tediousness of repeating the same advice about skirt lengths, the latest fashion colours for spring or fall, and home-made remedies for freckles 'every Saturday.' Despite her protests that women were also interested in the affairs of the world, 'Woman's Kingdom' continued to feature its staple of fashion illustrations and notes. Assigned to go to New York to cover a fashionable society wedding, she grumbled, 'I am upon fashions, which I cordially detest but are supposed to be necessary to a Woman's Page.'[31]

Descriptive accounts of what women wore to high society weddings, the governor general's ball, and other elite social events appealed to class snobbery and public curiosity, and gave the journalists an opportunity to educate their readers about upper-class dress codes and etiquette, thus presenting the elite as role models for all their readers. The Toronto journalists promoted the belief, as did most of their contemporaries, that style and cultural behaviour 'trickled down' from the upper classes, regardless of the fact that it could also originate with working-class women.[32]

Many historians believe that shop girls and factory workers copied fashionable dress as a sign of independence, as did secretaries, saleswomen, and telephone operators. Women professionals such as teachers welcomed their expanded horizons, but many of them were aware of being on public display and were uncertain how to maintain their femininity in their new roles, since there were few role

models for them to emulate. The Toronto journalists addressed their questions, providing the answers these new working women sought while invoking the lessons of household thrift in fashion as well as in other domestic matters. Generally, the journalists agreed that a woman should do her best with what she could afford, and not dress above her social station in life. As Madge succinctly put it, if a woman was not dressed 'in accordance with her means, we cannot call her well-dressed.'[33]

The woman who strayed too far over the class line was seen to threaten the status quo, especially domestic servants who appeared to be putting on airs. Maids, Kit wrote, should not try, on their days off, to emulate their mistresses because they just looked silly in 'those terrible splashes of ribbons, those hideous chains and lockets and bangles which appear every Sunday afternoon.' She was annoyed by the Irish domestic servant or barefoot 'Bridget,' a stereotype, for abandoning the peasant dress of her homeland for the corsets, overembroidered white skirts, and supercilious air of the new world. Kit commented to another 'Bridget,' who wrote to her: '"Liberty" had come to the Irish country girl. She could "spake her moind" and was going to, now she was in a free land – and I don't want any of her, Bridget.'[34] Her sentiments said as much about the prejudices commonly held against the Irish working class as it did about fashion.[35]

Despite the sometimes patronizing attitudes of the journalists who wrote the women's pages, women of all classes looked to them for sophisticated guidance and leadership on the variety of styles and choices they could wear. The journalists demurred from setting themselves up as paragons of fashion, however. As Madge once explained, she didn't want to have to live up to the latest trends, mainly because women who did were often stared at, and 'women resent the gaze which measures, dissects and forms opinions about their garments.' Their role was to translate for their readers, sometimes literally, the finer points of high style, making it accessible, affordable, and locally available. In one of her columns, for example, Faith explained a number of fashion terms, most of them French, for the benefit of her less worldly readers, who were no doubt grateful to learn that a 'filet' was not fish or steak, but a waistcoat or vest, and that 'suivez-moi' was not an enticing invitation but the falling ends of ribbons.[36] Sometimes Kit used subversive humour when giving advice, especially when she did not approve of the latest trend. The best way to make a fashionable hat, she once wrote, was to take a factory-made hat shape, beat it up thoroughly and then trim it with 'four rows of lace, a bunch of ribbon, some lilac or yellow tulips all bunched up at the back, several yards of jet lace, two rows of withered cornflowers, a snake's head, a bunch of grass, a bare twig and a bird's head stuck on the crown.' She was ridiculing the latest recurring fad in millinery for the spring of 1891 – stuffed snakes and birds – which she regarded as both foolish and cruel.[37]

37 'The Picture Hat' was typical of the kind of fashionable headwear that appeared in the women's pages in the spring. (*Toronto Globe*, 25 March 1893)

As well as acting as fashion barometers for their readers, the journalists also provided advice on how women could dress themselves well at the least expense, or sew their own versions of the latest fashions. Sama explained how, by saving feathers and other material from her old hats, for two dollars a woman could duplicate a fashionable chapeau that would ordinarily cost her twenty-five dollars in the shops. Madge also gave advice to her readers. A 'plain skirt with a long, double-breasted coat-bodice will look well in tweed' with large buttons or feather trim, she told 'Little Dorrit.'[38]

Regardless of their attempts to be helpful, the journalists usually promoted fashions that were well beyond most women's financial reach, including their own. The need to foster consumer consciousness in their readers to please advertisers and local merchants likely had much to do with this anomaly. More than one reader complained about the extravagant fashions that Kit chose to highlight in her pages. But the journalist, who was not a fashion plate herself, argued that even she liked to read about what she could never afford.[39] Essentially, she was inviting her readers to share a fantasy that took them beyond the mundane, toned-down versions of the leading French styles that were available to them locally:

> Dear sisters, nobody ever did write practicable fashions – at least, I never read a fashion letter yet that didn't revel in passementerie and diaphanous draperies, jewelled ceintures, and loves of bonnets that only cost $25 or so. Labourers' wives, or merchants' wives for that matter, can hardly afford the wonderful garments that are written up by fashion writers, but even newspaper people … like to write about these lovely things which they never can hope to have themselves.[40]

On other occasions, she became reverential and wrote up fashions in the same breathless prose other journalists used. She appreciatively compared a gorgeous lace and satin nightgown she saw in the trousseau of a young American belle, to a 'moonlight sonata,' adding 'the thought of anyone going to bed in it made me shudder.'[41] Similarly, Madge could be downright syrupy in her role as a chronicler of fashion, once describing feather boas as

> … fluffy bits of vanity. They embrace the rosiness and whiteness and smoothness of complexions by their lustre and depth of color. They flutter in the wind and they cling with bewitching tenderness to pretty white necks and even flirt a little with stray locks from my lady's coiffure.[42]

Such recognition of the importance of sexual appeal was central to woman's culture throughout the nineteenth century, but personal deportment and healthy living were also considered important in this era of rapid change in gender roles.

Social reform influences encouraged women to strengthen both their political and their physical muscles. They joined various organizations to increase their impact on social policy and conditions in the workplace, and participated in healthy leisure activities such as tennis, bicycling, and archery. While changing fashion and other cultural trends reflected women's more active lives, they stopped short of revolutionizing what they wore and how they behaved. This lack of wholehearted enthusiasm for dress reform may have been a reflection of a shortcoming in the feminist movement of the day which did not embrace the cause wholeheartedly either.

The female role models in the popular culture of that era were not reform movement feminists. According to Lois Banner, the two feminine icons touted in the 1890s were the voluptuous woman, modelled after stage performers such as Lillian Russell, and the tall, athletic, and patrician Gibson Girl, who was slowly replacing her. The Gibson Girl was created by an illustrator for *Life* magazine, Charles Dana Gibson, and was depicted as middle-class, although she sometimes belonged to high society. She was the American 'new woman' who wore skirts, blouses, and suits for street wear, played sports, and pursued a career. She was not a radical, however, for motherhood was still her ultimate goal. Faith used a picture captioned 'C.D. Gibson's Typical American Woman' on her page in the *Toronto Empire* in December 1893 (illustration 38).[43]

The Toronto journalists did not always take these icons seriously, and could be critical of the kinds of images that ordinary women were expected to live up to. According to Faith, the 'new woman' was not real, but was a 'mythical creature of the syndicate letter or magazine article who serves well enough as a dummy for needy writers to trick out in feminine apparel.' The middle-aged Kit bemoaned the lack of fashion plates representing women who were older, or not perfectly shaped. She said fashionable women were always depicted as young, slim, and beautiful when most women were nothing of the kind.[44]

There was, indeed, some tension between the cultural images promoting the ideal or 'new' woman, and the social reformism that suggested that women had more important matters to think about than fashion accessories. Faith saw it as a women's right to pursue beauty aids of different kinds, but, as a feminist, believed that women's movement leaders should dress and conduct themselves in both a modern and a ladylike fashion if they wanted their ideas to be accepted. Of the political meetings held in the Women's Building at the 1893 Chicago World's Fair, which she attended, she wrote, somewhat defensively:

> It was a wonderful week of womanly intellectuality and pretty gowns. For be it known unto the cynical men of Canada that the day of strong-minded frumps has passed, and the day of clever, deep, broad-thinking, daintily-gowned woman has arrived.'[45]

38 'Mr. C.D. Gibson's Typical American Woman,' a fashion icon, as she appeared in 'Faith Fenton's' page. (*Toronto Empire*, 9 December 1893)

Lois Banner has suggested that there was a split among women over fashions, or, as she puts it, 'feminism opposed fashion and ... the "fashionable" woman opposed the "natural woman."' Recently, however, scholars such as Cynthia Wright have argued for more complexity in that analysis.[46] When the Toronto journalists criticized fashions, it was not because they thought a woman's appearance did not matter, but because they believed that a woman's apparel should not restrict her movements or otherwise jeopardize her well-being. Reform dress designed to modify women's fashions became a hot topic for the journalists, who believed that tightly-laced corsets, restrictive bodices and sleeves, heavy petticoats, and long hems that trailed in the mud were uncomfortable and possibly dangerous to a woman's health.

There were two different but overlapping branches of dress reform, one seen as more feminist and practical, and the other as more aesthetic or artistic. While feminist dress tended to be loose, but plain, sensible, and bordering on the masculine, aesthetic dress was flowing and graceful, often featuring Liberty prints and inset yokes of white muslin, or lace frills at the neck. Another version of this style, the Greek dress with its empire line, was also popular. Fashion scholars believe that feminists saw reform dress in terms of physical, psychological, and economic freedom, while anti-feminists saw the style in terms of healthy, natural motherhood.[27] (See illustration 39.) But the issue was not as clear-cut. By the 1890s both reform camps had been taken over by clubwomen, such as the members of the Woman's Christian Temperance Union, who mostly advocated simple 'alterations of currently fashionable dress.' Even American dress reformer Mabel Jenness, a frequent visitor to Toronto, wore a loose-fitting corset under her Greek gown.[48]

Historians have made much of the role that corsets played in women's fashions, as did nineteenth-century doctors and other experts. It is apparent that the Toronto journalists were not necessarily opposed to women wearing corsets, which would have been a radical position at the time, but were concerned about tight lacing. Sama of the *Globe* wrote that the practice was worse than Chinese footbinding. 'One can live without walking,' she said, 'but it is still necessary and fashionable to breathe.' As late as 1900, Madge was still cautioning her *Star* readers about it. There was nothing wrong with being stout, she told them, but 'a contorted waist and swelling figure above and below is hideous in its deformity ... a corset does not reduce corpulency. It only moves it.'[49]

The other two journalists revealed their own personal preferences, letting their readers know that they had rebelled against corsets for themselves, at least the tighter ones. The more radical Faith told her *Empire* readers that she had abandoned her own corset altogether in favour of a short-sleeved, ribbed cotton shirt, similar to the Health Brand vest manufactured in Montreal, 'and now a corset seems to me the cruellest and hardest thing woman ever invented – if she did

39 'A Charming Toilette' was clearly for women who could afford it, or liked to dream. (*Toronto Globe*, 6 May 1893)

invent it.' In 1891 Kit wrote discouragingly about a renewed fashion in London for '19 and 20–inch corsets,' noting that dress reformers did not seem to be making their influence felt after all. 'I was goose enough to get a tailor-made gown from London recently. A friend brought it out, and now I can't get into it under a 22-inch corset, and *as I won't wear one*, I have the delightful pleasure of looking at my gown.'[50]

Reform dress promised more than just freedom from tight corsets. Even male editorial writers saw shorter and looser skirts as more hygienic, especially in rainy and muddy weather. Sama enthusiastically boosted a rainy-day outfit the American dress reformer Mabel Jenness modelled for a Toronto audience in 1892. This outfit consisted of a dress that ended just below the knees and gaiters that extended to just above them. Sama observed that one day she just might adopt the style herself, but only 'when public opinion has cut its eye-teeth and learned wisdom.'[51]

The debates in the newspapers about dress reform and the benefits of exercise were really thinly disguised concerns about gender identification and sexual liberty. It was the advent of the bicycle that brought arguments about femininity in dress to a head in the 1890s. Apparel for bicycle riding, such as divided skirts, oriental trousers, and bloomers, allowed more freedom of movement, but conservative critics saw these garments as a threat to a woman's essential femininity and perhaps her chastity as well. One of Madge's readers, 'Rex,' made it clear in a letter to her that the well-dressed woman did not transgress gender lines: 'A woman is well-dressed when she wears womanly garb, and not well-dressed when she affects the garments and manners of a man.'[52]

In another case concerning a critical male reader, Faith displayed an understanding of the cultural nature of social gender divisions that bordered on the radical. When 'An Old Bachelor of Three-Score-Years-and More' complained to her about bloomers, she replied:

> The 'womanliness' of any costume is not inherent, but a matter of custom. Had you never seen women in other dress than trousers and coat, while men wore skirts, you would have deemed it an equal sacrifice of 'womanliness' had a transposition of garments been proposed.[54]

Faith well understood that reform dress could herald new freedoms for women. As her younger 'sister' put it in one of her columns, '"Why, every woman will be a girl, and every girl a child again when we get our oriental trousers. Oh those blessed bicycles!"'[54]

While the sport of cycling caught on, the most masculine garb did not, at least not in Toronto. The new freedom inevitably inspired a mix of the old and the new in fashions. In Canada and the United States most women chose not to rebel too

strenuously against social mores, and their own fashion sense, and compromised with shorter or divided skirts rather than adopt undisguised bloomers or trousers.[55] In 1891, however, Faith noted the latest fashionable bicycling garb did not include divided skirts.[56] In contrast, women riding bicycles in Chicago were outfitted in short divided skirts worn above gaiters which covered the lower legs, according to Kit, who found them far more sensible than the long skirts worn by women who rode in Toronto. She once claimed to enjoy wearing divided skirts herself, but usually she advocated both comfort *and* femininity: 'There is more deadly mischief in half an inch of lace petticoat than in forty pairs of knickers,' she wrote.[57]

New fashions above the waist also presented a challenge to observers who were anxious about gender identity. Especially problematic were the plain shirt fronts, ties, and vests that were coming into vogue along with empire lines and shorter hems. Madge didn't like the style, believing ruffles were more becoming on women than the stiff shirt front and tie. Of one new style, she wrote,

> And now you must have a waistcoat back to your blouse. The belt is found to be unworthy the confidence placed in it, and some girl with a brother decided that straps and a buckle keep the gathers in order and blouses are to be so fashioned for future use.[58]

Kit declared that the masculine girl was depressing and that her shirt front was 'a vast blunder ... The female form divine will not accommodate itself to [*it*].' She also believed that if there was to be dress reform, it should be brought about carefully. 'No woman, or committee of dress reform women, should try this sort of thing in an obstinate, overbearing way; the consent of those who change must be gained very slowly.'[59] Perhaps this caution on the part of the journalists contributed to the lack of enthusiasm about dress reform. As a movement, it had more intellectual than physical impact in Canada, as it did elsewhere. Part of the problem may have been the fear of changes in the social order that new fashion freedoms would have signalled.

The fashion articles, illustrations, and advice columns that appeared in Toronto's daily newspapers in the last decade of the nineteenth century certainly underscored the gendered nature of consumerism, and its complexity as well. As journalists who individually supported some women's causes, Kit, Faith, Sama, and Madge were not always champions of fashion, but they were not indifferent to its charms either. They were inconsistent in their approach to writing fashion news and commentary, partly because of the professional and social pressures on them as women journalists who were expected to respond to the multiple and conflicting demands of readers, editors, and advertisers. Although they occasionally railed

against fashion's most repressive aspects, ridiculed its excesses, and supported moderate changes in women's dress and deportment, by and large, they played a promotional role where the latest trends were concerned. It was a role very much in keeping with the business direction of Canada's newspapers at the time, and prevented the journalists from writing about many of the issues they cared about, such as gender politics. Their proscribed role likely offset the effects of any column they did manage to write that might have truly challenged the established gender divisions between women and men, and class divisions among women readers.

NOTES

1 Freeman, *Kit's Kingdom: The Journalism of Kathleen Blake Coleman*, chapter 1; Downie, *A Passionate Pen: The Life and Times of Faith Fenton*, chapter 9.

2 Thorstein Veblen, 'The Economic Theory of Woman's Dress,' 67–74; and Veblen, *Theory of the Leisure Class*; Banner, *American Beauty*, and Wilson, 'Fashion and the Postmodern Body,' 3–16.

3 Damon-Moore, *Magazines for the Millions,* 3; see also Scanlon, *Inarticulate Longings*.

4 Henry, 'Changing Media History through Women's History,' 341–62.

5 For a brief history of Canadian advertising during this period, see Singer, *Advertising and Society*, 23–28.

6 Toronto *Evening News*, 1 April 1893, 1 April 1899, 24 June 1899, 14 April 1900.

7 Freeman, *Kit's Kingdom*, chapter 5.

8 'The Little Woman' [Sara McLagan], *Vancouver Daily World*, 6 July 1895, 2.

9 Faith began her career as a freelancer, writing a regular letter from Toronto as Stella for the Barrie, Ontario, *Northern Advance*. See Downie, *A Passionate Pen*, chapters 5 and 6.

10 Morgan, *Canadian Men and Women of the Time*, 287; on the pen-name Sama, see 'From A Woman's Standpoint,' *Toronto Empire*, 11 March 1893, 6.

11 On Madge, see Harkness, *J.E. Atkinson of the Star*, 16, 45; Wayne Roberts, 'Rocking the Cradle for the World,' in Kealey, ed., *A Not Unreasonable Claim*, 39. See also her column in *Toronto Star*, 15 October 1904, 17.

12 Rutherford, *A Victorian Authority*, 113; Vipond, *The Mass Media in Canada*, 13, see also Moffett, *The Americanization of Canada*, 96–103.

13 See 'The Globe's Special Page for Women,' *Toronto Globe*, 9 April 1891, 11. Examples of foreign fashion letters include those 'Canadienne' wrote from London and 'J.L.' wrote from Paris. *Toronto Empire*, 15 and 22 April 1893, 7; see also the *Toronto Star*, 8 January 1898, 5.

14 These changes are traced in Sotiron, *From Politics to Profit*. See also Stephenson and McNaught, *The Story of Advertising in Canada: A Chronicle of Fifty Years*, (Toronto: The Ryerson Press 1940), 265; Rutherford, Chapter 3.

15 Vipond, *The Mass Media in Canada*, 17. American historian Michael Schudson sees the establishment of the women's pages as symptomatic of consumerism rather than sexual equality. See Schudson, *Discovering the News,* 100.

16 For a typical example of a women's page with advertising, see, 'Woman's Kingdom,' *Daily Mail,* 30 April 1892, 5. Stephenson and McNaught, *The Story of Advertising in Canada,* 46, 219–32.

17 The subtitle of 'Woman's Kingdom' was 'Kit's Gossip and Chit-Chat.' See the illustration in Freeman, *Kit's Kingdom,* 50.

18 There are few reliable records of the salaries newspapermen and women made at the time. Freeman, *Kit's Kingdom,* 10, 55. Kit complained that syndication editors were paying male journalists ten dollars for political columns and women two dollars for fashion columns. *Mail and Empire,* 3 June 1899, 16. Faith made an estimated two dollars for her column when she started, forcing her to keep her full-time job as a teacher. Downie, *A Passionate Pen,* 92.

19 Freeman, *Kit's Kingdom,* 55. On contemporary advice for women journalists, see Steiner, 'Construction of Gender in Newsreporting Textbooks, 1890–1990.'

20 Kit's response to 'Balmaceda,' *Daily Mail,* 14 November 1891, 5.

21 See Madge Merton's page, *Globe,* 18 April 1891, 12; and Freeman, *Kit's Kingdom,* 95.

22 Toronto *Empire,* 26 June 1895, 11.

23 Ibid., 20 January 1894, 11. See also her accounts of later excursions to the same store; ibid., 2 June 1894, 11, and 22 September 1894, 11.

24 Ibid., 17 March 1894, 11. Sama of the *Globe* also wrote up department store openings. See Toronto *Globe,* 22 September 1894, 7. Ads for the same stores appeared in the *Globe,* 15, 21 and 22 September 1894.

25 *Daily Mail,* 30 July 1892, 5; 22 November 1890, 5.

26 On Kit's approach to personal involvement in her work, see Freeman, *Kit's Kingdom,* 37–38, 147–48.

27 Toronto *Globe,* 17 February 1894, 7.

28 See the illustrations in the *Daily Mail,* 12 March–16 April 1892, 5.

29 For example, *Toronto Empire,* 24 August 1894, 11; *Toronto Globe,* 14 January 1893, 5; *Daily Mail,* 24 September 1892, October–30 December 1892, 5.

30 *Mail and Empire,* 20 July 1895, 6. See also ibid., 13 July 1895, 5, 6 and 27 July 1895, 5.

31 See, for example, her response to 'Matilda,' *Daily Mail,* 30 May 1891, 5, and her responses to 'Jinks' and 'Mary,' *Daily Mail,* 8 August 1891, 11; *Mail and Empire,* 2 and 5 November 1895, 5.

32 These theories originated with Thorstein Veblen, George Simmel, and others. See Partington, 'Popular Fashion and Working-Class Affluence,' in Ash and Wilson, eds., *Chic Thrills,* 145–46. Kathy Peiss is a modern scholar who has challenged these theories. See Peiss, *Cheap Amusements,* and *Hope in a Jar.*

33 Response to 'Dunbar,' Toronto *Globe,* 13 June 1891, 11.

34 *Daily Mail*, 5 September 1891, 5; response to another 'Bridget,' *Daily Mail*, 17 June 1893, 8.
35 Barber, 'The Women Ontario Welcomed,' 102–5.
36 *Globe*, 28 November 1891, 11; Toronto *Empire*, 24 November 1894, 4.
37 *Daily Mail*, 28 March 1891, 5, 25 April 1891, 5, and 28 February 1891, 5. The birds mode persisted, much to Madge's disgust. *Toronto Star*, 18 August 1900, 19.
38 *Toronto Globe*, 24 March 1894, 6, 24 October 1891, 11.
39 She wrote humourously of her attempts to look fashionable for her presentation to the governor general and his wife at a ball in Ottawa. *Mail and Empire*, 12 February 1898, part 2, 4.
40 *Daily Mail*, 20 June 1891, 5.
41 Ibid., 16 November 1889, 5. See also Faith Fenton's description of Princess Alix's trousseau in Toronto *Empire*, 1 December 1894, 1.
42 *The Globe*, 17 October 1891, 11.
43 Banner, *American Beauty*, 129, 158–69; 174. The Gibson Girl had a freerer sister in the 'Girl of the Golden West,' a Calamity Jane figure. See 'C.D. Gibson's Typical American Woman,' *Toronto Empire*, 9 December 1893, 11.
44 Toronto *Empire*, 5 January 1895, 11; *Mail and Empire*, 15 July 1899, part 2, 4.
45 Toronto *Empire*, 18 March, 27 May 1893, 7.
46 Banner, *American Beauty*, 9–15; 23; Wright, '"Feminine Trifles of Vast Importance,"' 237.
47 Steele, *Fashion and Eroticism*, 146; Roach and Musa, *New Perspectives on the History of Western Dress*, 57–62; Newton, *Health, Art and Reason,* 130.
48 Banner, *American Beauty*, 147; Roach and Musa, *New Perspectives on the History of Western Dress*, 63, 87. Mabel Jenness wrote *Comprehensive Physical Culture* (1891) and her sister Annie Jenness-Miller wrote *Physical Beauty, How to Obtain and How to Preserve It* (1892). Both lectured widely.
49 *Toronto Globe*, 22 April 1893, 6; *Toronto Star*, 7 July 1900, 10.
50 *Toronto Empire*, 27 January 1894, 11; *Daily Mail*, 14 November 1891, 5 (my emphasis).
51 *Toronto Globe*, 18 March 1893, 6. See also Faith Fenton's column about an earlier visit from Mrs Miller in Toronto *Empire*, 9 January 1892, 5.
52 *Toronto Globe*, 6 June 1891, 11.
53 *Toronto Empire*, 26 January 1895, 11.
54 *Empire*, 25 August 1894, 11. It is not clear if this person, 'La Soeur' was really her sister or a literary device.
55 Sims, 'The Bicycle, the Bloomer and Dress Reform in the 1890s,' 125–45.
56 *Toronto Empire*, 11 April 1891, 5. See also Sama's column in the *Toronto Globe*, 16 June 1894, 6.
57 *Mail and Empire*, 25 July 1896, 24; *Daily Mail*, 21 June 1890, 5; *Mail and Empire*, 17 August 1895, 5.

58 *Toronto Globe*, 12 September 1891, 11.
59 *Daily Mail*, 22 August, 12 September 1891, 5.

SELECTED BIBLIOGRAPHY

Ash, Juliet, and Elizabeth Wilson, eds. *Chic Thrills: A Fashion Reader*. Berkeley and Los Angeles: University of California Press, 1993.
Banner, Lois W. *American Beauty*. New York: Alfred A. Knopf, 1983.
Careless, J.M.S. *Brown of the Globe*. 2 vols. Toronto: Macmillian, 1959, 1963.
Creedon, Pamela J., ed. *Women in Mass Communication: Challenging Gender Values*. 2nd ed. Newbury Park, CA: Sage Publications, 1993.
Cunningham, Patricia A., and Susan Voso Lab, eds. *Dress and Popular Culture*. Bowling Green, OH: Bowling Green State University Popular Press, 1991.
Damon-Moore, Helen. *Magazines for the Millions: Gender and Commerce in the Ladies' Home Journal and the Saturday Evening Post, 1890–1910*. New York: State University of New York Press, 1994.
Downie, Jill. *A Passionate Pen: The Life and Times of Faith Fenton*. Toronto: HarperCollins Publishers Ltd., 1996.
Freeman, Barbara M. *Kit's Kingdom: The Journalism of Kathleen Blake Coleman*. Ottawa: Carleton University Press, 1989.
Harkness, Ross. *J.E. Atkinson of the Star*. Toronto: University of Toronto Press, 1963.
Henry, Susan. 'Changing Media History through Women's History.' In Creedon, ed., *Women in Mass Communication*, 341–62.
Hollander, Anne. *Seeing through Clothes*. New York: Viking Press, 1978.
Iacovetta, Franca, and Mariana Valverde, eds. *Gender Conflicts: New Essays in Women's History*. Toronto: University of Toronto Press, 1992.
Kealey, Linda, ed. *A Not Unreasonable Claim: Women and Reform in Canada, 1880s–1920s*. Toronto: Women's Educational Press, 1979.
Lang, Marjory. *Women Who Made the News: Female Journalists in Canada, 1880–1945*. Montreal and Kingston: McGill-Queen's University Press, 1999.
Laver, James. 'Taste and Fashion since the French Revolution.' In Willis and Midgley, reprinted from Laver, *Taste and Fashion*. London: Harrup, 1937, 380–1.
Luck, Kate. 'Trouble in Eden, Trouble with Eve: Women, Trousers and Utopian Socialism in Nineteenth-Century America.' In Ash and Wilson, eds. *Chic Thrills*, 200–12.
Moffett, Samuel E. *The Americanization of Canada*. Introduction by Allan Smith. Toronto: University of Toronto Press, 1972.
Morgan, Henry. *Canadian Men and Women of the Time*. Toronto: William Briggs, 1912.
Newton, Stella Mary. *Health, Art and Reason: Dress Reformers of the 19th Century*. London: John Murray, 1974.

Partington, Angela. 'Popular Fashion and Working-Class Affluence.' In Ash and Wilson, eds. *Chic Thrills*, 145–61.

Peiss, Kathy. *Cheap Amusements: Working Women and Leisure in Turn-of-the Century New York*. Philadelphia: Temple University Press, 1986.

– *Hope in a Jar – The Making of America's Beauty Culture*. New York: Metropolitan Books, Henry Holt and Company, 1998.

Prentice, Alison, Paula Bourne, Gail Cuthbert Brandt, Beth Light, Wendy Mitchinson, and Naomi Black. *Canadian Women: A History*. 2nd ed. Toronto: Harcourt Brace Jovanovich, 1996.

Prentice, Alison, and Susan Mann Trofimenkoff, eds. *The Neglected Majority: Essays in Canadian Women's History*, Vol. 2. Toronto: McClelland and Stewart, 1985.

Prestoungrange, Gordon, Gordon Willis, and David Midgley, eds. *Fashion Marketing*. London: George Allen and Unwin, Ltd. [*c.* 1973].

Roach, Mary Ellen, and Kathleen Ehle Musa. *New Perspectives on the History of Western Dress*. New York: Nutri-Guides Ltd., 1980.

Roberts, Wayne. 'Rocking the Cradle for the World: The New Woman and Maternal Feminism, Toronto 1877–1914.' In Kealey, ed. *A Not Unreasonable Claim*, 15–45.

Rutherford, Paul. *A Victorian Authority: The Victorian Press in Late Nineteenth Century Canada*. Toronto: University of Toronto Press, 1982.

Scanlon, Jennifer. *Inarticulate Longings: The Ladies' Home Journal, Gender, and the Promise of Consumer Culture*. New York: Routledge, 1995.

Schudson, Michael. *Discovering the News: A Social History of American Newspapers*. New York: Basic Books, 1978.

Sims, Sally. 'The Bicycle, the Bloomer and Dress Reform in the 1890s.' In Cunningham and Lab, eds. *Dress and Popular Culture*, 125–45.

Singer, Benjamin. *Advertising and Society*. 2nd ed. North York, ON: Captus Press, 1994.

Sotiron, Minko. *From Politics to Profit: The Commercialization of Canadian Daily Newspapers, 1890–1920*. Montreal and Kingston: McGill-Queen's University Press, 1997.

Steiner, Linda. 'Construction of Gender in Newsreporting Textbooks, 1890–1990.' *Journalism Monographs* 135 (October 1992).

Stephenson, H.E., and Carlton McNaught. *The Story of Advertising in Canada: A Chronicle of Fifty Years*. Toronto: Ryerson Press, 1940.

Veblen, Thorstein. 'The Economic Theory of Woman's Dress.' In Leon Ardzrooni, ed., *Essays in Our Changing Order*. New York: Viking Press, 1945, 67–74.

– *Theory of the Leisure Class*. New York: Macmillan, 1912.

Vipond, Mary. *The Mass Media in Canada*. Toronto: Lorimer, 1989.

Wilson, Elizabeth. 'Fashion and the Postmodern Body.' In Ash and Wilson, eds. *Chic Thrills*, 3–16.

Wright, Cynthia. '"Feminine Trifles of Vast Importance": Writing Gender into the History of Consumption.' In Iacovetta and Valverde, eds. *Gender Conflicts*, 229–59.

The Fashion of Writing, 1985–2000: Fashion-Themed Television's Impact on the Canadian Fashion Press

DEBORAH FULSANG

Karl Lagerfeld, the ever-dramatic designer for the house of Chanel, waved his signature fan and declared 'the pussy' as fashion's newest erogenous zone. The *FashionTelevision* camera then turned to the runway. With pulsing club music in the background, the photographer's lens zoomed repeatedly to the hip area of a string of strutting models in effort to record the runway's latest G-spots shown highlighted with plunging necklines and provocative cross pendants.

Pre-television, fashion belonged to the rarified world of the elite. But as Lagerfeld's street-lingo summation of the trend-of-the-moment illustrates, times have changed. Today, with television broadcasting fashion news from the world's runway capitals to millions of viewers on a daily, if not hourly basis, fashion has become the stuff of everyday life. But it was not until 1985 when the pioneering fashion-themed Canadian television show *FashionTelevision* (*FT*) picked up the cause that fashion truly became an international hot commodity. *FT* and the myriad fashion shows that now crowd the viewing schedule have forever changed the way that the media reports on fashion and the way the public consumes it.

This chapter will explore how, from a distinctly Canadian perspective, *FashionTelevision* and its like have eroded the mystique of fashion. It discusses how they have democratized fashion and broadened the appeal of fashion across genders as well as class and economic distinctions. It will also discuss how Toronto-based City-TV's *FT* fuelled the proliferation of fashion media in Canada and precipitated an increase in staccato-style reporting, accompanied by plenty of high-gloss visuals as well as a more in-depth style of fashion reportage.

Fashion Television: In the Beginning

Canadians have not always been so fashion-informed. Leading American fashion periodicals such as *Vogue* and *Harper's Bazaar* have been available in this country

for decades but, in the wake of *FT*, the volume of reporting available to the average Canadian consumer has expanded exponentially.

A Canadian consumer magazine dedicated to fashion did not appear until *Flare* hit the newsstands in 1979. Maclean Hunter Publishing's (Rogers Communications as of 1999) *Chatelaine* magazine had been on the scene since 1928 but it defined itself, first and foremost, as a women's lifestyle magazine, not a publication with fashion as its raison d'être. *Mayfair*, another Maclean Hunter monthly fashion glossy, sold an editorial mix of art, fashion, and society gossip, and existed from 1927 until 1959.

Before fashion-themed television's introduction in the early 1980s, broadcasters considered fashion more a light-hearted filler than newsworthy editorial content. Coverage did not focus on the celebrity or the spectacle of the fashion arena – as was increasingly the case in late 1990s fashion coverage. Terry Lewis, news/special productions for Global News remembers that in 1980/81,

> we didn't have a fashion reporter per se – or a dedicated fashion department. We used to do fashion on the news at noon in the late seventies and early eighties but it would be a segment, not [by] a regular contributor. We'd have a fashion show – I remember cutting, directing it – in the studio ... we certainly didn't have anyone travelling the world.[1]

Canadian newspaper coverage of fashion in the pre-*FashionTelevision* era was, likewise, less glamorous. It was a beat, like politics or any other. As the 1980s approached and the economy prospered and consumers rallied to buy, fashion surfaced at the top of the shopping list. Society's growing obsession with cash and flash was the perfect stage for a new television show that focused on the world's most beautiful people and possessions.

Within the context of international fashion, France's Socialist government, elected in 1981, encouraged the Paris fashion industry and allowed designers to show their collections in the Louvre. In Italy, the fashion industry was building steam with the creative forces of Gianni Versace, Giorgio Armani, and Gianfranco Ferre. In New York, fashion enthusiasm centred on a growing number of big-name designers from Halston, Perry Ellis, and Donna Karan to Ralph Lauren. In Canada, the fashion industry was coming into its own. Its prosperity echoed fashion's international momentum. Federal and municipal government ministries and agencies were keen to promote top designers and manufacturers, especially to American buyers.[2]

'Out of the Toronto club scene of the mid-eighties emerged the next generation of stars, and the infrastructure was finally there to support them,' writes Leanne Delap in the *Globe and Mail*:

Suzanne Boyd, the editor of *Flare* magazine beginning in 1996, remembers hanging around Century 66 restaurant and watching the underground designers first flirting with the mainstream. 'Comrags and Loucas and Anne Sealy were starting out. And Ruth-Ann Lockhart [now a buyer at Holt Renfrew] owned the key shop, Atomic Age on Queen West. It felt like a ground swell then, but I guess I was naive, because there was something really big happening.'[3]

John Mackay, publicist and founding editor of *Toronto Life Fashion* magazine, remembers the time:

The last year of the '70s and the first six years of the '80s were a time that we'll never have again in our lifetime. The world embraced clothing and shopping in a way that [it] never [had] before. I think it made sense why you had the largest group of the population – the baby boomers in their millions – all reaching 30, all with some money, all looking, in their narcissism, to clothing. People who never before and never will again, look at a label, knew what they were wearing – and cared about what they were wearing.[4]

In 1985 Steven Levy launched the Canadian Festival of Fashion, a forum for designers to show their clothing on the runways to both the retailers and press, and later, to a fashion-obsessed public. A fashion retrospective in *Flare* magazine's September 1999 twentieth anniversary issue quotes Levy reminiscing about that time.

I could not believe that these wonderful things called fashion shows were being cloistered away in dark paces where so few were enjoying them when so many could. That's when I hatched the idea [of The Festival of Canadian Fashion] with [designers] Linda [Lundstrom] and Marilyn [Brooks]. I was ready in 1985 and so was the industry. We had 16 fashion shows over three-and-half days. Peter Laurence brilliantly put together the first Festival. Each show was exciting. I remember Saul Mimran from the Monaco Group saying, 'You've got to remember this: Play to the back rows. The people sitting in the front don't count.' And I think, to this day, the great success of the Festival [was] the back rows. The whole world of fantasy was created in front of them and they loved it – every moment of it.[5]

The popularity of music videos, which had pushed into mainstream culture in the 1970s, inspired the production of fashion videos by the early 1980s. These were an important precursor to *FT* and the other fashion-themed television programs. These videos came 'complete with upbeat scores, special effects and stimulating images that range from the pop to the surrealistic.'[6] Designers and

manufacturers could then also edit their video tape to create dynamic thirty- and sixty-second commercials for their labels which could then be aired in stores, at events, or used as actual television commercials.

Paul French, a Toronto producer of such fashion videos, reasoned that the success of the video as a product or concept stemmed from the notion that 'fashion itself is being considered as an entertainment medium.'[7] As Caroline Routh says in her book *In Style: 100 Years of Canadian Women's Fashion*, 'The ready-to-watch fashion era was quickly ushered into Canada.'

Fashion as Entertainment

By the time *Fashion Television*'s now internationally recognizable host Jeanne Beker entered Canadian living rooms, the peasant-style dressing of the 1970s had given way to the drama of the eighties. On one hand, Japanese designers such as Rei Kawakubo, Yohji Yamamoto, and Issey Miyake were making fashion headlines internationally with their avant-garde silhouettes and textiles. On the other, Western ready-to-wear was delivering line-backer shoulder pads, mini skirts, and bold jewelry as popularized by leading television series such as *Dallas* and *Dynasty*. In both modes, fashion revelled in the dramatic.

In Canada, the retail scene was flourishing with hot-ticket labels from Europe. Creeds on Toronto's Bloor Street was seducing its customers with prestigious labels such as Yves Saint Laurent. High-end fashion emporium Holt Renfrew was also prospering. In 1979 it had more than doubled the size of its store and was bringing in four- and five-digit ticket-priced couture designs for its style-conscious customers. The city had been bitten by the fashion bug. *Toronto Life Fashion* magazine was picking up steam since launching in 1977, and then *Flare* appeared on the newsstand in 1979 as a more sophisticated remake of its earlier incarnation as the teen-focused *Miss Chatelaine*.

For Canadian companies, it was a moment of opportunity, spurred on as they were by the enthusiasm of buoyant international markets: junk-bond trading was to the 1980s what the dot.com frenzy was to the 1990s. More women than ever had entered the workforce, and they were shopping like never before. In the United States it was the era of Reaganomics. Here at home, Mulroney and his Progressive Conservative party were spending big. So were consumers. And everyone was looking for their fifteen minutes of fame at the latest high-style clubs and restaurants.

Alfred Sung, backed by Mimran brothers Joseph and Saul, was forging into the United States – one of the first Canadian designers to do so – with myriad licensing agreements. Mirroring the bullish stock market and the spendthrift era, the sportswear designer also introduced a fur collection in the spring of 1985. 'Fur

should be fun,' he declared in the *Globe and Mail*, 'just like a cloth coat. I'd like to see my mink trenchcoat worn with sweat pants and a pair of white runners. I think that would look great.'[8]

In Montreal, big names in the industry included Jean-Claude Poitras, Hilary Radley, Parachute, and Leo Chevalier. Parachute came to understand the power of television in promoting its fashion with its exposure through the 1980s, which it achieved by dressing Don Johnson in the prime-time detective television series, *Miami Vice*. In Vancouver, fashion enthusiasm lagged slightly behind east-central Canada, but the international attention of Expo 1986 meant a boom to the city. Tourism dollars precipitated the immigration of prestige labels such as Versace, Christian Dior, and Valentino to the Vancouver retail landscape.[19]

Toronto designer Wayne Clark, known for his elaborate evening wear, was perfectly in sync with the era's flair for the dramatic. He remembers the jet-setting high life: 'It was like everything was possible ... I would be picked up in Dallas and there would be two limousines – one for me and one for the clothes. Designers and models were the new celebrities and it was wonderful to taste a little bit of that.'[9]

On the topic of doing business in the 1980s, Judy Cornish, one of the designers behind the Toronto-based Comrags label, says, 'It was a joke ... We never liked selling our collection, so stores would come to the showroom, and we'd say, 'lock the door when you leave, here's the order form.' We wouldn't even be there and we sold. It was a great time. It was very easy.'[10]

In retrospect, the birth and success of *FashionTelevision* was a natural, given the consumer-crazy mindset. To exemplify the era's excesses, statistics from the Diamond Information Centre report that North American diamond jewellery sales during the period from 1980 to 1987, exploded, ballooning by 310 per cent.[11]

In Toronto, Moses Znaimer was building City-TV, a renegade television station that embraced the unorthodox. It ditched the traditional anchorman news approach for dynamic video-camera work, on-screen text, and newsreaders with legs. Znaimer launched *MuchMusic* in 1984, an all-music TV show, modelled after successful American music video show *MTV*. Because of its resounding success, *MuchMusic* was followed by the introduction of *FashionTelevision* in 1985. A year later the station moved the program from bi-monthly to weekly broadcasts. Other fashion television projects were also being given the green light across the country. In Quebec a weekly program called *Quebec Flash Mode* was launched, the CBC introduced a pilot show called *In Fashion*, and the Life Channel aired a show called *Fashion America*.[12]

City-TV's *FashionTelevision* expanded the fashion video concept and looked to the music videos of the day for inspiration. Its on-air personality had been weaned on rock 'n' roll – Jeanne Beker had been the host of Canada's first all-music magazine show, *TheNewMusic* – and the show kept up its tempo with a lively

soundtrack, sexy characters, and provocative dialogue. 'We really set the pace for the way fashion started to be covered,' explains Beker.:

> Designers started to realize, in the same way that TV started to revolutionize the music industry in the late '70s and early '80s with MTV and MuchMusic, [that] ... Musicians had to be personalities ... they had to develop an image that worked on camera. Designers, too, started to realize that. On the other hand, TV did a lot to popularize fashion, it made designers household names.[13]

Runway footage of models in scanty ensembles – eye candy, as Beker has called it – was a sure sell on a glamour-obsessed public. In an interview, Jay Levine, one of *FT*'s co-creators, explained that 'television could take the imagery of fashion and give it action and emotion, complete with a rock 'n' roll soundtrack ... Add it up, and it's entertaining.' He supplemented this thought during an early 1999 in-person interview. '[*FashionTelevision*]; it's not about fashion the way people think it's about fashion,' he said. 'We're not in the fashion business. Fashion is the vehicle for entertainment.'[14]

The concept was seductive. Since entering the pop-culture canon in the mid-1980s, *FT*'s expanding global exposure fuelled a fashion curiosity both in the public and the press. For 1980, just five years before the show officially went on air, just sixteen listings for fashion-themed stories appeared in the Canadian Periodical Index. Ten years later, and five years after *FT*, that number had risen to one hundred.

Up Close and Personal

In 1983 CNN's *Style with Elsa Klensch* attempted to open the glamorous arena of hemlines and haute couture to the world. But while Klensch has maintained a stereotypically reserved British demeanour in her weekly thirty-minute program for more than fifteen years, *FT*'s Jeanne Beker broke the mould. From the beginning, Beker has positioned herself as friendly and approachable; as she sees it, 'real in an unreal world.' When she first landed on the fashion scene, Beker's style was a far cry from the journalism typical of the mainstream fashion media. She asked the personal questions, dished gossip, and professed to reveal what it was really like behind the scenes. The fashion press has picked up the trust-me, I'm-your-friend practice.

Flare magazine's Suzanne Boyd gets up close and personal in her editor's letter of June 1999. 'Mark, a former bodybuilding champion, promised me that he could do miraculous things with my body,' she says. 'Unrealistic ideals,' she laments. 'My road to a wardrobe full of pants that no longer fit is paved with them, along

with a "what's hot, what's not" litany of fitness trends ... I haven't been able to stick to anything. Does that make me commitment-phobic or just lazy?' she asks.[16] The reader empathizes. Boyd may be the editor of the magazine, but she affirms herself no different than her reader in her own body-dissatisfaction.

In the past, the mandate of magazines appeared to be less best-friend confidante than educator and motivator. Take for instance, an eight-page special career feature entitled, 'Anything you want to be,' which ran in a spring 1975 spring issue of *Miss Chatelaine*, the precursor to *Flare*. It was a rallying call. The intro page ran: 'Beginning in this issue, a year-long, celebratory career series, that not only lays down solid advice about specific fields, but profiles young women who are competing openly and equally for jobs, and shattering the myth of female weakness. Hallelujah! Our time has come.' Text-heavy career profiles followed on various women and detailed job descriptions.

One could argue that fashion publications no longer need to be motivational, given the successes of feminism and equal rights. Fashion magazines reason that with women firmly instilled in the workplace, what they really need is the inside scoop. The reader is now given first-person 'test-drive' articles on topics as far ranging as the best maternity wear, tanga underwear, and hosiery.[33]

Eye Candy for the Masses

In the early 1980s, as the popularity of fashion videos was rising, countless runway tapes from leading Italian, French, and American designers were landing on the editors' desks at City-TV. It didn't take long to realize their entertainment potential. Ironically, when shaping City-TV's *FashionTelevision*, the station turned to fashion's print medium, to the undisputed bible of fashion: *Vogue*. 'We were looking for a sleek look. We were trying to match the slickness of the industry at all levels,' says Hernan Morris, *FT*'s supervising camera man.[17] *FT* managed to carve out a niche for itself by specializing in fashion's moving images.

In fact, the medium of video has played an important step in the evolution of fashion photography both in Canada and abroad. It has propelled fashion photography to the next level. If in the 1960s and 1970s leading fashion photographers were pushing away from the elitism of posed fashion images characteristic of the 1950s, video represented a complete departure from the staged, formal fashion photo shoot.

As a process, fashion on TV represented the ultimate democratization of fashion photography. As the 1980s arrived, magazines caught models in action – walking, running, sailing. Just as photography's replacement of illustration was seen as a more truthful document of fashion, so fashion on television took this truth or freedom a step further. It implied the absence of staging altogether, and made it

40 This Canadian edition of *Time*, 24 March 1997, features one of Canada's supermodels, Shalom Harlow.

appear to the audience that they were witnessing *a fashion moment* – a split-second of spontaneous reality and unorchestrated glamour. Ironically, the runway show preparation required for broadcast coverage requires as much, if not more, pre-production and post-production work as the traditional studio fashion shoot.

In the wake of its success, *Fashion Television's* bread and butter, the exotic runway image, has subsequently been spliced into countless media forms and plays an increasing role in fashion periodicals and newspapers, from home decor magazines such as *Canadian House & Home*, to glossy trade magazines like *President's Choice*, a publication packaged by the Canadian grocery chain.'

Fashion and the MTV Generation

Television's impact on fashion reporting, and reporting in general, has been twofold. It has fostered a form of 'lite'-journalism, reporting where information is crafted into tight sound bites; bullet-form lists and snappy, provocative headlines. But it has also been the impetus for longer, more thought-provoking fashion writing. During the 1990s, the *Toronto Star's* lead fashion page routinely featured a trend story with text that amounted to little more than an extended caption. Take for example an article in the 25 April 1996 edition of the paper headed 'Party planning.' Accompanying the five colour photos that illustrated the story, ran the copy:

> Dressing for the prom has never been simpler. Overblown ball gowns have given way to fuss-free shifts and easy-going slips. Details are minimal – a tiny jeweled button or single back bow – but color lights up the night. Look for the new icy pastels in silhouettes ranging from bone straight to softly flare. And don't forget that the sleeveless look is considered this year's bare essential. With a small hangbag and wrist corsage, you'll be well-armed to face the evening.[18]

Seventy-nine words: short and sweet, and typical of the newspaper's format.

In the wake of *Fashion Television*, a picture and a caption suffices to deliver the information. Mimicking the quick hits characteristic of the television script, newspapers and magazines increasingly have relied on plenty of pictures and light copy treatments. Canada's national newspapers such as the *Toronto Star* and the *Globe and Mail* have come to use scrapbook-type columns to provide quick hits of information on varied fashion and design subject matter. The *Star's* regular department is called 'Fashion Notebook,' while the *Globe's* is referred to simply as 'Stuff' or 'What you want.'

Reduced volume of text also suggests the paring down of staff that occurred in the Canadian publishing industry in the early 1990s as the country's economy

slowed with a serious recession. Staff had been eliminated at *Flare* and *Toronto Life Fashion*, as well as at the fashion desks of the national newspapers. Other fashion publications such as the high-end *Domino* magazine fell by the wayside altogether.

Sidebars, snippits of text, and often point-form notation represented the tendency of simplifying information for a public inundated with an ever-increasing volume of information presented at an increasing speed for those with an ever-decreasing amount of free time. *Flare*'s Boyd sees the less-type, more-pictures approach to fashion reporting as a byproduct of the MTV generation. 'Before fashion was looked at more seriously and as an art form. There was more intellectualizing of it,' she says. 'But *FT* and similar shows have given eye-candy; visual gratification for the viewer.'[19]

Chatelaine magazine defined the quick-hit appeal of several fashion-themed TV shows in a June 1994 issue. Of CBC Newsworld's *Fashion File* it said, 'Lightweight fashion patter; Blanks [Host Tim Blanks] is too nice to needle his interviewees and too serious to dig the dish.' Its modus operandi was defined thus: 'a techno-pop sound track links postcard-perfect shots of major meccas, fast runway footage and plodding profiles.' The magazine awards *Fashion Television* a four-star rating for its 'runway footage of top and offbeat designs ... sandwiched between bitchy gossip, ambush interviews and on-the-scene party coverage.'[20]

Prior to *FT*, Canadian fashion magazines regularly ran lengthy articles on fashion specific topics. Long articles were commonplace in early 1980s issues of *Toronto Life Fashion*. In the spring 1980 issue an approximately 2,700-word story on the exotic fashions of New York-based designer Mary McFadden appears, as does an equally long feature on the style of American fashion journalist Kennedy Fraser. During the same period *Flare* magazine, reserved lengthy articles for lifestyle topics.

Again in the late 1990s, now that fashion had been neatly slotted into pop culture, more and more media started allotting extra ink and air time to the runway's latest offerings. Anne Johnston, an editor with *Maclean's* magazine, believes that the longer, more analytical fashion features are the result of what has become a saturated media market. 'There is such competition now for people's attention and for people's interest and spare time – leisure time and leisure dollars – that I think there's a legitimate and worthy approach to say, let's make [writing on fashion] more interesting. Certainly people like Kennedy Fraser [an American writer who has written for the *New York Times, Vogue, Vanity Fair*] have made fashion more interesting.'[21]

Fashion-themed TV's focus on the industry's elite, extreme and provocative, created fallout here at home. In reality, it opened up the country to the world. More specifically, it upped the competition. Shoppers were seduced by the industry's

big international names and they wanted a piece of that worldly style. '[In] the '90s, I would say the advent of fashion television, to a certain degree has really globalized the whole fashion mentality, but its dark side has been that it has made it very difficult for the non-*FT* designers to survive,' commented Ruth-Ann Lockhart, director of designer women's wear for upscale, Canadian fashion retailer Holt Renfrew in a *Flare* magazine article. 'I'm not saying that *FT* killed Canadian fashion – [but] there was always a little bit of 'shop Canadian' [attitude] – but then when they saw Claudia Schiffer and the otherworldliness of the catwalk, it just drowned out what was happening in our own city and our own country.'[22]

A Fashion Free-for-All

'It used to be that fashion was for those fashionistas, people who really did care about hem lengths and what they said about society,' Beker has said. 'I think we've helped make people understand that fashion is something we can all take part in.'[23]

Part of the seduction of fashion *TV* is its candid-camera tact. It takes the audience backstage, behind the curtain. In 1986, Jeanne Beker, in typical *Fashion Television* style, ran a profile on American designer Geoffrey Beene. The camera visited the designer in his studio; it spied Beene sketching; it saw his work on the runway; it got backstage to see the heels, the makeup, the legs, the bare breasts. Post-*FT*, this insider-angle device has been exploited repeatedly. Leafing through the Summer 2000 issue of *Toronto Life Fashion* reveals a behind-the-scenes story of the Canadian collections as told diary-style by fashion insiders, from designer Joeffer Caoc to model Yvonne Davis. Photography captures the country's most promising fashion stars in pre-show frenzy. In the September 1999 issue of *Flare*, beauty editor Kathy Mackenzie sneaks backstage at the fall 1999 Chanel show in Paris.

But while it spliced its footage with these one-on-one interviews and behind-the-scenes vignettes, *Fashion Television* relied on the provocative images of the world's most beautiful women. If fashion TV brought these images to the masses, it was not surprising that its runway coverage tended to attract just as many male viewers as female. One September 1991 *Fashion Television* program featured the 'controlled eroticism' of photographer Helmut Newton's work. The year before, the program had spotlighted the supermodel Natassja Kinski, complete with Richard Avedon's legendary portrait of her, nude but for a python draped across her body. There was plenty of skin for the viewing public.

In the evolution of fashion trends, the decadent 1980s were, not surprisingly, a time of much bodily exposure.

[T]he runways were too often cluttered with excessive displays of nudity – models were literally falling out of their clothes, with derriere-grazing skirts and shorts, almost total transparency, awkward proportions, overwrought, wrapped effects and navel-baring cutouts that might be amusing, even titillating on the catwalk, but, in the end, are irrelevant on the street and often frankly unwearable.[24]

But it made for good TV ratings. '[These shows] did open up the world of fashion to a broader audience,' says Vince Carlin, former head of Newsworld and now chair of Ryerson Polytechnic University's school of journalism. He recalls that the network's 'FashionFile was very profitable ... but the demographics were interesting because it wasn't all women. My memory,' he says, 'was that the demographics [had] quite a significant component of male viewers [and] obviously, they weren't looking at the latest hemlines.'[25] In March of 1996 Maclean's magazine alluded to what Carlin calls the soft-core quality of some of these fashion shows. It reported that between 30 and 40 per cent of FT's quarter of a million viewers in the Toronto area were men. 'There is even a story – no doubt apocryphal,' continues then-staff writer Joe Chidley, 'that FT is the most popular program in Canada's prisons.'[26]

The Cult of Celebrity

Through television, fashion became hipper than it had ever been before. FashionTelevision helped breed the supermodel, the celebrity photographer, and the designer as superstar. And it was certainly fashion-themed TV that made the flamboyant, fan-waving Lagerfeld a household-name in the far reaches of Canada from the Sault to Shawinigan. '[It was about 1992] when all of a sudden, fashion was in fashion and celebrity was in fashion,' says City-TV's Hernan Morris.[27] Television beamed fashion into the living rooms of the masses and put the beautiful people into focus. What perfect irony, too, that fashion, in its narcissism, was now affording celebrity status to its own. Several articles have been penned on Beker. She has been profiled in countless publications, including Saturday Night, Flare, the Globe and Mail, the National Post and the Toronto Star.

Since exposure via television begets larger-than-life status, models quickly became as important, if not more so, than the clothing they sported. Veteran fashion editor Iona Monahan commented on the phenomenon in the Montreal Gazette:

First it was Models. Then Top Models. Then Star Models. Then Supermodels. Model Superstars. Mega Models ... Today, fashion fans who gorge on magazines and television, know more about models Christy Turlington, Linda Evangelista,

Naomi Campbell and Claudia Schiffer than they do about the designers whose clothes they wear.[28]

To document the attainment of absolute pop-culture stardom, the *Financial Post* reported on the launch of supermodel dolls – Claudia Schiffer, Naomi Campbell, and Karen Mulder had given permission – by American toy maker Hasbro to manufacture dolls sold under their given names. In retrospect, the supermodel dolls signalled the beginning of the end for the superstar model era. Designers were fed up. Many did not take kindly to Linda Evangelista's notorious quote: 'We have this expression ... we don't wake up for less than $10,000 a day.'[29] As the supermodel fell from grace – *People* magazine officially declared her demise on the cover of its 23 November 1998 issue with the cover line 'Supermodel Meltdown' (see illustration 41) – the media turned back to Hollywood actors and musicians for its usual coverage.

As if to sustain the public interest in celebrity à la *People* magazine, writer Leanne Cottler attended the fall/winter 1999 Paris couture collections for *Flare* magazine. But it was not the clothes that were the focus of her three-page feature. The closest to information the reader could glean from the text about what the models were actually wearing on the runway was, 'the models strut tough and sassy [at the Versace show]. They move faster than at any other show.' She does, however, mention that actors Isabella Rossellini, Anne Archer, director George Lucas, and musical performers Boy George, Sean Puffy Coombs, and Madonna, were in attendance.

Fashion Imitates Art; Art Imitates Fashion

FashionFile's Tim Blanks attributes the trend to more detailed and in-depth fashion reporting as simply the result of fashion designers referencing art and culture in their work. The work of Canadian women's wear designers Lida Baday, Marie Saint Pierre, and Joeffer Caoc have often been discussed within the context of their architectural significances. There is also the designs of custom glove-maker Daniel Storto who, in one innovative body of work, chronicles the obituary of legendary New York fashion designer Bonnie Cashin in white script on long, elegant over-the-elbow handmade gloves. His 'sculptural series' of gloves, which were included in US designer Geoffrey Beene's fall/winter 2000 collection, likewise reference the art of the American sculptor Louise Nevelson.[30]

The work of other Canadians, such as the design duo of Jennifer Halchuk and Richard Lyle, who produce under the Mercy label, further illustrates the notion of fashion as art and fashion imbued with complexities and layers of meaning. Their designs are individually crafted. 'Every item is an idea,' they have been quoted as

41 Linda Evangelista, from St Catharines, Ontario, was one of the first supermodels in the 1980s. (*People*, 23 November 1998)

saying. For their fall 1999 seasonal showing, the two eschewed the traditional runway approach in favour of an installation-art setting where mannequin limbs, clothed in their fashions, were submersed in low containers of earth while a video played against an accompanying wall. Resulting media coverage went on to explore the notions of deconstruction, mixed media, and clothing as art.

But in-depth, investigative fashion reportage reflects not just the presence of more thoughtful designers, but also that the buying public is more curious about fashion, thanks to fashion-themed television putting the subject in our collective consciousness. People want to know more about fashion; about its place within our culture and about what it says about us as a society. 'It's become truly fascinating to watch,' says *Maclean's* Johnston. 'It has credibility, or it has earned its credibility.'[31]

When fashion TV shows report on fashion exhibitions, they put fashion in a category worthy of study and analysis. They also help offset the image of fashion as trite and vacuous. Although fashion has long been considered the ugly duckling of design – a purely superficial endeavour compared to the respected discipline of architecture, for example – its artistic institutionalization in museums as well as galleries has made the viewing public take it seriously.

Consider 'Pop in Orbit: Pop Design from the '60s,' an exhibition at Toronto's Design Exchange from September 1995 to January 1996, which featured Paco Rabanne's metal-paillette mini dress alongside Aero Saarinen's space age Aarnio Chair. (See illustrations 45, 46.) *FashionTelevision*'s Jeanne Beker interviewed Sandy Schreier, one of North America's most avid costume collectors, who had loaned several pieces to the institution, as well as Design Exchange's curator Rachel Gotlieb, for an upcoming *FT* segment. The Art Gallery of Ontario has also given fashion credence. Its spring 1998 Andy Warhol Exhibit suggested to the public that fashion, like art or music, should be included when evaluating our history and culture. Recognizing the exhibition's significance, *Canada AM* hosted a program on 21 March 1998, and interviewed the gallery's curator, Matthew Teitelbaum. Teitelbaum comments that

> this exhibition puts Andy Warhol's work in the context of his peers (other artists, other designers) which is why you see his paintings with a frieze of fashion in front of it – mannequins with dresses by Versace, by Armani, by Halston ... to sort of suggest that there's always a give-and-take. In fact, there's more give-and-take than we often think between the world of the artist which is the museum-based profession and the world of popular culture.[32]

By viewing and reporting on fashion within a museum or fine-art gallery context, fashion-themed television has helped educate the masses. Fred Davis in his book *Fashion, Culture and Identity* comments on the value of fashion as a

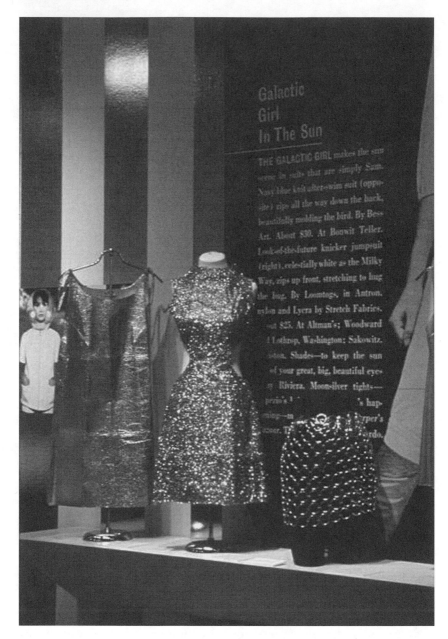

42 'Pop in Orbit' exhibition at the Design Exchange, Toronto, 1995.

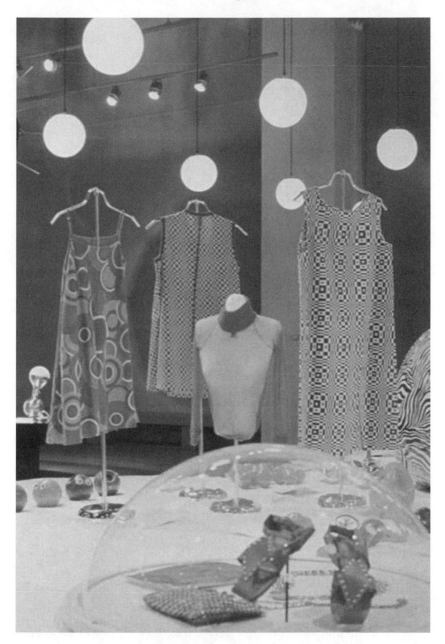

43 'Pop in Orbit' exhibition at the Design Exchange, Toronto, 1995.

vehicle for the broadening of minds. 'Much as fashion seduces ... it can also initiate persons into realms of thought and experience that could otherwise have bypassed them,' he says. 'Some of this can be attributed to the circumstance that the molders of fashion, whatever area they work in, are persons who often are ... in close contact with leading creative and progressive elements in the arts, sciences, politics and culture generally.'[33]

Fashion Reporting: Real Journalism?

The credibility of fashion reporting in the Canadian media has often been called into question. In fact, Jeanne Beker considers herself to be more a liaison between the public and the fashion world than a critic. 'I'm an entertainer, first and foremost,' she has said. 'I do think of myself as a reporter. I guess I'm a journalist, but that's further down the line.' In an American *Vogue* magazine article on Beker that probed the success of the program, the TV host quips to writer Giselle Benatar that 'we're not producing *60 Minutes* here. This is the schmatta business. You just can't take fashion that seriously.'[34]

Adding to the problem of credible criticism is the fact that anyone can now be seen as an expert, explains past *Flare* editor Suzanne Boyd. (It is also this factor that makes the subject so universally appealing.) Boyd recalls watching one television spot where celebrity plus-size mannequin Emme and model Ingrid Cañadas act the part of fashion editors. Their story focuses on the challenges of prepping for a party, and plays out with them shopping at a slew of fashionable boutiques in New York City. 'Anyone can be a fashion authority,' says Boyd, 'and that's danger-ous'[35] – most dangerous perhaps for the legitimate press, who need to be considered the experts in their field for their own self-preservation.

Everyone wants some of the fashion excitement dished out by fashion-themed TV. The appearance of countless 'magalogues' – retail-conceived catalogues that are designed to look like magazines – has further confused the area. Many carry runway coverage, fashion shoots, and claim to be experts in the field. Holt Renfrew produces its in-store catalogue *Point of View*, men's wear chain Harry Rosen delivers its glamourized sales brochure *Harry*, quarterly, Montreal women's wear apparel manufacturer Joseph Ribcoff likewise produces a magalogue, as do stores such as Simon's of Quebec and the Bay. These sales tools mimic traditional magazines right down to the editor's letter and masthead. Harry Rosen's *Harry* 'magazine' includes an editor's letter written, of course, by the company founder, Harry Rosen. (See illustration 44.)

'Some are nothing more than glorified flyers that clearly ignore journalistic ethics by touting corporate products every chance they get, but others include informative articles and seem not so different from legitimate publications,' writes

A MAGAZINE FOR MEN BY HARRY ROSEN MENSWEAR

harry

SPRING/SUMMER 2000
$5.00

Fresh Outlook

Sartorial Splendour
THE SUIT SHAPES UP

Business Casual
GETTING IT RIGHT

Exclusive Interview:
GIORGIO ARMANI ON THE FUTURE OF MENSWEAR

44 Canada's premier men's clothier, Harry Rosen, has his own in-house magazine, which
began in the 1990s. (harry, spring/summer 2000)

Janet Hurley of the *Toronto Star*. She quotes Gary Garland, president of Magazines Canada, a division of Maclean Hunter, on the subject. 'While I understand why retailers want to do this sort of thing, it can have a negative effect because these magazines blur the line between editorial and advertising,' he says. 'There's a very clear separation between church and state, and when it gets blurred, it reduces credibility ... It casts other magazines in doubt.'[36]

Concerning the legitimate mainstream media, accusations have been made suggesting that the fashion press is soft, that it takes the 'if you can't say anything nice, don't say anything at all' approach. *Style* magazine, the Canadian industry's monthly trade journal, provides a democratic overview of the fall/winter 1998 season in its 'Clearly Canadian' feature of May 1998. Every designer participating at the ready-to-wear event is represented by a runway photo and a few lines of text summing up their aesthetic message. The reporting is thorough, giving highlights from each show, but the nearest it approaches to criticism or opinion is in the writer's choice of words for the story's deck or subhead. 'The 18 designers who showed over the two-day event offered consistent collections combining fashion with function.' Only in the editor's column is criticism wielded. 'Sometimes off-site events work and sometimes they don't,' wrote Doris Montanera:

> With a little more organization (and probably more funding) the Mercy, Crisostomo, Majak & Staffiere, Daniel Storto and Lili Sac collections in Toronto would have been dubbed innovative. While the milling, crushing crowd that waited outside an abandoned city-owned downtown building lent an air of excitement before the show, it was indicative of the confusion that subsequently reigned within. Instead of a traditional take-a-seat runway presentation, the audience was forced to move from 'vignette' to 'vignette.' The idea was interesting but the reality was not.[37]

Canadian designer Judy Cornish, co-designer of Comrags, comments on this non-critical trend. 'The Canadian press has been unbelievably supportive of Canadian fashion – almost to a fault,' she says. She does suggest signs of change afoot. 'I think [the fashion press has] taken steps recently to be more constructive and more critical but in a very Canadian way where they just don't talk about stuff that isn't up to scratch.'[38]

The tide is changing. Fashion journalists, now conditioned to the high quality of international designer shows and collections, have begun to express their disappointment and disapproval. Take for example, the *National Post* reporter Serena French's article covering the fall 1999 fashion shows conducted for the Toronto Ready-to-Wear collections. 'The Matinée Fashion Foundation gave $700,000 to 25 designers across Canada for the 1998–1999 season ... At their worst, many designers appear not to have cracked a fashion magazine in the last

three years. No themes, no obvious inspiration, no focus, and worst of all, no innovation.'[39]

In university-level journalism programs, effort is now being made to tailor courses to the specialized niche of fashion journalism, leading one to believe that greater effort is being made to ensure the journalistic integrity of those interested in working in the fashion media. 'There are people who see this as a legitimate avenue,' believes Ryerson University's Vince Carlin. 'I think people used to fall into it before. Either you came out of the fashion side and you started writing about it or you were a journalist who was unemployed. Now, I think there are more people setting out to say, "I want to work in this."' Despite this, the comment does suggest that fashion, as a beat, continues to be suspect from a serious news perspective.

Fashion, the Future

Fashion-themed television's impact on fashion journalism in Canada has been multi-faceted. It has altered both the content and style of print and broadcast reporting. It has opened up the international world of fashion to the Canadian audience and therefore allowed observers to be more critical of what is available to them in their own backyard.

FT and other fashion TV shows have affected the tone of fashion reportage in many magazines in the last two decades of the twentieth century. And it is because of its all-inclusive mandate that much writing has become more personal. Many editorials, in fact, take the form of a first-person perspective, which used to be avoided in journalism's old days. Now fashion, because of programs like *FT*, has become mass entertainment. It has challenged publishers and broadcasters alike to provide more information, faster, to a public anxious for the new and exciting. The complete democratization of fashion as facilitated by fashion television shows is illustrated by the experience of the *Toronto Star* fashion editor Bernadette Morra. She recently speculated that more and more internet publications may be responsible for the difficulty in getting tickets for the designer shows that she has travelled down to New York to cover. She begins talking to those around her at one runway show and discovers a law student, tourists, a mother of an assistant to the designer, even protesters from PETA (People for the Ethical Treatment of Animals) who somehow have managed to gain entrance to the high-profile event.[40]

Fashion has become completely accessible. The fashion press faces increasing pressure to deliver information first, find the next rising fashion star, and make intelligent observations on fashion within the larger, popular-culture context of modern life. For the TV and the print journalist, pressure to secure the exclusive interview with the camera-shy designer also increases, for that is something that

the person on the street cannot obtain. When all have first-hand access, the proverbial news scoop becomes powerfully important, as does the writer who can deliver a new and distinctly informed point of view on the topic.

Fashion television as a medium has also helped create the celebrities of our time. It has made stars of individuals who, fifty years ago, would be familiar only to an elite few. Videography has also pushed the envelope of modern visual art/graphics by striving to present a more 'realistic' reality. It has made the moving image a mainstay in our popular culture. To be competitive with live broadcasts of fashion on television, the race for the fashion scoop has quickened. Given that fashion enthusiasts can access live runway or fashion events via international web sites such as Vogue.com or Firstview.com, that makes the media's challenge to be timely and topical much more demanding. In 1999 *Flare* magazine introduced its fall/winter 1999–2000 runway coverage in its May issue. It followed up with a June story, mainly visual, highlighting the upcoming trends accompanied by one-liner commentary by Canadian comedian Mike Bullard. Although not qualified to comment on the relevance of the new trends, Bullard's presence also illustrates that increasingly fashion is primarily about entertainment.

In the past, magazines were less concerned about being first with the runway news than they were with coordinating with retail clothing deliveries. Back in 1983, *Flare* magazine editor Bonnie Hurowitz waited until the July issue to preview fall fashion. That made practical sense since July was, and remains, routinely the month when the first of the fall fashion deliveries arrive.

Fashion reporting, in all areas from print to broadcast to internet media, has proliferated in the wake of *FT*. In the overwhelming volume of material, it is encouraging that the demand is still for quality over quantity. Opinion has become increasingly important within a field that all can contribute to and that all can access. So fashion is no longer the arena of the privileged; thanks to fashion TV, the public is more knowledgeable and demands more from their media. The broadcast medium continues to force the development of more insightful material on the subject and is responsible, at least in part, for the validation of fashion as credible subject of study in popular art and culture.

NOTES

1 Terry Lewis, interview with author, October 1999.
2 Mulvagh, *Vogue,* 342; Routh, *In Style,* 176.
3 Leanne Delap, 'Taking a Long Look Back at Toronto Fashion,' *Globe and Mail,*
 1 November 1997, C21.
4 John Mackay, 'A Dictionary of Fall Trends,' *Toronto Life Fashion,* spring 1980, 44.

5 Steven Levy, 'That Was Then, This Is Now,' *Flare*, September 1999, 40.

6 Noah James, 'Video Making Waves,' *Globe and Mail*, 6 December 1984, F2.

7 Salem Alaton, 'The Video Game: Fashion Takes a Starring Role in New Entertainment Format,' *Globe and Mail*, 18 August 1986, C12.

8 Joyce Carter, 'Sung Furs for Fun,' *Globe and Mail*, 30 April 1985, F4.

9 Wayne Clark, 'That Was Then, This Is Now,' *Flare*, September 1999, 34.

10 Judy Cornish, 'That Was Then, This Is Now,' ibid., 38.

11 Kimberly Sutch, interview with author, December 1998.

12 Alaton, 'The video game.'

13 Jeanne Beker, 'That Was Then, This Is Now,' *Flare*, September 1999, 44.

14 Joe Chidley, 'From Rags to Riches: *FashionTelevision* Is a Global Success.' *Maclean's*, 11 March 1996, 60; Jay Levine, interview with author, February 1999.

15 Anne Kingston, 'The Prime of Ms. Jeanne Beker,' *Saturday Night*, October 1996, 96.

16 Suzanne Boyd, 'Editors letter,' *Flare,* June 1999, 12.

17 Hernan Morris, interview with author, January 1998.

18 Bernadette Morra, 'Party Planning,' *Toronto Star*, 25 April 1996, C1.

19 Suzanne Boyd, interview with author, March 1998.

20 Barbara Sgroi, 'Fashion Mavens: Who's Hot, Who's Not.' *Chatelaine*, June 1994.

21 Ann Johnston, interview with author, December 1997.

22 Ruth Ann Lockhart, 'That Was Then, This Is Now,' *Flare*, September 1994, 44.

23 Chidley, 'From Rags to Riches,' 60.

24 Marina Sturdza, 'The Troubled Trench,' *Globe and Mail*, 11 December 1985, F1.

25 Carlin, interview with author, June 1999.

26 Chidley, 'From Rags to Riches,' 60.

27 Morris, interview with author, January 1998.

28 Iona Monahan, 'Bright Runway Lights: Homegrown Beauties Shine in Europe,' *Montreal Gazette*, 23 August 1994, C2.

29 Michael Gross, *Model: The Ugly Business of Beautiful Women* (New York: William Morrow and Company, 1995), 437.

30 Tralee Pearce, 'T.O. Designers Get Raves in the Big Apple,' *Globe and Mail*, 26 February 2000, R23.

31 Johnston, interview with author, December 1997.

32 Rob Faulds, *Canada AM*, 21 March 1998, Matthew Teitelbaum and Liza Minelli on the Andy Warhol exhibit at the Art Gallery of Ontario.

33 Davis, *Fashion, Culture and Identity*, 198–99.

34 Kingston, 'The Prime of Ms. Jeanne Beker,' 102; Giselle Benatar, 'Candid Camera,' *Vogue*, February 1994, 104.

35 Suzanne Boyd, interview with author, March 1998.

36 Janet Hurley, 'The Pros and Cons of Corporate Magalogues,' *Toronto Star*, 12 May 1998, K5.

37 Doris Montanera, 'Clearly Canadian,' and 'That's Entertainment,' May 1998, 20.
38 Judy Cornish, interview with author, June 1999.
39 Serena French, 'Oh No Toronto: If All Canadian Designers Were as Together as David Dixon, Perhaps the Country Wouldn't Seem so Fashion-challenged,' *National Post*, 29 March 1999, D1.
40 Bernadette Morra, 'Protesters Disrupt New York Shows – Working Journalists Bumped from Seats by Tourists, Interlopers,' *Toronto Star*, 17 February 2000, FA02.

SELECTED BIBLIOGRAPHY

Craik, Jennifer. *The Face of Fashion: Cultural Studies in Fashion*. London: Routledge, 1993.
Davis, Fred. *Fashion, Culture, and Identity*. Chicago: University of Chicago Press, 1992.
Hall-Duncan, Nancy. *The History of Fashion Photography*. New York: Alpine Books, 1979.
Mulvagh, Jane. *Vogue: History of 20th Century Fashion*. London: Viking, 1988.
Pevere, Geoff, and Greig Dymond. *Mondo Canuck: A Canadian Pop Culture Odyssey*. Toronto: Prentice Hall, 1996.
Routh, Caroline. *In Style: 100 Years of Canadian Women's Fashion*. Toronto: Stoddart, 1993.

Interviews

Tim Blanks, December 1997.
Suzanne Boyd, March 1998.
Vince Carter, June 1999.
Judy Cornish, June 1999.
Ann Johnston, July 1999.
Diti Katona, July 1999.
Jay Levine, February 1999.
Terry Lewis, October 1999.
Hernan Morris, January 1998.
Geoff Pevere and Greig Dymond, June 1999.
Kim Sutch, December 1998.

A Little on the Wild Side:
Eaton's Prestige Fashion Advertising
Published in the *Montreal Gazette*, 1952–1972

KATHERINE BOSNITCH

Beginning in the 1950s, a team of three artists working for Eaton's of Montreal developed an innovative new style of fashion illustration which would quickly attract the attention of the design art world and continue to captivate it for more than twenty years. The prestige fashion ads which Eugenie Groh, Jack Parker, and Georgine Strathy created for the *Montreal Gazette* received international acclaim, both for their unusual design and their complex use of colour. Over one hundred awards and countless accolades, including mentions in *Women's Wear Daily* (New York), the Art Directors Club of New York, *Graphis* (Zurich), *Communication Arts* (Palo Alto), and *Idea* (Tokyo), are testimony to the extent of their impact. This text outlines the events leading to this important period in Canadian fashion illustration history, and explains how through the pioneering work of three artists, the Eaton's advertisements published in the *Gazette* would become recognized as some of the best in the world.

Fashion Illustration: A Historical Perspective

Europe introduced modern fashion illustration to the rest of the world. During the peak period, from 1909 to 1939, illustrations were regularly seen in the editorial pages of de luxe magazines. The Second World War saw the most celebrated European illustrators flee to the United States, which then became the leader in fashion illustration. By the early 1960s, after the death of two of the industry's most celebrated artists, Eric and René Bouché, editorial illustration had fallen from favour and had been largely replaced by photography.[1] Newspapers such as the *New York Times*, the *Herald Tribune*, and the professional fashion trade paper, *Women's Wear Daily*, were among the few publications which continued to commission fashion artists for editorial portfolios.

Just when editorial fashion illustration was disappearing, advertising fashion

illustration for department stores was increasing at an unprecedented rate. Canadian artists were at the forefront of this developing newspaper art and Eaton's of Montreal began creating some of its finest examples. Foreign artists understood fashion illustration primarily as an editorial art, yet most local artists had not participated in the type of magazine work created abroad and therefore saw the increasing demand for commercial work as a positive change. Canada, unlike Europe and the United States, did not witness a decline in the popularity of editorial fashion art as it had never been that common in this country. For the first time in retail history, the advertising needs of the major Canadian department stores had created plentiful work for Canadian fashion illustrators and artists who were being given many opportunities to perfect their skills.

Postwar Montreal, Eaton's and the *Gazette*

After the Second World War, Canada welcomed immigrants from many European countries, fuelling one of the greatest demographic changes in its history. Montreal was then Canada's largest city, with a population of over one million in 1961, a 25 per cent increase over that of twenty years before.[2] Renowned across North America as a cultural centre, Montreal was the home of many celebrated personalities, including the neurologist Wilder Penfield, the writer Mordecai Richler, the jazz pianist Oscar Peterson, actors Christopher Plummer and Gratien Gélinas, the hockey legend Maurice (Rocket) Richard, and the famous strippers, Lily St Cyr and Peaches. The city was noted for its many restaurants and nightclubs, which boasted chorus lines and comedians. Mount Royal divided the English- and French-speaking elite into the municipalities of Westmount and Outremont. These two groups seldom crossed paths except when purchasing fancy attire at department stores or salons of local couturiers. At this time the city's wealth was held predominantly by its English-speaking inhabitants.[3]

Montreal was also Canada's fashion centre; it possessed the country's largest domestic garment industry and was home to a developing import trade. As is true today, the principal shopping district stretched along St Catherine and Sherbrooke streets between Crescent and Aylmer. All the large department stores, with the exception of Dupuis Frères, were located in this commercial area of the city. Eaton's of Montreal was established in 1925, when Robert Young Eaton (RY), the third president of the T. Eaton Co. Ltd. and the nephew of Timothy Eaton, the store's founder, took over the former Goodwin's Ltd. By 1931 extensive renovations had been undertaken, including the addition of a splendid Art Deco dining room designed by Jacques Carlu of Paris. Upon completion of these renovations, the Montreal store was reputed to be 'the finest outlet in the whole Eaton chain.'[4] Under the direction of John Wallace Eaton (Jack), another series of renovations

was begun in 1957, bringing the rear portion of the store up to the nine-storey height of the section fronting St Catherine Street.[5]

Eaton's was a retailer of not only local but also international reputation. Rod McQueen lauds Jack's merchandising talent, praise echoed by others who have identified Jack's management as one of the main reasons for the store's popularity.[6] While the Montreal store stocked an impressive variety of merchandise, it was most famous for its fashion apparel. Largely responsible for this was fashion director Doreen Day, who, as Eatons' style ambassador, travelled the world promoting the store's fashion image. The third floor was the main fashion area, and it was primarily for the merchandise sold at three exclusive boutiques on this floor that Groh, Parker, and Strathy created their prestige ads. Groh claims that it was the buyers, particularly those of these exclusive boutiques, 'who gave the store its character, at a time when Eaton's was the best store in the city.'[7] The Ensemble Shop catered to the store's wealthiest and most fashion-conscious consumers. Joan Aird, the buyer for this boutique, travelled regularly to London, New York, Paris, and Rome to purchase *prêt-à-porter de luxe* from the *hautes boutiques* of Pierre Balmain, Jeanne Lanvin, Jacques Heim, and others. European-born Kathy Hill bought for the New Orleans Town House, which carried international *prêt-à-porter* and accessories bearing labels such as Bill Blass, Mr Gilbert, and Eloise Curtis. Parisian Anne La Flèche was another outstanding buyer. She purchased for the Coach House, which sold fashion from the avant-garde ateliers at home and abroad: Austria, Switzerland, France, Italy, Spain. When La Flèche left Eaton's in the mid-1960s, she was replaced by Ivana Sadikovic.[8]

Like all the large Montreal department stores, Eaton's relied on newspaper advertisements to promote their merchandise, and advertised in Montreal's dailies, the *Gazette*, the *Montreal Star*, and *La Presse*, but until the mid-1960s, their prestige colour fashion ads appeared only in the *Gazette*. The history of the *Gazette*, Canada's oldest newspaper, dates back to the American Revolution. By 1785 the weekly newspaper had evolved from its unilingual French beginnings to a bilingual combination of French and English; from 1853 onward, it was published daily and solely in English, as it is today. Thomas and Richard White purchased the paper in 1870, and the family owned it for almost a century before selling to Southam Press in 1968.[9] Now owned by CanWest Global Communications Corporation, the paper has been published from its present location at 250 St Antoine Street in old Montreal since the late 1970s. When Groh, Parker, and Strathy were creating Eaton's prestige fashion ads, the newspaper was still situated at its original location on St Antoine, on the block between Cathedral and St Cecile streets.

The 1950s were a prosperous time for Canada's oldest newspaper. In 1944 its circulation averaged 40,500 and by 1956 had climbed to 99,100. To accommodate

the new demands generated by these increased numbers, the paper upgraded its facilities, first in 1952 and later in 1957.[10] During the first phase of the expansion, a new five-unit, colour convertible high-speed letterpress was installed. With this additional press, the *Gazette* became the first Quebec newspaper to offer run-of-paper colour to its advertisers.[11] In 1957 two new floors were added to the original five-storey building, amounting to an increase of 41,500 square feet. At this time, three more colour units were installed on the letterpress, greatly increasing the paper's flexibility for printing spot and full colour.[12]

The relationship between Eaton's of Montreal and the *Gazette* was one of mutual benefit: Eaton's relied on the newspaper to deliver its advertising messages to a specific Montreal audience and the *Gazette* relied on Eaton's to help subsidize the cost of its editorial content and attract subscribers who counted on newspapers for sales information.[13] The Eaton's advertising account was one of the *Gazette*'s most valued. In 1950 the Montreal store already held the preferred regular position of pages five to seven in the *Gazette*, and as the store's profits increased, so their position in the newspaper improved. By August of 1966 Eaton's had acquired the most desirable advertising position in the *Gazette* – the pages leading up to and including the back page of the paper. If we estimate that from 1952 to 1972 three ads were created daily, six days a week, fifty-two weeks a year, Eaton's created approximately 19,000 ads for the *Gazette* alone.[14] Of these ads, only about 6 per cent (1,071) were in colour, and of those, about 60 per cent (655) were prestige fashion ads. In other words, only a scant 3 per cent of all the ads published in the *Gazette* from 1952 to 1972 were prestige fashion ads, the focus of this chapter.[15]

The prestige colour fashion ads which Eaton's of Montreal created for the *Gazette* were the most successful; that is, they were cleverly designed and artistically rendered in full colour by the store's most gifted artists. Ads which the store created for newspapers other than the *Gazette* were not of this calibre. The motives for Eatons' decision to publish its prestige colour advertisements in the *Gazette* before any other daily newspaper in Quebec and also before most newspapers in North America, even those in fashion-wise New York, garnered them an exclusive feature that radically distinguished the *Gazette* from its competitors.

Colour aside, Eatons' advertisements were not the same in the *Gazette*, the *Montreal Star*, and *La Presse*. These papers targeted readerships at differing levels of society. The *Gazette*, Montreal's only local morning paper, catered to a wealthy, English-speaking, style-conscious clientele and was 'the nearest thing to a class newspaper in the upper brackets.' To appeal to these affluent readers, Eaton's used a type of institutional advertising known as prestige advertising. According to *Marketing: Strategy and Management*, institutional advertising 'almost never stresses products, but focuses, instead, on the character, reputation, reliability and the responsibility of the company.' Prestige advertising is described in *Retail Advertis-*

ing and Sales Promotion as advertising which above all 'attempts to establish the store's reputation for fashion authority, complete sections, and general progressiveness. It builds and maintains confidence in the store's label.'[16] In sharp contrast to the *Gazette*'s elite target readership, the local evening papers, the *Montreal Star* and *La Presse*, had a broader range of readers and were consequently considered much more effective as vehicles for mass advertising.[17] The promotional advertising created by Eaton's for these papers was aggressive, often repetitive, and aimed at generating immediate sales of inexpensive consumer goods.[18]

The Eaton's Montreal Art Department

In 1950s Montreal, all the large department stores – Eaton's, Morgan's (now the Bay), Simpson's, Holt Renfrew, Ogilvy's, and Dupuis Frères – relied on illustrators to sketch their newspaper advertisements. Many of them established their own specialized commercial art departments, while a few relied solely on freelance artists or used the services of the art departments of the daily newspapers to execute their ads.

Eatons' illustrated prestige colour fashion ads in the *Gazette* were conceived, designed, and rendered by the store's own in-house art department. Under the direction of the store manager and other members of upper management, the advertising manager allotted a specific budget to each fashion department and boutique. The department managers and buyers then decided upon the number and type of ads, as well as the merchandise they wished to promote. Schedules for the appearance of the ads in the *Gazette* were determined at least six weeks before an ad was published, and up to several months before fall and spring promotions. The creation of a prestige colour fashion ad for the *Gazette* began when the art director met with his staff of designers, artists and copywriters to discuss the concept for an individual ad or a series of ads.[19] Once the theme was determined, the designer or layout artist would make a rough sketch to show how the merchandise would be featured, showing the size, form, and arrangement of all the different elements. The layout was then given to the artist, who brought the whole concept to life with his or her own artistic interpretation. The finished artwork was sent to the *Gazette*'s photoengraving department to have proofs made. The copywriters' spirited commentary on the merchandise being promoted was sent to the *Gazette* to be typeset as per layout specifications.[20] Finally, the proofs and copy were combined to make a paste-up of the finished ad to be printed in the *Gazette*.

While Eaton's had many staff members to look after all the different aspects of the store's advertising, only a few select artists were chosen to work on the prestige fashion ads. Groh, Parker, and Strathy are the only names associated with these ads throughout the period under discussion.[21]

A New Style

Eugenie Groh, née Juklicková, was born in Chrast, a small town in Bohemia, in the present-day Czech Republic. While still a child, her family moved north to the Sudetenland, an area of the country close to the German border which was forcibly annexed to Germany by Hitler in 1938. When the Second World War began in 1939, Groh was completing the gymnasium, a rigorous eight-year college preparatory program. Hopes to further her studies at the Academy of Art in Prague were lost when the school was closed by the Germans in wartime. She enrolled instead for a short time at the privately-owned Rotter School of Graphic Arts, a Jewish-run institution with an excellent reputation for commercial art instruction. Hired in 1943 to work in the art department of Melantrich, Prague's largest publishing house, Groh was given the chance to perfect her creative skills. At Melantrich, which published a variety of newspapers and magazines as well as books, she illustrated fashion and women's interest periodicals and later wrote and edited articles. After the war ended, Groh continued to work in Prague as an editor, writer, and illustrator of the new monthly fashion magazine *Malé Mody*. In 1948 the magazine was discontinued by the Communist regime, and in February of the following year Groh and her husband fled to Canada. Almost immediately, Groh began her new career in advertising, freelancing in Montreal for Ogilvy's and Eaton's. A mere six weeks after her arrival, she accepted a salaried position as a fashion artist in the Eaton's art department.

At first, many within the store had difficulty understanding Groh's new approach. Jack Parker, however, knew immediately what she was attempting to accomplish. Born in Toronto in 1927, Parker's post-secondary art education included two years of studies at the Montreal School of Commercial Art, New York Famous Artist's Course; a three-year correspondence program, a summer session at the Banff School of Fine Arts and night courses in life drawing held at the Montreal Museum of Fine Arts. Parker began his career as a freelance illustrator working for various commercial companies in Montreal. In the late 1940s, he accepted his first salaried position as a layout artist at Morgan's department store. There he gained the overall experience in design which prepared him for the demanding work ahead of him. In 1951, after responding to an ad, he was hired as a layout artist in the Eaton's art department; by 1959, he had become the store's senior art director.

Groh and Parker were just beginning to develop their new style when Strathy, hired as a junior artist, became the third member of their team. Georgine Strathy, née Ferguson, was born in Winnipeg in 1931. In 1945, the family moved to Montreal, where Strathy attended junior and senior high school. After high school, she enrolled in the Fine Arts program at the Ontario College of Art in

Toronto. Upon graduating with honours in 1952, Strathy returned to Montreal to look for work as a fashion illustrator. Al Leduc, the art director of Eaton's at the time, hired her as a junior artist after she had successfully completed a take-home assignment. Strathy returned briefly to Toronto in 1953, when her husband was transferred there. Her first fashion illustration – a corset sold at Eaton's Annex – was published in a Toronto newspaper. She returned to Eaton's of Montreal only a year later, and chose to freelance for the store.

At the Blue Bird, a bar located near the Montreal store, Groh, Parker, and Strathy met frequently to share ideas, hopes, and artistic aspirations, while enjoying 'a drink or two or seven, served by flat-footed Charlie, their waiter.' It was not long before the trio won the support of store manager Jack Eaton, paving the way for further experimentation. Groh explains that their ads were so unusual for the time that they were sure to attract attention: 'This was good for business and Eaton's of Montreal got the message.'[22]

Although editorial fashion illustration was disappearing from glossy magazines such as *Vogue* and *Harper's Bazaar*, the 1930s-era style of René Bouët-Willaumez (RBW), Carl Erickson (Eric), and René Bouché, expressive and fluid, featuring elegant society women caught up in frivolous pursuits, remained influential. A similar trend dominated in Canadian magazines such as *Mayfair*, *Chatelaine*, *Canadian Bride*, *Idéal Féminin*, and *Revue Moderne*. Newspaper ads for American department stores also reflected the popular Expressionist style. Canadian department stores usually looked across the border for the latest trends in fashion art. Groh remembers that at Eaton's, ads from the *New York Times* 'were being used as textbooks, with everyone building up files of clippings, the best-known artist being Dorothy Hood of Lord and Taylor.'

As the 1950s progressed, a marked reversal took place: the trend-setting artists were no longer the editorial artists of the glossy magazines but the fashion illustrators creating newspaper ads for the large department stores. It was these artists who initiated the most exciting changes in the fashion art of the time. In reaction to the freely rendered Expressionist fashion art that predominated from the 1930s onward, a few adventurous newspaper fashion artists broke with tradition to create a fresh new graphic style, with emphasis on the designed page and a bold use of flat colour. Eaton's subscribed to *Retail Advertising Week*, which featured the most successful ideas in retail advertising across the continent. Around 1953, while browsing through this magazine, Groh discovered the beginnings of the new trend in newspaper fashion advertising: a very stylized art that was being created for Joseph Magnin in San Francisco and Neiman-Marcus in Dallas. She explains: 'This new art style was in line with my own tendency to change the technique currently used and greatly encouraged me to do so.'

But what made the new Eaton's style so distinctive? Two physical features have

been repeatedly cited as characteristic: unusual page designs and bold use of colour. A third distinction must be emphasized: the ads pioneered a new approach in fashion advertising, moving away from the precise rendering of specific garments to the use of symbolic images which conveyed a multitude of subliminal messages. As never before, the fashion ads closely reflected not only trends in fashionable dress, but also the cultural events and social mores of the lives of Eatons' target consumers, Montreal's young, English-speaking elite.

In sharp contrast to the loosely rendered drawings in the popular traditional style, the Eaton's art was clearly contrived, with every compositional element meticulously planned. Compare the ad for Simpson's published in the *Gazette* on 27 December 1950 with the Eaton's chemise ad appearing in that newspaper's 20 January 1958 edition (see colour plates E and F). The first ad resembles a snap shot, with the natural and spontaneous movement of the figures frozen in time. The second, a typical example of the new Eaton's style, is obviously divorced from reality. The artists have produced a calculated rendering of an imagined scenario, complete with its own stylized characters.

A study of the Eaton's chemise ad serves as an example to explore the contrived nature of this design. The two figures and the text type are strategically positioned to form a balanced composition with equal forces of attraction on either side of the fulcrum, represented by the central figure in the black dress. The scarfed head at the top right looks inward, preventing the viewer's eye from leaving the page by directing it back to the fulcrum. Further securing the impression of a balanced composition, the text type under this head cleverly suggests the presence of a third figure by mimicking the rectilinear shape of the chemise.

The symmetry created by the juxtaposition of different tonal values and ornamental patterns is another key feature. The two figures are virtually positive and negative images of the same silhouette. One has black hair, white skin, and black stockings, while the other has white hair, black skin, and white stockings. The blossoms on the scarf of the frontal head and the floral pattern on the shoes of the central figure compete for the eye's attention, pulling it from the top to the bottom of the page and back again. And the text type of black lettering in the word 'chemise' adds weight to the characters and orients the eye downwards, only to be led upwards in turn by the contrasting weightlessness of the floating head.

As one looks over the twenty-plus years of prestige colour fashion ads in the *Gazette*, definite design patterns become apparent. First of all, the artists experimented with framing. Refusing to be limited by the standard rectangular boundaries of the newspaper page, the artists also explored the use of composite formats, or frames within the frame. Compositions were lively, often directed by strong diagonal, vertical, or horizontal motion. While the dynamic within the images guided the viewer in different directions across the page, the artists were also

careful to orient where the viewer's eye would stay. The artists experimented with extremes: large tracks of unused white space contrast with dense compositions. Deviating from the conventional parallel perspective, in which there is a single and often central vanishing point, the Eaton's ads frequently used angular and oblique perspectives, in which there are two and three vanishing points. The new oblique perspectives effectively replaced the classical *contrapposto* stance commonly chosen for the silhouettes in Expressionist fashion art. They often skewed fashion figures to conform to the contours of different objects. Figures were frequently truncated and often decapitated, and mirrored and inverted images were also used. The fashion figure could be represented as a two-dimensional form, or as a silhouette. Another clever visual game was the artists' use of 'hidden' forms: in the 29 December 1972 ad, a small three-quarter figure has been seamlessly integrated into the palazzo pants of the larger figure (see colour plate G). Colour and pattern blend together harmoniously.

An additional feature of the new Eaton's style was the repetitive use of specific imagery. The repeated motifs can be divided into two broad categories: those of natural and those of manmade origin. Natural objects vastly outnumbered the others and included the sun, a variety of trees, flowering plants, leaves and fruit, and a surprising number of animals and insects. Favourites included cats, dogs, birds, and horses of all types, as well as camels, sheep and elephants. The 18 February 1960 ad presents several of these design motifs (see colour plate H). The entire design concept has been structured around a single tree; even the text type has been incorporated into the leaves of the lower branches. Three fashion figures are framed within the main body of the tree by small, narrow, uniquely patterned leaves. The four different types of birds, the nest filled with eggs, the squirrel, the caterpillar, and the insect who have all found their home in the tree serve no structural purpose – they exist simply as ornaments. Among objects of manmade or imaginary origin, the glove was unquestionably the most repeated design element. Others included musical instruments, various vases, pots and baskets, cars and other vehicles, as well as architectural structures from foreign lands and even mythical creatures.

The new Eaton's style bears many striking similarities to the Japanese wood block cuts or *ukiyo-e* prints from the seventeenth and eighteenth centuries. Although the artists referred to Oriental art when designing the pages of the 1965 ad campaign, *The Lands of the Far East*, not all their 'Japonismes' were so contrived. In fact, by the mid-twentieth century, it was easy to be unknowingly influenced by Japanese art, as the Impressionists, the Symbolists, and the poster artists from the turn of the century had all borrowed ideas from this tradition.

Some obvious comparisons may be drawn between the new Eaton's style and the Japanese woodblock cuts. Both project a stylized reality, as opposed to art which

imitates life. The work was not spontaneous but rather carefully designed. The new style also shares many compositional arrangements with Japanese prints: the use of composite formats and other unusual frames including 'pillar pictures,' the separation of planes with a grill or a strong diagonal, new perspectives seen from varied viewpoints, the use of the silhouette and ornamental pattern. The portrayal of living creatures, particularly animals and insects, was uncommon in fashion art. Many of those found in the Eaton's ads, including the wild carp, the cat, the tiger, the antelope, various birds, and the butterfly, can be traced to the Japanese woodblock cuts.[23] The artists' repetition of specific objects such as the wave and the decorated fan may also stem from this source.

While the similarities between the new Eaton's style and the Japanese woodcuts are pronounced, the artists also borrowed techniques from the Impressionists (pointillism), the Symbolists (mosaics and ornamental pattern), and the Cubists (collage). When promoting Yves Saint Laurent's 'Mondrian Look' (1965), they chose mannequins instead of live figures, as their rigid joints seemed to better comply with the de Stijl technique of compartmentalizing form and colour. Drawing inspiration from the pop artists Roy Lichtenstein and Andy Warhol, they created their own comic-strip heroes and silk-screened portraits. The illusory effects of optical art are visible in ads created after 1964. A series of ads entitled 'Eaton's Fashion Flair '64' reflected the influence of Abstract Expressionism in contemporary art. Sinuous lines and foliate forms that borrow from the Art Nouveau and the sketches of Aubrey Beardsley were present in many of the artists' ads from the 1950s. Illustrations inspired by the work of Toulouse-Lautrec, with oblique asymmetrical compositions, thickly outlined silhouettes, and isolated areas of vibrant colour were also seen. In the early 1970s, Art Deco was enjoying a strong revival; Eatons' streamlined, elongated silhouettes clearly recall the work of the Deco period.

In fashion art, the new Eaton's style is best compared to the illustrations of Europe's 'golden years,' particularly those found in the hand-stencilled albums of Poiret (1908–11), and in the later luxury fashion magazines, until about 1930. Both Poiret and the Eaton's artists expressed the vision that fashion is the business of selling dreams as well as clothes and that strict realism is rarely equal to this end. Images of fantasy conveyed far more potent messages. As with Eatons' *Gazette* campaign, Poiret's stylish, witty and modern advertising images were directed at a youthful, affluent audience. The resemblance between Eatons' fashion art and that produced in Europe from 1909 to 1930 is not limited to similar audiences and the corresponding intellectual approach needed to captivate them. The two artistic outputs also shared many physical characteristics, including Japanese-like clarity of shape with flat non-naturalistic colour, and compositions based on new, astonishing angles of vision. The first of the golden age's de luxe magazines, *La Gazette*

du Bon Ton, described itself as 'a showcase in which only the most luxurious examples of high fashion and the best of the decorative arts could be displayed, regardless of the cost involved.' Eaton's high-profile prestige fashion advertising in the *Gazette* seemed to share this objective.[24]

Printing in Colour

Colour played an equally significant role in defining Eaton's prestige fashion ads. The store's early integration and abundant use of colour in their *Gazette* advertising brilliantly separated their ads from those of their competitors, allowing them to stand 'out in a sea of black and white newspaper ads.'[25]

Run-of-press newspaper colour had existed as early as 1891, but it wasn't until after the war and the introduction of offset printing in the 1950s that its use flourished.[26] On 19 December 1952 the *Gazette* became the first Quebec newspaper to advertise in colour, as Eaton's, Simpson's, Ogilvy's, and Morgan's each published a full-page ad composed in the standard black ink and the new magenta. The second appearance of colour was three days later: on 22 December Eaton's published its first colour fashion ad in the *Gazette,* a cyan Christmas ornament printed over fashion silhouettes in black ink. From these simple beginnings, Eatons' colour advertising in the *Gazette* would eventually become recognized as among the best in the world.

There are two methods of newspaper colour reproduction: spot colour and four-colour process. Spot colour is used for the reproduction of line copy, or solid forms without gradation, and is defined by the number of colours used.[27] As black is considered a colour in printing systems, the first colour ads that Eaton's published in the *Gazette* were examples of two-colour printing. Each colour requires a separate printing plate and press run, so this method is seldom used for more than four colours. Four-colour process is used to reproduce full-colour continuous-tone copy, or images which possess a full range of tones, such as photographs. Four-colour process is also used to reproduce line copy, but usually only when more than four colours are required. The original image is shot with a process camera,[28] which filters it into four colours: yellow, magenta (process red), cyan (process blue) and black. To reconstitute the full-colour image, these colours are printed as screens of solid dots of various sizes and patterns. Although the *Gazette* had the equipment to print in four-colour process, early reproduction of this type was unreliable due to problems with registration.[29] As spot colour offered better results, Eaton's chose this method to print their prestige fashion ads.

Spot colour also had its limitations. Initially, advertisers could only print in black and one other colour. A limited number of colours was available and a surcharge was applied for special colour requests. For the first few years after 1952,

Eaton's tested new colours in combination with black, but on 4 March 1958, the company published its first three-colour fashion ad in the *Gazette*. The conspicuous image by Parker and Groh, printed in cobalt, pastel blue, and black, won an award in the three or more colours newspaper illustration category at the Eleventh Annual Exhibition of the Toronto Art Director's Club. This was a notable achievement as newspaper colour had existed in Toronto for at least a decade before it was used in Montreal. Three-colour printing added a wealth of creative possibilities. The two colours and black could be used separately, combined as solids, or screened as tints to produce a wide range of colours. Eaton's published eight additional three-colour ads that year.

Changes were now occurring rapidly. On 9 March 1959 Eaton's published the first five-colour ad in the *Gazette*. Orange-red, turquoise, bright green, lemon yellow, and black were chosen to feature spring shoes. There was never a six-colour ad. Instead, the artists experimented with different screened mixtures to achieve additional colours. In some cases they created the effect of process colour, using screens of the primaries and black to make many new colours. The artists also experimented with specialty inks exclusive to spot colour. The advertisement on 4 April 1960 was the innovation of Jack Parker. Finding the grayish newsprint colour inappropriate for a wedding dress, Parker insisted upon a pure white ink. Unfortunately the result was not what he had hoped; as Groh explains, 'we opened the paper to see a grey bride.' A couple of years later a series of successful white ads for summer dresses and fashion accessories was published in the *Gazette*. The reproduction of these ads, from 2 to 8 May 1962, was not without incident. When the proofs turned out pink due to red ink residue on the rollers, the *Gazette*, stopped the presses and bought new rollers in order to achieve Parker's desired result.[30]

Michel Eugène Chevreul, author of *The Principles of Harmony and Contrast of Colours*, believed that colours look best together in either analogous or contrasting harmonies (which include complementary colours, split complements and triads).[31] A close analysis of every ad in the first twenty years of the *Gazette*'s prestige colour fashion campaign reveals that almost 60 per cent of the ads used analogous harmonies. Complementary and split complementary harmonies each amounted to less than 5 per cent of the prestige fashion ads. First used in the *Gazette* ads of 1960, triads represented about a third of the annual ads until 1967, when they began to predominate; they remained prominent at least until 1972.[32]

These statistics reveal a great deal about the colour choices made by the artists. While the creation of illustrations with pleasing, eye-catching colour combinations was a definite objective, several external factors influenced their decisions. As we have seen, when colour was first introduced in the *Gazette* few options were available. Only when working in collaboration with the *Gazette* staff were they

able to experiment with the new colour technology. With the introduction of three-colour printing in 1958, the cost of reproduction figured into the artists' colour selections, as each additional colour increased the price of an ad. Initially, three-colour combinations which included black were popular. A wise choice was magenta, yellow, and black, which when screened and mixed, produced a analogous series of yellows, reds, and oranges. The contrasting harmonies created by combinations of complementary colours were not cost-effective because only greys could be derived from their mixtures. Why choose violet and yellow, which could only produce grey, when other two-colour combinations such as yellow and cyan could add green to the artist's palette for the same money? Mixtures of split complementary colours produce a rather dreary ensemble of muted shades. This explanation makes clear why examples of complementary and split complementary harmonies are extremely rare in the prestige ads. The three-colour combination of magenta, yellow, and cyan, when screened and mixed, produced the semblance of full-colour printing. Not surprisingly, this mixture of colours became the most popular choice at the onset of Eaton's financial difficulties. The store paid only for three colours, but virtually any colour could be made from mixtures of these primaries.

Quite independent of the dictates of technology, economics, and fashion, the artists invariably expressed their own colour preferences. Visibly swayed by the current of Japonisme present in the work of the Impressionists, the Symbolists and the artists of the early de luxe fashion magazines, Groh, Parker, and Strathy chose unusual combinations to symbolize their personal responses to the world. In the Eaton's prestige ads, fashion figures with flesh tones in jet black, violet, loden green, cobalt blue, and dusty rose were topped with brilliant orange, pink, yellow, and blue coiffures. Suggestions for trees and leaves were painted in cherry red, deep purple, medium brown, and violet. Clouds in tints of lawn green, violet, and crimson; waves in lime, forest and cobalt blue; and animals in pastel hues of pink, blue, and yellow were not uncommon. Just as the Japanese *ukiyo-e* prints had liberated European artists from traditional classical modelling with light and shade, the Eaton's artists' disposition of brilliant colour on flat surfaces released their images from the graded washes of Expressionist-style fashion art.

Selling with Images

What, exactly, was the underlying purpose of the artists' work? These illustrations were created to promote Eaton's Montreal store as a fashion leader and to move its merchandise. If art is designed to sell, what processes are involved? How does one sell with an image? Novelty, gimmicks, clever use of colour and original design are all characteristics of good advertising, according to the authors of *Advertising*

Media and Campaign Planning.[33] In short, to be successful, advertising art must first be eye-catching. Equally important are the messages which advertising transmits to the consumer. Clever visual effects might draw attention to an ad, but offensive messages will never encourage sales.[34]

It has been shown that the use of newspaper colour was exceptional in early 1950s Montreal; Eaton's colour advertisements, therefore, stood out dramatically amidst the surrounding black and white pages. The store's regular use of colour established 'pack recognition,' meaning that consumers were able to distinguish Eatons' ads from others and began to associate the store with the avant-garde fashion images portrayed in the ads. The vast majority of the prestige colour ads depicted women's fashion and were thus targeted specifically at female readers. It has been claimed that while most people prefer colour to black and white, women seem particularly partial or receptive to its use; this theory offers another suggestion as to why Eaton's colour advertisements were so effective in attracting their desired audience.[35] Colour was not the only drawing card; even in black and white, Eaton's bold, graphic new style caused a stir from the beginning, receiving awards from outside Montreal as early as 1956. The original page designs in flat greys and black were so successful because they dramatically contrasted with older ads conceived in the Expressionist style. Eaton's combined use of bold colour and unusual design resulted in visually striking imagery, easily meeting the primary criteria of good advertising.

Eaton's strategy for appealing to their *Gazette* target readership was crucial to the success of the company's advertising. The artists had to understand the basic needs and values of that readership, a small, wealthy segment of Montreal society, in order to determine what would appeal to them at any given time. To cater to this elite group, the Montreal store pioneered a new approach in fashion advertising, moving away from solid, unemotional ads based on volume sales to create, instead, imaginative, concept-driven advertising geared at selling exclusive merchandise to a smarter, younger, fashion-conscious customer. The ads were more likely to show something that was suggestive of a certain product than the product itself. Parker adds, 'We weren't just selling merchandise: we built stories around it.'[36]

By the 1960s, when the new style was already well established, the baby boomers had come of age and a new youth culture had erupted. Eaton's artists immediately understood the importance of this dramatic social change and began to interpret the fashion world from the youthful new perspective. For the young boomer, fashion was not just about clothing. It was seen as a reflection of how one lived, as an expression of one's individuality and personal style. Seeking to translate this new, all-encompassing perception of fashion, the Eaton's artists focused less on rendering specific garments and instead chose to incorporate sales merchandise within layouts that projected a brave new world, full of promise, freedom, adven-

ture, and humour. John Berger provides a contemporary analysis of the psychology behind this strategy for selling high-end merchandise: 'Publicity is always about the future buyer. It offers him an image of himself made glamorous by the product or opportunity it is trying to sell. The image then makes him envious of himself as he might be. Publicity is about social relations, not objects.'[37]

Eaton's Narrative of 1960s Youth Culture

Eaton's new strategy for appealing to the 1960s youth culture resulted in the production of a visual history of the times. The ads published in the *Gazette* offered social commentary with iconic reference to popular culture – book dust jackets, pop music posters, album covers, musicals, and comics – and current events – political unrest, technological advances, sporting events, and life in high society. The most obvious commentary provided by the prestige ads is that of costume history and timely concepts of ideal beauty. The avant-garde 1960s fashion phenomenon was labelled a 'youthquake' by British designer Mary Quant. The rounded and sophisticated fashion silhouette of the late 1950s was replaced by a feminine ideal typified by a new model, England's skinny, child-like Twiggy. Reflecting these fashion changes, the Eaton's artists began to sketch lean figures which pranced across the page with youthful spirit. The Italian-inspired 'sun cult' was in full sway and cruise wear became popular for exotic winter escapes. The new importance of having a golden glow was evident in ads which depicted the many faces of the sun and its 'beneficial' rays.

Horizons were broadening. Economic prosperity coupled with rapid developments in aviation technology now allowed for time-saving and affordable air travel. The opening of the country's newest and most efficient international air terminal at Dorval in 1960 signalled the beginning of the jet age in Canada. With foreign lands now easily accessible, people began to travel as never before. Influences in Eaton's ads from virtually every continent reflected this new cultural awakening.

Eaton's target consumers were not only affluent and young, they were also well-travelled. They had seen the world and knew of its treasures. *Applied Arts* notes that 'Parker and his talented team of illustrators and designers set out to appeal to this growing sense of sophistication.'[38] One strategy was their use of the pastiche. Historically an exercise in skilful imitation of a recognized work of art that dates back to seventeenth- and eighteenth-century Italy and France, pastiche in visual art today describes the playful, irreverent incorporation of a traditional artistic style or motif into a new form or setting.[39] One of the more obvious examples of pastiche is an Eaton's advertisement for foundation garments published in *Grenier: Master Artist of the Underworld*, in 1969, that was inspired by Pablo Picasso's *Les*

Demoiselles d'Avignon. A witty correlation is made: Picasso painted a brothel, the artists were trying to sell lingerie, relying upon a sophisticated cultural knowledge of the reader.

Another feature that appealed to Eaton's sophisticated target market was the artists' use of thought-provoking images. The advertising pages which announced new seasonal themes were often created even before the merchandise had arrived in the store. In such cases, the artists were obliged to communicate fashion trends through the use of symbols which were merely suggestive of certain products. At first glance, these ads often did not seem to convey a fashion message. However, a closer examination shows that the artists had craftily projected the most visible attributes of the upcoming season's apparel. As *Applied Arts* aptly explained, 'they were more likely to show an illustration of sheep for a line of sweaters than the products themselves.'

A large young demographic of new consumers with ample free time and money to spend gave rise to the popularization of many leisure activities. According to the ads, sailing, surfing, skiing, jogging, and biking were all popular youth sports. In discotheques, the new temples of youth culture, the Shimmy, the Monkey, and the Swim were the hip dances. Attending rock concerts was another favourite pastime. In 1965, 15,000 fans attended a Beatles concert at the Montreal Forum. Two years later, the fabled Woodstock festival drew a crowd of over 400,000 young people to a farm in upstate New York. Movies, too, sustained a faithful following. *Cleopatra*, starring Elizabeth Taylor and Richard Burton, launched the return of kohl-rimmed eyes, or the Cleopatra Look, as illustrated in a 8 July 1963 Eaton's ad, while Stanley Kubrick's 1962 adaptation of Vladimir Nabokov's novel *Lolita* inspired an ad for Fabergé cosmetics.

Conclusion

If an artist's work is best judged by his or her peers, it is difficult to view the work of Eugenie Groh, Jack Parker, and Georgine Strathy as anything but exceptional. Between 1955 and 1976 their work at Eaton's of Montreal garnered eighty-four awards, as well as numerous accolades from leading associations and publications specialized in advertising communication in North America, Europe, and Asia.[40] Because of this work, the T. Eaton Company was recognized as the supporter of one of the most avant-garde and striking ad campaigns in newspaper history. The *Gazette* also basked in its new fame as the publisher of some of the world's most remarkable newspaper colour. These two institutions received an additional thirty-seven awards for their support and contribution to the art of advertising.[41]

The ads received countless accolades. *Applied Arts* wrote that 'Parker and his

creative team secured a place for themselves in the picture book of Canadian advertising history.' In 1968 the Bureau of Advertising of the American National Press Association explained that the advertising of Eaton's Montreal store 'demonstrates why department stores are leaders in newspaper run-of-paper colour. Their work reflects everything modern in off-beat colours, poster design and the smart use of white space.' A feature story in *CA Magazine* recognizes that Eatons' Montreal store 'has produced outstanding ad concepts and graphics, and some of the finest newspaper colour reproduction ever achieved.'[42] The Eaton's ads have appeared in six volumes of *Graphis Design: International Annual of Design and Illustration*. Publication of their work in this exceptional annual of the world's best commercial art was one of the greatest honours bestowed upon the artists.[43]

The postwar prosperity of the 1950s and 1960s ushered in a new era of social and cultural upheavals. These were very important years at Eaton's of Montreal: business was booming and under Jack Eaton's direction, an educated, often socially prominent staff remained devoted to the company store. However, the cultural climate in Montreal was changing. The French-speaking population of Quebec, frustrated with its lack of status and real power, began to organize its cultural and political emancipation. Few understood the changes which were taking place until the situation escalated to the point where letter-box bombs were targeting the anglophone elite of Westmount. Rod McQueen pinpoints the end of an era: 'Eatons' own season in the sun ended at 3:30 a.m., November 22 1968, when a bomb exploded in a locker on the Métro level of the Montreal store. In the weeks that followed, other devices were discovered and dismantled. Eaton's store windows were fitted with wooden shutters that could be quickly bolted against bombs or riots.'[44]

The underlying tension and resulting economic confusion convinced large numbers of this wealthy community's members to flee the city. Canada had celebrated its centennial in 1967, but it was not long before the issue of Canadian unity began to overshadow the festivities. Jack Eaton, a staunch supporter of the new style of fashion illustration, moved back to Toronto in 1968. When he left, the number of prestige colour fashion ads dropped from a peak of one hundred in 1966 to fifty in only two years. In 1969, when John David Eaton retired, the Eaton's presidency was occupied for the first time by a man from outside the family. That year, the Montreal art department's colour budget was suspended. Colour was used only when a manufacturer agreed to pay the additional printing costs. This new policy limited the artists' creative freedom, as it was now the manufacturers, and not the art department, who had the final say about what appeared in the *Gazette* advertisements.

During this tumultuous time in Montreal, less and less attention was given over

to seemingly frivolous pursuits: Eatons' use of colour advertising drastically declined, as if to prove the Latin dictum *inter arma, silent musae* (in times of conflict muses are silent). By 1971 the number of prestige colour fashion ads had dropped to fourteen. Eaton's was adapting to the different mood of the time and to the changing economy. In 1976 the mail-order catalogue offices were closed; by the late 1970s, photography had replaced illustration as the preferred medium for fashion advertising and an increasing amount of the advertising budget was being set aside for television commercials. The final demise of the Montreal store's independent status came in 1982, when the local administration offices were permanently closed. The staff, including the fashion director, the managers of the different departments, buyers and artists, were all dismissed. Advertising and buying activities were centralized at the Toronto head office.

It was a combination of factors – postwar optimism, economic prosperity, management with vision, technological advances, and an exceptional group of talented artists – that contributed to the creation of Eaton's prestige fashion advertising. It was a series of equally timely events – economic recession, a decline in consumer spending, political turmoil, changes in Eaton's upper management, the increasing costs of colour printing, and those very technological advances which had facilitated inexpensive photographic reproduction and introduced television advertising – that ultimately resulted in the end of this spectacular era in Canadian fashion illustration.

The value of Eaton's ads as travelogue and illustrated commentary on 1960s youth culture leads one to question why this work has not been more faithfully preserved as an important part of Canada's cultural heritage. One may posit that responsibility for this neglect lies within an art/commercial-art tension: the conflict between the perception of art for art's sake and art as a part of everyday life. Commercial art still occupies a marginal place in Canadian art history. In a society shaped by national advertising and mass media, it appears puzzling that many scholars regard work commissioned to sell products or appeal to a popular audience as unworthy of serious study. The repercussions of the divide between fine art and commercial art have resulted in more than semantic scrutiny. Art historians have tended not to focus on the role played by commercially employed artists and thus systematically downplayed the importance of art produced primarily for commercial reasons. As did Oscar Wilde before him, Albert Dorne has argued, in *The Illustrator in America*, that one can differentiate only between good and bad work in any field – which leads to the conclusion that those who were historically influential and successful in their art must have been among its best practitioners.[45] Eugenie Groh, Jack Parker, and Georgine Strathy have played an important role in shaping the course of fashion art and therefore merit recognition in accounts of this field.

NOTES

The title of this essay is taken from the caption of an Eaton's prestige fashion ad published in the *Gazette*. This article has been adapted from the author's thesis of the same title, Department of Art History at Concordia University, Montreal, 2000.

1 These celebrated *Vogue* illustrators died in 1958 and 1963 respectively.
2 Canada, Dominion Bureau of Statistics, Department of Trade and Commerce, Canada 1951, Ottawa, Edmond Cloutier C.M.G., O.A., D.S.P. (Ottawa: King's Printer and Controller of Stationery, 1951), 56, and *Annuaire du Québec 1963*, cited in Linteau et al., *Histoire du Québec contemporain*, 281.
3 Weintraub, *City Unique*, 168.
4 Stephenson, *The Store That Timothy Built*, 86.
5 Jack, the son of RY, was transferred in 1947 to the Montreal store and by 1949 had become the assistant general manager.
6 McQueen, *The Eatons*, 167–68. Joan Aird described Jack Eaton as 'the one who had the fashion flair ... the type of person who would listen' (conversation with Joan Aird, 26 January 1999). Jack Eaton was a staunch supporter of the new style of fashion advertising initiated by Eugenie Groh and Jack Parker and allowed them tremendous artistic freedom, frequently intervening in favour of the artists when their ideas were met with opposition from buyers.
7 Conversation with Eugenie Groh, 27 January 1999.
8 Aird became the store's new fashion director in 1964. She was replaced at the Ensemble Shop by Jean-Pierre Allemand. David Barrington took over the buying for The New Orleans Town House in 1968.
9 Stewart, *Canadian Newspapers*, 75.
10 'It is interesting to note that the renovations to the *Gazette* building in 1957 coincided with the final additions to the Montreal Eaton's store. The two companies were natural partners, both expanding their businesses at a then unprecedented rate.
11 Run-of-paper colour denotes advertising which appears within the newspaper itself, as opposed to colour which is pre-printed and inserted into the newspaper.
12 'A New Stage of Growth: With Splendid Morale ... and New Dedication,' *Gazette*, 4 October 1957, 17 and 20.
13 The two types of newspaper advertising, classified advertising and display advertising, when combined, take up about 50 percent of the space in a successful Canadian daily. See Kesterton, *A History of Journalism in Canada*, 150.
14 Eaton's advertising was so important to the *Gazette* that even the artists received surprising perks. Groh remembers that the newspaper would print her personal Christmas cards in any and as many colours as she wished.
15 Although these statistics have been carefully recorded and verified, it is possible

that some pages were missing from the *Gazette* newspapers consulted in this
survey.

16 McNaught, *Canada Gets the News*, 7; Markin, *Marketing*, 390; Edwards and Brown,
Retail Advertising and Sales Promotion, 161.

17 Eaton's Montreal store used promotional advertising in all the dailies, but it is im-
portant to note that their advertising in the *Montreal Star* and *La Presse* was predomi-
nantly of this type, whereas such advertising was relatively rare in the *Gazette*. It was
the prestige ads, particularly those in colour, which caught the attention of the design
world.

18 Jack Eaton was named general store manager of the Montreal store in 1960. Swin-
dells, *Advertising Media and Campaign Planning*, 141.

19 Jack Clifford was manager of the advertising department when Groh, Parker and
Strathy were hired. Al Leduc took over this position in 1959. Groh often helped
select the merchandise, which was then stored, along with any corresponding written
information, in the 'famous merchandise cupboard' in the advertising department.
Al Leduc was art director from 1949 to 1959, when he was promoted to advertising
director. Layout artist Jack Parker became the new art director. When Parker left
Eaton's in 1966, Neil Whitworth replaced him. After Whitworth's departure in 1969,
Harriet Santroch assumed the position until the art department was closed by the
Toronto head office in 1982.

20 Betty Butler and Jane Campbell wrote the copy for most of the early new-style
fashion ads. They were succeeded by Gordon Wright and Ann Hutchins in the mid-
1960s.

21 Other names, such as Al Leduc and Neil Whitworth also appear. Leduc was the art
director when the three artists were hired, but he was never credited with the initiation
or development of the new style. Later, when he became manager of the Montreal
store, he was one of the executives who promoted this style. Whitworth, also an art
director, oversaw the production of promotional ads for the *Montreal Star* and *La Presse*,
while Parker worked on the prestige ads for the *Gazette*. When Parker left Eaton's in
1966, a team of new designers was hired: Carol Sedgewick, Harriet Golfos (Santroch),
Denis Robert, David Fong, Marcus Fordham, and Ginny Poisson. Without Parker,
Groh designed most of her own pages and also many for Strathy. As Groh was never
officially recognized as art director in title, Whitworth's name would occasionally
appear in association with the prestige ads. In 1969 Groh left Eaton's of Montreal for
Toronto. She continued to illustrate for her old employer as a freelance artist; layouts
were sent to Toronto for her to complete. Although by this time a new team of design-
ers had begun creating layouts for the prestige ads, the new style introduced and de-
veloped by Groh, Parker, and Strathy had already forged an international reputation for
the store. While the new designers made valuable contributions, their art is featured in
this study only when it was created in collaboration with members of the original trio.

22 Eugenie Groh, unpublished ms., 3.

23 Wichmann, *Japonisme*, 6–10.

24 *Fashion Illustration*, introduction, 1, 3.

25 McKay, 'A Little on the Wild Side,' 26.

26 *Editor and Publisher* credits the *Milwaukee Journal* as the first newspaper to use run-of-paper colour in 1891, when it reproduced a red, white, and blue banner on its front page.

27 Spot colour, flat colour and match colour are used interchangeably to refer to the colour reproduction of line copy. Four-colour process is also known as full colour. Tri-colour preceded four-colour process. The tri-colour system was essentially the same, except that black was not used. In the printing industry, copy refers to anything which is to be printed: type, photographs, illustrations, etc.

28 Today this procedure is done with an electronic scanner.

29 Registration refers to the alignment of the different printing plates. If the plates are not properly aligned, the resulting printed images will appear muddy or blurred.

30 Conversations with Eugenie Groh, 18 June 1998, and Jack Parker, 27 August 1998.

31 Birren, *Principles of Color*, 27.

32 Difficulties arose when it came time to analyse Eatons' colour schemes. I was unable to match and therefore compare the colour harmonies with those in the ads using a traditional artist's colour wheel. The colour harmonies in the standard wheel I used were developed from mixtures of the primaries – red, yellow, and blue – but, more importantly, cadmium red, cadmium yellow and cobalt blue. It finally occurred to me that the printer's primaries, also red, yellow, and blue, but more specifically magenta, yellow, and cyan, could never produce harmonies comparable to the artist's wheel. I then sought and found a printer's wheel, but it is made up of acetates in magenta, yellow, cyan and black, and is not designed to show colour harmonies. Finally, using tearsheets from the Eaton's *Gazette* ads, I experimented until I was able to create acrylic mixtures which matched the printed examples of magenta, yellow, and cyan. From there, I created an artist's colour wheel using these primaries. The results surprised me: I was at last able to see patterns in the artists' colour choices. I proceeded to analyse each colour ad using this unique wheel.

33 Swindells, *Advertising Media*, 52.

34 A few advertising campaigns have succeeded in increasing sales revenues by using images which are particularly disturbing. A perfect example of this is Toscani's graphic photography for Benneton. In this unusual case, the consumer seems to appreciate the 'candour' of the clothing company, its willingness to address 'real' issues as opposed to just manufacturing glamour.

35 Swindells, *Advertising Media*, 19–21.

36 'Eaton's of Montreal,' *CA Magazine* 7, no. 5 (September–October 1965), 36; McKay, 'A Little on the Wild Side,' 26–7.

37 Berger, *Ways of Seeing*, 132.
38 McKay, 'A Little on the Wild Side,' 26–7.
39 Hoesterey, *Pastiche*, 2–5.
40 Eighty-four awards have been verified. It is possible that the artists received more.
41 Groh, Parker, Strathy, and Eaton's received eighty-four awards from the Art Directors Clubs of New York, Toronto and Montreal, between 1955 and 1976, a tremendous accomplishment by any standard. In 1961, when Eaton's became the first Canadian store to receive *Retail Advertising Week*'s highest award, the Gold Cup, a special issue entirely devoted to reproductions of Eaton's advertisements was published. Between 1954 and 1975, in addition to the Gold Cup, Eaton's of Montreal received twelve awards from this magazine. In 1963, the T. Eaton Company was presented with *Merchandising Motivation*'s first Gold Nugget Award for its outstanding colour advertising in the *Gazette*. When the New York fashion trade paper *Women's Wear Daily* reported on the award, they noted that the Eaton's colour ads had made 'fashion promotional history.' Around this same time, Groh was selected to represent Canada at an international awards banquet organized by the Advertising Women of Los Angeles; on the day of her arrival, she was interviewed for a live television broadcast. At the annual exhibitions of *Communication Arts*, or *CA Magazine*, Eaton's and the Eaton's artists received nine awards. The T. Eaton Company and the *Gazette* newspaper won three awards at *Editor and Publisher*'s Annual Newspaper Colour Awards Competitions in 1965, 1966, and 1968. Le Publicité-Club de Montréal awarded the T. Eaton Company a *Coq D'or* in 1976.
42 McKay, 'A Little on the Wild Side,' 28; *Creative Newspaper '68*, Bureau of Advertising, American Newspaper Publishers Association; 'Eaton's of Montreal,' 36.
43 Groh is listed in the 1972 editions of *Who's Who in the East*, *The World's Who's Who of Women*, *Who's Who in American Women*, as well as in the *Dictionary of International Biography*, published in Cambridge, England. In 1975 Groh became a fellow of the International Biographical Society. She is also listed in *Personaggi Contemporaneous*, published by Academia Italia in 1984.
44 McQueen, *The Eatons*, 166.
45 Reed, *The Illustrator in America, 1860–2000*.

SELECTED BIBLIOGRAPHY

'A New Stage of Growth: With Splendid Morale ... and New Dedication.' *Gazette*, 4 October 1957.
Barnes, Colin. *The Complete Guide to Fashion Illustration*. Cincinnati: F & W Publications, 1988.

Batterberry, Michael, and Ariane. *Fashion: The Mirror of History*. New York: Greenwich House, 1982.

Beaudoin-Ross, Jacqueline. *Form and Fashion: Nineteenth-Century Montreal Dress*. Montreal: McCord Museum of Canadian History, 1992.

Berger, John. *Ways of Seeing*. London: British Broadcasting Corporation and Penguin Books, 1972.

Birren, Faber. *Principles of Color: A Review of Past Traditions and Modern Theories of Color Harmony*. New York: Van Nostrand Reinhold, 1969.

Bogart, Michele H. *Artists, Advertising, and the Borders of Art*. Chicago: University of Chicago Press, 1995.

'Color Lifts Eaton's Ads to Prize Level.' *Women's Wear Daily* 107, no. 90 (5 November 1963).

Craig, James. *Production for the Graphic Designer*. New York: Watson-Guptill, 1974.

Davis, Angela E. *Art and Work: A Social History of Labour in the Canadian Graphic Arts Industry to the 1940s*. Montreal: McGill-Queen's University Press, 1995.

Desbarats, Peter. *Guide to Canadian News Media*. Toronto: Harcourt Brace Jovanovich, 1996.

'Discotheque Temples Rise: Yeah, Yeah, Yeah.' *Gazette*, 5 November 1964.

'Down through *Gazette* History.' *Gazette*, 4 October 1957.

'Eatons' Man on Colour Ads: "Whole Store Gets A Lift."' *Gazette*, 12 May 1964.

'Eaton's of Montreal.' *CA Magazine*, 7, no. 5 (September-October 1965).

'Eaton's Sets New Record with 24 Pages.' *Gazette*, 18 July 1961.

Edwards, Charles M., Jr., and Russell A. Brown. *Retail Advertising and Sales Promotion*. New York: Prentice-Hall, 1959.

Elkin, Frederick. *Rebels and Colleagues: Advertising and Social Change in French Canada*. Montreal: McGill-Queen's University Press, 1973.

'Expo '67 Fair Made City Talk of World.' *Gazette*, 27 April 1997.

Fashion Illustration. London: Academy Editions, 1979.

Ginsburg, Madeleine. *An Introduction to Fashion Illustration*. Owings Mills, MD: Stemmer House, 1982.

Hoesterey, Ingeborg. *Pastiche: Cultural Memory in Art, Film, Literature*. Bloomington: Indiana University Press, 2001.

Hunt, R.W.G. *The Reproduction of Colour*. London: Fountain Press, 1967.

Jasmin, Claude. 'Une Exposition d'art publicitaire où le talent ne manque pas.' *La Presse*. 9 June 1962.

Kesterton, Wilfred H. *A History of Journalism in Canada*. Toronto: Macmillan of Canada, 1978.

Linteau, Paul-André, René Durocher, Jean-Claude Robert, and François Ricard. *Histoire du Québec contemporain*. Rev. ed. Montreal: Boréal, 1989.

Markin, Rom. *Marketing: Strategy and Management*. New York: John Wiley and Sons, 1982.

McKay, Shona. 'A Little on the Wild Side.' *Applied Arts* 8, no. 4 (November-December 1993).

McNaught, Carlton. *Canada Gets the News: A Report in the International Research Series of the Institute of Pacific Relations*. Toronto: Ryerson Press, 1940.

McQueen, Rod. *The Eatons: The Rise and Fall of Canada's Royal Family*. Toronto: Stoddart, 1998.

Mercer, Harry E. 'Montreal Is Bursting at the Seams.' *Saturday Night* 75, no. 2 (23 January 1960).

'New Look Monday.' *Gazette*, 12 April 1997.

'Newspapers Offering ROP Colour: Rates and Data.' *Editor and Publisher*, 30 March 1957.

'Ninety-nine Years of Colour.' *Editor and Publisher*, 29 September 1990.

Packer, William. *Fashion Drawing in Vogue*. London: Thames and Hudson, 1995.

Parramón, José M. *The Big Book of Drawing*. New York: Watson-Guptill, 1987.

Pop Art. Exhibition program. Montreal Museum of Fine Arts, 23 October 1992–24 January 1993.

'Quebecor Graphique-couleur: Gagnant du Grand Gutenberg 1998.' *Annuaire des Medias et de la Publicité au Québec* 4, no. 3 (April 1999).

Reed, Walt. *The Illustrator in America, 1860–2000*. Rev. ed. New York: Society of Illustrators/Watson-Guptill, 2001.

Stephenson, William. *The Store That Timothy Built*. Toronto: McClelland and Stewart, 1969.

Stewart, Walter. *Canadian Newspapers: The Inside Story*. Edmonton: Hurtig Publishers, 1980.

Swindells, Anthony P.F. *Advertising Media and Campaign Planning*. London: Butterworths, 1966.

Wallace, C.E. *Commercial Art*. New York: McGraw-Hill, 1939.

Weintraub, William. *City Unique: Montreal Days and Nights in the 1940s and 1950s*. Toronto: McClelland and Stewart, 1996.

Wichmann, Siegfried. *Japonisme: The Japanese Influence on Western Art in the 19th and 20th Centuries*. New York: Harmony Books, 1981.

Interviews

Aird, Joan. Conversation with the author, 26 January 1999.

Barrington, David. Conversation with the author, 30 August 1999.

Fordham, Marcus. Conversation with the author, 8 September 1999.

Groh, Eugenie. Conversations with the author, 1997, 18 June 1998, 27 January,
 12 April and 14 December 1999.

Groh, Eugenie. Unpublished manuscript (8 February 1999).

Parker, Jack. Conversations with the author, 27 August 1998 and 7 February 1999.

Santroch, Harriet. Conversation with the author, 6 September 1999.

Sadikovic, Ivana. Conversation with the author, 2 February 1999.

Sedgewick, Carol. Conversation with the author, 7 September 1999.

Strathy, Georgine. Conversations with the author, 1997, 18 June 1998 and 26 January
 1999.

Whitworth, Neil. Conversation with the author, 7 March 1999.

Contributors

Christina Bates (MA) is the Ontario historian at the Canadian Museum of Civilization, Gatineau, Quebec. As well as conducting a research program, she is responsible for the artifact collections pertaining to Ontario, women's history, and clothing. She is the author of *Out of Old Ontario Kitchens*, and has written many articles in books such as *Framing Our Past: Canadian Women's History in the Twentieth Century*, and in journals such as *Material History Review, Dress* and *Muse*. She is on the national board of directors of the Costume Society of America, and past chair of the Ontario Women's History Network, and the eastern branch of the Ontario Costume Society.

Katherine Bosnitch (MA) is a visual artist and a teacher. Her chapter is adapted from her MA thesis in art history from Concordia University. Passionately interested in fashion illustration, Bosnitch has long sought to bring critical attention to the subject. As an artist, she has worked in Canada and abroad, contributing illustrations to books, magazines, and advertising campaigns, primarily in the fashion industry. She is an instructor at Ryerson University, School of Fashion, teaching traditional and computer-generated illustration. She was recently invited to lecture, exhibit her own work, and to serve as a judge at an international fashion illustration contest organized by the Shanghai International Fashion Culture Festival Committee, Donghua University, Shanghai. Bosnitch has been cited in articles about fashion illustration in numerous periodicals, including the *National Post, Clin d'Oeil*, and *Applied Arts*.

Gail Cariou (BA) first became interested in men's clothing in 1976, when she studied traditional men's tailoring techniques under an Italian master tailor at the Northern Alberta Institute of Technology in Edmonton. She subsequently studied historic costume at the University of Alberta and Art History/History at Carleton University. She is a former costume curator for Parks Canada, responsible for

research on men's clothing, and is the co-author of two Parks Canada publications on the cut and construction of eighteenth-century men's and women's costume. In 2002 she guest-curated 'Clothes Make the Man,' an award-winning exhibit of men's fashion from the eighteenth century to the present, with Cynthia Cooper and Eileen Stack at the McCord Museum of Canadian History in Montreal.

Susan Turnbull Caton (PHEc, PhD) was a professor of clothing and textiles for twenty-three years at the universities of New Brunswick and Manitoba. She holds a doctorate in textiles and clothing from Ohio State University. She taught and researched in the areas of history, education, and consumer behaviour, and served as department head at the University of Manitoba from 1987 to 1998. Her research on civilian dress in Commonwealth countries during the Second World War took her to study primary documentation in Canada, England, and Australia. She curated and co-curated several costume exhibits in Winnipeg, including 'Fashion Marches On' at the Western Canada Aviation Museum, 'Where/Wear to Stare' at the Centre Culturel Franco-Manitobain, and 'In Pursuit of Dragons' at the Architecture Gallery, University of Manitoba. She has published extensively. She authored the book *'Clotheslines'* (1998), was a contributor on fashion in the 2001 edition of the *Reader's Guide to the Social Sciences* (UK), and edited the *Canadian Home Economics Journal* for three years. She presently owns a small business in Victoria, BC, designing and producing west coast fabric accessories for boat and home.

Cynthia Cooper (MSc) is curator, Costume and Textiles at the McCord Museum of Canadian History. She is the author of *Magnificent Entertainments: Fancy Dress Balls of Canada's Governors General, 1876–1898* (Fredericton, New Brunswick: Goose Lane Editions and Canadian Museum of Civilization, 1997), and was guest curator of the related exhibition, 'Dressing Up Canada: Late Victorian Fancy Dress Balls' held at the Canadian Museum of Civilization, Hull, Quebec, from October 1997 to October 1998. At the McCord Museum, she was a member of the curatorial team, along with Eileen Stack and Gail Cariou, that produced the exhibition Clothes Make the Man, winner of the Costume Society of America's 2003 Richard Martin Award. She received her M.Sc in Historic Costume and Textiles from the University of Rhode Island.

Barbara M. Freeman (PhD) is an associate professor in the School of Journalism and Communication at Carleton University, Ottawa, where she teaches, among other subjects, journalism history, and historical and contemporary perspectives on women and the media. She holds a doctorate in history from Concordia University, Montreal, and is the author of *The Satellite Sex: The Media and*

Women's Issues in English Canada 1966–1971 (2001). She is also the author of *Kit's Kingdom* (1989), a study of the life and journalism of Kathleen Blake Coleman (1856–1915). She has contributed an entry on Coleman to the *Dictionary of Canadian Biography*, vol. XIV (1998) and has also written articles for several anthologies and scholarly journals, including *Framing Our Past: Canadian Women's History in the Twentieth Century* (2001), *Canadian Journal of Native Studies, International Journal of Canadian Studies*, and *American Journalism*. Before she began her academic career, Dr Freeman was a journalist and broadcaster in Canada and England.

Deborah Fulsang is the fashion editor of the *Globe and Mail*. Previously she held the position of senior editor of fashion and design at *Flare*, and before was the fashion editor at *Style*, Canada's trade journal for the women's apparel industry. She has taught in the fashion program at Toronto's Humber College and worked jointly with the city's Design Exchange to curate a show promoting leading-edge Canadian fashion designers entitled *Fall Forward* in the fall of 1995. She has conducted talks on fashion for New York–based Fashion Group International and has also contributed to *Azure, Canadian House & Home* magazine, *Marketing* magazine, as well as the *Toronto Star* on subjects pertaining to fashion and style.

Barbara E. Kelcey (PhD) is a Winnipeg historian. She is the author of *Alone in Silence: European Women in the Canadian North Before 1940* (McGill-Queen's University Press, 2001) and co-author of *A Great Movement Underway: Women and the Grain Growers' Guide 1908–1928* (Manitoba Record Society, 1999). She completed a doctorate in Canadian history at the University of Manitoba. She is an accomplished needleworker and dressmaker which prompted her interest in the subject of dress reform when considering the subject of women's dress on the Klondike Trail in her article 'What to Wear to the Klondike. Outfitting Women of the Gold Rush' (*Material History Review*, Spring 1993). Her current project is organizing the parish records of the Anglican Diocese of Rupert's Land and a book on mystery writers.

Peter J. Larocque (MA) is curator of New Brunswick Cultural History and Art at the New Brunswick Museum in Saint John, New Brunswick. Among his curatorial responsibilities is the largest collection of fashion costume in Atlantic Canada. One recent project specifically related to the garment industry, *Vanity and Virtue: Women's Dress from nineteenth-Century New Brunswick,* was an exhibition of twenty dresses made and worn in the province between 1800 and 1900. Focusing on both serviceable and stylish garments, the exhibition explored some aspects of society's attitudes towards, and expectations of, their wearers.

M. Elaine MacKay (BA, CCS, ADCS) has taught pattern drafting, modern draping, costume history and construction at Dalhousie University and the Nova Scotia College of Art and Design. She has worked as a professional cutter and tailor in theatres across Canada, including the Stratford Festival, the Banff Centre, and Mirvish Productions. She studied theatrical costuming at Dalhousie University in Halifax, Nova Scotia, where she earned an advanced diploma in Costume Studies with a museum specialization. She contributed to the styling of 'The Cutting Edge: Fifty Years of British Fashion,' at the Victoria and Albert Museum in London, England.

Jan Noel (PhD) is a member of the history department of the University of Toronto at Mississauga. She has also taught at York, Trent, and Simon Fraser universities. Noel's book *Canada Dry: Temperance Crusades before Confederation* won the 1996 John A. Macdonald Award as book of the year in Canadian history. Her 1998 booklet *Women in New France* was published by the Canadian Historical Association. Her latest work, 'Decoding Gender in Colonial Canada,' is forthcoming from University of Toronto Press. Professor Noel has published a dozen books and articles on gender, social reform, and pre-Confederation society. She is currently completing a book on women in New France.

Alexandra Palmer (PhD) is the Nora E. Vaughan Fashion Costume Curator in the Textile and Costume section at the Royal Ontario Museum, Toronto. She is also adjunct faculty in the graduate program in Art History, York University and teaches in the Art History Department, University of Toronto. Her book *Couture and Commerce: The Transatlantic Fashion Trade in the 1950s* (UBC Press and ROM, 2001) won a Clio award for Ontario history. Her publications include 'Italian Couturiers in Postwar Toronto,' in *Framing Our Past. Constructing Canadian Women's History in the Twentieth Century*, eds. Sharon Cook, Lorna McLean, and Kate O'Rourke (McGill-Queen's University Press, 2001) and 'Virtual Home Dressmaking: Dressmakers and Seamstresses in Postwar Toronto, Canada,' in *The Culture of Sewing: Gender, Consumption and Homedressmaking*, ed. Barbara Burman (Oxford: Berg 1999), and she is co-editor of *Old Clothes, New Looks: Second Hand Fashion* (Oxford: Berg, 2004). She is working on a book, *20th Century Culture and Couture in Toronto*, that has been supported by a grant from the Social Sciences and Humanities Research Council of Canada.

Lydia Ferrabee Sharman (PhD) is a designer, writer, teacher, and artist. She was a professor in the Department of Design Art at Concordia University for ten years, three as department chair, where she taught design history and theory, and studio courses. She now continues to teach as an emeritus professor at Concordia and an

adjunct professor at the School of Industrial Design at Carleton University, and advises graduate students in both universities. She has practised as a professional designer in London, New York, and Montreal, written extensively on Canadian design for European and North American design journals, lectured and presented papers on design subjects in Canada, England, and the United States, and contributed essays on the designers Douglas Ball and Robert Gersin for *Contemporary Designers* (Macmillan, 1984). Her children's book, *The Amazing Book of Shapes* (1994), published by Dorling Kindersley, has sold over seventy thousand copies, and been translated into Dutch, Greek, German, Hebrew, Catalan, and Castilian. The Victoria and Albert Museum has published her booklet, *Teaching Math through Islamic Art*, based on the geometry of items in the museum's collection. Lydia Sharman's prints and photographs have been exhibited in solo exhibitions in Quebec and the United States, in group shows in London and Montreal, and are in collections in England and Canada.

Elizabeth Sifton (MA) a Montrealer by birth, graduated from McGill University in 1952. A career in merchandising spanned three decades, first at Eaton's, and later at the Hudson's Bay Company, where she became a specialist in children's wear, planning merchandise assortments and developing product lines in the domestic, European, and Asian markets. She returned to academic studies receiving her MA in art history from Concordia University in 1994. Her thesis topic was nineteenth-century retailing in Montreal. Since spring 1985, Elizabeth has been an active volunteer at the McCord Museum of Canadian History, and is a research associate in the Costumes and Textiles Department.

Eileen Stack (MSc) is communications officer at the McCord Museum of Canadian History. Previously, she worked as curatorial assistant on the McCord exhibition 'Clothes Make the Man,' winner of the Costume Society of America's 2003 Richard Martin Award for Excellence in the Exhibition of Costume. Her article 'Highland-Inspired Clothing at the McCord Museum' will appear in the upcoming volume *A Kingdom of the Mind* (McGill-Queen's University Press). As a graduate intern she conducted research for the exhibit 'The Ceaseless Century: Three Hundred Years of Eighteen-Century Fashion,' at the Metropolitan Museum of Art, New York. She received her MSc in Historic Costume and Textiles from the Univesity of Rhode Island, and her BA from Concordia University, Montreal, in Communication Studies.

Index

Page numbers given in italics refer to illustrations.

evening gowns, 96, 207, 219, 279–80, 282, 298, *299*
foundation garments (*see* underwear)
jackets: men's, 55, *56, 57, 58*, 68, 195, 252; differences in quality between custom-made and mass-manufactured, 189; women's, 91, *92, 99*, 102
jumpsuits, 102–3
palazzo pants (*see* trousers)
shirts, men's, 68, 75, 81, *82*, 83, 196
skirts, 27, 44, 91, *92, 94*; changes in styles in the Second World War, 252, 260; detrimental to women's health, 236–8; divided, 240, 308–9; in nineteenth century, 85, 229–30, 241
slacks (*see* trousers)
trousers: men's, 69, 78, 176, *176*, 195; women's, 9, 76, 91, 241, 260, *263*, 292, 308–9, 347, *colour plate G* (*see also* bloomers)
suits: men's, 76, 79–81, *82*, 86, 252; women's, 260, *261*, 275
undergarments, 234, 321, 353; crinolines, cage, 85, 230; crinolines, horsehair, 85; petticoats, 85, 236–7 (*see also* corsets)
waistcoats, men's, 68–9, 73–5, 167, 189, 195
wedding dresses, 6, 279
clothing industry. *See* garment industry
Cockburn, Mr A.P., 52
Colonial House, Montreal. *See* Morgan, Henry and Company Limited
Communication Arts, 339
costume. *See* fancy dress; fashion
costume collections in Canada: Canadian Museum of Civilization, Hull, Quebec, 5–6, 130; Costume Museum of Canada, Dugald, Manitoba, 5; McCord

Museum of Canadian History, Montreal, 5–6, 82, 189, 270–1, 276, 282; Royal Ontario Museum, Toronto, 5–7; Ryerson Polytechnic University, Toronto, 5; Seneca College, Toronto, 5, 7
Counter, John, 195
couturiers. *See* fashion designers
Creeds, Toronto, 318
The Critic (Halifax), 173

Davidson, Arthur, 68, 75
Day, Doreen, 280, 341
The Delineator, 241
department stores, 131–3, 293, 340. *See also* Carsley; Eaton's; Fairweathers; Goodwin; Hudson's Bay; Morgan; Murphy; Murray; Ogilvy; Rea; Simpson
Design Exchange, Toronto, 4, 329, *330, 331*
Diamond Information Centre, 319
Diefenbaker, Olive, 278
Dollars for Britain, 274, 276
Dominion Board of Trade, 51–2
Domino, 324
Doull & Miller, 168–9, 173, 174, 175
Dress Reform Association, 231
dress reform movement, nineteenth-century: in Britain, 232, 235; in Canada, 229–30, 232, *233*, 235, 237–8, 239–44, 292, 304, 306, 308–9; in the United States, 231–2, 234, 241–2
dressmakers and seamstresses, 48, 141, 144, 150–2, 154, 158, 184, 238–9
Dry Goods Review, 123, 127, 131
Drummond, Helen Redpath, 84–5
Dupuis Frères, 343

Eaton, John Wallace [Jack], 340–1, 345, 355